ACC. NO. BK38701

CLASS NO. 760.92/H

MID CHESHIRE COLLEGE

ORDER NO. O8307

KT-237-687

This book is due for return on or befo

BK38701

HOWARD HODGKIN PRINTS

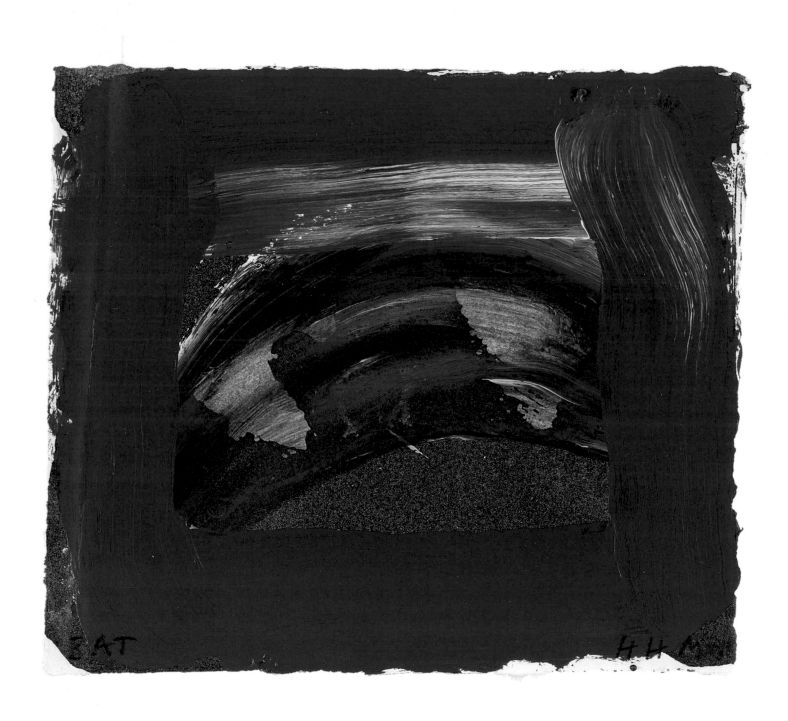

Sea 2002–03 (cat. no. 117)

Liesbeth Heenk
introduction by Nan Rosenthal

HOWARD HODGKIN PRINTS
a catalogue raisonné

with 209 illustrations,
including 83 in full colour and 126 in duotone

Thames & Hudson

This book is dedicated to Esther and Naomi

Acknowledgments

I have received help from many people, but I would particularly like to record my gratitude to Yvonne Andrews, Paul Cornwall-Jones, Alan Cox, Alan Cristea, Keith Davey, Robert Delvaney, Kathleen Dempsey, Pat Gilmour, Deborah Haley, Susan Harris, Susan Haskins, Anthony Hepworth, Howard Hodgkin, John Hutcheson, Richard Ingleby, Stanley Jones, Christine Kurpiel, Ian Lawson, Danny Levy, Ann Marchini, Anthony Matthews, Maurice Payne, Antony Peattie, Bruce Porter, Jeremy Rees, Bob Saich, Jack Shirreff, Tessa Sidey, Judith Solodkin, Cinda Sparling, Joe Studholme, Åsmund Thorkildsen, Joanna Thornberry, Perry Tymeson, Caroline Wiseman, Louise Wright and above all to Menno Lievers, and to the many dealers and curators who have provided details about their Hodgkin exhibitions and publications.

Any copy of this book issued by the publisher as a paperback is sold subject to the condition that it shall not by way of trade or otherwise be lent, resold, hired out or otherwise circulated without the publisher's prior consent in any form of binding or cover other than that in which it is published and without a similar condition including these words being imposed on a subsequent purchaser.

First published in the United Kingdom in 2003 by Thames & Hudson Ltd, 181A High Holborn, London WC1V 7QX

www.thamesandhudson.com

© 2003 Thames & Hudson Ltd, London
Introduction © 2003 Nan Rosenthal

All Rights Reserved. No part of this publication may be reproduced or transmitted in any form or by any means, electronic or mechanical, including photocopy, recording or any other information storage and retrieval system, without prior permission in writing from the publisher.

British Library Cataloguing-in-Publication Data
A catalogue record for this book is available from the British Library

ISBN 0-500-09309-1

Printed and bound in Germany by Steidl, Göttingen

Contents

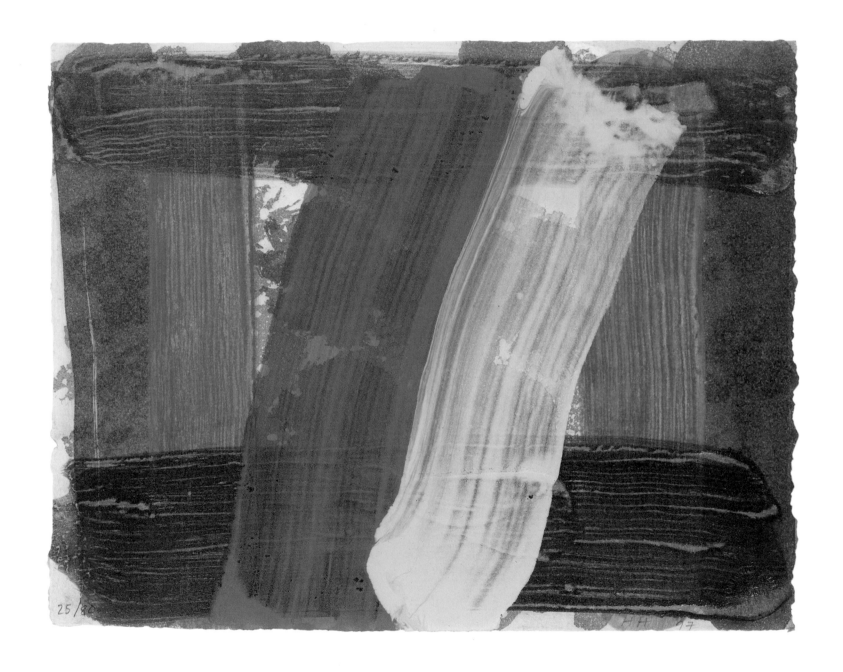

Summer 1997 (cat. no. 98)

Introduction:
'To make the most of an image...'

Nan Rosenthal

Howard Hodgkin is by temperament a painter. An account of his unusual achievement as a printmaker needs to begin with a description of his painting, including the environment in which it continues to develop. His London studio, a large, skylit, brick-walled space, is painted refrigerator white. At any given time a number of paintings in progress lean against the walls. These oil on wood objects, which Hodgkin may work on over a period of years, are shielded from view by easily moveable rectangles of white fabric on stretcher bars. Only the particular panel on which he is working at a given time is visible as he paints. The white expanse provides an immaculate foil for the brilliantly saturated hues Hodgkin usually employs. The manner is what used to be called painterly, but the colours are distinct from one another. Sometimes velvety blacks, richly modulated greys or unexpected pastel tones set off the strong hues and intensify them.

Since the late 1960s Hodgkin has painted on supports of wood instead of canvas because, he has said, he likes the resistance of wood as well as its character. It is also convenient for revisions. Sometimes Hodgkin uses pieces of wood he has found; most of the time he uses plywood. His application of paint to wood is boldly assertive. In recent years his characteristic repertoire of marks – stippled dots marshalled into loose grids, splotches, enlarged commas and fatly modelled cylinders – has come more and more to be dominated by long, broad brushstrokes.

What appears to the viewer to have been laid down with exceptional spontaneity has been – but in layers applied over a period of time. In part because Hodgkin uses Liquin, a fast-drying alkyd medium that increases the flow of oil paint and intensifies its translucency, his layers of overpainting do not build up a thick, impastoed surface. The top layer seems to prevail. However, in painting after painting, glimpses and, more often, distinct patches or larger areas of the underlayers are left visible, as if to disclose some of the history of the work, that is, the mind that decided what to paint over and where. This is one of several conspicuous contradictions in Hodgkin's work: the spontaneity, although real, has been considered. And one 'spontaneity' often supplants another.

Before he begins to paint a picture, Hodgkin typically surrounds his wooden panels with moulded frames he has collected (usually) or ordered (sometimes). These frames are painted; they are part of the composition of the pictures. This is true whether the paint is applied to the frames so as to stress their nature as borders or whether the paint sweeps across the frames so as nearly to obliterate the physical fact that they exist in relief and are nearer the viewer than the rest of the panel. With the visible passages of underpainting, the frames often suggest, as most frames do, that the viewer may imagine an illusion of depth receding from the picture surface. On the other hand, the moulded frames, together with the wood supports they surround, emphasize the object-like quality of Hodgkin's pictures, that these pictures are things, rather than windowed depictions into an imaginary world that is different from the actual space in which the viewer is standing. It's something of a contradiction.

The strong presence of Hodgkin's painted frames also prevents the imposition of any others. To impose a frame around a Hodgkin painting would be as absurd as framing a Robert Rauschenberg combine painting or setting a Donald Judd floor sculpture on a pedestal. In the end what dominates is Hodgkin's luscious application of paint. His much quoted statement of several decades ago – 'I am a representational painter, but not a painter of appearances. I paint representational pictures of emotional situations' – seems, especially in his recent work, no longer to tease the viewer into (inevitably) futile attempts to decode either the emotions or

the situations, even when these are hinted at by the artist's suggestive titles. The titles in any case reveal no narratives. One critic has asserted that the forcefulness of Hodgkin's paint application prevails over the suggestions of illusion and that this makes his 'representations' seem like abstractions.[1] Another contradiction.

Hodgkin's manner of painting, to proceed slowly to find an image while alone in a clean white studio, is in some respects quite incompatible with the actualities and economics of contemporary printmaking. Printmaking is a mediated medium, somewhat analogous to filmmaking. The artist goes out of his studio, often to another city, to work at an expensive specialized shop with other people. Their craft and knowledge of techniques, such as how to etch, ink and wipe a plate from which to print the image in an edition, is crucial to the outcome. Hodgkin recalls that early in his career as a printmaker, after he had produced some screenprints but before he had worked with techniques that are less immediately reproductive, the print publisher Paul Cornwall-Jones, whom he has described as 'an amazing teacher', told him the following, 'You don't quite understand, prints are made for people who already have an image, not for people who are searching for one. If you know what you are going to do, you'll make a print. If you don't know what you are going to do, you'll make a mess.'[2] This sergeant-majorly advice encouraged Hodgkin to begin to conceptualize images in advance, an approach that goes somewhat against the grain of his method of painting slowly, although spontaneously, in layers. As he gradually acquired knowledge of what printmaking methods were particularly compatible with the directness of his painting, for example, soft-ground etching or a tonal technique such as aquatint, it became easier to think in advance about an image without sacrificing a direct way of working. Today he may keep ten future prints in his head.

Hodgkin's method of painting so that successive layers of paint deposits are left conspicuous (whether to serve an illusion of depth, or to function as a metaphor for the personal memories that inform the paintings, or to make the surface vivid) seems in one sense utterly compatible with the nature of intaglio and planographic printing. The etchings and lithographs that dominate his prints

Indian View C, from 'Indian Views' 1971 (cat. no. 13)

Indian View J, from 'Indian Views' 1971 (cat. no. 20)

of the last twenty-five years are – like most prints – produced in successive layers. Printing plates inked with different colours and different parts of the imagery deposit ink in careful registration on the same sheet of paper. In this respect, thinking in layers, Hodgkin has for a long time thought like a printmaker. Given his approach to painting, layers come naturally to him.

An irony here is that it is much easier to conduct a visual archaeological dig back through the strata in one of Hodgkin's paintings than in one of his prints. Although it is well known that etchings and lithographs are produced in successive runs through a press, even with the aid of a paper conservator's intensely lit magnifying glass it is not a simple matter for an expert to read the exact order of the layers in a Hodgkin print. It seems that he prefers it that way. Still another contradiction.

William Ivins wrote sixty years ago, in his classic text *How Prints Look*, that 'a print may be defined as an image made by a process that is capable of producing an exact number of duplicates. Such an image cannot be made directly by hand, for no copy is like the original from which it is copied, and no two copies are alike. This means that no two handmade pictures can tell the same things about the same object.'[3]

Hodgkin stood this axiom on its head in 1977 when he introduced into his printmaking the practice of hand colouring each different sheet in a numbered edition. This has nothing to do with the kind of hand colouring common to early woodcuts, when outlined areas were filled in with watercolour. (Outlines of a coloured shape in any case are very rare in Hodgkin's work. He does not like lines and does not make drawings, except small, private schematic ones.) In respect to their sizes and shapes, the hand-coloured areas in Hodgkin's prints do not differ greatly from the printed areas. Hodgkin reminisced recently that one of the reasons he may have initiated the practice of hand colouring, at a time when he was not yet deeply experienced about effects that can be achieved with intaglio processes, is that 'you can cancel out what you have already done.'[4] However he began, his use of hand colouring very soon became something other than corrective. Hodgkin almost immediately put into inverted commas his curious diversion from Ivins' statement

about exact duplicates. For one thing, he assigns the hand colouring to hands other than his own, those of an individual working in the print shop who could follow his instructions about how to make the coloured deposits he wanted. He specifies such things as the kinds of paint – watercolour, gouache, or acrylic, for example, the exact colours (selected from a chart), the widths of the brushes to be used, and the size and placement of the paint strokes. In occasional cases he himself paints an example to be followed by the hand colourist. More often he describes in language the strokes he seeks, even describing the kind of gesture the assistant might aim for when applying the paint ('as easy as hitting a baby' or 'too much is usually just enough'[5]). The idea was to repeat the same image throughout an edition, yet with freshness. With the assistant Hodgkin then editions the prints, discarding examples he deems unsatisfactory. By assigning the hand colouring to another hand, he accomplishes something that seems to attract him, a slightly ironic or distancing effect. Personal marks, even painterly ones, become on some level impersonal if they are not, in fact, his own. This territory lies somewhere between Laszlo Moholy-Nagy's ordering geometric abstractions on the telephone in 1922 and the gestural paint handling of an Abstract Expressionist working in isolation in the 1950s. Perhaps it is closer to an activity of certain artists of Hodgkin's generation, Minimalist sculptors, whose works are fabricated by craftsmen, but according to the artists' meticulous instructions. Hodgkin has discussed it by analogy to the handwriting characteristic of many drawings by Saul Steinberg, wherein the loopy cursive script from Steinberg's pen forms not letters of the alphabet but supremely elegant lines of nonsense that distance handwriting from meaningful language, while implying that meaning is there.[6]

The hand colouring in Hodgkin's prints varies from edition to edition. Sometimes it is used as a bottom layer, primarily to colour the paper. Sometimes it is sandwiched between different printed runs through the press. At other times it is applied after the print run is complete. Several of these methods may appear in one print. It has brought to many of the prints the *alla prima* quality and vividness of surface found in his paintings.

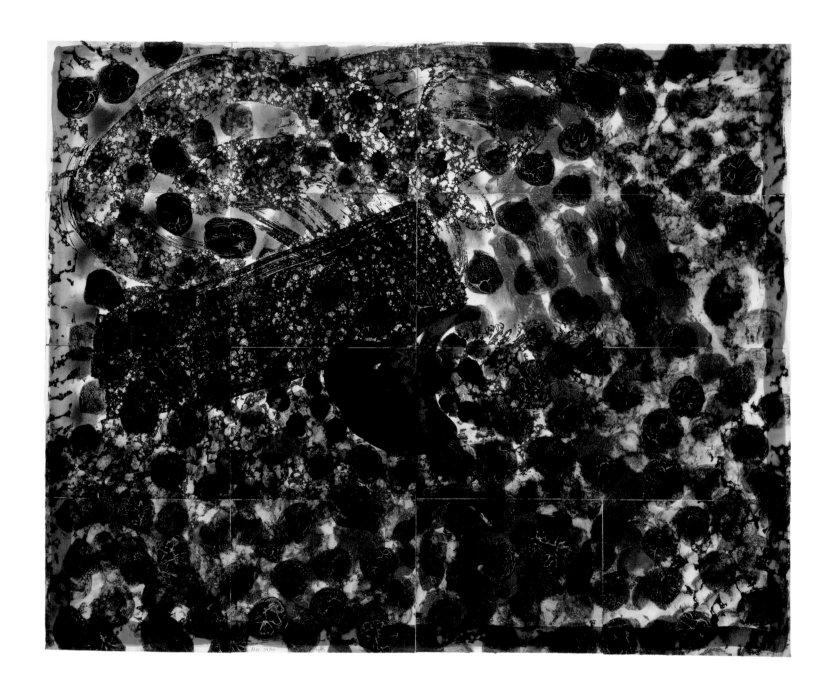

Venice, Morning, from 'Venetian Views' 1995 (cat. no. 93)

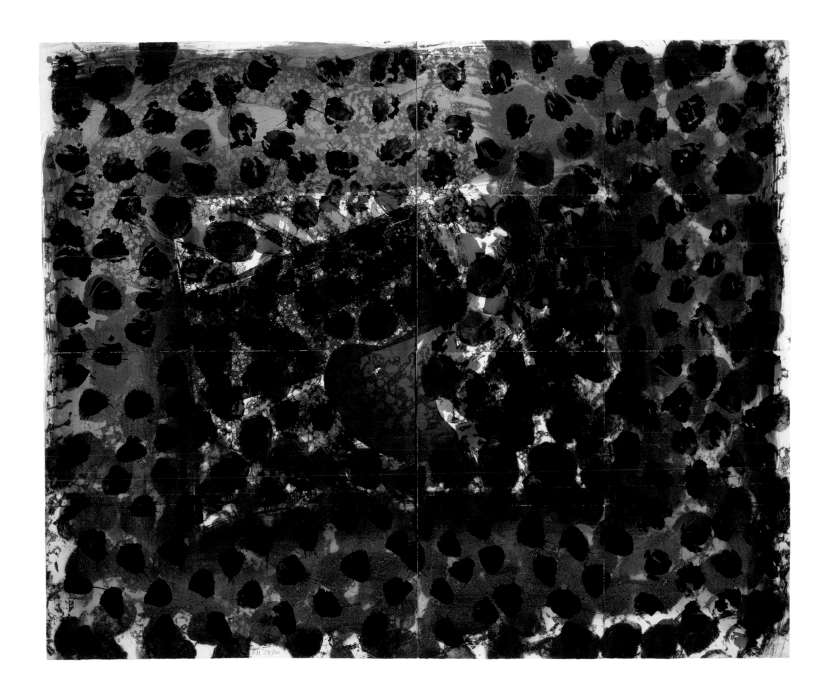

Venice, Afternoon, from 'Venetian Views' 1995 (cat. no. 94)

As early as 1971, when Hodgkin made the 'Indian Views' (pages 10 and 11), a series of twelve screenprints of his recollections of exterior scenes of India as glimpsed through the small windows of a moving train, the frames that form part of the compositions of his paintings appear in depicted, although abstract, form as wide borders in the prints. In the 'Indian Views' these frame-like borders originated, at least conceptually, as the perimeters of actual windows or at any rate as a marker between the position of the artist-viewer inside the train and what he saw through the window. In the intaglios and lithographs of the late 1970s and early to middle 1980s the emphatic frame-like elements, sometimes created by hand colouring, frequently help to establish a window-like view into interior scenes. It is interesting that often these painted or printed 'frames' do not extend to the edges of the printed sheets but are set some distance inside the periphery. The engraving line that forms a natural inkless border around most intaglio prints, made by the imprint of the metal plate on the dampened paper as it goes through the press, has no place in Hodgkin's work. In all of his intaglio prints the size of the plates is at least slightly larger than the size of the papers – or the papers were torn down after printing – with the result that no engraving line is created. For Hodgkin the appearance of such a traditional border would evoke the fussier aspects of printmaking, which he strives to avoid. It would also introduce a mechanical frame into an image conceived as having an imaginary frame of the artist's own making. Here Hodgkin seems intent on *removing* a possible contradiction.

In many of the intaglio prints of the 1990s, the wide vertical and horizontal frame-like elements are still a strong part of the composition. Yet for several reasons – such as the thickness of hand-made papers used, the superimposition of large swaths of colour going in diagonal directions over parts of the frame-like elements, and the use of carborundum paste on the etching plates, which creates embossed areas on the paper – in a number of the more recent prints the function of the depicted frames as illusionistic devices seems to give way to the material and abstract qualities of the prints.

It is the fate of most works on paper that hang on the wall to be protected. Often they are set off by mattes; almost inevitably they are glazed and encased in real frames. This presents a quandary for Hodgkin. He said not long ago that, 'I want my prints to be like my pictures only in one way and that is, I want them to be things that are self-sufficient. I don't like mattes, frames, and glass. That's all distancing and takes people away from the prints, which I want to be as physically powerful as possible.'[7]

Hodgkin has approached the challenge of powerful physicality in various ways. One has been to exploit a strong visual memory of Paris in the late 1950s when he saw enormous advertising posters in metro stations. In a series of exceptionally direct, readable hand-coloured etchings made between 1986 and 1991, some of African palms, one of a Moroccan door, one of a mango, Hodgkin enlarged both the actual size of his prints relative to most earlier graphic work and the internal scale of the imagery. For example, in the nearly 1.5 x 1.2 metres (5 x 4 ft) *Palm and Window* (1990–91; page 116), the reach of the intensely green palm fronds, seen on a black ground, exceeds the height and width of the sheet. That is, the tips of the fronds are cut off, which lends a forceful sense of compressive energy to the print.[8]

Over the past two decades Hodgkin has worked with the printmaker Jack Shirreff at the 107 Workshop in Wiltshire on prints that combine hand colouring with lift-ground aquatint and the relatively new medium of carborundum. Using a range of different grains of resin in the aquatint grounds, from fine to very coarse, has varied the texture of areas of his prints. The carborundum medium varies the texture even more emphatically. A thick paste made of this very hard substance is distributed on the plate by the artist, using a brush or his hands. It then dries. Shirreff has likened the plate at this point to a relief map of the Alps, with peaks, escarpments, valleys and plains. When the plate is inked and wiped, ink remains trapped in the escarpments and valleys but disappears from the peaks and the smooth plains. Dampened hand-made paper, thick enough to adapt to the hardness of the dried carborundum, is pressed on the plate and two things occur: the paper takes on the structure of the peaks and valleys – it becomes a

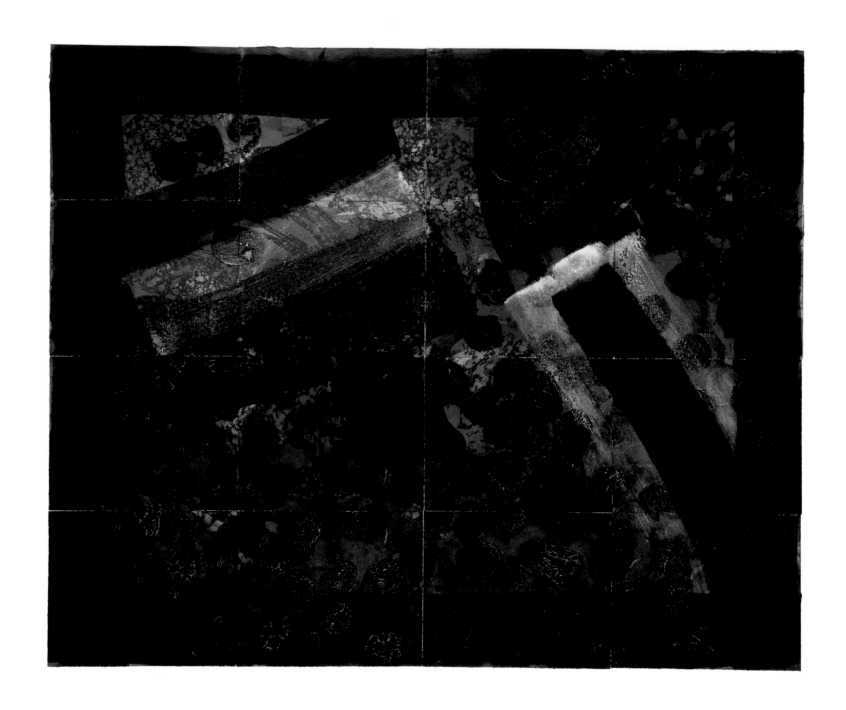

Venice, Evening, from 'Venetian Views' 1995 (cat. no. 95)

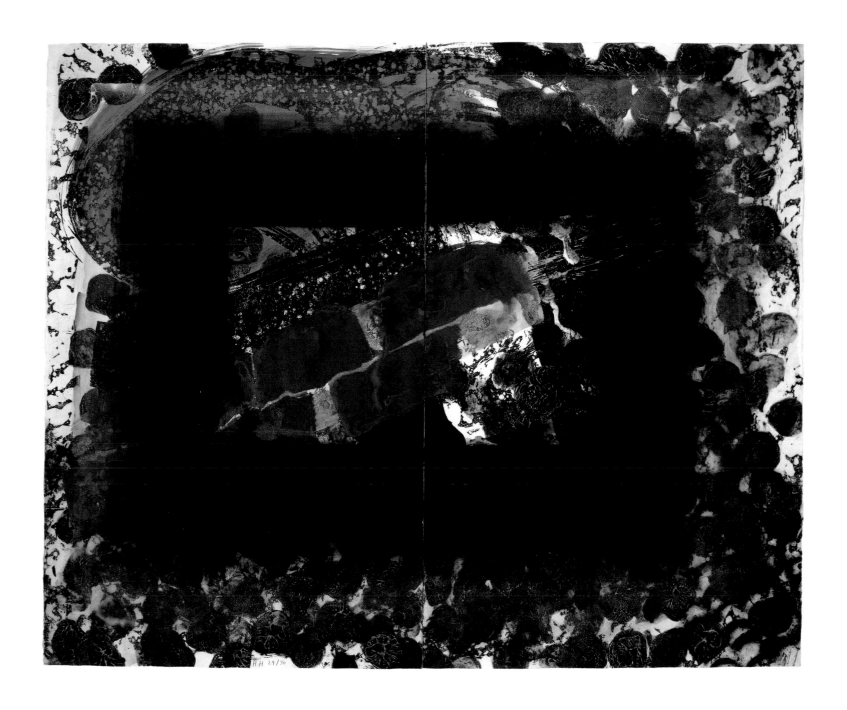

Venice, Night, from 'Venetian Views' 1995 (cat. no. 96)

Red Print 1994 (cat. no. 91)

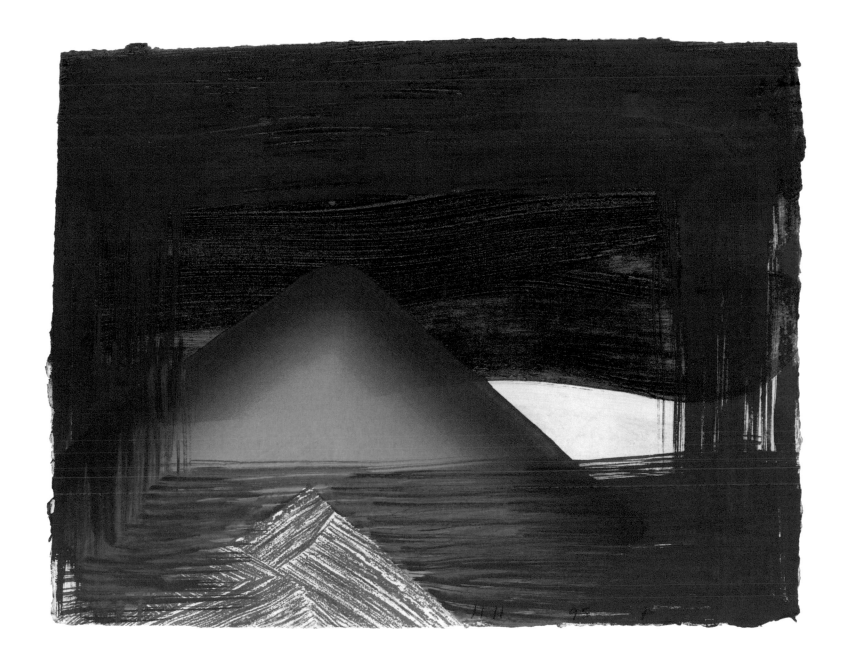

Snow 1995 (cat. no. 92)

Howard Hodgkin's printed oeuvre

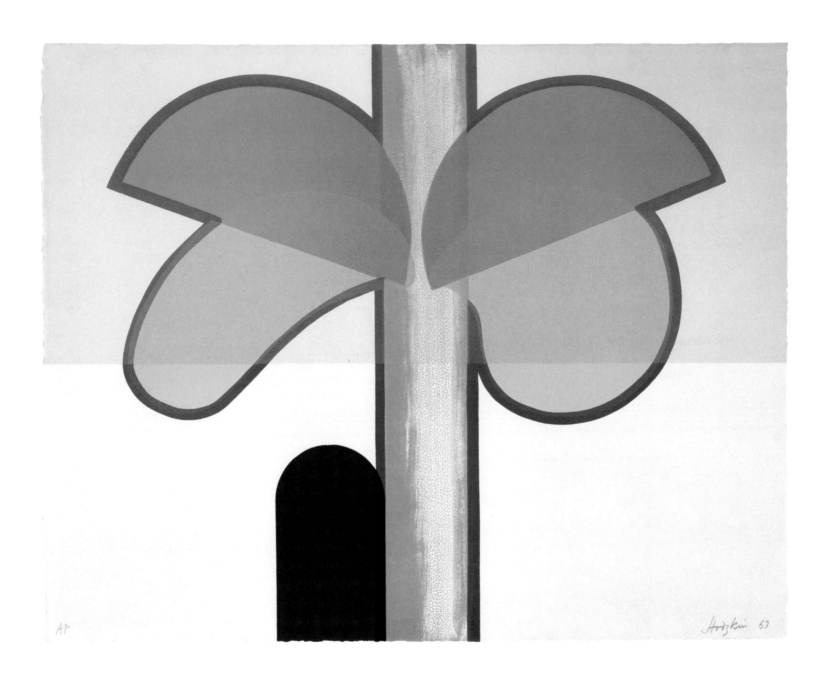

Indian Room, from '5 Rooms' 1967 (cat. no. 7)

Writing about Howard Hodgkin's work confronts the author with a dilemma. Hodgkin strongly believes that art should be concerned with the communication of pure aesthetic emotion through form. In his opinion, words stand in between the work and the viewer and make a sheer sensual response impossible. Words do not bear the slightest resemblance to what the work expresses. They do not do justice to the work; they interfere with the viewer's appreciation. Hodgkin wants the work to speak for itself.

As early as 1966 Hodgkin laid down his credo by quoting Matisse, 'A work of art must carry in itself its complete significance and impose it upon the beholder even before he can identify the subject matter. When I see the Giotto frescoes at Padua I do not trouble to recognise which scene of the Life of Christ I have before me, but I perceive instantly the sentiment which radiates from it and which is instinct in every line and colour. The title will serve only to confirm my impression.'[1] Hodgkin is therefore reticent about the sources of his imagery, and especially about the specific elements in his prints or paintings. This view implies that it is impossible to write about his work, because it would inhibit its proper appreciation.

It is, however, impossible to avoid using words altogether, even for Hodgkin. As a representational artist he regards the subject matter of his work as being of primary importance. Apart from a group of mainly very large prints made between

1986 and 1991 and some small prints made between 2000 and 2002, the subjects of his prints are abstracted to such an extent that they cannot be recognized. At the same time, however, his prints bear titles, which, being words, determine to a great extent how an image is read. As such they can stand in between the object and the viewer who is never certain that he has cracked the code. It would, therefore, have been more consistent with his view on the perception of art to refrain from giving his works titles. But Hodgkin does give them titles and apparently they are as precise as possible.

The dilemma is therefore whether to write or not to write about Hodgkin's prints. He himself has opted for a middle course. His titles, though with a precise and evocative sense, offer no more than vague clues about the elusive prints to which they refer.

This way of going through the horns of the dilemma is not available for the art historian who wants to understand Hodgkin's work. Vagueness in an essay on art does not enhance our understanding. It does suggest, however, that the art historian should refrain from trying to uncover meanings in individual pieces. Accordingly, this introduction is not an essay in hermeneutic exegesis unless first-hand information has been available. The subject matter of Hodgkin's prints is discussed in general terms only.

This section primarily tries to deal with the facts and is intended to serve as a background to the technical information provided by the catalogue raisonné. In discussing Howard Hodgkin's prints made from 1953 to 2002, an attempt is made to throw light not only on the prints, their genesis and their development, but also on the artist's working habits, and on his ideas about printmaking. The collaborative relationship between the artist and his printers will be examined.

The connection with Indian art is briefly discussed and, occasionally, parallels are drawn between Hodgkin's printed and painted oeuvre while differences are shown. However, his prints are not compared with work done by fellow printmakers, because there are few parallels to be found. Hodgkin has always had an individual voice, and has steered his own course throughout the years.

I have used information from several different sources. During meetings with Howard Hodgkin between 1997 and 2002 various aspects of his printmaking were discussed, and further interviews with eleven of his printers and several of his publishers have revealed the artist's attitudes towards printmaking and his working procedures. The vast literature on his printed and painted oeuvre has also been consulted.

The first part of this section looks at general aspects of Hodgkin's printmaking: his initial difficulties with the medium, the differences between his prints and his paintings, the development in his prints and the introduction of editioned hand colouring. It will show the type of printmaker Hodgkin is and how he views the medium. In the second part Hodgkin's published prints are surveyed in chronological order. Although there are no dramatic changes in his printmaking in the forty-nine years up to 2002, roughly three phases can be discerned in style, subject matter and technique. The early period comprises those prints completed before 1977. The second period consists of all prints made between 1977 and 1986. A third period starts in 1986. The boundaries of these phases are not clear cut, but the introduction of periods offers a useful tool for discussing the developments in his work.

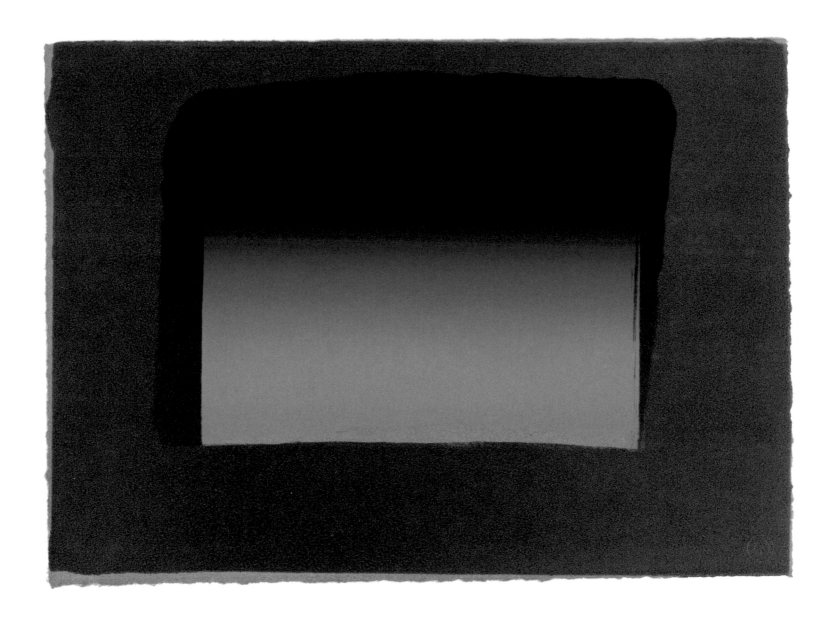

Sky, from 'More Indian Views' 1976 (cat. no. 26)

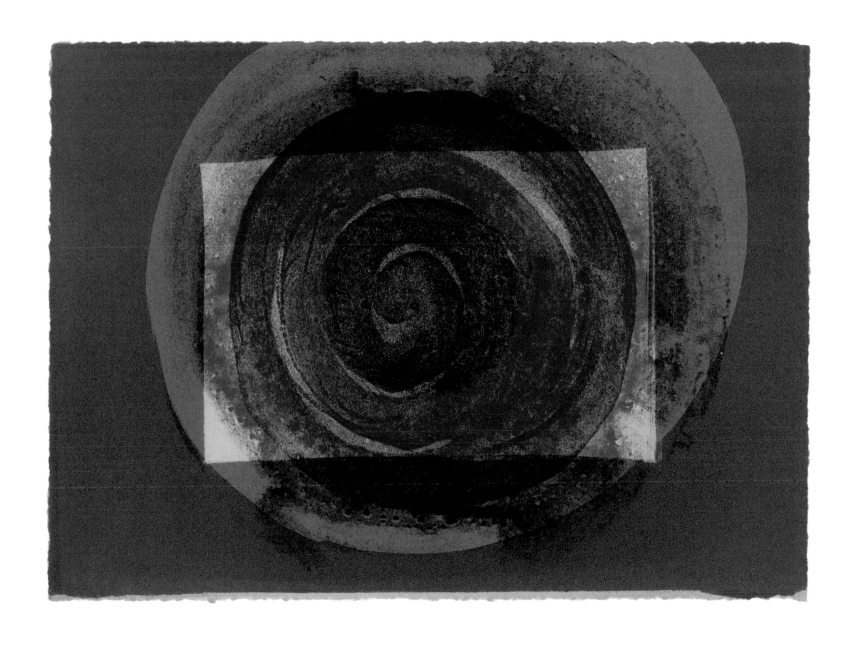

Sun, from 'More Indian Views' 1976 (cat. no. 27)

General aspects of Hodgkin's printmaking

Hodgkin is primarily known as a painter, and considers himself to be a painter in the first place. This is reflected in the several hundred paintings he has produced so far. It is an impressive number given the fact that he is generally perceived to be a slow worker. Printmaking became an integral part of his artistic activity once he began making prints in 1953, four years after he started to paint. Since 1953 he has published 117 prints, 11 limited edition reproductive prints and has illustrated two books.

Hodgkin regards printmaking and painting as two entirely separate activities. Each medium has its own physical identity and poses different challenges for the artist; each also has its own language and subject matter, and should be valued on its own terms. Neither medium is used to imitate the other, nor do they reflect on each other. Only occasionally he converts a painted image into a print. It is therefore striking that Hodgkin's stylistic development displays a convergence between his prints and his paintings. This was not a gradual process, but one that has resulted from an innovation intrinsic to his printing activity: the introduction of editioned hand colouring delegated to his printers. In addition, he started to use tonal printing techniques.

The subject matter of Hodgkin's paintings is highly personal and emotionally charged. His painted work has its roots in the French tradition known as *Intimisme*,

which is concerned with ordinary, day-to-day experiences in the artist's private life. The paintings are mainly about intimate human encounters in domestic interiors in which the expression of the artist's innermost feelings is essential. The spectator witnesses scenes of passion in which sexuality plays an important role. The sources of these scenes are Hodgkin's memories.

His prints, by contrast, are more light hearted, more distanced, their emotional content not as strong. Some are based on memories, others are simply representations of objects or places. For about a decade, between 1977 and 1986, the prints revealed a stronger emotional involvement without ever becoming as intense as his paintings. Their subject matter also evolved around encounters in an interior. Between 1986 and 1991, the gap between the two media temporarily widened. The prints produced during those years are visual records, depictions of physical reality, instead of evocations of mood and sensations, as the paintings are. These prints, which are often large in size, represent objects such as palm trees, a mango, a moon, or a door. In these large prints Hodgkin has tried to imitate posters that he saw in Paris in the late 1950s or early 1960s.

Similar titles appear in both media: *Bedroom, Girl on a Sofa , Window, You and Me, (The) Green Chateau, (In) Alexander Street, Souvenir(s), (The) Moon, After Degas, Venice Evening, In a Public Garden (Naples)*. They may not refer to the same occasion, place, object or people, but they share a similar subject.

The fact that prints are made in the presence of several technicians could explain their more general character. So, too, could the fact that prints are multiples. According to Hodgkin, the number of prints has an impact on the print itself.[2] If the edition is too large, it loses its authenticity or aura, as Walter Benjamin has put it. Stylistically the prints differ from the paintings in various respects, which is dictated largely by the different possibilities of each medium. Compared to the rich, condensed intensity of the paintings, his prints have a broad, expansive quality. In his paintings Hodgkin is trying to create an illusion of space, often employing a mirror, a painting or a window to open up an interior. In his prints he concentrates more on surface and flatness than on the illusion of depth.

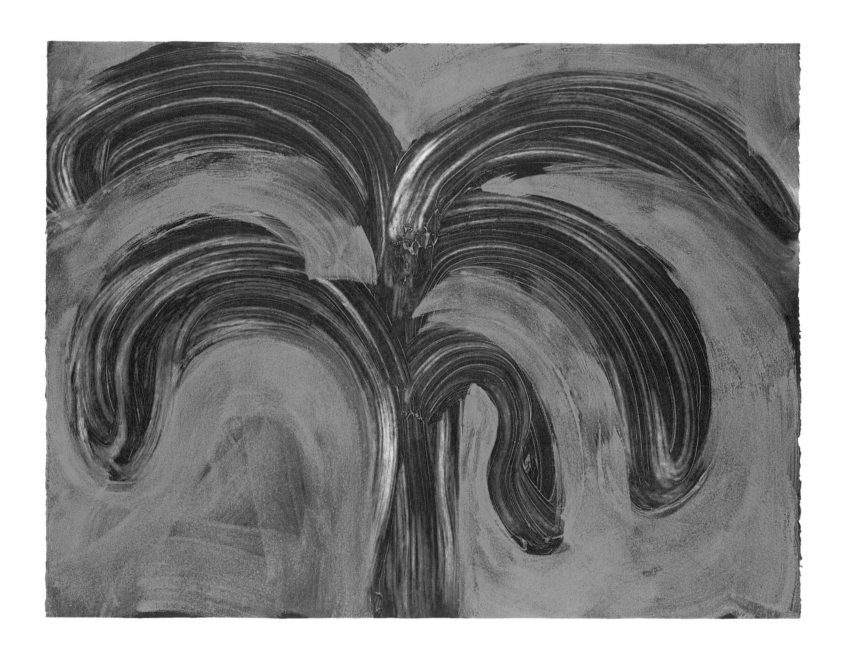

Indian Tree 1990–91 (cat. no. 85)

The frame, which features so prominently in both Hodgkin's painted and printed work, plays a different role in the two media. According to the artist he often paints frames around his paintings both as a protection of the delicacy of the memory depicted and also, simply, to create an illusion of space. The emotional content of the prints only occasionally demands a protective barrier. In his prints the frame more often functions as a stylistic feature, or as a window. Its function is decorative, as well as structural, and is limited to defining and arranging space.

In making prints, Hodgkin is a traditional artist who is not seeking new, unconventional working procedures or fresh combinations of techniques. He sees himself as an amateur printmaker: in arriving at an image he follows his printer's advice on technical matters without getting involved in the process. The printer plays a crucial role in the printing process in the sense that the artist leaves a good deal to his or her judgment. Hodgkin is too much of a painter to be interested in the precise mechanics of printmaking, and does not want to become more involved than is necessary to make prints to his liking. He is a painter who makes prints rather than an artist printmaker.

It is, therefore, a mark of his artistic talent that he has been able to carve out a niche for himself in printmaking, in two respects. The first is the introduction of editioned hand colouring in his prints, an activity he delegates to an assistant. Hodgkin first applied hand colouring in 1977, and it has become a hallmark of his printed work ever since. The second is that he has successfully bent printing techniques to his will, taking advantage of those techniques that enabled him to work the plates in a painterly manner and thus make them more spontaneous and physically direct. This explains the convergence of his paintings and prints.

The changes visible in Hodgkin's printmaking in 1977, and later in 1986, are related to new partnerships with different printers, Maurice Payne in 1977 and Jack Shirreff in 1986. Both printers introduced him to new techniques which enabled him to overcome some of the limitations of printmaking. *Nick* (page 60), the print that marked a new phase in Hodgkin's printing career, was made with Maurice Payne in 1977. Although it was the second time that the two had worked on a print together,

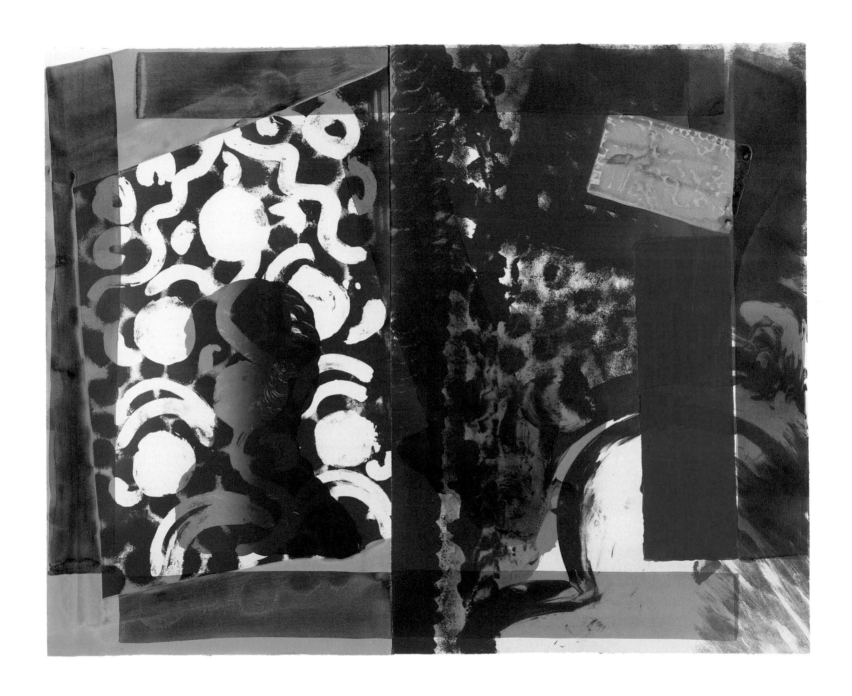

Moonlight 1980 (cat. no. 61)

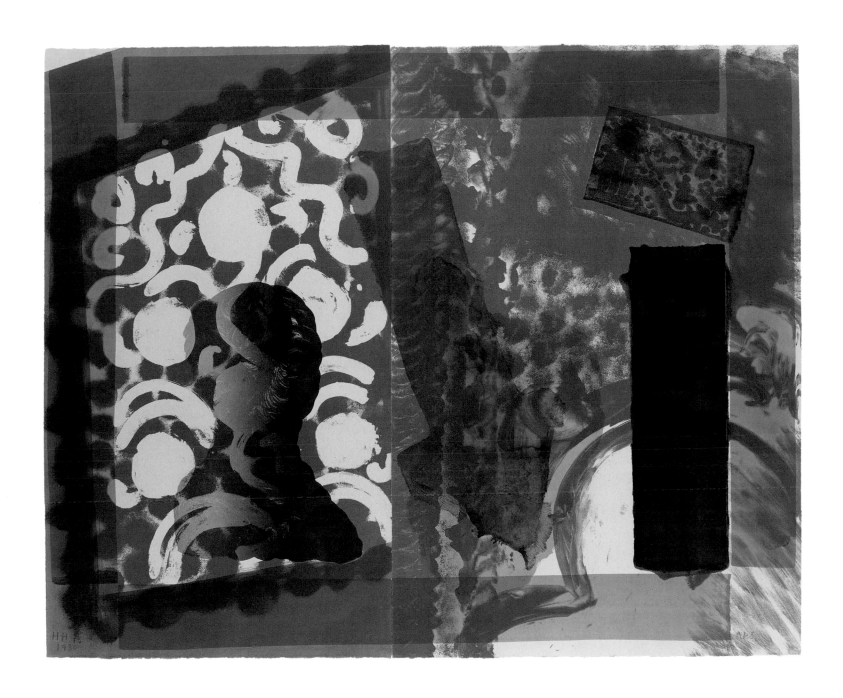

Black Moonlight 1980 (cat. no. 62)

the techniques they used were new to Hodgkin: soft-ground etching with sugar lift and aquatint. Soft ground meant a great step forward, a development to which the prints testify. It allowed him to work on the plate more freely and to create more immediacy in the prints. As Hodgkin himself stated, 'Softground etching is about the most immediate medium imaginable – more immediate than drawing or painting, because it is just the plate covered with grease which can be easily removed or worked into, with almost fatal facility.'[3] At the same time Hodgkin started to use editioned hand colouring, which increased the lushness and intensity of his prints.

In 1986 Hodgkin entered another phase in his printmaking when he started to work with Jack Shirreff at the 107 Workshop in Wiltshire. With Shirreff he began to make prints with carborundum in combination with lift-ground etching. These tonal techniques enabled him to work the printing plate in a painterly way. The prints show a build up with broader masses and textures. With Shirreff the character of the hand colouring also underwent a radical change: rather than, as previously, merely covering a border, or forming parts of the subject or the background, the main image from then on was shaped by painting.

It was only after twenty-four years that Hodgkin felt entirely happy with printmaking. Used to working alone in his studio, he was disconcerted by the presence of printers and their assistants in professional workshops. It took several years before he was self-confident enough to be able to concentrate fully on his prints. An additional factor that initially complicated matters was the high cost involved in printmaking. Hodgkin has compared printmaking to a taxi drive on which one is charged for every second.[4]

The process of making a print requires some knowledge of specialized techniques. It also demands a different frame of mind from that needed for painting. As is well known, Hodgkin arrives at a painted image very slowly. It is therefore to be expected that he cannot easily think through a printed image before he begins working. Before entering the printing studio he has a strong idea of the subject of the print and its approximate format. In the past he has tried to make all the corrections in his head and think through the various stages of the printing process before

working the plate.[5] When working at Solo Press in New York in the 1980s Hodgkin began the process of making a print by staring at a blank sheet of paper pinned to the wall. During the 1990s he increasingly valued spontaneity and directness in his prints, and developed the image while working in the printing studio. He tried to get to the final image during the creative process of working the plates.[6]

Hodgkin is not an artist who carefully prepares his prints, and is happy to accept the unpredictability that is inherent in printmaking. He is the opposite of a graphic artist who makes his prints in many different states – he has produced preparatory studies for only a few of them. The first of these, *Jurid's Porch* (1977; page 62), was prepared by means of two studies in wax crayon and gouache. The fact that the final image took shape only while working with his printer on the plates gives an idea of the artist's working methods. The two preparatory drawings differ considerably from the final result.

The second work for which a study was made is *Moonlight* (1980; page 38). During the process of making the print a large maquette was produced in which the artist experimented with the composition and colouring.[7] The maquette was not used, however, in the printing studio in New York, and in arriving at the final print Hodgkin deviated from the maquette. Both *Bleeding* (1981–82; page 42) and *Mourning* (1982; page 43) were prepared by means of pencil studies of Indian panels and a photograph of the gates of the Alhambra in Granada, Spain.[8] All Hodgkin's other prints were produced without the help of preparatory studies. He views printmaking as a process of constant improvisation. Little 'accidents' that happen while printing are readily accepted, and the ideas of his printers are incorporated.[9]

Hodgkin's major innovation in printmaking has been his introduction of editioned hand colouring at any stage of the printing process by an assistant. It is quite common for printers to carry out colouring by hand, but Hodgkin's use of the technique and his reasons for using it are unique. Colouring was traditionally used when the technology of printing in colour was not available.[10] It could also be employed to embellish a print, by giving it the appearance of a watercolour, which increased its market value. Alternatively, an artist could experiment with the final

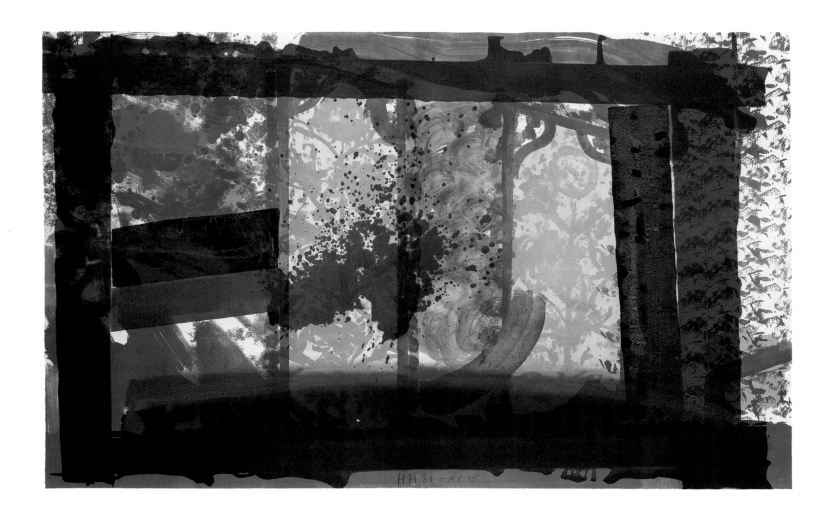

Bleeding 1981–82 (cat. no. 67)

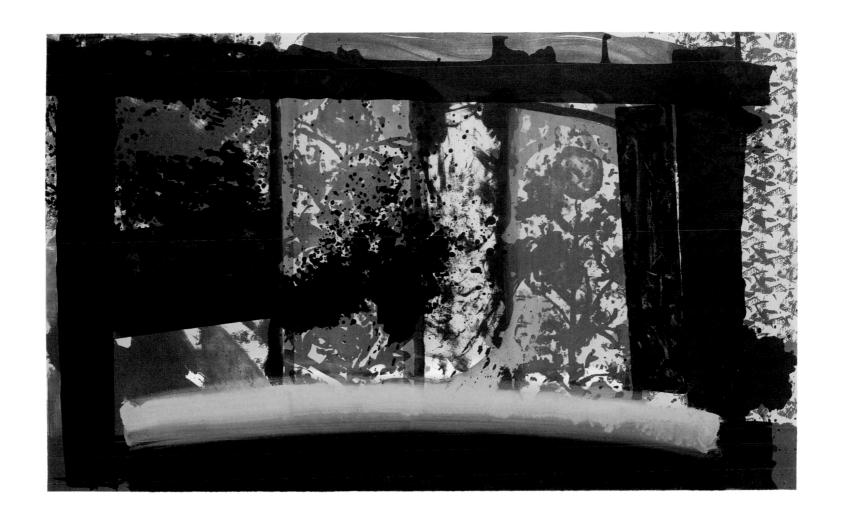

Mourning 1982 (cat. no. 68)

printed image by colouring it. Hand colouring was usually applied to a print after the printing stage. The Impressionists sometimes overpainted impressions with gouache, watercolour, pastel or chalk. In the early twentieth century artists such as Edvard Munch, Marc Chagall, Ernst Ludwig Kirchner, Paul Klee and Max Pechstein thus brought colour to an essentially black-and-white print. In the 1970s artists started to demand 'uniqueness' in a medium dedicated to multiplication. Jasper Johns began to experiment in 1978 with his prints by embellishing a few unprinted plates with monotype, and Jim Dine started to produce some of his prints in plain and hand-coloured versions. In the 1980s many more graphic artists were to use colouring and monotype in their prints.

Striving for uniqueness is not Hodgkin's reason for using hand colouring; he is not concerned with uniqueness as an aesthetic quality. The application of colour by hand turned out to be a brilliant method for bringing directness and spontaneity into his prints: touches of pure, often unmixed, colour make them richer and more immediate, and they give the prints a more luxuriant texture and a subtle glow. Hand colouring overcomes the lack of contrast and saturation in his earlier work, bringing the immediacy and directness so familiar from his paintings to his prints.

In addition to these aesthetic qualities, Hodgkin likes the fact that hand colouring can be done quickly; there is no need to wait between printing stages. And, very conveniently, it is a way to cover up any printed imperfections. At the same time, hand colouring introduces a degree of unpredictability. When the materials used are watercolour or gouache, both water-based media, they can amalgamate with the greasy printing ink. This can create unexpected effects that are clearly visible only when both layers have dried fully. Because the colouring is not applied mechanically, variations among copies of an edition are unavoidable. When there is time between editioning one batch of prints and another, variations are even more likely to occur. As long as these differences are not intentional, but a consequence of the hand-finish, they are acceptable to the artist. Allowing ink to bleed into the surface of the print, although seemingly spontaneous or even accidental, is usually intentional. Hodgkin accepts this on the condition that it is kept within certain

parameters. However, a change of colour, which is Hodgkin's most important means of communication is unacceptable. In the case of *Indian Tree* (1990–91; page 36) about forty prints were destroyed, when the green egg tempera turned dirty due to a reaction with the underlying printed orange.[11]

The trial proofs of *A Furnished Room* (1977; page 57) show what different reactions the water-soluble watercolour can have on the printed surface. The green watercolour sometimes thinly covers the printed orange-red central area, but at other times it almost makes the orange-red invisible. To some extent this is still visible in the edition.

Although Hodgkin sees painting and printmaking as two entirely separate media, and tries to make his prints as different as possible, hand colouring has stylistically narrowed the gap between the two. A crucial characteristic of the artist's use of hand colouring is that the activity is delegated to assistants. There are several reasons for not applying it himself – most importantly, it is a way of avoiding the autographic mark. Hodgkin's dislike of the autographic mark is known, 'I want the language to be as impersonal as possible…. It's a major concern of mine that every mark I put down should not be a piece of personal autograph but just a mark, which then can be used with any other to contain something. I want to make marks that are anonymous as well as autonomous.'[12] Because of his dislike of the autographic mark he once asked an assistant to help him to paint a picture, but this was not successful.[13]

A second reason for asking assistants to perform the hand colouring is that Hodgkin is interested primarily in the decision that leads to the production of a mark, not in the act of making that mark. As an artist, he would be tempted to alter the image by introducing variations. Since an assistant is asked specifically to repeat the marks as consistently and closely as possible, the chances of variation are limited. For an artist who does not particularly like numbering, signing and dating his prints, there can be little doubt that he is also not attracted to the repetitive act of hand colouring.[14]

The printer has to become acquainted with the process of hand colouring to such a degree that he or she is capable of introducing some spontaneity, some 'life'

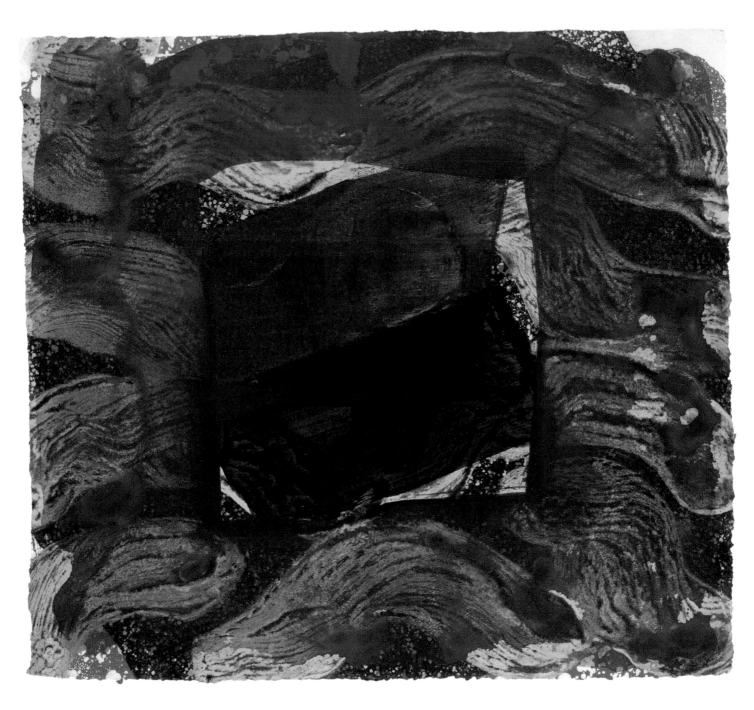

Books for the Paris Review 1997–99 (cat. no. 100)

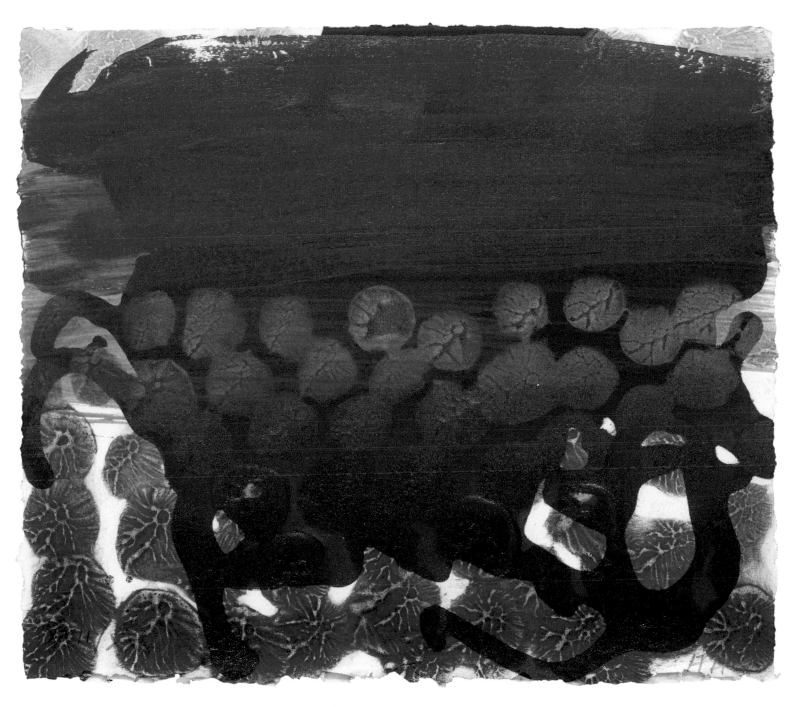

In a Public Garden, 1997–98 (cat. no. 99)

into the movements. Over the years, various printers have been involved in the hand colouring – Maurice Payne, Ian Lawson, Ken Farley, Bruce Porter, Alan Cox, Don Bessant, John Hutcheson and Jack Shirreff. The artist's son, Sam Hodgkin, has assisted on two occasions. All prints that were made with Judith Solodkin at Solo Press in New York were hand coloured by her curator Cinda Sparling, with whom Hodgkin's collaboration has been exceptional.

The role of the colour additions has become increasingly important. In the 1970s its role was mainly supportive, providing a background wash, reinforcing the borders, and enhancing the printed surface in places. In the 1980s the colouring formed an integral part of the composition. The prints were composed of interleaved passages of printing and hand colouring in which the printed and the painted areas could not be distinguished easily. By the 1990s, the central motif was shaped by painting. In the group of prints produced in 2000 and 2001, the acrylic paint was mainly applied to create the borders which are vital elements of the prints.

In an introduction to Hodgkin's prints, brief mention should be made of Indian art. If we were unaware of Hodgkin's great passion for Indian paintings and drawings, the Indian connection would perhaps not be immediately obvious in his prints. *Moonlight* (1980; page 38), *Black Moonlight* (1980; page 39), *Bleeding* (1981–82; page 42), and *Mourning* (1982; page 43) are exceptions because they contain ornaments that are directly based on Mughal and Indian art. In subject matter the prints seem barely related to Indian art – Hodgkin's prints are not naturalistic in character, nor do they contain the floral decorations that are so abundant in Indian painting. Hodgkin's India is the country seen by a first-class traveller who views the world from hotel rooms and railway carriages. All we see in his prints are landscapes, isolated palms or interiors. Temples, palaces, Indian people or elephants do not feature in his work.

If there are affinities between Hodgkin's prints and Indian art, they are limited to a richness and boldness of colour, the use of a border and the flatness of space. They have their bijou quality, a jewel-like opulence in common.

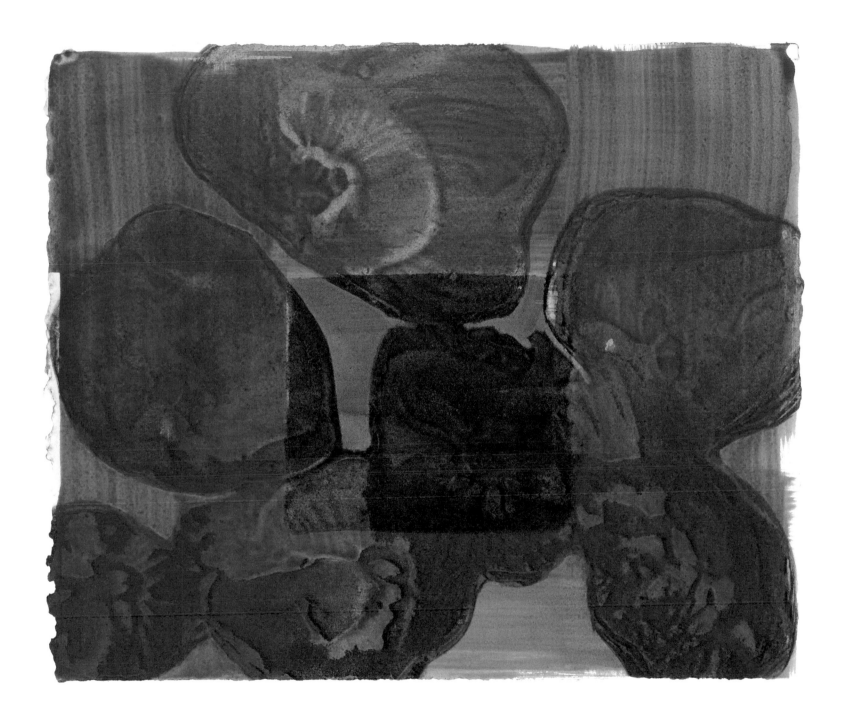

Window 1996 (cat. no. 97)

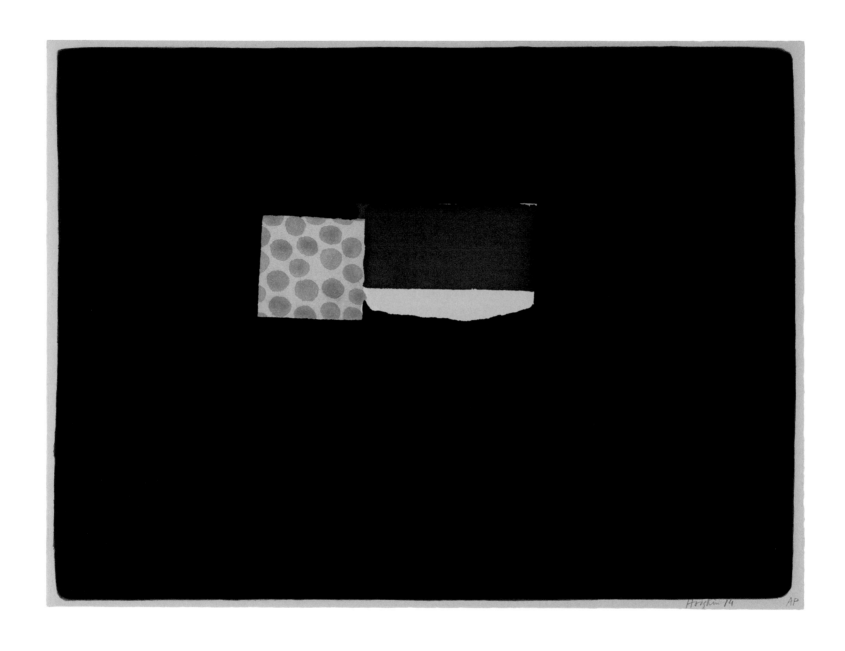

Interior (Day) 1973–74 (cat. no. 23)

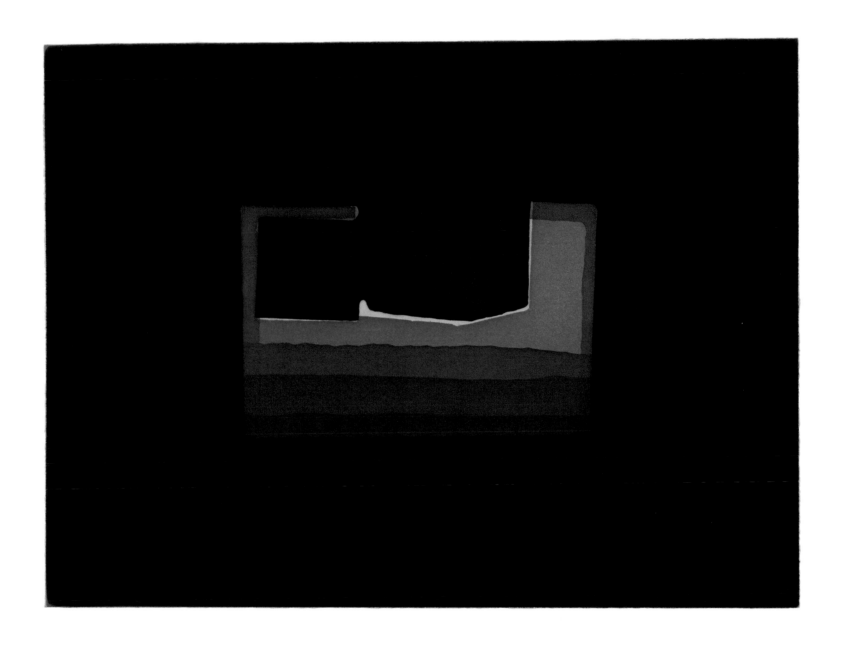

Interior (Night) 1973–74 (cat. no. 24)

became very popular in the 1960s. Because the screenprint was inexpensive and designed for a mass audience, it fitted in perfectly with the ideas behind Pop art.

In 1966 Hodgkin was commissioned by Paul Cornwall-Jones of Editions Alecto to make some prints. This resulted in the series of lithographs called '5 Rooms'. Together with Bernard Cohen, Hodgkin was sent to Zurich to work with the printer Emil Matthieu. At the end of an agonizing week in which Cohen produced numerous prints, Hodgkin finally made *Interior with Figure* and *Girl at Night*. The three other lithographs of this group were printed at Editions Alecto in London. Despite the artist's inhibitions about working directly on the plates and about getting the registration right, the project resulted in brightly coloured, witty and well-structured lithographs. He experimented with the splatter technique, over-printing colours, and contrasts between flat, evenly coloured areas and grainy, chalky effects. In each print he tried to achieve a certain autonomy of form. With hindsight, he considers the five lithographs are too large, too self-conscious in their execution, and technically inhibited. In subject matter they are close to his paintings of the time: the relationship between human beings and their surroundings. People are shown interlocked with their environment. However, there are no one-to-one relationships between the works in the two media, even where the same title appears.

Through working with Prater, Hodgkin began to realize the possibilities of screenprinting. After an unsuccessful experiment with the screenprinter John Vince at the Bath Academy of Art in 1966 he worked again with Prater on a portfolio of twelve screenprints called 'Indian Views' in 1971 (pages 10 and 11). They were conceived as a series that should ideally be hung along a wall in a single line. The subject matter was inspired by India. In 1964 Hodgkin had made his first trip to India, and many more visits followed. Initially he intended to give the twelve screenprints titles referring to the times of the day, but he abandoned this idea because he feared that it would prevent their being viewed together as an entity. Their blunt, rectangular forms find their origin in the tiny holes around the edge of windows in old-fashioned Indian railway carriages. Through these holes the

landscape could be viewed in a very concentrated way. Back in England, Hodgkin translated these views into minute colour collages, trying to remain as close as possible to what he had seen. *Indian View L* is the only one that is not based on a collage, but on a very small drawing.

In producing the maquettes, Hodgkin used materials such as corrugated cardboard, brown paper tape, yellow bicycle tape and Letrafilm. He drew over these materials with pentel, acrylic paint, polished wax crayon, watercolour and chalk. To give Prater the opportunity to translate the collages freely on a much larger scale and go beyond the original concept, he produced collages that were sometimes smaller than a matchbox. Some of these maquettes were difficult to translate, and as many as fourteen or fifteen printings of one view were necessary in some cases.

The views of horizons, fields, mountains, skies and different times of the day are enclosed by very wide borders which work like frames of a window and intensify the key-hole character of the views. The series were first printed with a white border, before it was decided to overprint them in black or a creamy yellow. The frame, introduced in 'Indian Views', became an important formal device for most of his future prints.

In 1971 Hodgkin was asked to contribute to the portfolio 'Europäische Graphik VII', which was dedicated to British artists. He made two lithographs with Stanley Jones at Curwen Prints in London, one of which was abandoned at the proofing stage. Its motif, a shuttered room where a picture hangs close to a window, returns in the pair of aquatints *Interior (Day)* and *Interior (Night)* (both 1973–74). The second lithograph, *Composition with Red* (1970), was chosen for the portfolio. It is roughly based on a medieval arch seen in India. It has a linear composition consisting of a bold, curved shape which encloses brightly coloured bands.

Interior (Day) (page 52) and *Interior (Night)* (page 53) are the artist's first aquatints. Hodgkin worked on them daily with Maurice Payne over a period of nearly two months during which the plates were re-worked several times. At the time Payne was at Petersburg Press in New York. The aquatints are the first prints that formed a pair. Some of the same plates were used for both. In the 1980s many

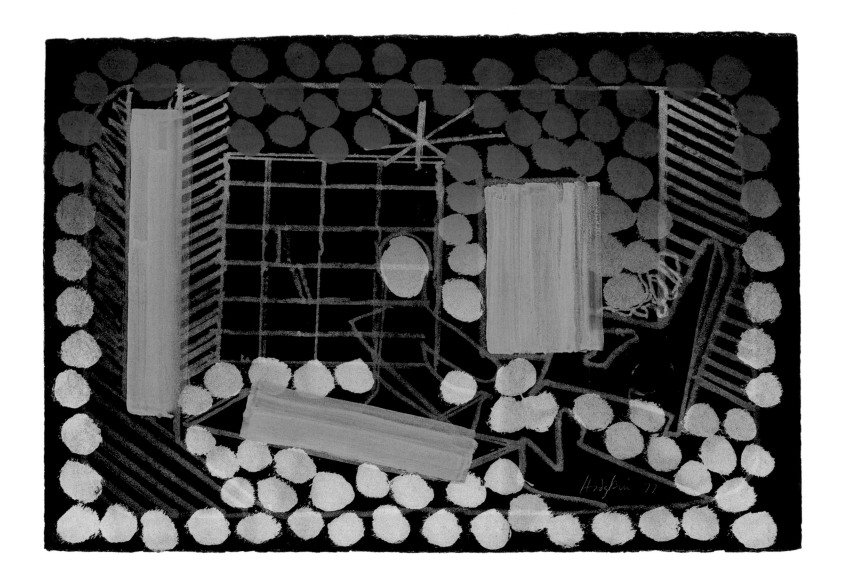

Julian and Alexis 1977 (cat. no. 31)

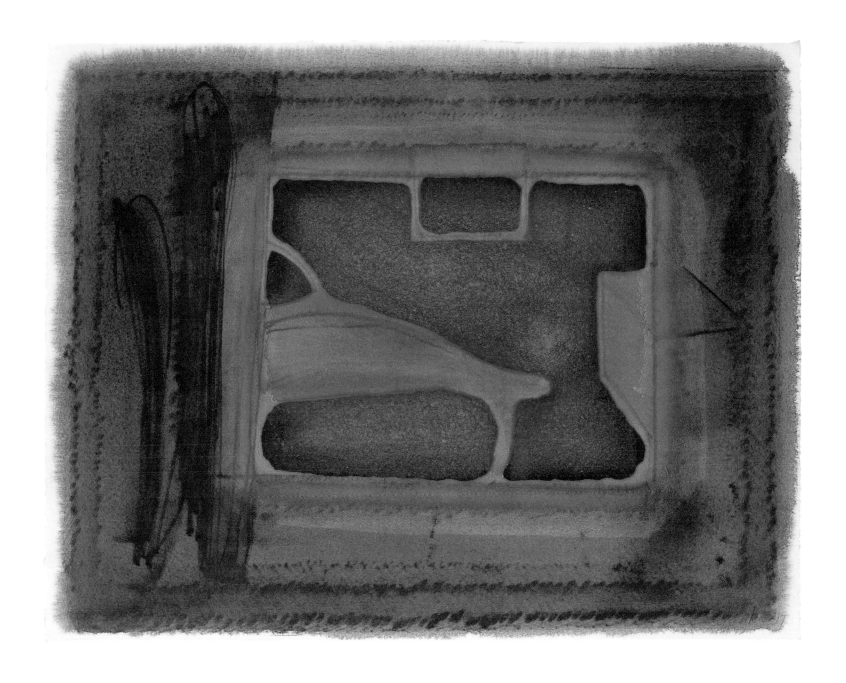

A Furnished Room 1977 (cat. no. 33)

more pairs followed in which the same set of plates were used for both images to create variant views. Despite these efforts, the two aquatints were not commercially successful. A few years later Hodgkin and his publisher Paul Cornwall-Jones decided that they should be hand coloured. The prints were sent to England where they were torn down by the artist and his son Sam. The pencil inscriptions were torn off, leaving only the central panels. After painting by hand, renumbering and signing they were given new titles: *Bed* and *Breakfast*.

In 1976 Hodgkin did two print projects with Ian Lawson at Aymestrey Water Mill in Herefordshire. 'More Indian Views' (pages 32 and 33) are a continuation of the earlier 'Indian Views', albeit much smaller and conceived as lithographs, a technique that generally allows for more subtle effects in the gradation of tone. The prints in 'More Indian Views' had a rather glossy build up of colours, producing an effect very much like screenprinting. This happened by chance – there was a long interval between printing the first and second plates, so the ink had completely dried. The two inks therefore did not blend, and the combination of the two layers created a peculiar effect. The artist was rather pleased with the effect and wanted to leave a similarly long period between subsequent print runs, but this was logistically impossible. Leaving a few weeks between consecutive print runs appeared to be enough to create a similar mottled effect.

The other print made with Ian Lawson in 1976 is *After Luke Howard*. To celebrate the bi-centenary of John Constable's birth in 1976, Bernard Jacobson commissioned nineteen artists to pay tribute to Constable by producing a print for the portfolio 'For John Constable'. Hodgkin, who is a distant relative of Luke Howard F.R.S. (1772–1864), the inventor of the classification of cloud formations, made a lithograph of a cloud formation. In honouring Constable as the great painter of clouds, Hodgkin simultaneously paid tribute to the forebear after whom he had been named. *After Luke Howard* is loosely based on drawings by Luke Howard at the Courtauld Institute of Art in London.

The transformation of *Interior (Day)* and *Interior (Night)* into *Breakfast* and *Bed* shows Hodgkin's changing ideas about his prints. Printed in 1973 and 1974 they have

the flatness and lack of intensity which is a characteristic of his early prints. Like every print in this early period they are trials, in this case a first attempt to make intaglio prints. Due to their hand colouring in 1978 they achieved a lushness, comparable to the prints of his next phase. They are the only aquatints made in a period in which Hodgkin's output was composed of fifty per cent lithography and fifty per cent screenprinting.

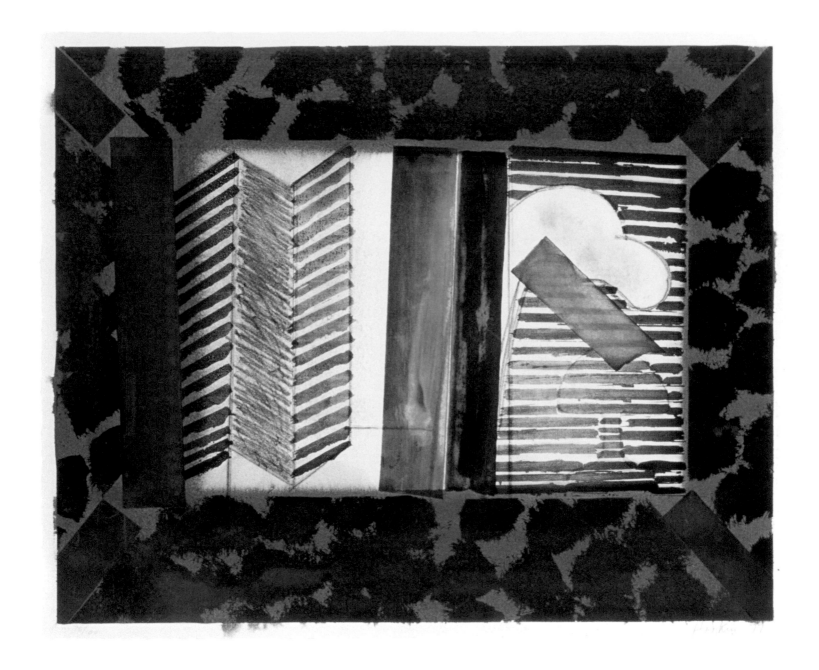

Nick 1977 (cat. no. 32)

Nick's Room 1977 (cat. no. 35)

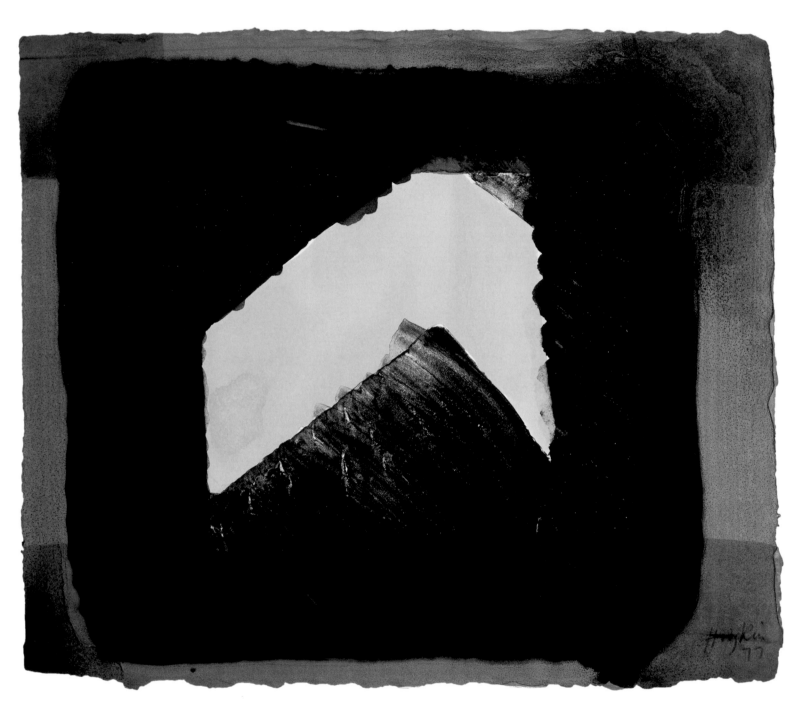

Jarid's Porch 1977 (cat. no. 34)

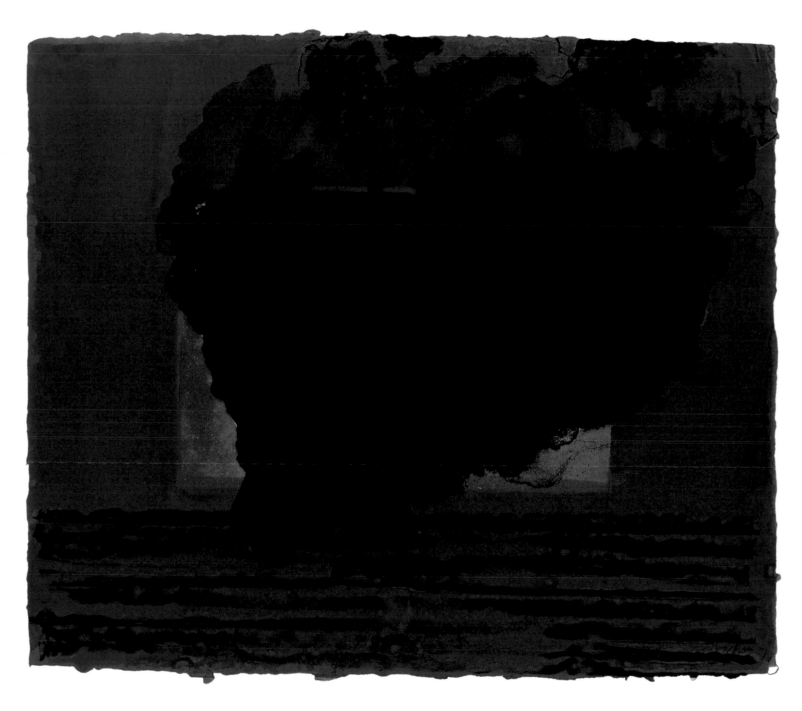

A Storm 1977 (cat. no. 36)

The prints made between 1977 and 1986

In 1977 Hodgkin's work showed changes preceded by dramatic experiences in his life. In 1975 he had been severely ill from amoebiasis, and came close to death, suffering from extreme depression in the six months after his operation. Having discovered his own homosexuality, he left his wife later the same year, although they never formally separated.

Hodgkin regards the year 1977 – or to be more precise, the production of *Nick* in 1977 – as the beginning of his printing career, and acknowledges a change in his work. Although he believes that the change may have been caused by his illness and subsequent recovery, it is generally thought to have been the discovery of his homosexuality that affected his work the most. Sexuality, which had always been expressed in his work to some extent, came closer to the surface. The artist's 'coming out' had a liberating effect on his work, not only on content, but also on style. The year 1975 saw a breakthrough in his paintings, whereas his prints show a more gradual transition.[16]

The prints executed between 1977 and 1986 show an increase in emotional content and intensity which render them more complex and suggestive. Compared to the early prints the language became more fluid and lush because of an increased looseness of handling. They showed a richness and a surface texture previously lacking – mainly due to the application of gouache or watercolour by hand, but also to the more tonal techniques of aquatint and soft-ground etching with its chalk-like lines.

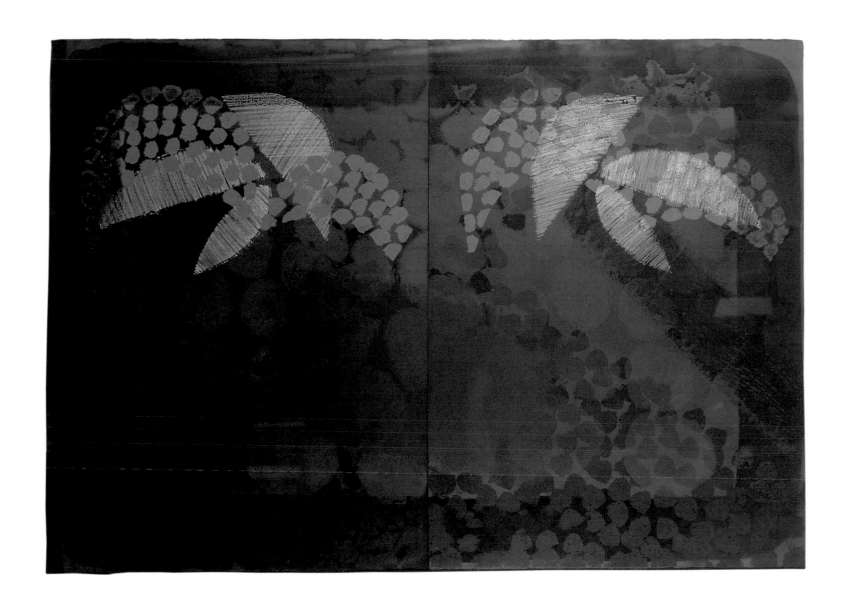

For Bernard Jacobson 1977–79 (cat. no. 38)

Green Chateau II 1978 (cat. no. 40)

Green Chateau IV 1978 (cat. no. 42)

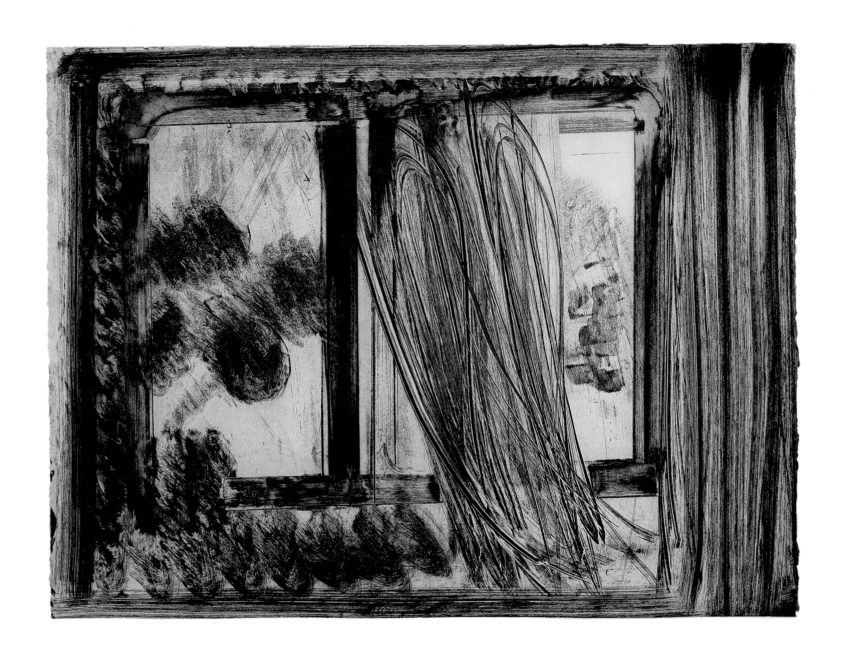

Late Afternoon in the Museum of Modern Art,
from 'In the Museum of Modern Art' 1979 (cat. no. 50)

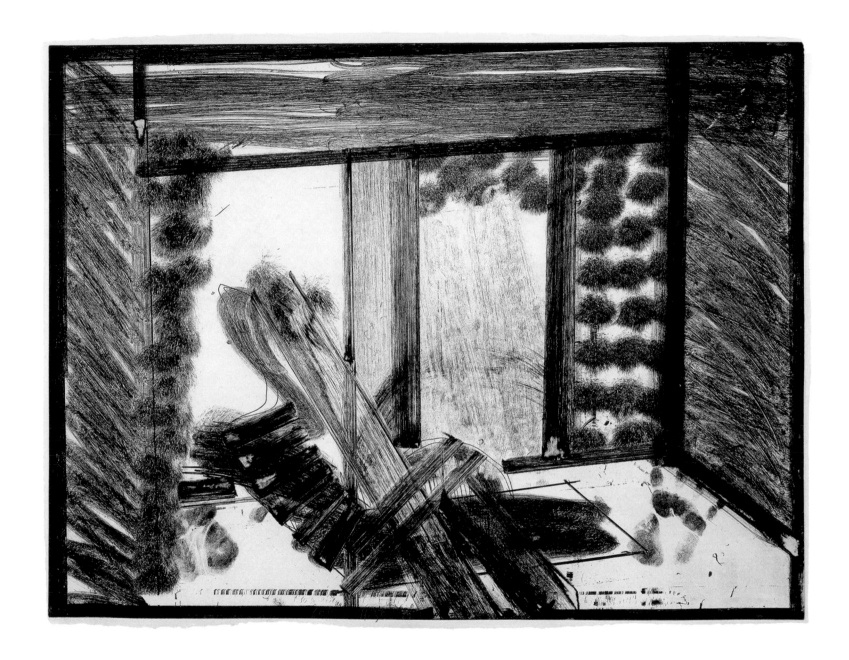

Thinking Aloud in the Museum of Modern Art,
from 'In the Museum of Modern Art' 1979 (cat. no. 52)

About three quarters of the prints of this period represent interior scenes, often showing windows, shutters or blinds. Like his paintings, these interior scenes show a particular moment, usually an encounter of an erotic or emotional nature. If the human figure is shown, it is either roughly outlined and printed over, or reduced to the form of a bust. The spacial arrangement in the prints is often ambiguous, except where human figures can be recognized. It is not clear whether the space is viewed from a bird's eye perspective, particularly in the prints made in 1977 and 1979. Despite their narrative element they remain elusive.

These changes were first apparent in *Nick* (1977). A few months before making this print Hodgkin produced another print with Ian Lawson called *Julian and Alexis* (page 56). It was the largest print he had so far executed and was finished by adding three rectangular blocks of green gouache by hand, because, according to Hodgkin, 'there was nothing else I could do'.[17] He liked the immediacy of the hand colouring and has used it ever since with one important change: he has not applied it himself. In *Nick* the hand colouring was delegated to someone else for the first time.

Nick (page 60) initiated another phase in Hodgkin's career as a graphic artist in terms of technique, style and subject matter. The production was described by the artist as 'a battle' with the printer Maurice Payne, and consisted of long discussions at the Petersburg Studios in London. Payne introduced Hodgkin to the technique of soft-ground etching with sugar lift and aquatint, a perfect technique for Hodgkin because it is so immediate. It allowed him to work the plate without having to imagine the result in reverse. It also loosened his approach to making marks on the plate. The production of *Nick* took about a month of intense work during which Hodgkin was able to make quite radical changes. The stage proofs show how much the etching was altered. The sheet of paper was torn down the middle to check whether the area right of the printed, green vertical could stand on its own. Hodgkin experimented with washed backgrounds and various shades of blue on the borders. In the end the plate was cut down and an extra plate was added. When *Nick* was finished Hodgkin felt in control: he had understood the infinite possibilities of printmaking.

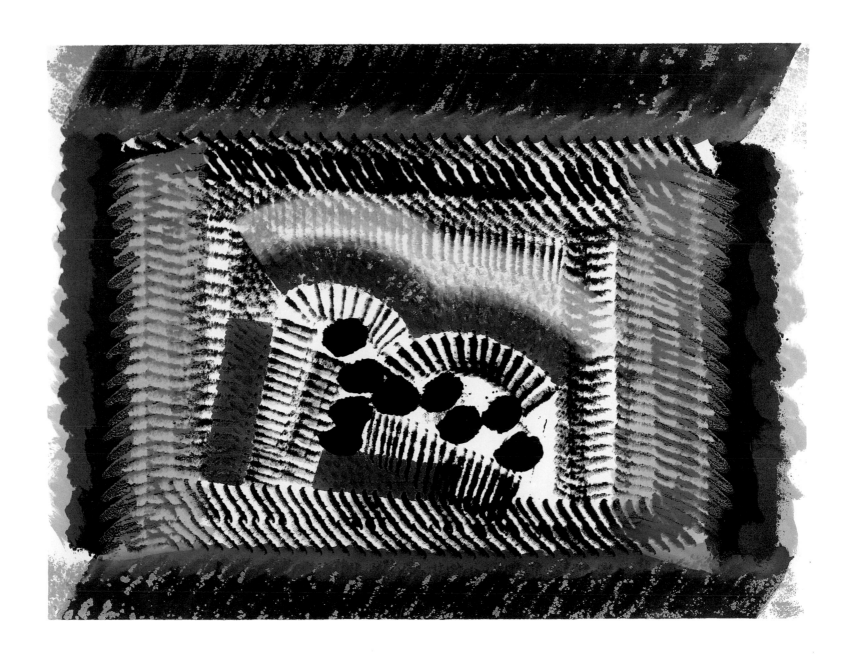

Two to Go 1981–82 (cat. no. 66)

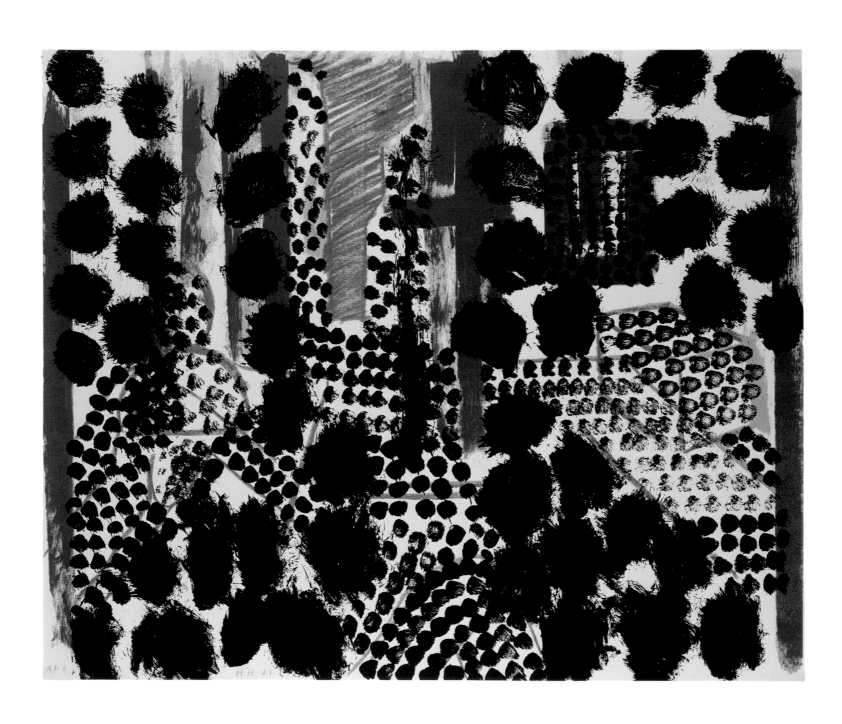

Souvenir 1981 (cat. no. 64)

With its clear horizontals and verticals the print has a formal structure, but the image is imbued with an intensity none of his prints had shown before. The artist allowed more of his personal experience to be part of the print. The etching shows a friend as a curiously shaped, flesh-coloured figure bending over a lamp. Rather than being called 'Figure in Interior' it carries the first name of his friend. Both print and title testify to an increased directness. In later works, especially those made between 1980 and 1983, sexuality often lies under the surface, and in some cases was rather explicit.

Productive years followed in which Hodgkin concentrated on lithographs, aquatints and soft-ground etchings. A visit to Oklahoma in 1977 resulted in a burst of printing activity. Altogether seven prints were based on that visit, though made in two phases. *A Furnished Room* (page 57), *Jarid's Porch* (page 62), *Nick's Room* (page 61) and *A Storm* (page 63) were produced in 1977. *Cardo's Bar (Black)* (page 78), *Cardo's Bar (Red)* (page 79) and *Here We Are in Croydon* (page 82) followed in 1978 and 1979. They were based on the same trip, but vary in style, size and motif. *Here We Are in Croydon* was a comment made by a visiting English friend about an interior in Tulsa. They were all made in Claes Oldenburg's studio in New York which Petersburg Press was using at the time. Different printers were employed. Bruce Porter printed the lithographs, and John Hutcheson or Ken Farley were responsible for the intaglio prints.

The prints made by Bruce Porter, a printer with whom Hodgkin very much enjoyed working, stand out from the rest. They show Porter's background as a painter as they are much freer in style, more dramatic than the other prints made in these years. The printed border of *A Storm* (1977) barely seems to contain the thundery dark cloud which forms the central image. *A Storm* was indirectly inspired by a painting by Thomas Hart Benton. The stylized cloud formation in his previous print *After Luke Howard* (1976) seems to have been executed far earlier than just a year before.

Jarid's Porch owes its uneven surface to Porter's inventiveness. The wet-on-wet application of the yellow gouache on the black printing ink created the crinkled surface. Pleased with this wrinkly effect, Hodgkin decided that all his prints should have it. It had been difficult to represent the effect of light coming from indoors

You and Me 1978 (cat. no. 43)

Alexander Street 1978 (cat. no. 44)

onto the porch. Even two preparatory drawings had not brought a solution. The crinkled surface fittingly created the required luminosity in the print.

Cardo's Bar (Black) (1978–79; page 78) and Cardo's Bar (Red) (1979; page 79) were printed by Ken Farley who also editioned *A Furnished Room* (1977).[18] This was a soft-ground etching that Hodgkin worked on first with Maurice Payne and Danny Levy in London and later with Levy in New York for an entire month. The fact that Hodgkin felt more in control of his printmaking can be seen in the use of fingerprints in the two versions of *Cardo's Bar*. Similarly, fingermarks were used in the series 'Green Chateau' (pages 66 and 67). These fingerprints could be seen as another way of making his prints more direct.

In the soft-ground etchings *Thinking Aloud in the Museum of Modern Art* (page 69) and *All Alone in the Museum of Modern Art* (both 1979) the artist used the imprints of his entire hand to make marks. They are part of a group of four called 'In the Museum of Modern Art' which were printed by Ken Farley for Petersburg Press. They are the most graphic prints of Hodgkin's entire oeuvre. The artist worked on the plate with brushes that created the large sweeping swirls. They are complex in their spatial arrangement and illusion of depth. The monochrome tonal setting and subject matter of the four etchings reflect Hodgkin's unhappy mood at the time.[19] When he was asked, 'So why didn't the experience become a painting?', he answered, 'I wasn't *that* unhappy.' The prints are based on lonely wanderings through the Philip Johnson wing of the Museum of Modern Art in New York which has rooms with large windows reaching down to the floor. The spaciousness of the rooms is well represented, so much so that it seems surprising that the prints are rather modest in size. The etchings were made in pairs: *All Alone...* and *Thinking Aloud...* (page 69); and *Late Afternoon...* (page 68) and *Early Evening....* The same plate was used for each pair – hand colouring creates the difference between the two. *Thinking Aloud in the Museum of Modern Art*, initially entitled *Not Quite Alone in the Museum of Modern Art*, seems the most sexually explicit in the artist's printed oeuvre, if the central scene can indeed be interpreted as two people making love. Several prints of the following years also seem highly charged. In *After Lunch* (1980), for instance, a sexually aroused figure enters the room from the left.

Those...Plants, *Artist and Model* and *Artist and Model (in green and yellow)*, printed by Ken Farley and John Hutcheson in 1980, are a group of soft-ground etchings within which the two versions of *Artist and Model* (page 86) are identical images but for their variant colours. There is a pre-edition proof in which the artist experimented with crayons and gouache. The connecting element between the three prints is formed by a bust, turned into a silhouette by the light that shines through the window at the back. The title 'Artist and Model' is a little surprising as Hodgkin never works from a model.

Hodgkin continued to work with Alan Cox and Don Bessant at Sky Editions in London and made another seven lithographs with them in 1978 and 1979: the group of four called 'Green Chateau', *You and Me* (page 74), *Alexander Street* (page 75) and *For Bernard Jacobson*. The four tiny lithographs of 'Green Chateau' form a series (pages 66 and 67). They were printed in the same green colour from the same plate. They only differ in the colour of gouache applied to the printed surface with one broad stroke of a Japanese brush. The edition of each of these lithographs is limited to twelve which explains why they rarely appear on the market.

For Bernard Jacobson (1977–79; page 65) was one of Hodgkin's first prints to be similar in size to his paintings, and it was his most ambitious and elaborate print up till that point. It was the result of a failed project to illustrate the new edition of E. M. Forster's *A Passage to India* which Hodgkin had embarked upon in 1976. It was to be published in 1979, the centenary of the author's birth, and it did indeed appear in 1979, but without a direct connection to the book. Hodgkin gave the print its title after a conflict with the publisher. The two-sheet lithograph represents a view at night from a balcony in India. Banana trees with yellow and blue-dotted leaves can be seen in the garden below. A mysterious warm light pervades the night scene. With its rich, saturated colours and dense design it is particularly painterly. Despite its large size, it works extremely well. The terrace and the banana trees are surrounded by a black translucent border which ties the various elements together, and the lushness of the colours evokes a strong sensual response. The night scene required a saturated, densely coloured background of a black hand-made paper. Because this was

Cardo's Bar (Black) 1978–79 (cat. no. 47)

Cardo's Bar (Red) 1979 (cat. no. 48)

unavailable, large sheets of Arches were dyed blackish purple using vegetable dyes in large baths at the printing studio. The dyes were unstable, ranging in colour from light aubergine to a dark blackish purple, which meant that matching sheets had to be selected for each print. There were four print runs: dots printed in black, some more dots in a blend from blue to lilac. A round form at the left and a large rectangle followed in red-brown. In the fourth run the trunks of the palm trees were printed in another red-brown. The yellow stripes and blue dots indicating the banana leaves were hand coloured through stencils, while black gouache was used for the border.

For Bernard Jacobson and the two versions of *David's Pool* (page 83) that Hodgkin worked on between 1979 and 1985 display a tendency towards a greater painterliness and lushness which characterized the prints made from 1986 onwards. Rather than being interiors like the majority of works made between 1977 and 1986, they are all three views of the world outside. This shift would again mark the prints from the later period. In these respects the three prints can be seen as signalling a changing style and choice of motif.

Since *For Bernard Jacobson* Hodgkin has worked on a larger scale more often. This increase in size was partly caused by the limitations of the plate. Hodgkin said, 'In printmaking you can really only move sideways and up and down. You can only move across the surface, which is, I think, another reason why my prints grew larger.'[20] In painting one can try to achieve an illusion of depth more than in printmaking.

The 1980s were the decade of prints with paired sheets, the majority of which were rather large in size. Through variable inking and colouring Hodgkin explored the duplication of identical images and extended the reach of the image. The prints, one of which was usually made in colour, the other in monochrome, were not interdependent, they just explore alternative moods. The essentially monochrome version creates the effect of greater control. *Artist and Model* and *Artist and Model (in green and yellow)*, *Moonlight* and *Black Moonlight*, *Bleeding* and *Mourning*, *Sand* and *Blood*, *David's Pool* and *David's Pool at Night*, *Red Palm* and *Black Palm*, and *Monsoon* and *Black Monsoon* all are experiments in colour and mood. The coloured version often preceded the monochrome version.

Hodgkin is widely praised for his sense of colour, but, as David Sylvester has rightly argued, he does not need colours to make good work, 'He is among the many painters of our time who have been at or near their best when restricting their palette to black and white.'[21] This is equally valid for Hodgkin as a graphic artist. The artist himself often prefers the monochrome versions of his pairs because they are closer to what he saw when working the plates, and seem to reveal the essence of the image.

One Down (1981–82) and *Two to Go* (1981–82; page 71) is the only pair made in the 1980s of which both images were in monochrome. They were never intended to be printed in colours. The hand colouring, by Solodkin's curator Cinda Sparling, was an integral part of the process. It had ceased to be an element that was simply added to a print. The layering of printed and painted marks creates the rich effect of a tapestry. The pair refers to a reality known exclusively to the artist which has been coded in a rhythmic pattern of geometric ornaments.

Souvenir (1981; page 72) was also intended to be printed in a coloured version, but this version never materialized. Hodgkin had the idea of making a group of hand-coloured versions, but only one was ever created. It is one of only three prints made after 1977 that did not have editioned hand colouring, and is the only screenprint on which the artist worked directly on the screens. In spatial arrangement and perspective there can be little doubt that it is connected with a painting called *Souvenirs* that Hodgkin made between 1980 and 1984.[22] A drawing of recognizable human forms is partly covered by a surface of printed blobs. This was also the case in the earlier prints *Julian and Alexis* (1977) and *You and Me* (1978). Similarly, an initial drawing could be camouflaged in his paintings by layers of paint which made the drawing more or less illegible. *Souvenir* is the last print in which man, at least in a naturalistic form, appears. *David's Pool* (1979–85; page 83) and *David's Pool at Night* (1979–85) are among Hodgkin's best prints. They look deceptively simple, but took a considerable time to make. Hodgkin was introduced to Aldo Crommelynck by Paul Cornwall-Jones of Petersburg Press, who suggested they should work on prints together. Crommelynck and his brother, Piero, were Parisian printers who learnt intaglio printmaking in the studio of Roger Lacourière. Lacourière etched for Picasso

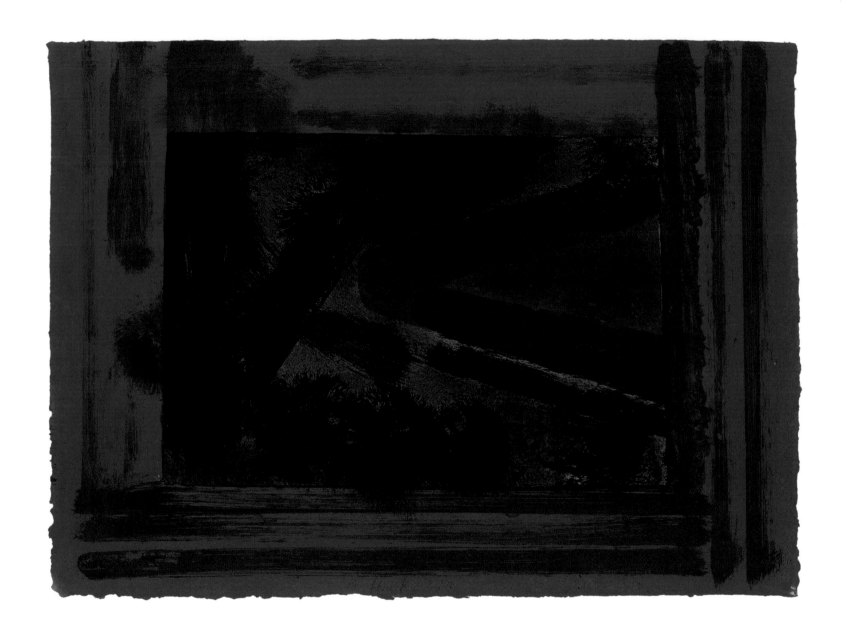

Here We Are in Croydon 1979 (cat. no. 49)

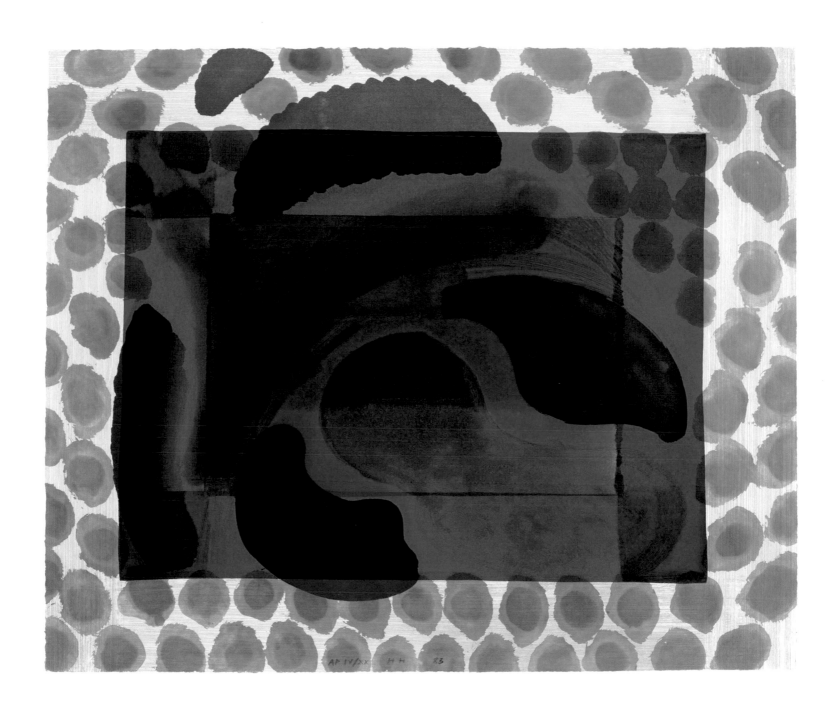

David's Pool 1979–85 (cat. no. 55)

between the wars. When Lacourière retired and Picasso moved to the south of France, the Crommelyncks set up a workshop especially for the artist. There they helped him make and proof about a thousand prints.

It was the first time that Hodgkin had worked with such an important printer and he was duly impressed by his great skill. The etching plate for *David's Pool* was made at the Crommelynck studio in Paris in 1979, and in the same year Aldo Crommelynck proofed it. Hodgkin resumed work on it in 1985 when the prints were editioned and hand coloured by Cinda Sparling in her studio in New York. One version was printed in green and hand coloured in blue fountain pen ink, applied by a large brush in four strokes. Hodgkin had been thinking about the colours for a long time. The application of the hand colouring on *David's Pool* would be all important, a question of 'kill or cure', as he told Cinda Sparling.[23] The warm cobalt blue hand colouring beautifully represents the water of David Hockney's pool. The blue saturates the paper and contributes to the illusion of wetness in the print. Trees and passing clouds cast their shadows in the water of the pool, and flagstones form the border. The monochrome version was printed and hand coloured in black. Together with *DH in Hollywood* (1979–85; page 87), also made at Aldo Crommelynck's studio, they are based on a trip to see the artist's friend David Hockney in Los Angeles. By choosing a pool, Hodgkin refers to Hockney's own series of pools. Hodgkin says of *David's Pool*, 'Unequivocally one of my very best prints, because all my feelings about how to use the medium come out with the greatest clarity.'[24] It won the Henry Moore Foundation Prize at the 9th British International Print Biennale in Bradford in 1986.

Cinda Sparling hand coloured all thirteen lithographs that Hodgkin made with Judith Solodkin at Solo Press between 1977 and 1988. Only *Birthday Party*, the first print executed at Solo Press in New York in 1977 was finished at Sky Editions in London in 1978. The finish consisted of tearing down the sheet and applying blue gouache to the borders. All further lithographs printed by Judith Solodkin were hand coloured by Cinda Sparling. Although she had no previous experience with hand colouring, the collaboration was fruitful and unique. Hodgkin did not show her how the paint should be applied, unless, in an exceptional case, she failed to understand

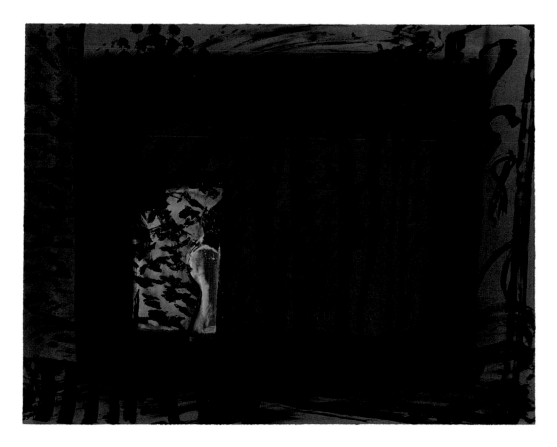

Blood 1982–85 (cat. no. 69)

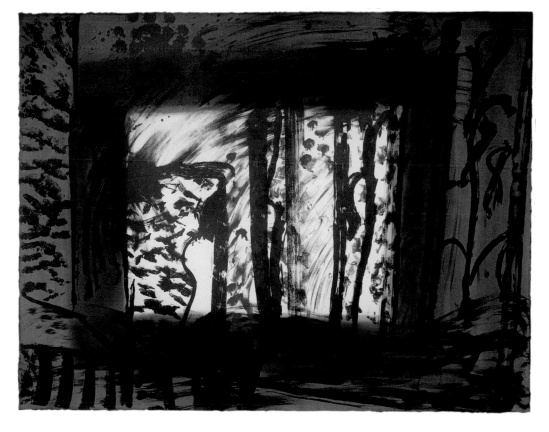

Sand 1982–85 (cat. no. 70)

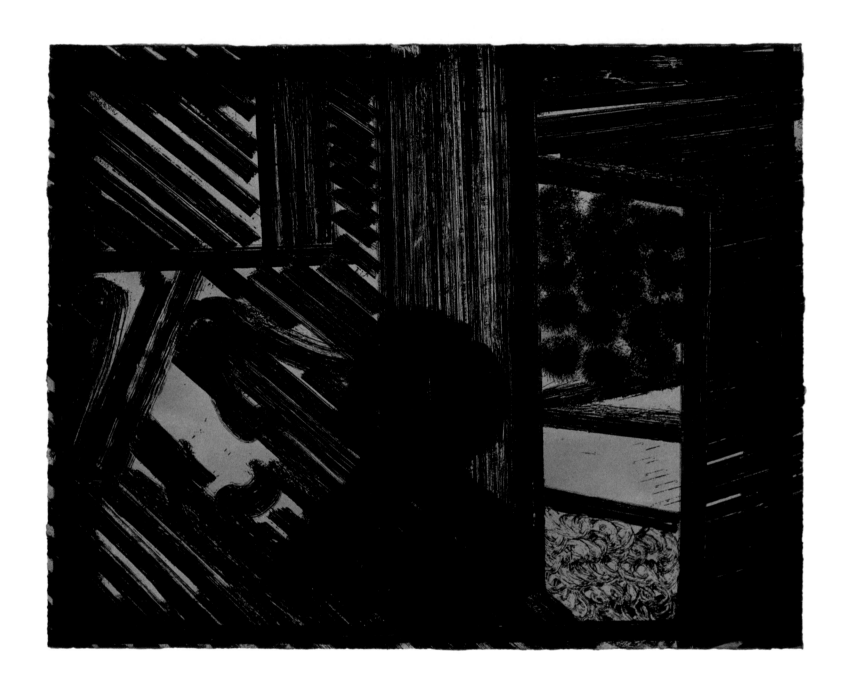

Artist and Model 1980 (cat. no. 59)

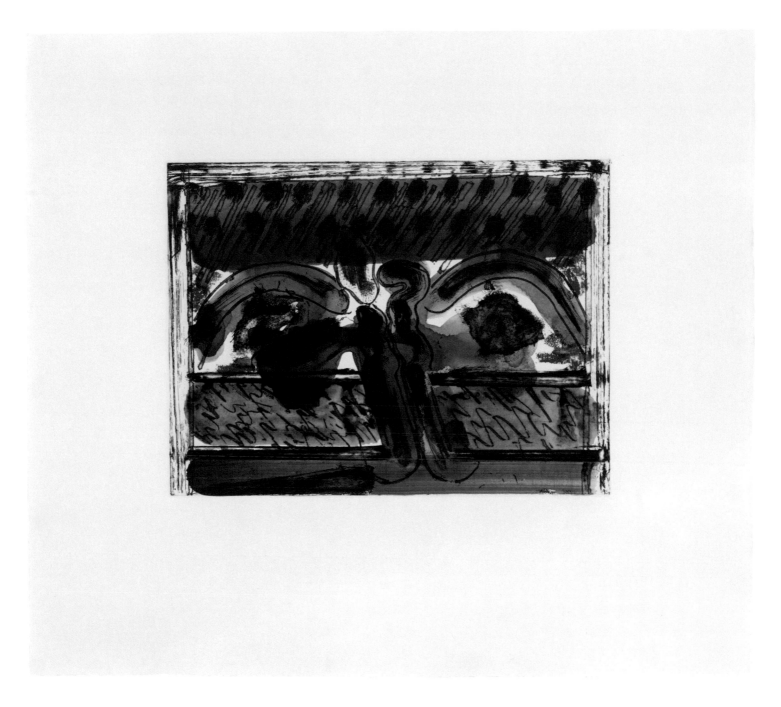

DH in Hollywood 1979–85 (cat. no. 56)

his intentions. In refraining from making the initial mark himself he was trying to bring maximum spontaneity to the hand colouring. Particularly in the case of the large format prints, Hodgkin's body movements in making marks would be automatically different from those of someone else. Any attempt to copy his movements would impair the spontaneity. Instructions were very specific: Hodgkin indicated the location of the mark, the amount of pigment on the brush, and, crucially, the type and intensity of the movement, using all kinds of metaphors such as 'like a silk-stocking', 'like a whisper', or 'like a bold explosion', never referring to the hand colouring of a previous print. As their understanding grew, Sparling only needed brief instructions. During the years of working side by side the hand colouring became an integral part of the print in which printed marks were difficult to tell from hand-applied marks. This is most clearly visible in *One Down* and *Two to Go* (page 71).

In the lithographs *Moonlight* and *Black Moonlight* (both 1980; pages 38 and 39), the earliest prints that were made in collaboration with Cinda Sparling, the hand colouring was rather simple. It was applied on top of the printed surface. The heavy downward-thrusting arrow that dominates the prints was thinly painted through a stencil in black watercolour which bleeds into the printed background. This bleeding is intentional.[25] The large maquette made for *Moonlight* differs in a few respects from the final image: an orange shape was added and the opaque black hand colouring on the borders was changed into a light ivory black.[26] The lithographs *Moonlight* and *Black Moonlight* are erotically charged, showing the artist's self-portrait in the form of a bust set against a background of a 17th-century Mughal hanging in an apartment in Manhattan. The large arrow forms the connecting element between the self-portrait on the left and the bust in the lower right.

The same Manhattan apartment features in *Bleeding* (1981–82; page 42) and *Mourning* (1982; page 43), another duo of highly charged lithographs. The occasions depicted here are two moments during a quarrel. By this time, the Mughal hanging that decorated the apartment at the time of making *Moonlight* had gone to the Metropolitan Museum of Art. It was replaced by an Indian cotton painted panel which plays centre stage in these prints. The layers of ink and touches of gouache,

the ornamental design, and the use of the uninked paper create an illusion of space which is not often found in Hodgkin's prints. They have a jewel-like opulence and an abundance which makes them Indian in spirit. The prints were based on detailed pencil drawings of the Indian panel and on a photograph of the Alhambra in Granada, Spain. When working on the plates the artist only referred to the photograph.

Red Eye (1980–81), the pair *Blood* and *Sand* (both 1982–85; page 85) and the much later *In an Empty Room* (1990–91; page 120) also depict moments of intense feeling. *Red Eye* refers to a terrible hang-over. The orange shape aggressively intruding the picture space plays an ambivalent role.[27] No pictorial significance can be assigned to the dots, dabs, stripes and blobs in *Blood* and *Sand*. They invite multiple interpretations.[28] A heavy frame gives structure to the rectangular image which is built up by means of various vertical bands.

In 1983 Hodgkin was asked by Andy Warhol to contribute to the official art portfolio of the Olympic Winter Games to be held in Sarajevo in 1984. Hodgkin's contribution was a very simple lithograph – *Welcome* (1983). In its emblematic simplicity, large size and lack of hand colouring, it is rather similar to a poster. The image itself has none of the elusiveness of other prints made in these years. Although it is a somewhat unimportant work which lacks all the lushness and richness of the prints in the next phase of Hodgkin's career as a printmaker, it does anticipate the next period through being direct and unambiguous. In *Welcome* Hodgkin has abandoned the frame around the image, something that became a hallmark of the poster-like images of the next phase.

This phase of printmaking in Hodgkin's career spans nearly a decade, from 1977 to 1986. It began with *Nick* (1977) as his first significant statement in printmaking, and ended when Hodgkin began working with Jack Shirreff in 1986. During these years Hodgkin made a large number of prints in pairs, one of which was usually in colour, the other in monochrome. Regarding subject matter, Hodgkin concentrated on interior scenes while working predominantly in lithography. He also enjoyed soft-ground etching, which he first used in 1977. In emotional intensity the prints are closest to his paintings in the years between 1980 and 1983.

Prints made between 1986 and 2002

The year 1986 can be seen as the start of a third, mature phase in Hodgkin's career as a graphic artist when he found techniques that perfectly suited him. Like the landmark year 1977, it was preceded by important events in his life, though of a less dramatic nature.[29] No printed work was made during 1984 or 1985, but as soon as new prints started to appear, a change in technique, style and choice of motif was noticeable.[30] These changes were linked directly to working with a new printer, Jack Shirreff, who introduced Hodgkin to new printing media. In 1977 Hodgkin found in hand colouring a technique that broadened the scope of his prints. In 1986 he found in carborundum, combined with lift-ground etching and aquatint, other techniques that helped him to overcome some of the technical limitations of printmaking. These new media had a great impact on the appearance of his prints.

When Hodgkin began to work with Jack Shirreff at the 107 Workshop in Wiltshire in 1986 he was shown how to use carborundum with lift-ground etching and aquatint. To understand properly how his prints underwent a transformation it is necessary to know how these techniques work. Carborundum is a carbon and silicon compound which is used in the printing process combined with synthetic resin or varnish. The process, invented by Henri Goetz in the 1960s, was frequently used by artists such as Antoni Clavé, Antoni Tàpies and Joan Miró. The use of carborundum involves applying lumps of sticky paste to an aluminium plate.

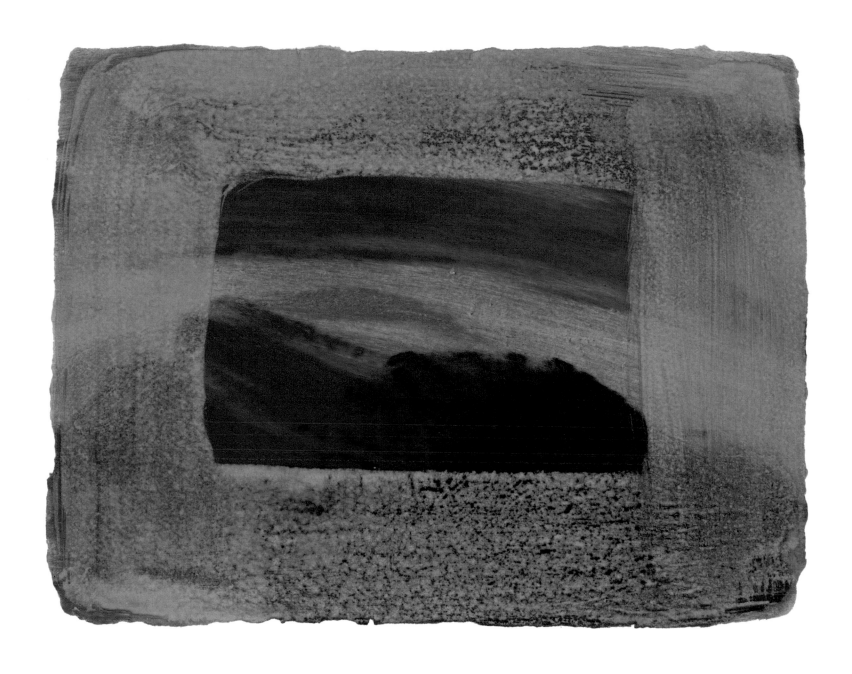

After Degas 1990–91 (cat. no. 81)

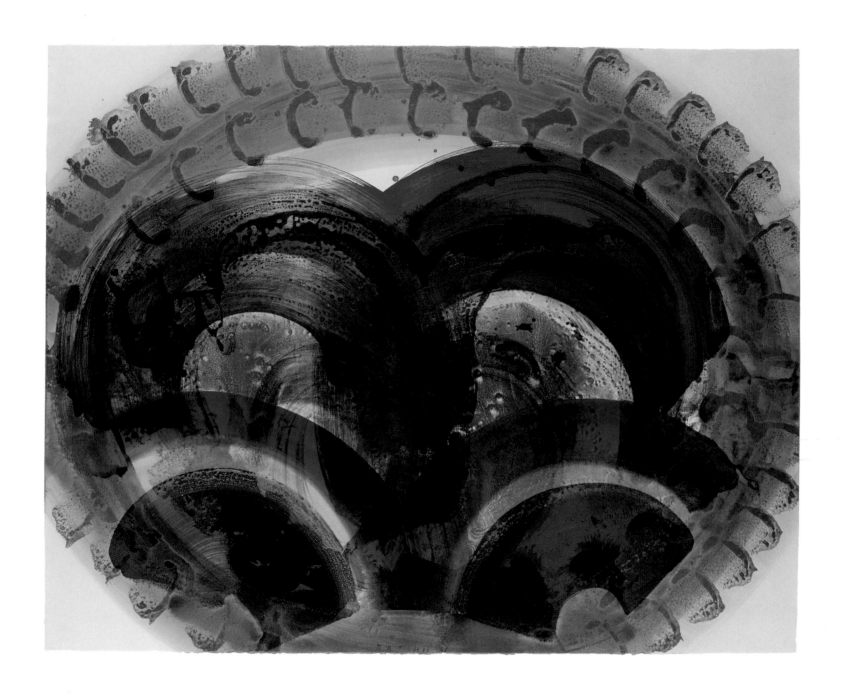

Red Palm 1986–87 (cat. no. 75)

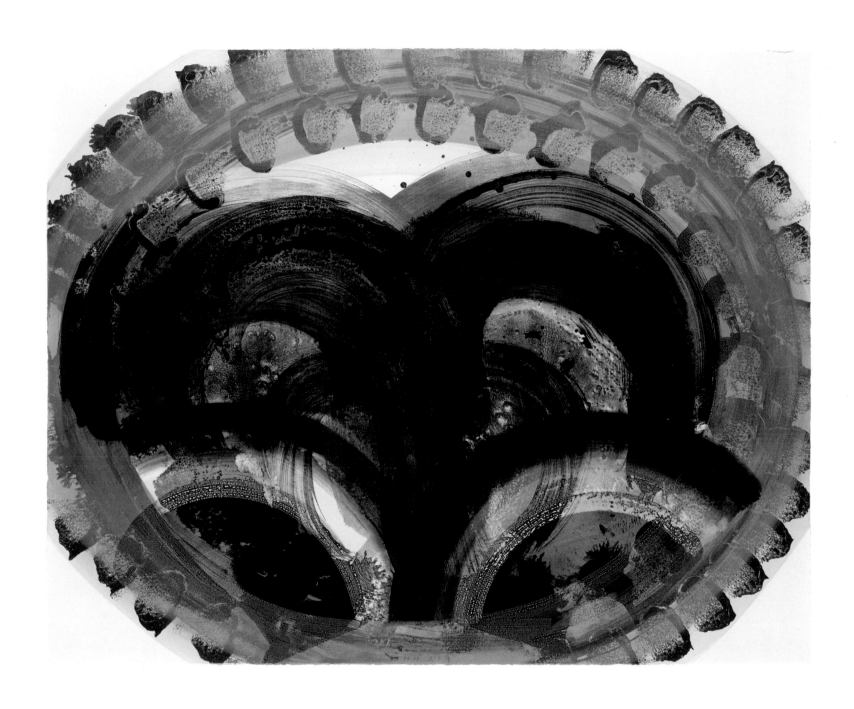

Black Palm 1986–87 (cat. no. 76)

Black Monsoon 1987–88 (cat. no. 78)

Monsoon 1987–88 (cat. no. 79)

Ivy 1990 (cat. no. 80)

This can be done with a brush or hand. It is a simple and direct method which Hodgkin has described as 'marvellously liberating'.[31] The carborundum, when dried, retains the ink wiped onto it and embosses the paper. It gives the paper a lively, tactile surface texture.

Lift-ground etching, also called sugar aquatint, is a process whereby the brushed area is bitten around the resin that was present in the ground. By varying the size of the particles of the resin, the effects can range from a fine watercolour wash to a coursely grained area.

The use of these tonal processes, always in combination with hand colouring, stylistically narrows the gap between printing and painting. They allow the artist to work the plate in a painterly way. Due to these techniques the prints became bolder and more physically direct. Hodgkin had finally found the printing media that suited him best. After he employed these methods, lithography lost its attraction; he made only five more lithographs with Judith Solodkin in New York.

Between 1986 and 1991 Hodgkin produced prints that were depictions of physical reality.[32] Except for *Moon* (1987) they were printed on large sheets of paper and were inspired by posters. He wanted to make prints 'as brutally direct as a rubber stamp'.[33] Whether or not the motifs were anchored to a particular incident in the artist's life no longer seems relevant. They were simply representations of objects such as a palm, a door, a branch of ivy, or a moon. Even their titles were unambiguous: *Red Palm, Moon, Mango, Flowering Palm, Moroccan Door*, etc. After 1991 he started to make more gestural work.

The first group of prints Hodgkin made with Jack Shirreff in 1986 was the group of interiors individually entitled *Green Room* (page 109), *Blue Listening Ear* (page 107) and *Listening Ear* (also called *Red Listening Ear*) (page 106). Being interiors they are a continuation of the subject matter of the past. They are just as puzzling as many of the earlier prints. Later in 1986 the perspective shifted to the exterior, to nature. With the focus shifting to the world outside, the printed frame, which often functioned as a window frame, was at times abandoned. By doing so, the artist asserted the flatness of the printed surface.

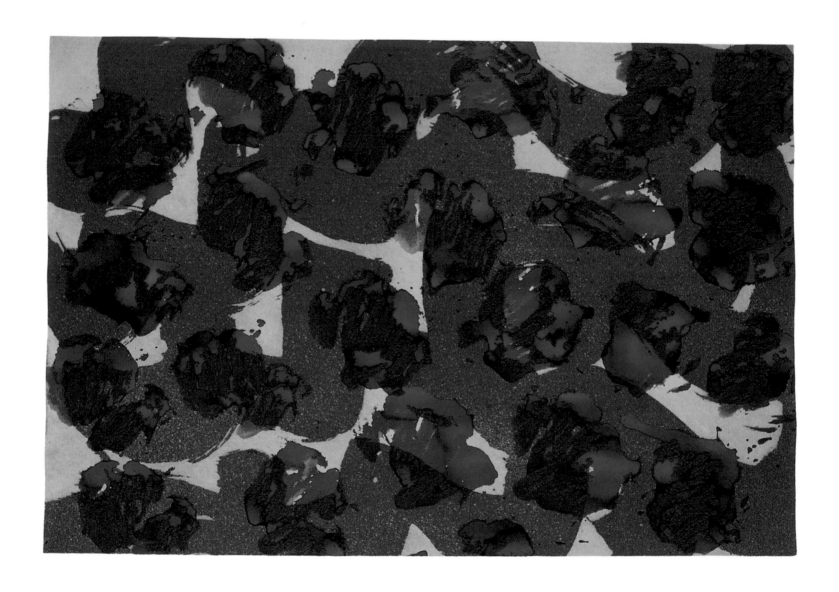

Fear Gives Everything its Hue, its High,
from *The Way We Live Now* 1990 (cat. page 216)

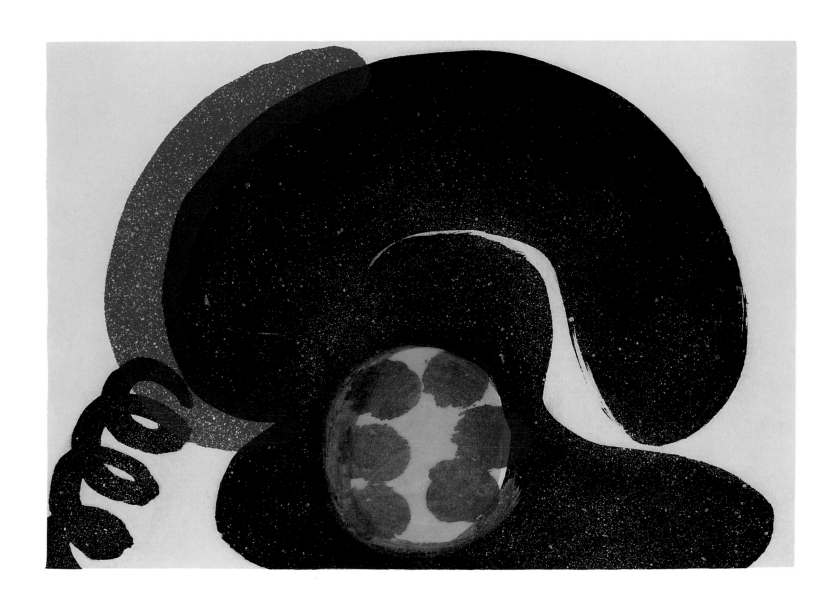

In Touch
Checking In,
from *The Way We Live Now* 1990 (cat. page 216)

The group shows a change of style and technique. In style, the prints are more fluid and broader than the earlier work. The two etchings in which carborundum was used, *Blue Listening Ear* and *Listening Ear* (also called *Red Listening Ear*), have an almost sculptural quality because of their rich surface texture. The group heralds a phase in which Hodgkin conceived his prints in terms of broader masses of tone and texture. The prints made after 1986 were increasingly flattened into simple shapes created by volumes or broad brushstrokes. Hodgkin worked towards a painterly effect rather than a graphic or linear one.

The change of style, the broader touch, was carried through in the last five lithographs that were made at Solo Press between 1986 and 1988: *Red Palm* and *Black Palm*, *Monsoon* and *Black Monsoon*, and *Moon*. The latter is simply a representation of a moon. It is a straightforward lithograph which is executed in a few colours. *Moon* (1987) probably represents what the artist means by making prints 'as brutally direct as a rubber stamp'. The other four are two pairs for which the same plates were used to achieve images in different colour variations. They are simply depictions of palms and the monsoon in variant colour combinations. The perspective has shifted to the world outside, although still seen from inside, judging from the window frames. In *Moon* the device of a frame has been abandoned.

Red Palm (1986–87; page 92) and *Black Palm* (1986–87; page 93) find their direct parallel in *Blue Palm*, a painting made around the same time and also oval in format.[34] They represent the same motif, albeit in different colours and much larger than in the painting.

The pouring rain is aptly captured in the printed splatters and puddles in *Monsoon* (1987–88; page 95) and *Black Monsoon* (1987–88; page 94). Although made from the same plates, they are entirely different in atmosphere. The frame which features so prominently and distinctly in the colourful *Monsoon* is wholly blended into the overall composition in the black version and creates an overall sombre effect.

Hodgkin's fascination with large travel posters, seen in the metro in Paris in the late 1950s or early 1960s, is expressed in a series of four large intaglio prints made with carborundum between 1990 and 1991: *Night Palm* (page 112), *Street Palm* (page 113), *Palm*

and Window (page 116) and *Flowering Palm* (page 117). They are equivalents to the travel posters in that they are huge, bright, spontaneous and straightforward. These large posters by artists such as Adolphe Mouron Cassandre (1901–68), Bernard Villemot (1911–89) and Raymond Savignac (1907–2002) were the only kind of print Hodgkin ever consciously tried to imitate.[35] The metro posters were loud, brightly coloured advertisements for companies such as the French Railways, Air France and the French National Tourist Office. Hodgkin tried to achieve a similar immediacy, spontaneity and directness in the group of palm prints, but also in much of his later work as, for instance, in *Put Out More Flags* (1992), *Red Print* (1994; page 22) and *Snow* (1995; page 23), and the small prints made in the second half of the 1990s. Spontaneity is important in his prints – a quality that his paintings lack.[36]

Moroccan Door (page 123), *Mango* (page 122), *Indian Tree* (page 36) and *In an Empty Room* (page 120), made during the same working period at the 107 Workshop in Wiltshire, share the large format of the group of palm prints. Their iconography, except for *In an Empty Room*, which visualizes a dramatic incident in an Indian interior, is equally self-explanatory. *Mango* was inspired by a poster of a huge Edam cheese that the artist saw in England in the 1970s. It is simply an enormous piece of fruit, 'meant to be the biggest mango in the world'.[37]

In an interview with Antony Peattie Hodgkin said about the eight prints, made between 1990 and 1991, that they are all very specific rather than generic.[38] However, by giving them generalized appearances, except for *In an Empty Room*, they have been made into vignettes. For instance, the palms themselves are all very similar and do not give the impression that they are based on actual palms Hodgkin has seen. They are bright, sumptuous images that are 'soothing, straightforward – uplifting and raising the spirits', as the artist intended. With the disappearance of the narrative element and the human figure, the images have lost much of their ambiguity. The unique print *Ivy* (1990; page 96) also belongs to this group of large, poster-like prints. It is nothing more and nothing less than a branch of ivy. What the mind knows on the basis of the title and what the eye perceives has become one. It hangs in the Ivy restaurant in London.

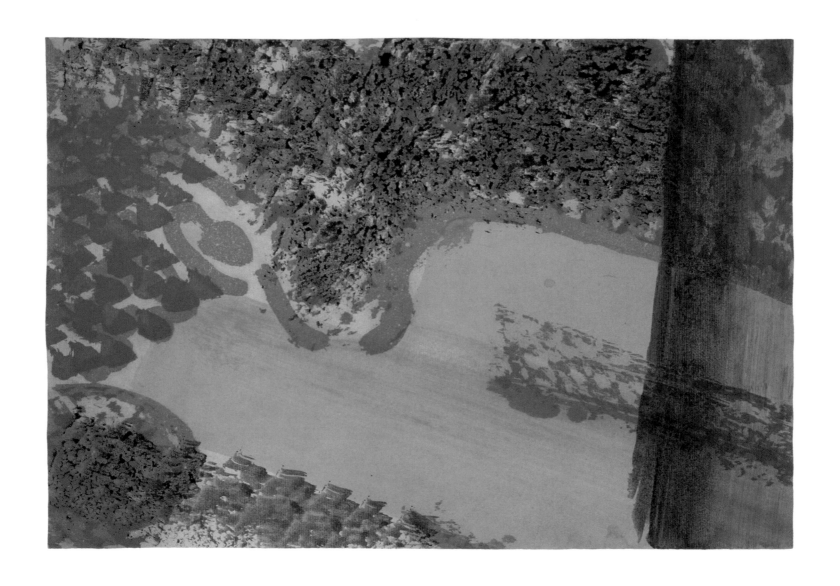

As You'd Been Wont – Wantonly
Wantonly
Eros Past,
from *The Way We Live Now* 1990 (cat. page 217)

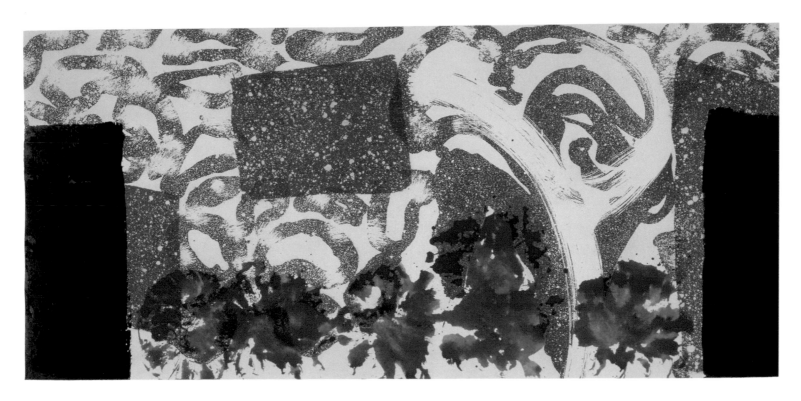

The Hospital Room was Choked with Flowers
Everybody Likes Flowers
Surplus Flowers
The Room ... was Filling up with Flowers,
from *The Way We Live Now* 1990 (cat. page 217)

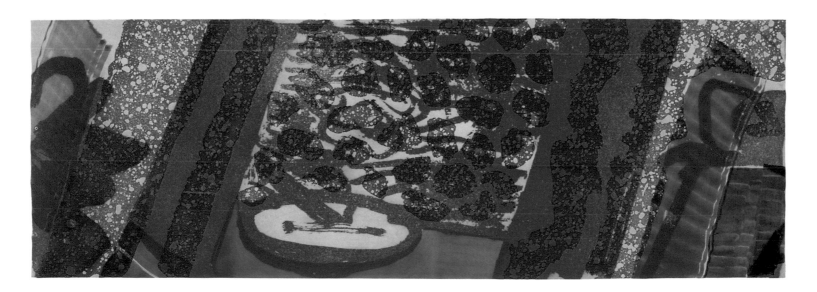

But He Did Stop Smoking
He Didn't Miss Cigarettes at All,
from *The Way We Live Now* 1990 (cat. page 217)

The images of palm trees are seen by Hodgkin as having the essential quality of prints: 'large pieces of coloured paper'.[39] He wants his prints to differ as much as possible from his paintings by having the simplicity and immediacy of metro posters. Ideally, he also wants them to be inexpensive. However, the materials the artist employs do not create the effect of posters. Carborundum and hand colouring give the print an impasto effect and a certain lushness. In addition, hand colouring is expensive. In this respect it may be telling that there were plans for Cinda Sparling to paint the screenprint of *Gossip* (1995), one of the prints Hodgkin made for the Lincoln Center for the Performing Arts in New York.

Having used Sparling as a hand colourist for so long, it was to take Hodgkin some time before he established a similar relationship with Jack Shirreff. He did not work in the same way as he had done with Sparling, but rather asked the printer to copy his marks. In the past, Hodgkin had followed a similar procedure with his other printers. Shirreff makes detailed notes describing each brushmark, the stops, the type of paint and the amount of pigment to be used when Hodgkin paints the model for the rest of the edition. Shirreff then repeats the marks under the artist's supervision and later, in the editioning, works on the basis of his notes. It often takes a few trials before the effect is satisfactory. The execution of the marks should look, as indeed it does, unpremeditated and direct. The yellow paint in *Flowering Palm* (page 117) looks as if it was spontaneously and freely applied, whereas every stop and movement of the brush was calculated. When the yellow paint accidentally covered the red form at the centre of the print, the printer was instructed to wipe it off carefully. The green paint of *Night Palm* (page 112) was intended to drip 'spontaneously', but within certain parameters. The three painted marks, the yellow, blue and orange, in *Put Out More Flags* (1992) were done in three, two and one precise movement of the brush, respectively.

The partnership with Shirreff proved very fruitful, and he and Hodgkin have collaborated ever since 1986, building a trusting relationship in which each knows his role. It is important to Hodgkin that he is left alone when he needs some time to think about the development of a print. Shirreff has learnt to appreciate that he

is not informed of the artist's plans and ideas. He does not know the title of a print or even what a print is about before it is finished, but regards this as positive because his mind is not clouded by any preconceived ideas. Hodgkin, for his part, relies fully on the printer for his advice on technical matters, and on the choice of printing colours. The artist's confidence in Shirreff is such that he lets Shirreff paint the central image of a print.

The role of hand colouring changed while working with Shirreff. It increasingly formed the central motif of the print. The books in *Books for the Paris Review* (1997–99; page 46), the flags in *Put Out More Flags* (1992) were shaped by means of painting. The form of the palms in *Indian Tree* (page 36) or in *Flowering Palm* (page 117) was created by hand colouring the entire background. Since 1986 hand colouring has become increasingly important to Hodgkin, culminating in the prints made in the 1990s.

The brushstroke itself, the gestural mark, dominates the prints of the second half of the 1990s. The central image of *Summer* (1997; page 6), *Books for the Paris Review* (1997–99), *In a Public Garden* (1997–98; page 47) and *Norwich* (1999–2000; page 25) is formed by one or two broad brushstrokes.[40] This is a simple, but very effective device, which, to a lesser extent could already be seen in *Put Out More Flags* (1992), *Red Print* (1994; page 22) and *Window* (1996; page 49). Shirreff has expressed his astonishment at the artist's ability to choose precisely the right brush for the job. Hodgkin has a wide range of brushes which he acquired abroad.[41]

The medium of the hand colouring also changed in the 1990s. Watercolour and gouache had been dominant in the 1970s and 1980s, while occasionally crayon was applied, and in one or two cases pastel or ink. In the group of large prints made in 1990 and 1991 Hodgkin first used egg tempera, and since 1995 he has exclusively used acrylic paint which makes his prints appear more saturated and seductive.

All prints completed since 1990 were made in basically two formats: either small, around 24 x 28 centimetres ($9^1/_2$ x 11 in.) or rather large, up to two metres high by over two and a half metres wide (78 x 98 in.).[42] Both the smallest as well as the largest prints were made in connection with illustrations to a text. *The Way We Live Now*

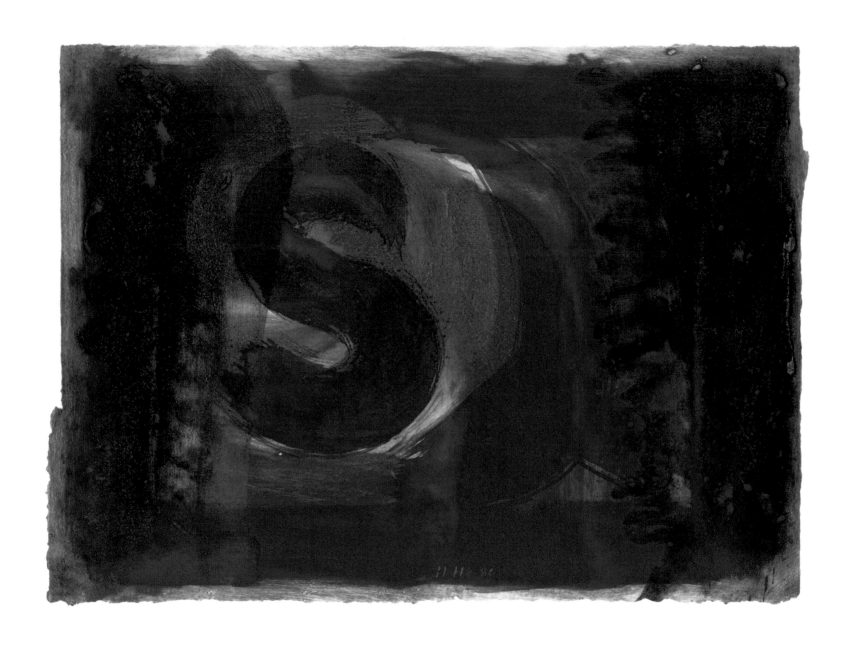

Listening Ear (also called Red Listening Ear) 1986 (cat. no. 74)

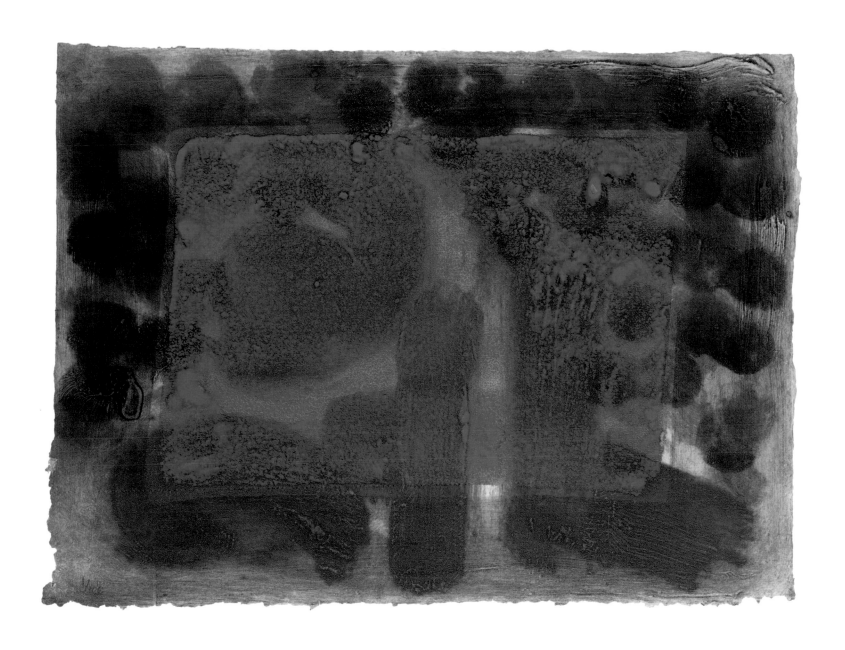

Blue Listening Ear 1986 (cat. no. 73)

(1990; pages 98, 99, 102 and 103) by Susan Sontag is a story about the reactions of a group of people in New York to a friend who is dying of AIDS. It was written in response to the death of her friend Robert Mapplethorpe. Hodgkin's prints, executed in 1990, refer to specific passages in the text, and are among the artist's most literal works. The second text Hodgkin illustrated is *Evermore* (1996–97), a story about a personal remembrance of a brother killed during the First World War. The story is written by Julian Barnes and appears in his collection *Cross Channel*. Hodgkin favoured a simple approach in line with the story and made straightforward, prosaic designs. The illustrations for the two books were printed with Shirreff at the 107 Workshop.

There have been other plans to illustrate books, but these have never been realized. Perhaps we should be grateful when we see the results of two abandoned projects. The first one is *For Bernard Jacobson* (1977–79; page 65), a print that resulted from an aborted plan to illustrate the new edition of E. M. Forster's *A Passage to India*. The second one is the series of 'Venetian Views' (pages 14, 15, 18 and 19), begun after an abandoned scheme to illustrate *Death in Venice* by Thomas Mann. The project was abandoned in 1993. Although the Venice prints bear no relation to the subject matter of the book, the book-size scale of the original project is reflected in the small size of the sheets of paper on which the prints were made. The first three of the views consist of sixteen individual sheets. Only *Venice, Night* is a diptych. Just as *For Bernard Jacobson* had been the most ambitious and most elaborate print of its time, the 'Venetian Views' (1995) constitute Hodgkin's most ambitious and most elaborate print project, not just in the 1990s, but of his whole career. 'Into the Woods' (pages 148, 149, 152 and 153), the set of four prints that he made between 2000 and 2002 are only more ambitious in scale, not in technique. In their richly worked surface and technical elaboration – they are etchings with lift-ground aquatint and carborundum with hand colouring – the 'Venetian Views' assume the same weight as his paintings. The interplay between printed and painted marks is so intricate that it obscures what is painted or not. All four views breath a luminosity, a timelessness and have the seductiveness and saturation of richly worked images.

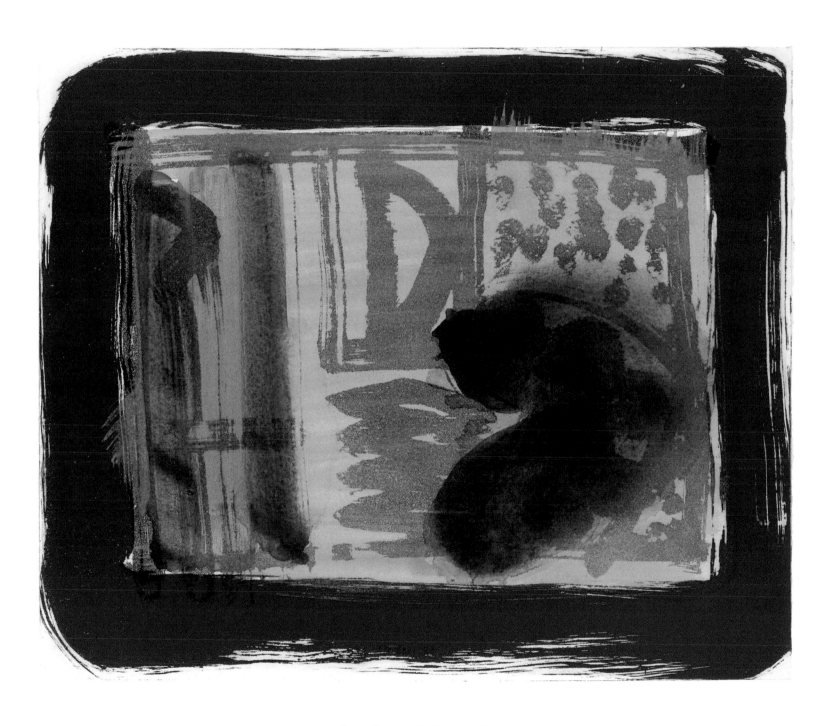

Green Room 1986 (cat. no. 72)

At first sight the four prints seem vaguely related, but for each print the same five plates were used to realize the same imaginary view of Venice. The printing inks and paints are varied to show the same view at different times of the day, and under different emotional circumstances. The 'Venetian Views' not only have the intensity and emotional aspect of his painted work, which is unlike the majority of his prints of the 1990s, they are also stylistically closer to his paintings than previous prints. The same can be said of *Norwich* (1999–2000; page 25), in which Hodgkin pushed hand colouring to its limits; its printed surface is thickly covered in ultramarine blue, white and cadmium red acrylic. So much so, that the original printed surface is barely visible.

In the summer of 2000 Hodgkin started work on a group of etchings: the huge set of 'Into the Woods', the medium-sized *Frost* (page 126), and *You Again* (page 131), *Rain* (page 136), *Dawn* (page 137), *Tears, Idle Tears* (page 144), *Away* (page 145), *Strictly Personal* (page 140), *Cigarette* (page 141), *Seafood* (page 133) and *Home* (page 130), nine small-format etchings.

'Into the Woods' was originally conceived as a single, independent work. *Into the Woods, Winter* (page 153) was done first. Using the same printing plates, Hodgkin made three variations which he entitled *Into the Woods, Spring* (page 148), *Into the Woods, Summer* (page 149) and *Into the Woods, Autumn* (page 152). They are the largest, most monumental set of prints Hodgkin ever made, printed to the size of murals. They are meant to be hung like posters: without a frame or mount, simply fixed onto the wall by means of a large piece of board. Compared to the 'Venetian Views', the only series of prints similar in size, they are minimalist, non-graphic and technically much less complicated. Shirreff, printer and hand colourist of 'Into the Woods', considers them to be a breakthrough in Hodgkin's printed oeuvre because they come closer to paintings than all his previously made prints. They seem to explore the threshold between paintings and prints.

'Into the Woods' carries an erotic charge due to large phallic shapes at the left. In three of the four prints they have been emphasized through hand colouring. Despite the presence of these recognizable elements, the mystery of the images cannot be unravelled. The prints are based on the libretto of Stephen Sondheim's

(b. 1930) musical 'Into the Woods', after the book by James Lapine.[43] In Sondheim's musical the woods serve as a metaphor for life.[44]

Each version of 'Into the Woods' consists of a first printing with carborundum, a second printing with lift-ground etching and coarse aquatint, and a layer of acrylic paint. The brushstrokes, swiped across the printing surface, are vigorous, gestural and broad. The expansive, extrovert quality of the prints is further enhanced by the lack of a painted or printed frame. For Shirreff the hand colouring posed particular problems. Firstly, the hand colouring had to look like random marks. Parts of the hand colouring had to be applied using his hands rather than a brush. Secondly, an assistant had to stand close behind him while he was painting these huge sheets in order to guide Shirreff in the right direction.

The nine small prints and the medium-sized *Frost* (page 126) form a diverse group of prints, technically as well as aesthetically.[45] For some prints only one plate has been used, for others, three plates. Where *Cigarette* (page 141) is accessible and immediate, *Strictly Personal* (page 140) is inscrutable. *Frost* looks deceptively simple and seemingly effortless. It has been printed using one single plate which is generally more difficult than using several different plates because the print is entirely dependent on one concept.

Although there is no intended coherency among them as a group, two of them form a pair by being each other's opposites: *Home* (page 130) and *Away* (page 145). The rectangular, enclosed composition of *Home* is the opposite of the oval, eye shape of *Away* whose lines vanish into the distance. The green acrylic paint unifies the pair.

Eye (2000; page 129), *Rain* (2000–02; page 136), *Dawn* (2000–02), *Cigarette* (2000–02) and *Frost* (2000–02) are straightforwardly representational just like the group of prints made between 1986 and 1991. Apart from the lush and delicate *Dawn* (page 137), in which printing and hand colouring alternate to create a splendid sunrise, hand painting has been largely restricted to the borders.

But these prints will not be Hodgkin's final ones: he has promised to make a print for the Metropolitan Museum of Art in New York, four for the Elton John AIDS Foundation and one for the *de-luxe* edition of this catalogue raisonné (page 2).

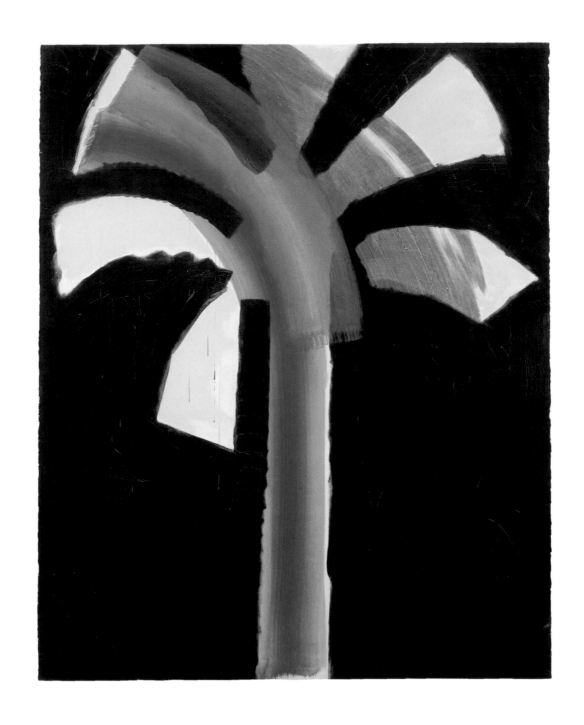

Night Palm 1990–91 (cat. no. 86)

Street Palm 1990–91 (cat. no. 87)

You Again (2000–02; page 131) and *Strictly Personal* (2000–02) could, to some extent, be seen as a summary of the artist's printed oeuvre and Hodgkin's ideas about his work. With *You Again* Hodgkin is back to where he started, but the print is embedded in the context of almost half a century of printmaking. Its simple, triangular composition and the combination of complementary green and orange refer to 'Indian Views', the artist's first ambitious group of prints made in 1971. The printing surface of *You Again*, made up of carborundum, aquatint and hand colouring, is the result of Hodgkin's long development as a printmaker. *Strictly Personal* reflects Hodgkin's aversion to interpretations of his work. Disclosure of its subject is explicitly denied to the viewer.

Since 1986 the deeply personal, emotional aspect has largely disappeared from Hodgkin's prints, with the exception of a few such as *Strictly Personal* and the 'Venetian Views'. Although Hodgkin believes that 'the only way an artist can communicate with the world at large is on the level of feeling', the lack of personal or passionate involvement did not result in a lack of communication.[46] His prints continue to communicate directly, albeit in a different way. It is the spontaneity, the straightforwardness of the prints that evoke a strong response. This was possible by using techniques such as carborundum, lift-ground etching or aquatint, always in combination with hand colouring. Being at heart a painter, Hodgkin has finally found printing media that enable him to achieve a strong response in his prints which is similar to the one he strives for in his paintings.

Notes

[1] Jasia Reichardt (ed.), 'On Figuration and the Narrative in Art. Statements by Howard Hodgkin, Patrick Hughes, Patrick Procktor, and Norman Toynton', *Studio International*, vol. 172, no. 881, September 1966, p. 140.

[2] Although the editions usually comprise 100 impressions due to commercial pressure, Hodgkin prefers editions of about 40.

[3] Teresa Gleadowe, *Howard Hodgkin: Prints 1977–83* (British Council Touring Exhibition), 1986–90 (n.p.).

[4] Åsmund Thorkildsen, 'En samtale med Howard Hodgkin', *Kunst og Kultur*, no. 4, 1987, p. 222.

[5] In this respect printmaking seems to have had an effect on his painting. 'I've tried increasingly,' Hodgkin has said, 'to sit for hours in front of the picture and make the mistakes in my head rather than on the picture surface.' Quoted in Judith Higgins, 'In a Hot Country', *ARTnews*, vol. 84, no. 6, summer 1985, p. 59.

[6] The artist's comments on his working methods show some discrepancies. Compare for instance, 'All the work, the changes of mind, as far as possible, happen in my head before I make them [the prints].' (Antony Peattie (interview), *Howard Hodgkin: Hand-coloured Prints 1986–1991*, Waddington Graphics, London, 1991, p. 3); 'I want to make prints as brutally direct as a rubber stamp and so, unlike when I am painting, I try to make all the corrections in my head before I begin working.' (Luciana Mottola, 'I Begin Pictures Full of Hope. Four Questions Posed to Howard Hodgkin', 891. *International Artists' Magazine*, vol. 3, no. 7, December 1986, p. 15); and the statement in the interview printed in this catalogue, 'I never envisage anything from the beginning. That is probably why I had such great trouble learning how to make prints. I develop the print as it goes along.' If we view them as general statements they do not seem to be compatible. I have interpreted them to relate to the prints made at the time.

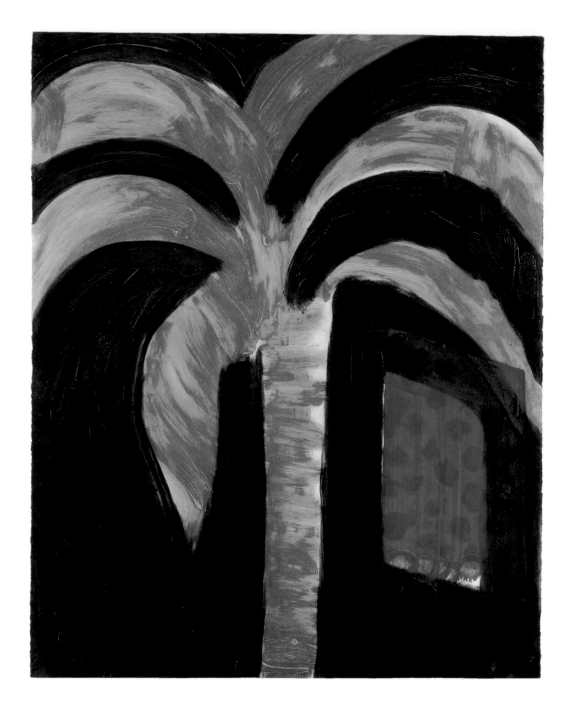

Palm and Window 1990–91 (cat. no. 88)

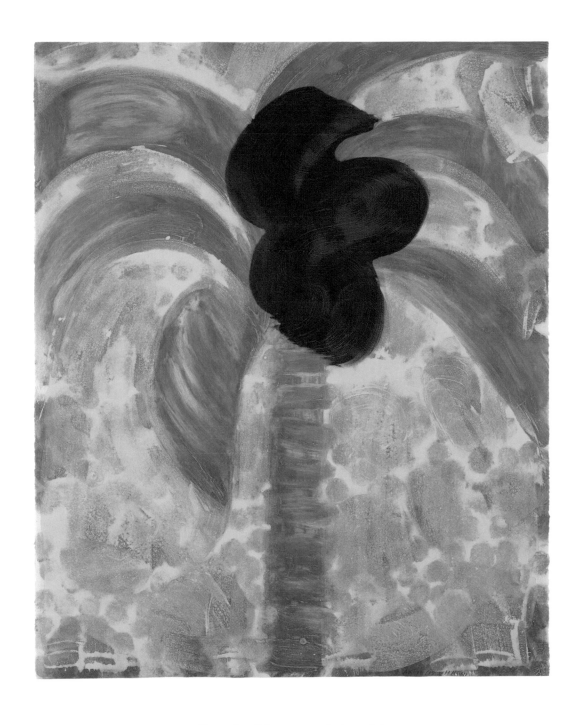

Flowering Palm 1990–91 (cat. no. 89)

[7] The maquette is in the British Museum in London (inventory number 1984-5-12-3).

[8] Personal communication with Judith Solodkin, November 1999.

[9] The embossed edge around *Lotus* (1980) was the idea of Douglas Corker at Kelpra Studio in London. He added it at the proofing stage because it resembled the double edge of the surface of the hand-made paper of the original gouache. Hodgkin decided to keep it on the entire edition. See A. R. Taylor, *Kelpra Studio: 25 Years*, exh. cat., Wigan Education Art Centre, Wigan, 1982–83.

[10] See Elizabeth Miller, *Hand-coloured British Prints*, exh. cat., Victoria and Albert Museum, London, 1987.

[11] Personal communication with Jack Shirreff, December 1997.

[12] David Sylvester, 'Hodgkin Interviewed by David Sylvester' in *Howard Hodgkin: Forty Paintings 1973–84* (British Council Touring Exhibition), 1984–85, p. 105.

[13] Åsmund Thorkildsen, 'En samtale med Howard Hodgkin', *Kunst og Kultur*, no. 4, 1987, p. 223.

[14] Hodgkin found historical justification in the fact that pottery was often decorated anonymously. He once read this in an essay by Herbert Read. See *The Tate Gallery: Illustrated Catalogue of Acquisitions 1984–86*, London, 1988, p. 385.

[15] For information on Hodgkin's prints made between 1964 and 1976 I have drawn largely on the unpublished transcript of an interview between Howard Hodgkin and Pat Gilmour held at the Tate Gallery in London on 1 April 1976.

[16] 'I can almost exactly date when the change happened…. It's a colored lithograph called "Nick" – 1977 – the one with the lamp and the boy pulling his shirt off. That, everybody says, is the key picture. This coincided with the great change in his personal life…. As with other artists as different as Picasso and Lucian Freud, the breakup of Hodgkin's marriage was accompanied by a major shift in painterly style. In this case it was a veritable blossoming.' Paul Levy quoted in Martin Filler, 'Howard Hodgkin is Tired of Being a Minor Artist', *The New York Times*, 5 December 1993, p. 43.

[17] Personal communication with Howard Hodgkin, December 1999.

[18] Unfortunately Ken Farley died before I began my research, so he is one of the few printers that I have not been able to speak to.

[19] See Catherine Kinley, 'Thinking Aloud in the Museum of Modern Art', in *Brancusi to Beuys: Works from the Ted Power Collection*, exh. cat., Tate Gallery, London, 1996–97, p. 62.

[20] Teresa Gleadowe, *Howard Hodgkin: Prints 1977–83* (British Council Touring Exhibition), 1986–90 (n.p.).

[21] David Sylvester, 'An Artist whose Métier is Black and White', *The Daily Telegraph*, 6 August 1994, p. 6.

[22] Michael Auping (et. al.), *Howard Hodgkin Paintings*, exh. cat., London and the Modern Art Museum of Fort Worth, Fort Worth, Texas, 1995, cat. 190.

[23] Verbal communication with Cinda Sparling, November 1999.

[24] Teresa Gleadowe, *Howard Hodgkin: Prints 1977–83* (British Council Touring Exhibition), 1986–90 (n.p.).

[25] At Solo Press in New York the stencils were often raised by means of coins which allowed for some limited bleeding.

[26] *Moonlight* was used as an example for a polychrome wool tapestry woven in the West Dean Tapestry Studio by Valerie Power in 1983. It is in the collection of the Fitzwilliam Museum in Cambridge (inventory number T. 2-1986). Three other works by Hodgkin served as examples for tapestries produced between 1982 and 1984. They were commissioned by an anonymous donor to benefit the Contemporary Art Society.

[27] The black marks were produced with red lipstick because a material that was thicker and greasier than lithographic tusche was required.

[28] It has been suggested that *Blood* represents the heat of an orgasm. See Jeremy Lewison, 'Howard Hodgkin', *Carte d'Arte*, 1986, p. 23.

[29] Hodgkin represented Britain at the Venice Biennale in 1984, and had his first American solo exhibition of paintings in the autumn of that year. In addition, he won the Turner Prize in 1985.

[30] In the winter of 1984 Hodgkin made a lithograph for the *de-luxe* edition of the exhibition catalogue *Howard Hodgkin: Forty Paintings 1973–84*, but this print project was abandoned.

[31] Antony Peattie (interview), *Howard Hodgkin: Hand-coloured Prints 1986–1991*, Waddington Graphics, London, 1991, p. 4.

[32] *After Degas* (1990–91) does not belong to this group.

[33] Luciana Mottola, 'I Begin Pictures Full of Hope', *891. International Artists' Magazine*, vol. 3, no. 7, December 1986, p. 15.

[34] Michael Auping (et. al.), *Howard Hodgkin Paintings*, exh. cat., London and the Modern Art Museum of Fort Worth, Fort Worth, Texas, 1995, cat. 205.

[35] Hodgkin's fascination with posters may be derived from his former headmaster Clifford Ellis and his wife Rosemary who designed posters for London Transport, Shell Mex and BP Ltd in the 1930s. See David Brown (intro.), *Corsham. A Celebration. The Bath Academy of Art 1946–72*, exh. cat., Victoria Art Gallery, Bath (touring), 1988–89 (n.p.).

[36] Teresa Gleadowe, *Howard Hodgkin: Prints 1977–83* (British Council Touring Exhibition), 1986–90 (n.p.).

[37] Antony Peattie (interview), *Howard Hodgkin: Hand-coloured Prints 1986–1991*, Waddington Graphics, London, 1991, p. 4.

[38] Ibid, p. 5.

[39] Ibid, p. 4.

[40] *Books for the Paris Review* (1997–99) finds its painted equivalent in *Books*, oil on wood, 1991–95. *Howard Hodgkin: Recent Work*, exh. cat., Galerie Lawrence Rubin, Zurich, 29 April–31 May 1997, no. 1.

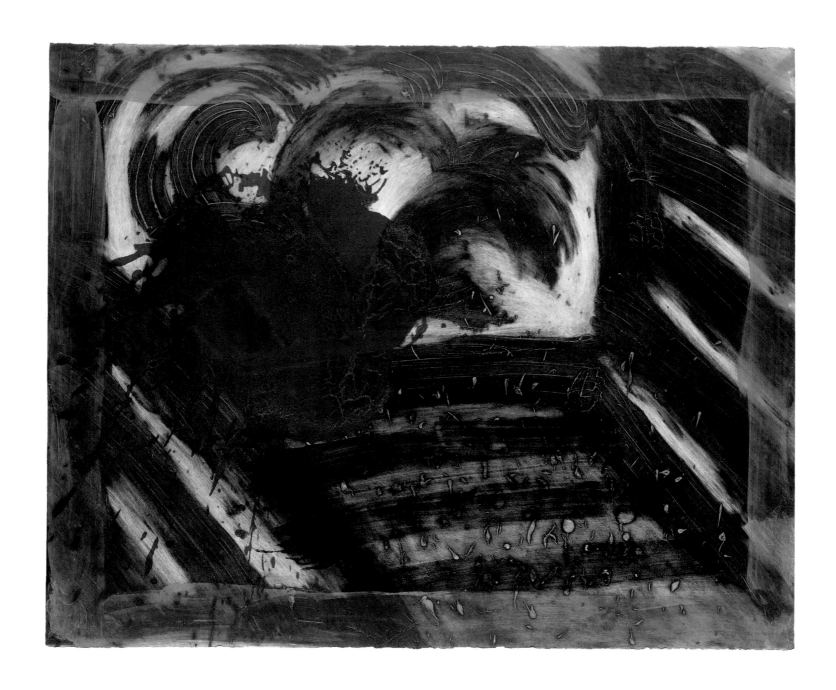

In an Empty Room 1990–91 (cat. no. 84)

41 'Von jeder seiner Auslandsreisen bringt HH [Howard Hodgkin] ein immer größer werdendes Sortiment außergewöhnlicher Pinsel mit. Pinsel sind das Geheimnis seiner langjährigen Erfahrung, und seine intuitive Wahl eines Pinsels für einen bestimmten Effekt ist immer wieder geradezu unheimlich.' ['From all his journeys abroad HH [Howard Hodgkin] brings back an ever-increasing variety of extraordinary brushes. Brushes are the secret of his long experience and his intuitive choice for a brush to get a certain effect is again and again astonishing.'] See Jack Shirreff, 'Drucken für Howard Hodgkin', in *Howard Hodgkin: Arbeiten auf Papier von 1971 bis 1995*, exh. cat., Staatliches Museum für Naturkunde und Vorgeschichte, Oldenburg (touring), 1998–99, p. 22.

42 For Jack Shirreff the small prints were more difficult to make because only a small surface area was available on which to achieve maximum directness

43 The musical first opened at the Martin Beck Theater in New York in 1987 and was staged in London from 1990.

44 From the Finale of Act Two:

to get your wish
You go into the woods,
Where nothing's clear,
Where witches, ghosts
And wolves appear.
Into the woods
And through the fear,
You have to take the journey.
into the woods
And down the dell,
In vain perhaps,
But who can tell?

45 In several prints the carborundum has been applied using a transparent plastic plate which facilitates the application of the carborundum paste when the plate is placed on top of another printed layer.

46 Timothy Hyman, 'Howard Hodgkin. Making a Riddle Out of the Solution', *Art & Design*, vol. 1, no. 8, September 1985, p. 6.

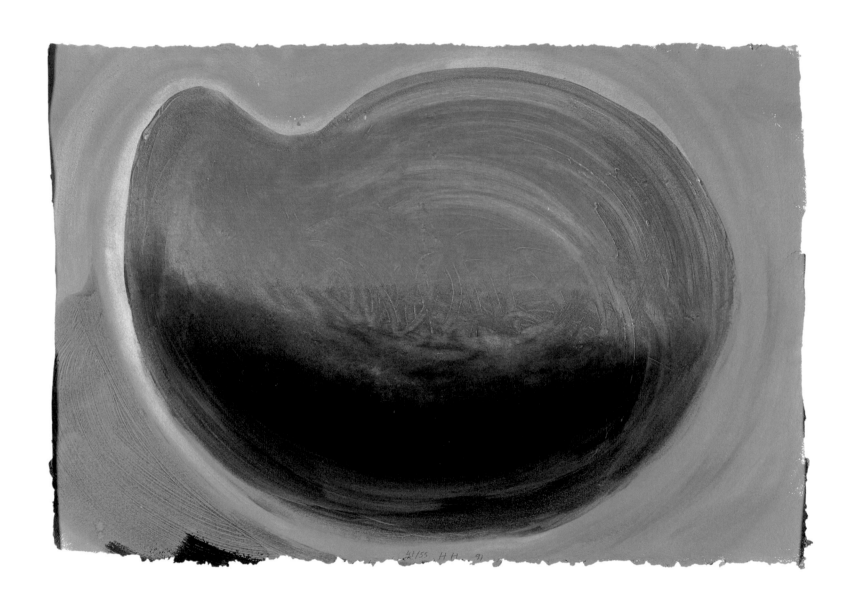

Mango 1990–91 (cat. no. 83)

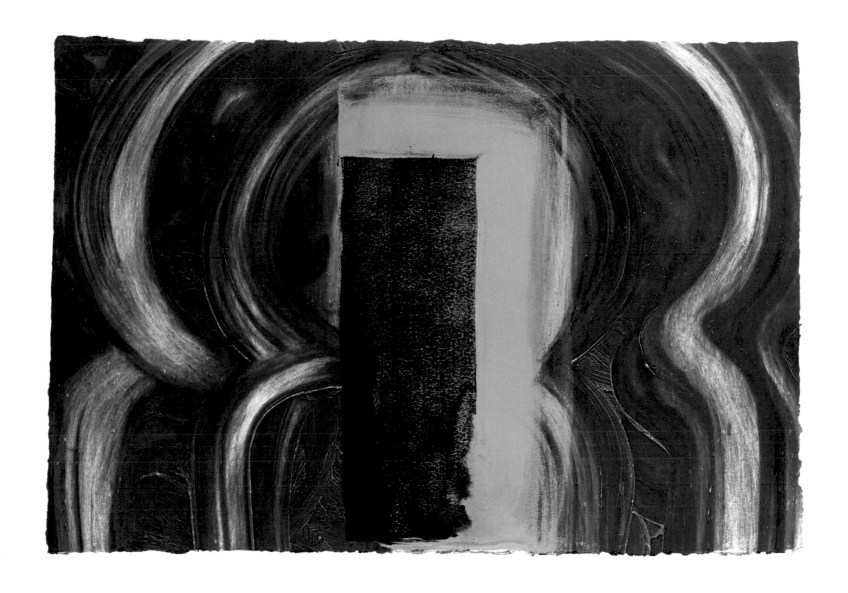

Moroccan Door 1990–91 (cat. no. 82)

A conversation with Howard Hodgkin

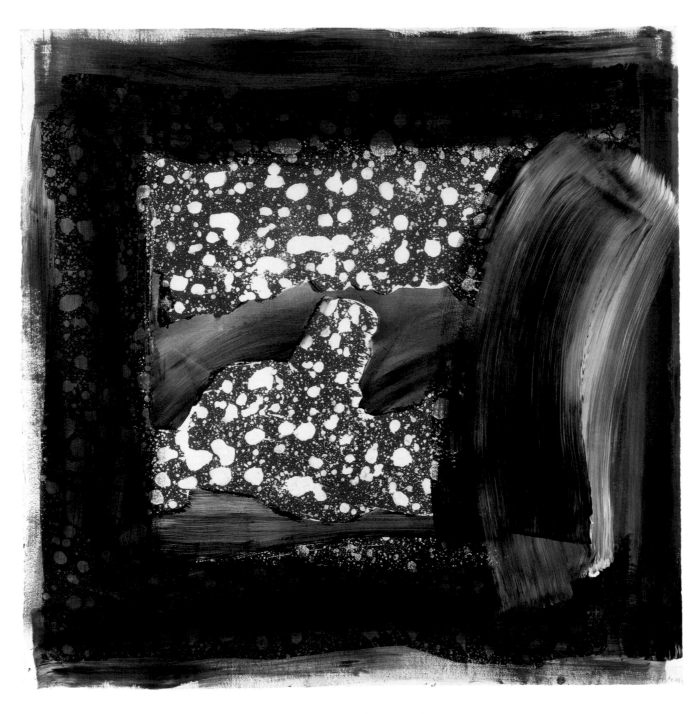

Frost 2000–02 (cat. no. 103)

Liesbeth Heenk How did you get involved in printmaking?

> **Howard Hodgkin** My first commercially published prints were
> made for Paul Cornwall-Jones at Petersburg Press. I knew him
> as a friend and greatly admired his work as a publisher. I was
> pleased when he asked me to make some prints for him, but
> it took me a long time to learn.

LH Why did it take such a long time?

> **HH** Printmaking was so different from the way I painted
> that I could not easily move on to a different way of thinking.

LH Perhaps also because you had to collaborate
with other people?

> **HH** Yes, I think that was difficult. The first prints I can
> remember making for him, *Interior with Figure* and *Girl at Night*
> [both 1966] in the '5 Rooms' series [1966–68], were made with
> Matthieu in Zurich. I felt overcome by seeing prints made by
> Giacometti, and by Bernard Cohen, who was working there

at the same time on another table. Bernard and I were both working for Paul Cornwall-Jones. Everybody seemed to know exactly what to do, whereas I was used to arriving at an image gradually. Paul said to me, 'printmaking is not about finding an image, it is about producing one', which I found a bit unnerving.

The '5 Rooms' series were not my first prints, however. The print I made for the Institute of Contemporary Arts, *Enter Laughing*, for instance, was done earlier, in 1964. I think it is one of my best prints, because of the technique of screenprinting. To me this technique is fundamentally reproductive. The subject matter and the print work perfectly; they are one thing. I didn't know anything about screenprinting and was actually apart from the whole process. I made the image at home, of course. I could see very easily what would happen, through using strips of paper tape and very different textures. Although I didn't know anything about the technique, I felt completely in control; I knew exactly what I was doing. Chris Prater at Kelpra Studio in London was encouraging and helpful. He was a wonderful printer to work with. He did not stand over you, but he was there, he explained what was possible and what wasn't.

LH Talking of *Enter Laughing*, there seems to be lot of humour in some of your prints. Not only in *Enter Laughing*, but also in prints such as *Here We Are in Croydon* [1979] or *Mango* [1990–91], for instance.

HH Yes, there is humour in some of them. I find it difficult to look at my prints, however. It is sometimes more difficult

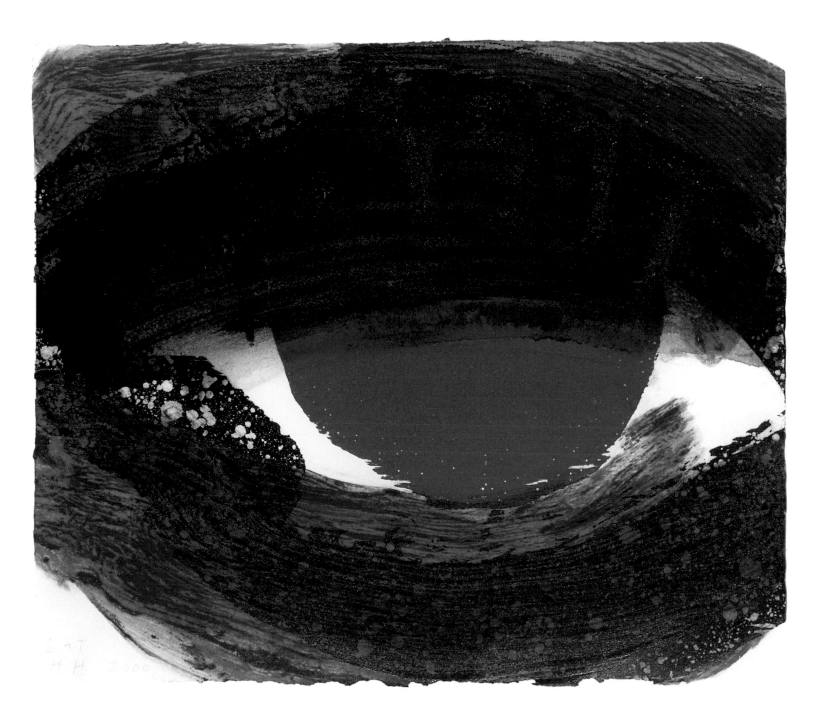

Eye 2000 (cat. no. 102)

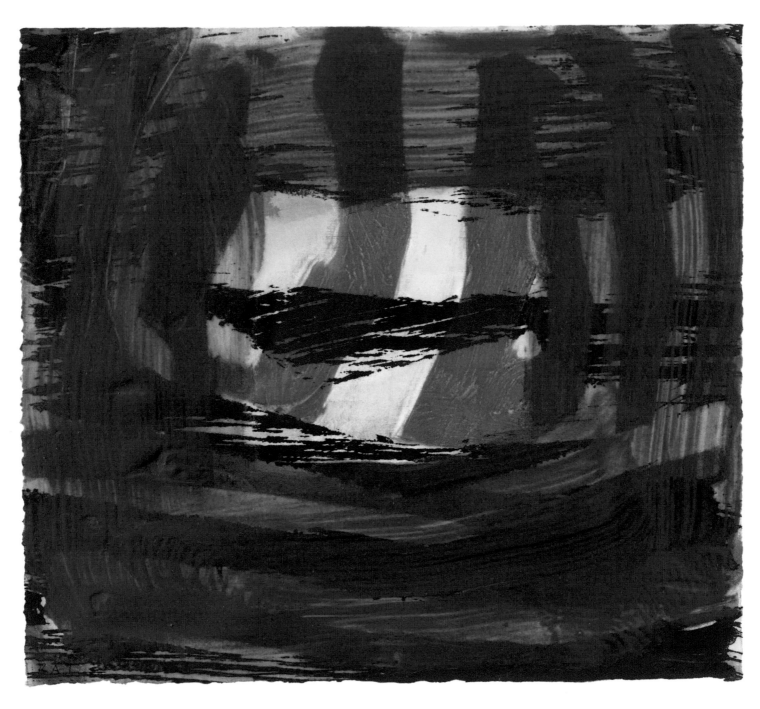

Home 2000–02 (cat. no. 112)

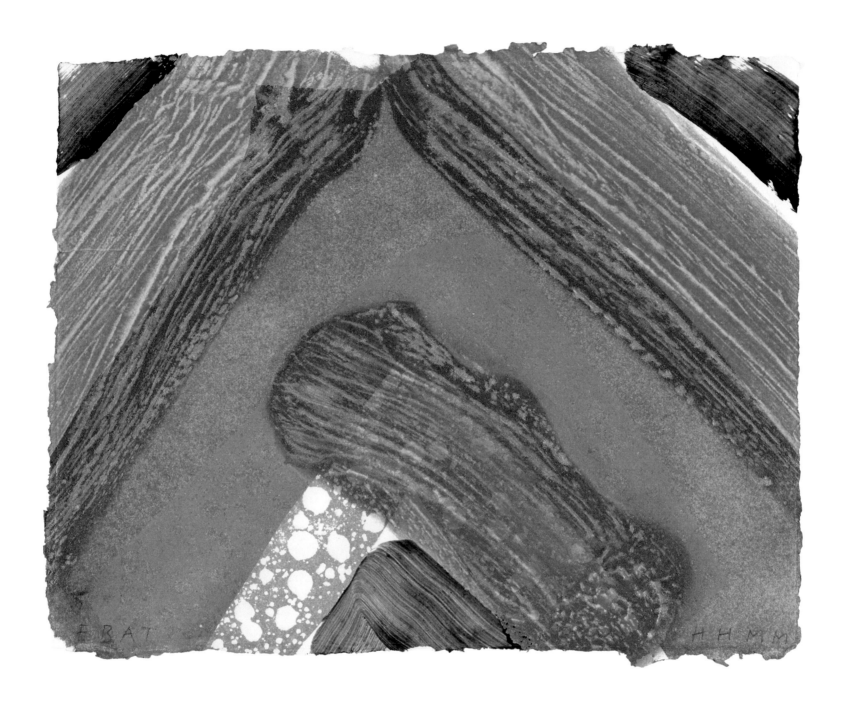

You Again 2000–02 (cat. no. 104)

to look at them as a member of the audience, or pretending to be, than at my paintings. Prints often seem too close. I am constantly reminded of the printer and the printing process, perhaps because there is more than one result: the prints of an edition are never precisely the same.

LH Have your prints ever been affected by the editing of over zealous publishers?

HH I have been lucky in that respect. Perhaps there should have been four rather than '5 Rooms', but I now quite like those prints.

LH As multiples, prints reach a large audience. Does this influence you in your printmaking?

HH Of course. An image that exists in an edition of four or five is therefore almost unique and totally different from one that exists in an edition of a hundred. I have at times tried to persuade my publishers that a smaller edition would be better. But that's not necessarily true. I am particularly pleased with the 'Venetian Views' [1995], which were produced in an edition of sixty.

LH Why would a smaller edition usually be better? If you strive to make prints that look like posters or pieces of coloured paper, wouldn't a larger edition seem more logical?

HH No.

LH On the one hand, you want your prints to be more like posters, on the other hand, you use hand colouring. Don't you think this is mutually exclusive?

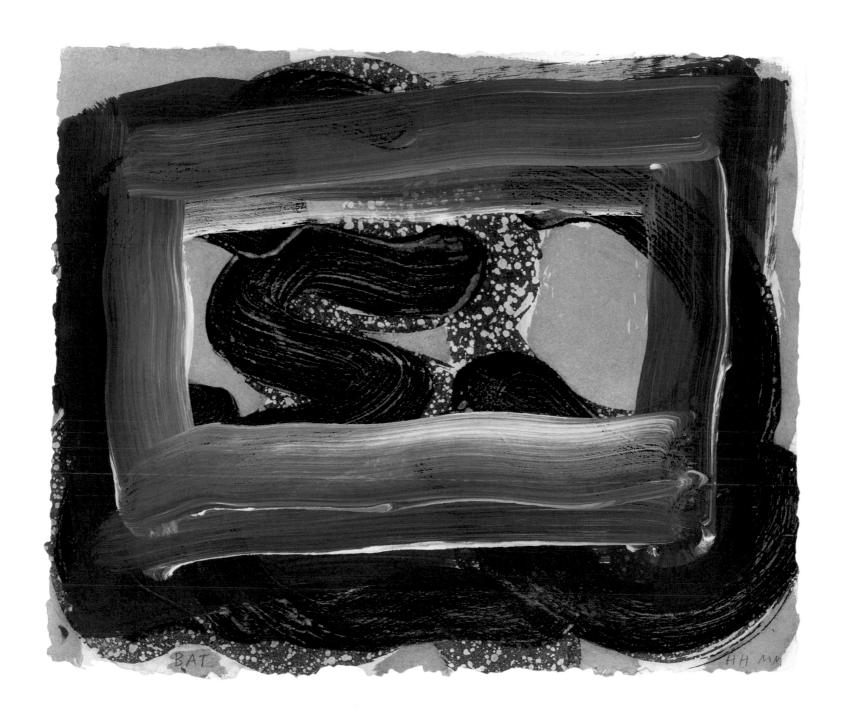

Seafood 2000–02 (cat. no. 111)

HH Yes.

LH Do you make an image more personal or less personal if you know that it is being produced in large numbers?

HH Of course it's less personal. I always think of my prints as being totally different from my paintings. My prints are more like posters that you just hang on the wall as a thing.

LH Does it interest you where your prints end up?

HH Not particularly. Not even if they end up in museums. Fashion rules in museums, particularly at the moment. Before I became a trustee of the Tate Gallery in 1970, I vaguely realized that curators judge work on whether it is part of history and whether it is any good. Nowadays curators only ask themselves whether the work is part of history.

I have been discovered in my career so many times that I've already had nine lives. I am delighted if a museum gives me an exhibition because exhibitions matter. Being bought matters less. On the other hand, at least people hang them up in their houses. In museums, most prints are not on view. The British Museum has the study for one of my best prints, *Moonlight* [1980], but they never display it.

LH Is there a printmaker you feel particularly close to? Do you follow exhibitions of any contemporary printmakers?

HH I wish I did feel close to Nabi printmakers, but I don't. I look at very few exhibitions.

LH Does the technique of painting or printmaking allow you to express something which the other technique cannot?

HH I certainly could never make a print that was like one of my paintings. In the beginning I was upset when publishers wanted me to make prints that were like my pictures.

My prints are the result of thinking about what prints can be. The last thing I want them to be is substitute paintings.

LH To some extent your paintings and prints have become more alike in the last few years.

HH I am sorry to hear that. I was actually hoping that they had become more different. In that case, I should stop making prints. There should be one sort of expression for prints and another one for painting.

When I recently showed *Into the Woods, Winter* to someone he said, 'That is not a print, but a painting.' In some respects that is a valid criticism, because of its scale and the way it is made. It isn't really a multiple image but rather a single image.

Prints such as 'Into the Woods' and 'Venetian Views' are becoming single images. Part of the reason that they work as prints is because they are actually on the edge of not being prints. That makes them much more risky than little prints. Real prints should perhaps be more multiple and less

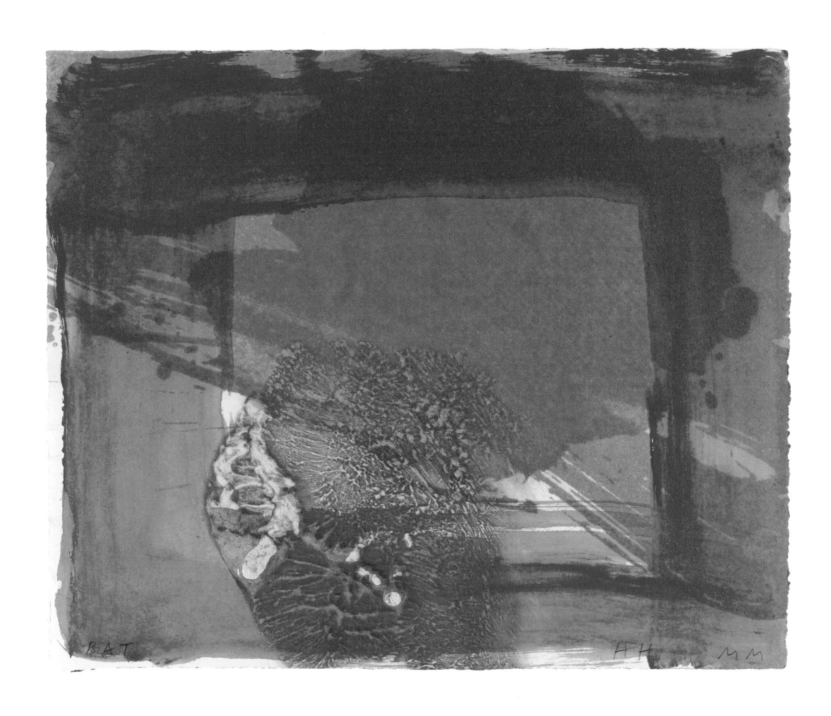

Rain 2000–02 (cat. no. 105)

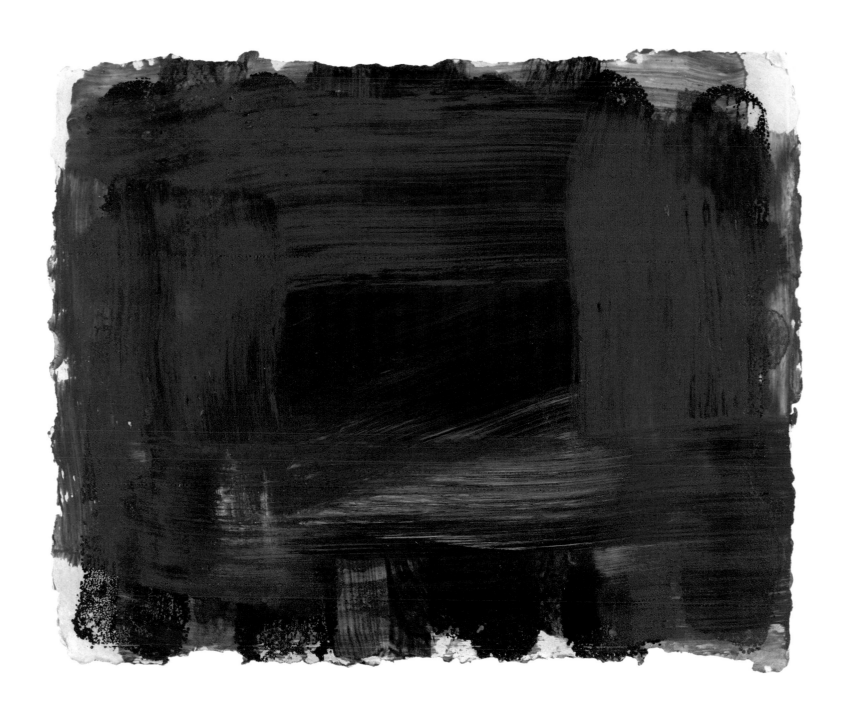

Dawn 2000–02 (cat. no. 106)

unique in spirit. Obviously you can say more with a painting
than you can with a print. Prints are not nearly as complex
as paintings.

LH In the series of 'Venetian Views' [1995] you have
shown that your prints can be very complex.

HH I want them to be as simple as possible, or as straight-
forward as woodcuts, *images d'epinal*, like Napoleon on
his charger wearing a big black hat. One of the advantages
of printmaking is that it forces you to do things like 'the cat
sat on the mat'. Prints are an invitation to banality. Sometimes
they are a relief from the complexities of painting.

LH An important contribution you made to the
history of printmaking was using an assistant to hand
colour your prints at any stage of the printing process.
Could you tell me how you got the idea of hand colouring,
 and how you got the idea of using an assistant?

HH I find it hard to remember. I coloured a whole edition
of *Julian and Alexis* in 1977 with the help of my son Sam, but
I'm not sure why.

I do remember what happened when I was working with
Maurice Payne in 1977 on *Nick*. I had trouble with it; I changed
the shape of the plate, and added another plate. In the end
there was nothing more that could be done, except hand
colouring it. It has very little hand colouring, but it totally
changed the image.

The person who really encouraged me was the printmaker Bruce Porter at Petersburg Press in New York. He had a very alert sensibility to what the artist wanted to do. I had never come across anybody like that before. For example, *Jarid's Porch* [1977] was coloured in such a way that its central shape was made of crinkled paper. Bruce made the paper surface expand, by painting it with watercolour, something nobody else would have done. One of the things that was so difficult was that there were so many *idées fixes* about what you could and could not do. That has long since gone.

I got seriously involved in hand colouring with Cinda Sparling at Solo Press in New York. That is when I learnt how to control it. We coloured prints half way through the printing process and then printed on top of the hand colouring, which was exciting.

The important thing about hand colouring is to get other people to do it. In the beginning I would do it partly myself, and then they would copy me. But with Cinda it was like having another instrument.

LH She told me how you instructed her using metaphors such as to paint 'like a silk stocking'.

HH Yes, she probably remembers the metaphors better than I do. She was horrified when I once said, 'That's easy, Cinda, it's just like hitting a baby', which is an old English expression. She had incredible control.

The wonderful thing about hand colouring is that it is so immediate. That is partly why I did it and why I have used

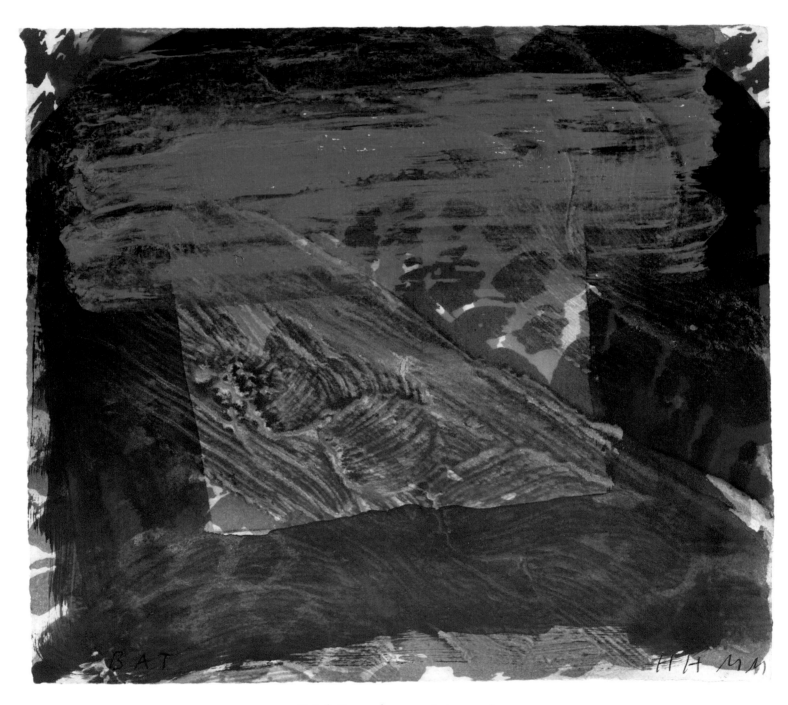

Strictly Personal 2000–02 (cat. no. 109)

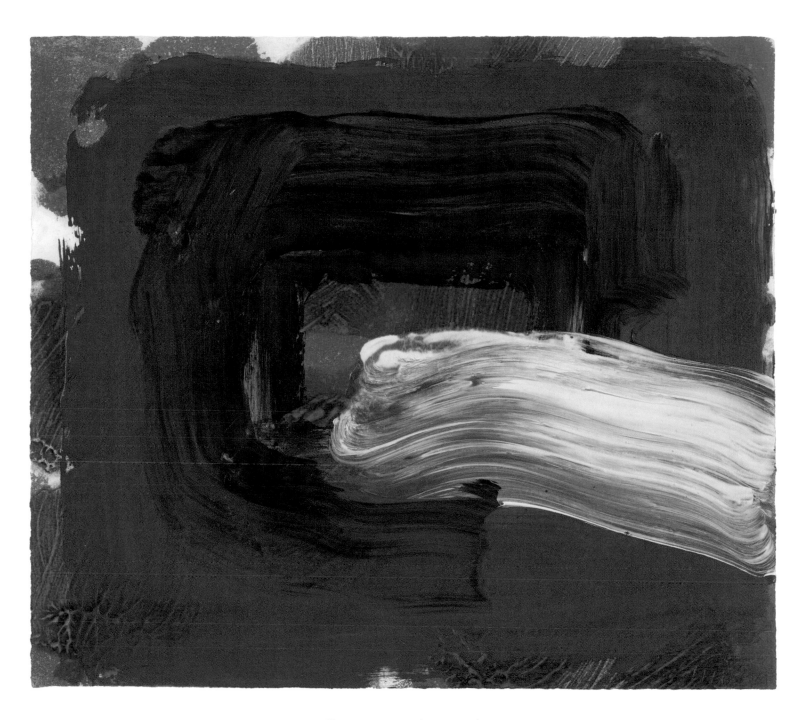

Cigarette 2000–02 (cat. no. 110)

it increasingly. I hate the printing process, where you make an image and you have to wait, sometimes for weeks, before you can see what you have done. And then it is back to front anyway. Hand colouring is also so quick – as it is for the printer as well. The other great thing about hand colouring is that you can correct what you have printed, instantly and radically.

I never hand colour the editions of my prints, although I have sometimes hand coloured the first one, to show the printer what to do. It can look difficult to do, and this is a way of explaining. Occasionally I hand colour single prints.

LH Did you think that the repetitive act of hand colouring was boring?

HH No, absolutely not. The whole point was to make it as impersonal as possible. I have always been interested – and am still interested – in trying to make impersonal marks. I try to reject the autograph aspect of printmaking as much as possible. I like to feel that I make prints that anyone could have made.

I never watch someone hand colouring. I would only see what Cinda Sparling had done afterwards. I would look out of the window while she was hand colouring a print.

If only I could do all my work over the telephone, ring up Jack Shirreff, tell him what to do, then fly over in a helicopter and sign the edition. But as I draw all the plates myself, this would not work.

LH What do you find so interesting about making impersonal marks?

HH Getting away from self expression.

LH To what extent do you think printers have influenced
the final result of your prints?

HH They enabled me to do things that I didn't know, and often
they didn't know, were possible to do.

I have never been a printmaker who collaborates with the
printing process. I ask printers what an image is going to look
like when printed, but I never participate. I am a complete
passenger. 'Can you print this?' 'Will it look the same when
it's editioned?' They're the sort of questions I ask. Most
printmakers are not like that. They get involved. I am a very
amateur printmaker. I have great trouble making prints.
I think it just happens. For instance, I don't deliberately say,
'I should have some relief, so I will use carborundum.' Which
is of course how you should think.

LH That is probably why the result often looks so
spontaneous.

HH I hope it does. But it usually looks spontaneous, because
everything has been shifted around so much. I never envisage
anything from the beginning. That is probably why I had such
great trouble learning how to make prints. I develop the print
as it goes along. I don't know what direction I am going in,
ever, until I make them.

LH Did you ever destroy a print in which the hand
colourist took too much liberty?

Tears, Idle Tears 2000–02 (cat. no. 107)

Away 2000–02 (cat. no. 108)

HH No, never. It would be very difficult to take too much liberty; there wouldn't be anywhere to go. No doubt there have been bad pieces of hand colouring that people have destroyed before I ever saw them, but that has nothing to do with me. I am very lucky in my hand colourists; also the process is very simple.

LH What is the atmosphere like at the 107 Workshop when you are at work?

HH Total dedication and silence.

LH Are you particular about the materials you use?

HH I am very particular about the paper and the colours that are used for hand colouring.

I am not the kind of printmaker who cares about states. When I was young there was still this tradition of making prints in different states. I was never interested in trying to pretend that each state was unique.

LH You have made various prints in series, mostly in pairs, such as *Blood* and *Sand*. Is this triggered by the nature of printmaking?

HH Not in the slightest. It is probably the desire to make the most of an image.

LH Is there a particular reason why you make the coloured version first and then the black-and-white version? I get

the impression that you make the coloured version first,
because the publisher wants to see it, and then work on
the black-and-white version for yourself.

> **HH** That is perfectly fair about the publisher. But I think
> about it in colour, initially, because the nature of printmaking
> means that each part of the process has its own colour. That
> makes it much more rational, or simpler, to think about the
> image. The black-and-white version really shows you what
> you have got, without the distraction of local colour. It is
> the final version because it is the complete image. And not
> an image where you have red on top of blue on top of green,
> which may be harder to read.

LH Why do you usually prefer the monochrome version?

> **HH** Probably because it is more complete; it is the completion
> of what has gone before. The colours remain as tones, but
> they don't distract from the final image.

LH You have illustrated two books, Julian Barnes's story
Evermore from *Cross Channel* [1996–97] and Susan Sontag's
The Way We Live Now [1990]. Did you ever contemplate making
a book together with a writer or a poet?

> **HH** Yes, but it has never happened.

LH Do you still feel the magic of printmaking?

> **HH** Yes, not least because it is done by other people. I am
> like the onlooker. 'Did I do that?' is my reaction. I still cannot

Into the Woods, Spring, from 'Into the Woods' 2001–02 (cat. no. 113)

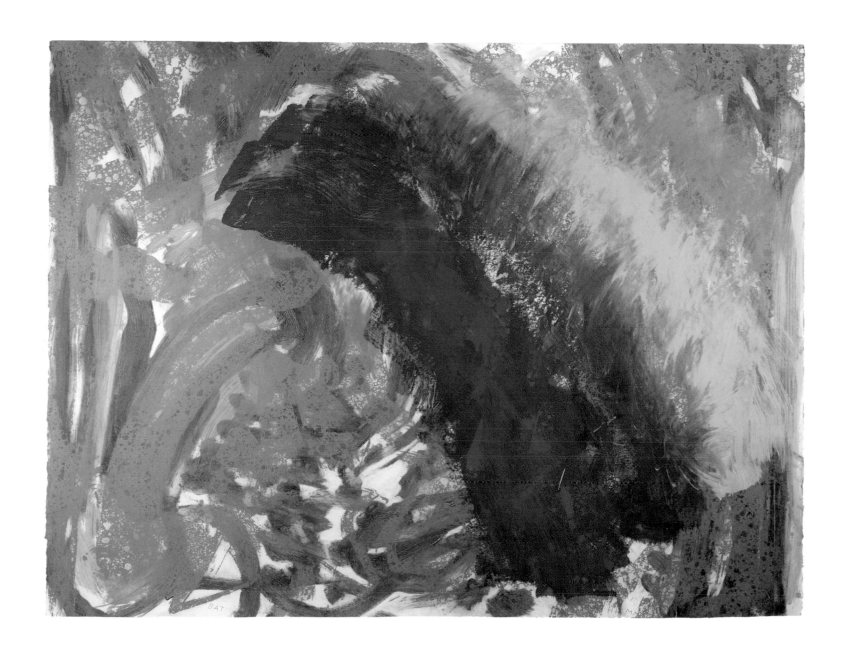

Into the Woods, Summer, from 'Into the Woods' 2001–02 (cat. no. 114)

believe it and I find that magic. That is probably the reason
why I have gone on making prints.

LH Do you enjoy making prints more now than you
used to, because of your familiarity with the process?

HH I have never enjoyed printmaking. But I equally hate
painting. I am growing old and I do what I can.

LH How did the group of small prints that you made
in the summer of 2000 evolve?

HH Alan Cristea simply asked me to make a group of prints.

LH Are you adopting a more relaxed attitude with
regards to printmaking?

HH I am busily shutting all the doors, and putting labels on
everything. Printmaking is extremely demanding. I'd rather
spend what energy I have left on painting. Prints are less
demanding than paintings, but they don't deliver quite so
much. This group of ten prints are probably my last prints.

LH Is there a print you particularly like?

HH I am afraid I don't have an overview. I'd need to see them
all together. I remember making *Enter Laughing* [1964] and
thinking, 'This is good'. I particularly like my last big prints
'Into the Woods' [2000–02] and 'Venetian Views' [1995].
But then again, people always like their last work best,
so I wouldn't pay too much attention to that.

LH Would you like to be remembered as a printmaker
by these last prints?

HH I have no thoughts about after I am dead. I don't have
a sense of my oeuvre at all, not of my prints. The print
retrospective at the Tate Gallery in 1976 surprised me.
I did not feel there was any autograph principle at work
at all. The opposite really.

London, November 1999, November 2000 and January 2002

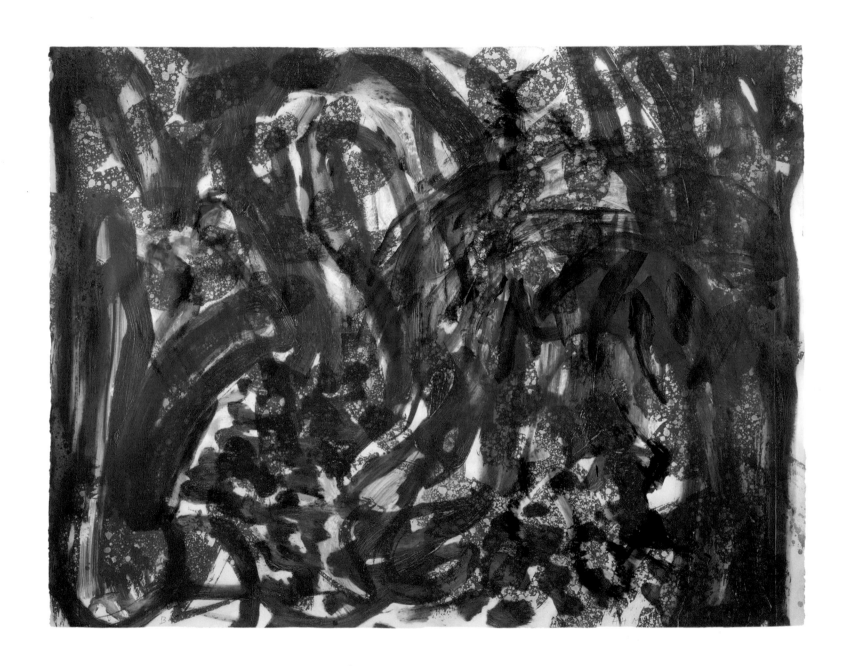

Into the Woods, Autumn, from 'Into the Woods' 2001–02 (cat. no. 115)

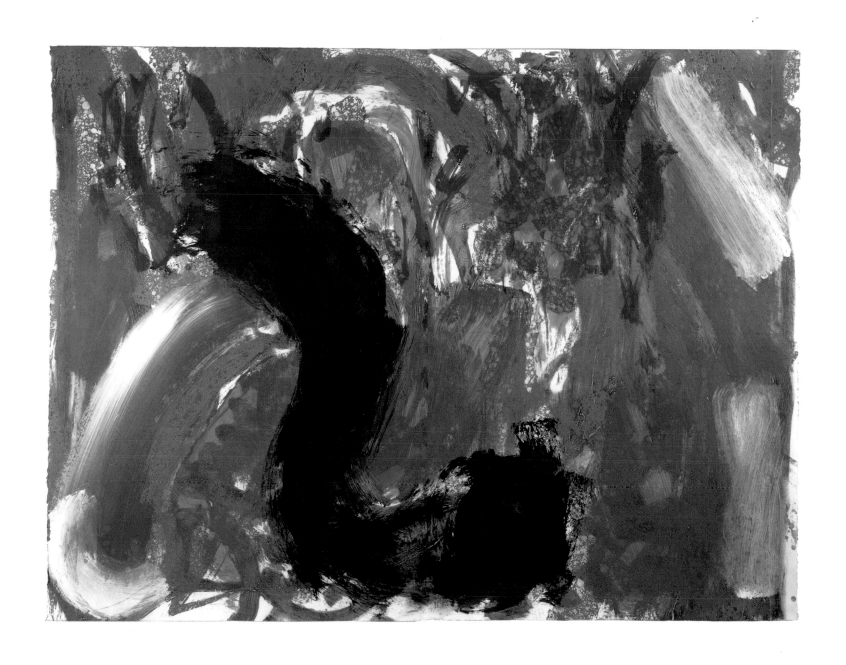

Into the Woods, Winter, from 'Into the Woods' 2001–02 (cat. no. 116)

Catalogue raisonné

Notes to the catalogue raisonné

The catalogue raisonné documents all of Howard Hodgkin's published prints, book illustrations, uneditioned prints and limited edition reproductive prints produced between 1953 and 2002. The prints are ordered chronologically in sequence of their execution.

Number
The number preceding each entry indicates the catalogue raisonné reference.

Titles
The titles used are definitive titles provided by the artist at the time of the print's execution. The uneditioned prints have not been given titles.

Dates
The date of a print refers to the year of execution, editioning and hand colouring. The date of publication is mentioned in the catalogue entry. From the 1990s onwards various prints were made in separate batches. Some prints were consequently printed and hand coloured after their publication date. When this publication went to press not all of the prints made between 2000 and 2003 had been editioned.

Medium
Details of the technique and printing process are given. For further information on printing techniques, see Antony Griffiths, *Prints and Printmaking: An Introduction to the History and Techniques*, London, 1980 and 1996. Please note that, although the precise colours were known for all prints produced at the 107 Workshop in Wiltshire, in most cases simplified terms have been used here. For instance, 'vert moyen' and 'laque verte solide' have been translated as 'two shades of green'.

Paper
The type of paper and, if records were available, the weight of the paper in grams per square metre (gsm) are given.

Inscriptions
All inscriptions on the prints are by the artist. The inscriptions on prints from the regular edition are described here and can vary from the inscriptions on proofs. The location of the numbering is often different. When this publication went to press not all of the prints made between 2000 and 2003 had been editioned.

Edition and proofs
Edition details for every print are given. Where possible, the number of artist's proofs, printer's proofs and B.A.T.s are recorded, and, in a few cases, the number of trial proofs, hors commerce impressions, record proofs, archive proofs and replacement proofs. Where Judith Solodkin was the printer, 'Solo Press impressions' are listed. These are archive proofs which are no different from artist's or printer's proofs. All prints are only states. At the 107 Workshop in Wiltshire there are several finished prints that are still to be hand coloured. If they are not hand coloured in due course they will be destroyed. They either bear no inscriptions or have been inscribed 'proof'. These proofs have not been included in the catalogue raisonné because they do not form part of the official edition.

Printer
The printer's studio is mentioned and, where known, the name of the printer and the person who proofed the print.

Hand colouring
The hand colouring is done by an assistant, usually a printer, following the artist's instructions. There are a few exceptions – the unique print *Ivy* (1990) was entirely hand coloured by the artist and *Julian and Alexis* (1977) was partly hand coloured by the artist.

Publisher
The publisher's name and publication date are recorded.

Blindstamps and chopmarks
Printer's or publisher's marks are catalogued.

Measurements
Measurements are given in millimetres, followed by inches in brackets, height before width. Sheet sizes are given, plus, where known or where possible to measure, the size of the plate for intaglio prints, or the printed image for lithographs and screenprints. Due to the use of hand-made papers measurements can vary.

Literature
Bibliographical information about publications in which a print, or its portfolio, is described or discussed is given. If a print or portfolio is only mentioned in the literature, it has not been listed. For the limited edition reproductive prints no references are given.

Public collections
This section is not exhaustive.

1 Acquainted with the Night, from 'Anthology: Poetry at Night'
1953

Lithograph printed in colours
On wove paper
Signed and dated in pen and ink, verso
Numbered
Edition details unknown
Printed by Henry Cliffe at the Bath Academy of Art, Corsham
Published by the Bath Academy of Art, Corsham, 1953
Accompanying poem, 'Acquainted with the Night' by Robert Frost
Sheet: 450 x 253 mm. (17³/₄ x 10 in.)

Note: Based on the poem 'Acquainted with the Night' by Robert Frost

Acquainted with the Night

I have been one acquainted with the night.
I have walked out in rain – and back in rain.
I have outwalked the furthest city light.

I have looked down the saddest city lane.
I have passed by the watchman on his beat
And dropped my eyes, unwilling to explain.

I have stood still and stopped the sound of feet
When far away an interrupted cry
Came over houses from another street,

But not to call me back or say good-by;
And further still at an unearthly height,
One luminary clock against the sky

Proclaimed the time was neither wrong nor right.
I have been one acquainted with the night.

Robert Frost (1874–1963)

The portfolio 'Anthology: Poetry at Night' further comprises four prints
by Thomas Burt, Monica Harman, Elizabeth Sinclair and Carolyn Smith.
One of these prints was called 'The Corresponding Fires', based on a
poem by James Kirkup.

Literature
Robin Garton (ed.), *British Printmakers 1855–1955: A Century of Printmaking
from the Etching Revival to St Ives*, Devizes, 1992, p. 324.

2 Untitled (Old Lady Walking Away)
1950s

Lithograph printed in colours
On wove paper
Edition details unknown
Printed by Henry Cliffe at the Bath Academy of Art, Corsham
Published by the artist
Measurements unknown

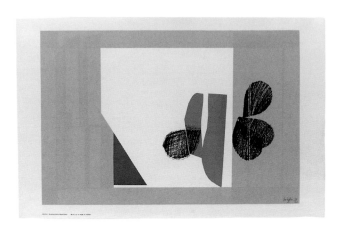

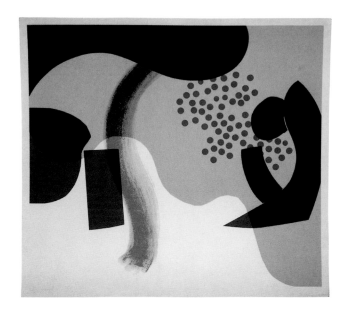

3 Enter Laughing, from the 'ICA Screen-print project'
1964

Screenprint in black, blue, green and beige-brown

On thin quality cartridge paper

Signed and numbered in pencil, lower right

Edition of 40, with 10 artist's proofs and a few printer's proofs

Printed by Chris Prater, assisted by Christopher Betambeau, at Kelpra Studio, London

Imprinted, lower left: ICA Print Screenprinted by Kelpra Studio Mount up to edge of colour.

Published by the Institute of Contemporary Arts, London, 1964

Image: 508 x 766 mm. (20 x 30¹/₈ in.)

Sheet: 588 x 915 mm. (23¹/₈ x 36 in.)

The portfolio of the ICA Screen-print project further comprises the following twenty-three screenprints:

Untitled by Gillian Ayres; *Beach Boys* by Peter Blake; *Untitled* by Derek Boshier; *Ruins* by Patrick Caulfield; *Taper* by Bernard Cohen; *Untitled* by Harold Cohen; *Untitled* by Robyn Denny; *5 Tyres Abandoned* by Richard Hamilton; *Study* by Adrian Heath; *Cleanliness is Next to Godliness* by David Hockney; *Eight Red Arcs* by Gordon House; *Brick Door* by Patrick Hughes; *Red Flush* by Gwyther Irwin; *Dream T Shirt* by Allen Jones; *Good God Where is the King?* by R. B. Kitaj; *Untitled* by Henry Mundy; *Conjectures to Identity* by Eduardo Paolozzi; *Points of Contact no. 2* by Victor Pasmore; *Untitled* by Peter Phillips; *Untitled* by Bridget Riley; *PM Zoom* by Richard Smith; *Lufbery and Rickenbacker* by Joe Tilson; *Untitled* by William Turnbull.

Literature

'Howard Hodgkin Talking to Pat Gilmour About his Prints', 1 April 1976 (notes of recorded interview); Penelope Marcus, *Howard Hodgkin: Complete Prints*, Museum of Modern Art, Oxford, 1977 (n.p.); Pamela Zoline, 'Chris Prater and Kelpra Studios', *Arts Review*, vol. 29, no. 16, 5 August 1977, p. 504; Pat Gilmour (intro.), *Kelpra Studio: An Exhibition to Commemorate the Rose and Chris Prater Gift*, Tate Gallery, London, 1980, pp. 16–17, 68–69; Pat Gilmour, 'Howard Hodgkin', *The Print Collector's Newsletter*, vol. 12, no. 1, March–April 1981, p. 3.

Public collections

The Arts Council Collection, Hayward Gallery, London; The British Council, London; Manchester City Art Galleries, Manchester; Tate Gallery, London (entire portfolio); Whitworth Art Gallery, Manchester.

4 Figure Composition
1966

Screenprint in bright yellow, blue, pink, orange and black

On wove paper

Signed, numbered and dated 66 in pencil, lower left

Edition of 10, with an unrecorded number of proofs

Printed by John Vince at the Bath Academy of Art, Corsham

Published by the artist, 1966

Image: 450 x 506 mm. (17³/₄ x 19⁷/₈ in.)

Sheet: 480 x 532 mm. (18⁷/₈ x 21 in.)

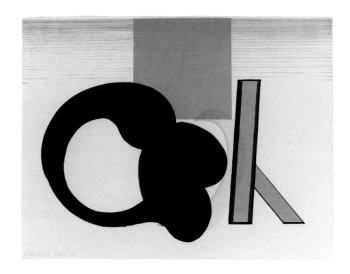

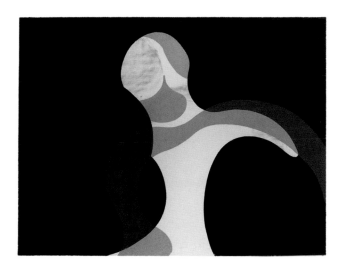

5 Interior with Figure, from '5 Rooms'
1966

Lithograph from four zinc plates using tusche and crayon, printed
in orange, two shades of blue and black

On BFK Rives wove paper (250 gsm)

Signed, numbered and dated '66 in pencil, lower left

Edition of 75, with 15 artist's proofs and a few printer's proofs

Proofed and printed by Emil Matthieu in Zurich, Switzerland, 1966

Published by Editions Alecto Ltd, London, 1968

With the publisher's stamp ea No. 300, verso

Image: 471 x 654 mm. ($18^{1}/_{2}$ x $25^{3}/_{4}$ in.)

Sheet: 505 x 654 mm. ($19^{7}/_{8}$ x $25^{3}/_{4}$ in.)

Note: The five lithographs were kept in a buff-coloured portfolio
with a screenprinted title page. The portfolio, containing three flaps,
was designed by Rudolph Reiser in Cologne and the title page was
designed by Roy Walker.

Literature
'Howard Hodgkin Talking to Pat Gilmour About his Prints', 1 April 1976
(notes of recorded interview); Penelope Marcus, *Howard Hodgkin: Complete
Prints*, Museum of Modern Art, Oxford, 1977 (n.p.); Pat Gilmour, 'Howard
Hodgkin', *The Print Collector's Newsletter*, vol. 12, no. 1, March–April 1981,
p. 3; Jeremy Lewison, 'Howard Hodgkin', *Carte d'Arte*, 1986, p. 19.

Public collections
Art Gallery of Ontario, Ontario; Tate Gallery, London; Victoria and Albert
Museum, London.

6 Girl at Night, from '5 Rooms'
1966

Lithograph from four zinc plates using tusche, printed in orange,
two pinks and black

On BFK Rives wove paper (250 gsm)

Signed, numbered and dated '66 in pencil, lower left

Edition of 75, with 15 artist's proofs, and a few printer's proofs

Proofed and printed by Emil Matthieu, Zurich, Switzerland, 1966

Published by Editions Alecto Ltd, London, 1968

Publisher's stamp ea No. 301, verso

Image and sheet: 502 x 648 mm. ($19^{3}/_{4}$ x $25^{1}/_{2}$ in.)

Note: The five lithographs were kept in a buff-coloured portfolio
with a screenprinted title page. The portfolio, containing three flaps,
was designed by Rudolph Reiser in Cologne and the title page was
designed by Roy Walker.

Literature
Auberry Pryor, 'Modern Primitives', *The Western Morning News*, 13 November
1970, p. 5; 'Howard Hodgkin Talking to Pat Gilmour About his Prints',
1 April 1976 (notes of recorded interview); Penelope Marcus, *Howard
Hodgkin: Complete Prints*, Museum of Modern Art, Oxford, 1977 (n.p.);
Pat Gilmour, 'Howard Hodgkin', *The Print Collector's Newsletter*, vol. 12,
no. 1, March–April 1981, p. 3; Jeremy Lewison, 'Howard Hodgkin', *Carte
d'Arte*, 1986, p. 19.

Public collections
Tate Gallery, London; Victoria and Albert Museum, London.

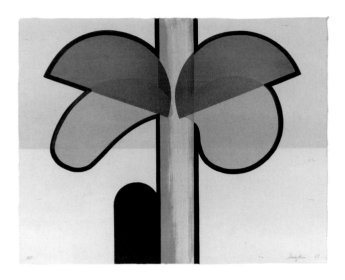

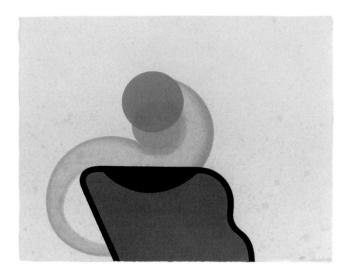

7 Indian Room, from '5 Rooms'
1967

Lithograph from six zinc plates using tusche, printed in two shades
 of yellow, blue-green, dark green, creamy white and red
On J Green paper (250 gsm)
Signed and dated '67 in pencil, lower right
Numbered in pencil, lower left
Edition of 75, with 14 artist's proofs, 1 trial proof, 1 printer's proof,
 1 B.A.T. and 1 incomplete proof
Proofed by Ian Lawson at the Bath Academy of Art, Corsham
Printed by Ian Lawson at Alecto Studios, London, 1967
Published by Editions Alecto Ltd, London, 1968
Publisher's stamp ea 519, verso
Image and sheet: 510 x 645 mm. (20⅛ x 25⅜ in.)

Note: The five lithographs were kept in a buff-coloured portfolio with
 a screenprinted title page. The portfolio, containing three flaps, was
 designed by Rudolph Reiser in Cologne and the title page was designed
 by Roy Walker.
The incomplete proof is inscribed: incomplete proof 1/1 for CE Hodgkin '68.
In the Editions Alecto print register *Indian Room* is incorrectly catalogued
 as printed in February 1968.

Literature

Pat Gilmour, 'Howard Hodgkin: Alecto Gallery', *Arts Review*, vol. 21, no. 8,
 26 April 1969, p. 277 (ill.); Auberry Pryor, 'Modern Primitives', *The Western
 Morning News*, 13 November 1970, p. 5; 'Howard Hodgkin Talking to Pat
 Gilmour About his Prints', 1 April 1976 (notes of recorded interview);
 Penelope Marcus, *Howard Hodgkin: Complete Prints*, Museum of Modern
 Art, Oxford, 1977 (n.p.); Pat Gilmour, 'Howard Hodgkin', *The Print Collector's
 Newsletter*, vol. 12, no. 1, March–April 1981, p. 3; Jeremy Lewison, 'Howard
 Hodgkin', *Carte d'Arte*, 1986, p. 19.

Public collections

Tate Gallery, London; Victoria and Albert Museum, London.

Colour reproduction on p. 28.

8 Bedroom, from '5 Rooms'
1968

Lithograph from five zinc plates, using tusche and crayon with splatter,
 printed in red, orange, green, black and pink
On J Green paper (250 gsm)
Signed, numbered and dated '68 in pencil, lower right
Edition of 75, with 15 artist's proofs and a few printer's proofs
Printed by Ian Lawson and Ernest Donagh at Alecto Studios, London
Published by Editions Alecto Ltd, London, 1968
Publisher's stamp ea 541, verso
Image and sheet: 515 x 650 mm. (20¼ x 25½ in.)

Note: The five lithographs were kept in a buff-coloured portfolio with
 a screenprinted title page. The portfolio, containing three flaps, was
 designed by Rudolph Reiser in Cologne and the title page was designed
 by Roy Walker.

Literature

Pat Gilmour, 'Howard Hodgkin: Alecto Gallery', *Arts Review*, vol. 21, no. 8,
 26 April 1969, p. 277; Auberry Pryor, 'Modern Primitives', *The Western Morning
 News*, 13 November 1970, p. 5; 'Howard Hodgkin Talking to Pat Gilmour
 About his Prints', 1 April 1976 (notes of recorded interview); Penelope
 Marcus, *Howard Hodgkin: Complete Prints*, Museum of Modern Art, Oxford,
 1977 (n.p.); Pat Gilmour, 'Howard Hodgkin', *The Print Collector's Newsletter*,
 vol. 12, no. 1, March–April 1981, p. 3; Jeremy Lewison, 'Howard Hodgkin',
 Carte d'Arte, 1986, p. 19.

Public collections

The Arts Council Collection, Hayward Gallery, London; The Fitzwilliam
 Museum, Cambridge; Tate Gallery, London; Victoria and Albert Museum,
 London.

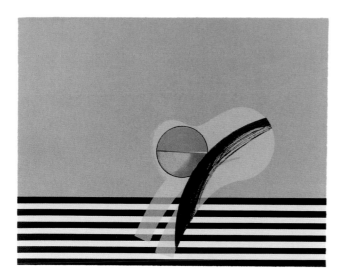

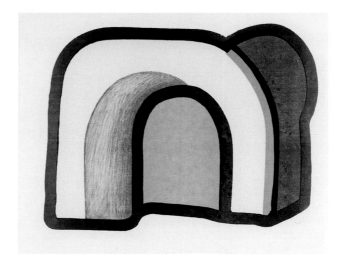

9 Girl on a Sofa, from '5 Rooms'
1968

Lithograph from six zinc plates, using tusche and crayon, printed
 in dark blue, black, orange, pink, green and brown
On J Green paper (250 gsm)
Signed, numbered and dated '68 in pencil, lower right
Edition of 75, with 15 artist's proofs and a few printer's proofs
Printed by Ian Lawson and Ernest Donagh at Alecto Studios, London
Published by Editions Alecto Ltd, London, 1968
Publisher's stamp ea 542, verso
Image and sheet: 515 x 650 mm. (20¼ x 25½ in.)

Note: The five lithographs were kept in a buff-coloured portfolio with
 a screenprinted title page. The portfolio, containing three flaps, was
 designed by Rudolph Reiser in Cologne and the title page was designed
 by Roy Walker.
One print has been signed 'Hod'.

Literature

Pat Gilmour, 'Howard Hodgkin: Alecto Gallery', *Arts Review*, vol. 21, no. 8,
 26 April 1969, p. 277; 'Howard Hodgkin Talking to Pat Gilmour About his
 Prints', 1 April 1976 (notes of recorded interview); Penelope Marcus, *Howard
 Hodgkin: Complete Prints*, Museum of Modern Art, Oxford, 1977 (n.p.); Pat
 Gilmour, 'Howard Hodgkin', *The Print Collector's Newsletter*, vol. 12, no. 1,
 March–April 1981, p. 3; Jeremy Lewison, 'Howard Hodgkin', *Carte d'Arte*,
 1986, p. 19.

Public collections

The Art Institute of Chicago, Chicago; The Arts Council Collection,
 Hayward Gallery, London; Tate Gallery, London; Victoria and Albert
 Museum, London.

10 Composition with Red (also called Arch), from 'Europäische Graphik VII. Englische Künstler' 1970

Lithograph from four zinc plates, printed in red, yellow, blue and green
On Hosho vellum Japanese paper or Arches (250 gsm)
Signed in pencil, lower right
Numbered in pencil, lower left
Numbered in Roman numerals on Hosho vellum Japanese paper: I–XXXV
Numbered in Arabic numerals on Arches: 1–65
Edition of 100, with 10 artist's proofs, a few working proofs (printed in
 various colour combinations), a few printer's proofs, 6 hors commerce
 impressions, about 4 record proofs (for the printer) and a few additional
 proofs for exhibition purposes
Proofed and printed by Stanley Jones at Curwen Prints Ltd, London
Commissioned and edited by Felix Man
Published by Felix Man and Galerie Wolfgang Ketterer, Munich, spring, 1971
With the publisher's blind stamp initials WK
Image: 485 x 635 mm. (19 x 25 in.)
Sheet: 507 x 660 mm. (20 x 26 in.)

All prints were unbound in a portfolio of slightly textured, loose-weave, beige cloth with black
tape, imprinted in black, upper right 'EUROPAEISCHE GRAPHIK VII'; size: 668 x 532 mm.
(26¼ x 21 in.). The portfolio 'Europäische Graphik VII. Englische Künstler' was published in
two editions: 35 copies of Edition A: 9 lithographs on Hosho vellum Japanese paper; signed by
the artists and numbered I–XXXV; signed by Felix Man on the justification page of the portfolio;
65 copies of Edition B: 9 lithographs on Arches; signed by the artists and numbered 1–65; signed
by Felix Man on the justification page of the portfolio; in addition 6 copies of the portfolio were
printed for the publishers, of which 2 were printed on Hosho vellum Japanese paper and 4 were
printed on Arches; signed by the artists and some inscribed H.C.; signed by Felix Man on the
justification page of the portfolio. The portfolio 'Europäische Graphik VII. Englische Künstler'
further comprises the following eight lithographs: *Vase and Falling Petal*, Derrick Greaves, 1971;
The Print Collector, David Hockney, 1970–71; *Lilies*, David Hockney, 1971; *Girl with a Hoop*, Allen
Jones, 1970–71; *Leg-Splash*, Allen Jones, 1970–71; *Madron*, Stanley Jones, 1970–71; *Northern Lass*,
Patrick Procktor, 1971; *Flowing in the Right Direction*, with hand colouring, Peter Schmidt, 1971.

Note: The portfolio refers to the print as 'Composition with Red'.

Literature

'Howard Hodgkin Talking to Pat Gilmour About his Prints', 1 April 1976
 (notes of recorded interview); Penelope Marcus, *Howard Hodgkin: Complete
 Prints*, Museum of Modern Art, Oxford, 1977 (n.p.); Pat Gilmour, 'Howard
 Hodgkin', *The Print Collector's Newsletter*, vol. 12, no. 1, March–April 1981,
 p. 3; Guy Burn, 'Prints: Curwen Gallery', *Arts Review*, vol. 49, no. 1, 13 January
 1989, pp. 11–13 (ill. colour, p. 13); *Galerie Wolfgang Ketterer, Editionen 1963–1995*,
 Galerie Wolfgang Ketterer, Munich, 1995, no. 102.

Public collections

British Museum, London; National Gallery of Australia, Canberra; National
Gallery of Victoria, Melbourne; Tate Gallery, London.

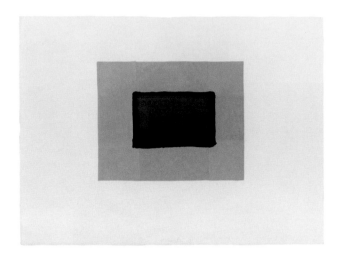

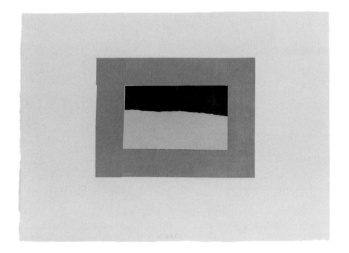

11 Indian View A, from 'Indian Views'

1971

Screenprint in colours

On J Green paper

Signed, numbered and dated 71 in pencil, lower centre

Edition of 75, with an unrecorded number of artist's proofs and trial proofs

Printed by Chris Prater, with the assistance of Christopher Betambeau,
 at Kelpra Studio, London

With the rubber stamp initial K of the printer in black plus number 7848,
 verso

Published by Leslie Waddington Prints, London, 1971

Image and sheet: 580 x 776 mm. (22³/₄ x 30¹/₂ in.)

Note: There are some uninscribed proofs with a white, unprinted border.

Literature

W. Oliver, 'Simple – but Subtle', *The Yorkshire Post*, 5 November 1971, p. 3;
 Carol Kroch, 'Quality of Calmness in Prints', *The Daily Telegraph*, 16 November
 1971; Arthur Hackney, 'David Hockney – Howard Hodgkin', *Arts Review*,
 vol. 24, no. 4, 26 February 1972, p. 105; Shelagh Hardie, 'Howard Hodgkin –
 John Hoskin,' *Arts Review*, vol. 24, no. 13, 1 July 1972, p. 398; Timothy Hyman,
 'Howard Hodgkin', *Studio International*, vol. 189, no. 975, May–June 1975, p. 183;
 and vol. 190, no. 976, July–August 1975, p. 88; Margaret Mcleod, *Howard Hodgkin:
 A Recorded Talk on his Paintings, 'Indian Views', Screenprints and Lithographs*,
 British Council Touring Exhibition, 1976 (n.p.); 'Howard Hodgkin Talking
 to Pat Gilmour About his Prints', 1 April 1976 (notes of recorded interview);
 Penelope Marcus, *Howard Hodgkin: Complete Prints*, Museum of Modern Art,
 Oxford, 1977 (n.p.); Pat Gilmour, 'Howard Hodgkin', *The Print Collector's
 Newsletter*, vol. 12, no. 1, March–April 1981, p. 3; Jeremy Lewison, 'Howard
 Hodgkin', *Carte d'Arte*, 1986, pp. 19–22; Lenore Miller, *Howard Hodgkin Prints:
 Vision and Collaboration*, Dimock Gallery, George Washington University,
 Washington, D.C., 1994 (n.p.).

Public collections

The Arts Council Collection, Hayward Gallery, London (complete set);
 The British Council, London (complete set); Isle of Man Arts Council,
 Douglas, Isle of Man; Tate Gallery, London (complete set).

12 Indian View B, from 'Indian Views'

1971

Screenprint in colours

On J Green paper

Signed, numbered and dated 71 in pencil, lower centre

Edition of 75, with an unrecorded number of artist's proofs and trial proofs

Printed by Chris Prater, with the assistance of Christopher Betambeau,
 at Kelpra Studio, London

With the rubber stamp initial K of the printer in black plus number 7847,
 verso

Published by Leslie Waddington Prints, London, 1971

Image and sheet: 580 x 776 mm. (22³/₄ x 30¹/₂ in.)

Note: There are some uninscribed proofs with a white, unprinted border.

Literature

W. Oliver, 'Simple – but Subtle', *The Yorkshire Post*, 5 November 1971, p. 3;
 Carol Kroch, 'Quality of Calmness in Prints', *The Daily Telegraph*, 16 November
 1971; Arthur Hackney, 'David Hockney – Howard Hodgkin', *Arts Review*,
 vol. 24, no. 4, 26 February 1972, p. 105; Shelagh Hardie, 'Howard Hodgkin –
 John Hoskin,' *Arts Review*, vol. 24, no. 13, 1 July 1972, p. 398; Timothy Hyman,
 'Howard Hodgkin', *Studio International*, vol. 189, no. 975, May–June 1975, p. 183;
 and vol. 190, no. 976, July–August 1975, p. 88; Margaret Mcleod, *Howard Hodgkin:
 A Recorded Talk on his Paintings, 'Indian Views', Screenprints and Lithographs*,
 British Council Touring Exhibition, 1976 (n.p.); 'Howard Hodgkin Talking
 to Pat Gilmour About his Prints', 1 April 1976 (notes of recorded interview);
 Penelope Marcus, *Howard Hodgkin: Complete Prints*, Museum of Modern Art,
 Oxford, 1977 (n.p.); Pat Gilmour, 'Howard Hodgkin', *The Print Collector's
 Newsletter*, vol. 12, no. 1, March–April 1981, p. 3; Jeremy Lewison, 'Howard
 Hodgkin', *Carte d'Arte*, 1986, pp. 19–22; Lenore Miller, *Howard Hodgkin Prints:
 Vision and Collaboration*, Dimock Gallery, George Washington University,
 Washington, D.C., 1994 (n.p.).

Public collections

The Arts Council Collection, Hayward Gallery, London (complete set);
 The British Council, London (complete set); Tate Gallery, London
 (complete set).

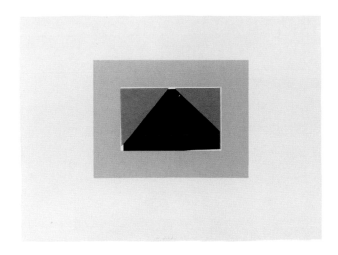

13 Indian View C, from 'Indian Views'

1971

Screenprint in colours

On J Green paper

Signed, numbered and dated 71 in pencil, lower centre

Edition of 75, with an unrecorded number of artist's proofs and trial proofs

Printed by Chris Prater, with the assistance of Christopher Betambeau,
 at Kelpra Studio, London

With the rubber stamp initial K of the printer in black plus number 7845,
 verso

Published by Leslie Waddington Prints, London, 1971

Image and sheet: 580 x 776 mm. (22³/₄ x 30¹/₂ in.)

Note: There are some uninscribed proofs with a white, unprinted border.

Literature

W. Oliver, 'Simple – but Subtle', *The Yorkshire Post*, 5 November 1971, p. 3;
 Carol Kroch, 'Quality of Calmness in Prints', *The Daily Telegraph*, 16 November
 1971; Arthur Hackney, 'David Hockney – Howard Hodgkin', *Arts Review*,
 vol. 24, no. 4, 26 February 1972, p. 105; Shelagh Hardie, 'Howard Hodgkin –
 John Hoskin,' *Arts Review*, vol. 24, no. 13, 1 July 1972, p. 398; Timothy Hyman,
 'Howard Hodgkin', *Studio International*, vol. 189, no. 975, May–June 1975, p. 183;
 and vol. 190, no. 976, July–August 1975, p. 88; Margaret Mcleod, *Howard Hodgkin:
 A Recorded Talk on his Paintings, 'Indian Views', Screenprints and Lithographs*,
 British Council Touring Exhibition, 1976 (n.p.); 'Howard Hodgkin Talking
 to Pat Gilmour About his Prints', 1 April 1976 (notes of recorded interview);
 Penelope Marcus, *Howard Hodgkin: Complete Prints*, Museum of Modern Art,
 Oxford, 1977 (ill.) (n.p.); Pat Gilmour, 'Howard Hodgkin', *The Print Collector's
 Newsletter*, vol. 12, no. 1, March–April 1981, p. 3; Jeremy Lewison, 'Howard
 Hodgkin', *Carte d'Arte*, 1986, pp. 19–22; Lenore Miller, *Howard Hodgkin Prints:
 Vision and Collaboration*, Dimock Gallery, George Washington University,
 Washington, D.C., 1994 (n.p.).

Public collections

The Arts Council Collection, Hayward Gallery, London (complete set);
 The British Council, London (complete set); Tate Gallery, London
 (complete set).

Colour reproduction on p. 10.

14 Indian View D, from 'Indian Views'

1971

Screenprint in colours

On J Green paper

Signed, numbered and dated 71 in pencil, lower right

Edition of 75, with an unrecorded number of artist's proofs and trial proofs

Printed by Chris Prater, with the assistance of Christopher Betambeau,
 at Kelpra Studio, London

With the rubber stamp initial K of the printer in black plus number 7842,
 verso

Published by Leslie Waddington Prints, London, 1971

Image and sheet: 580 x 776 mm. (22³/₄ x 30¹/₂ in.)

Note: There are some uninscribed proofs with a white, unprinted border.

Literature

W. Oliver, 'Simple – but Subtle', *The Yorkshire Post*, 5 November 1971, p. 3;
 Carol Kroch, 'Quality of Calmness in Prints', *The Daily Telegraph*, 16 November
 1971; Arthur Hackney, 'David Hockney – Howard Hodgkin', *Arts Review*,
 vol. 24, no. 4, 26 February 1972, p. 105; Shelagh Hardie, 'Howard Hodgkin –
 John Hoskin,' *Arts Review*, vol. 24, no. 13, 1 July 1972, p. 398; Timothy Hyman,
 'Howard Hodgkin', *Studio International*, vol. 189, no. 975, May–June 1975, p. 183;
 and vol. 190, no. 976, July–August 1975, p. 88; Margaret Mcleod, *Howard Hodgkin:
 A Recorded Talk on his Paintings, 'Indian Views', Screenprints and Lithographs*,
 British Council Touring Exhibition, 1976 (n.p.); 'Howard Hodgkin Talking
 to Pat Gilmour About his Prints', 1 April 1976 (notes of recorded interview);
 Penelope Marcus, *Howard Hodgkin: Complete Prints*, Museum of Modern Art,
 Oxford, 1977 (n.p.); Pat Gilmour, 'Howard Hodgkin', *The Print Collector's
 Newsletter*, vol. 12, no. 1, March–April 1981, p. 3; Jeremy Lewison, 'Howard
 Hodgkin', *Carte d'Arte*, 1986, pp. 19–22; Lenore Miller, *Howard Hodgkin Prints:
 Vision and Collaboration*, Dimock Gallery, George Washington University,
 Washington, D.C., 1994 (n.p.).

Public collections

The Arts Council Collection, Hayward Gallery, London (complete set);
 The British Council, London (complete set); The Fitzwilliam Museum,
 Cambridge; Tate Gallery, London (complete set).

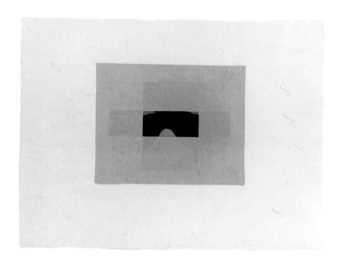

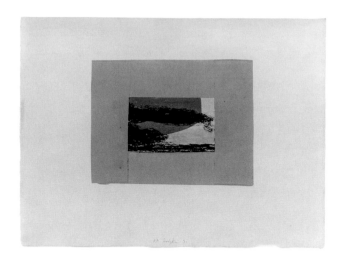

15 Indian View E, from 'Indian Views'
1971

Screenprint in colours

On J Green paper

Signed, numbered and dated 71 in pencil, lower centre

Edition of 75, with an unrecorded number of artist's proofs and trial proofs

Printed by Chris Prater, with the assistance of Christopher Betambeau,
at Kelpra Studio, London

With the rubber stamp initial K of the printer in black plus number 7849,
verso

Published by Leslie Waddington Prints, London, 1971

Image and sheet: 580 x 776 mm. (22³/₄ x 30¹/₂ in.)

Note: There are some uninscribed proofs with a white, unprinted border.

Literature

W. Oliver, 'Simple – but Subtle', *The Yorkshire Post*, 5 November 1971, p. 3;
Carol Kroch, 'Quality of Calmness in Prints', *The Daily Telegraph*, 16 November
1971; Arthur Hackney, 'David Hockney – Howard Hodgkin', *Arts Review*,
vol. 24, no. 4, 26 February 1972, p. 105; Shelagh Hardie, 'Howard Hodgkin –
John Hoskin,' *Arts Review*, vol. 24, no. 13, 1 July 1972, p. 398; Timothy Hyman,
'Howard Hodgkin', *Studio International*, vol. 189, no. 975, May–June 1975, p. 183;
and vol. 190, no. 976, July–August 1975, p. 88; Margaret Mcleod, *Howard Hodgkin:
A Recorded Talk on his Paintings, 'Indian Views', Screenprints and Lithographs*,
British Council Touring Exhibition, 1976 (n.p.); 'Howard Hodgkin Talking
to Pat Gilmour About his Prints', 1 April 1976 (notes of recorded interview);
Penelope Marcus, *Howard Hodgkin: Complete Prints*, Museum of Modern Art,
Oxford, 1977 (n.p.); Pat Gilmour, 'Howard Hodgkin', *The Print Collector's
Newsletter*, vol. 12, no. 1, March–April 1981, p. 3; Jeremy Lewison, 'Howard
Hodgkin', *Carte d'Arte*, 1986, pp. 19–22; Lenore Miller, *Howard Hodgkin Prints:
Vision and Collaboration*, Dimock Gallery, George Washington University,
Washington, D.C., 1994 (n.p.).

Public collections

The Arts Council Collection, Hayward Gallery, London (complete set);
The British Council, London (complete set); Tate Gallery, London
(complete set).

16 Indian View F, from 'Indian Views'
1971

Screenprint in colours

On J Green paper

Signed, numbered and dated 71 in pencil, lower centre

Edition of 75, with an unrecorded number of artist's proofs and trial proofs

Printed by Chris Prater, with the assistance of Christopher Betambeau,
at Kelpra Studio, London

With the rubber stamp initial K of the printer in black plus number 7851,
verso

Published by Leslie Waddington Prints, London, 1971

Image and sheet: 580 x 776 mm. (22³/₄ x 30¹/₂ in.)

Note: There are some uninscribed proofs with a white, unprinted border.

Literature

W. Oliver, 'Simple – but Subtle', *The Yorkshire Post*, 5 November 1971, p. 3;
Carol Kroch, 'Quality of Calmness in Prints', *The Daily Telegraph*, 16 November
1971; Arthur Hackney, 'David Hockney – Howard Hodgkin', *Arts Review*,
vol. 24, no. 4, 26 February 1972, p. 105; Shelagh Hardie, 'Howard Hodgkin –
John Hoskin,' *Arts Review*, vol. 24, no. 13, 1 July 1972, p. 398; Timothy Hyman,
'Howard Hodgkin', *Studio International*, vol. 189, no. 975, May–June 1975, p. 183;
and vol. 190, no. 976, July–August 1975, p. 88; Margaret Mcleod, *Howard Hodgkin:
A Recorded Talk on his Paintings, 'Indian Views', Screenprints and Lithographs*,
British Council Touring Exhibition, 1976 (n.p.); 'Howard Hodgkin Talking
to Pat Gilmour About his Prints', 1 April 1976 (notes of recorded interview);
Penelope Marcus, *Howard Hodgkin: Complete Prints*, Museum of Modern Art,
Oxford, 1977 (n.p.); Pat Gilmour, 'Howard Hodgkin', *The Print Collector's
Newsletter*, vol. 12, no. 1, March–April 1981, p. 3; Jeremy Lewison, 'Howard
Hodgkin', *Carte d'Arte*, 1986, pp. 19–22; Lenore Miller, *Howard Hodgkin Prints:
Vision and Collaboration*, Dimock Gallery, George Washington University,
Washington, D.C., 1994 (n.p.).

Public collections

The Arts Council Collection, Hayward Gallery, London (complete set);
The British Council, London (complete set); Cabinet des estampes du
Musée d'art et histoire, Geneva; Tate Gallery, London (complete set).

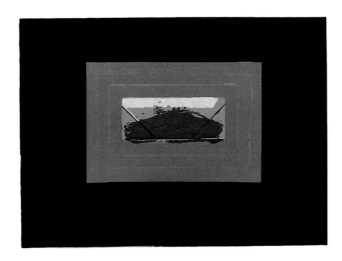

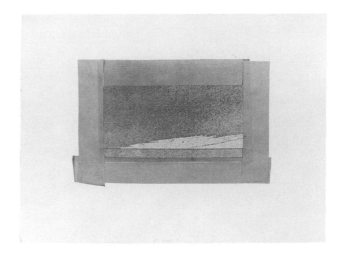

17 Indian View G, from 'Indian Views'
1971

Screenprint in colours

On J Green paper

Signed, numbered and dated 71 in pencil, lower centre

Edition of 75, with an unrecorded number of artist's proofs and trial proofs

Printed by Chris Prater, with the assistance of Christopher Betambeau,
 at Kelpra Studio, London

With the rubber stamp initial K of the printer in black plus number 7846,
 verso

Published by Leslie Waddington Prints, London, 1971

Image and sheet: 580 x 776 mm. (22³/₄ x 30¹/₂ in.)

Note: There are some uninscribed proofs with a white, unprinted border.

Literature

W. Oliver, 'Simple – but Subtle', *The Yorkshire Post*, 5 November 1971, p. 3;
 Carol Kroch, 'Quality of Calmness in Prints', *The Daily Telegraph*, 16 November
 1971; Arthur Hackney, 'David Hockney – Howard Hodgkin', *Arts Review*,
 vol. 24, no. 4, 26 February 1972, p. 105; Shelagh Hardie, 'Howard Hodgkin –
 John Hoskin,' *Arts Review*, vol. 24, no. 13, 1 July 1972, p. 398; Timothy Hyman,
 'Howard Hodgkin', *Studio International*, vol. 189, no. 975, May–June 1975, p. 183;
 and vol. 190, no. 976, July–August 1975, p. 88; Margaret Mcleod, *Howard Hodgkin:
 A Recorded Talk on his Paintings, 'Indian Views', Screenprints and Lithographs*,
 British Council Touring Exhibition, 1976 (n.p.); 'Howard Hodgkin Talking
 to Pat Gilmour About his Prints', 1 April 1976 (notes of recorded interview);
 Penelope Marcus, *Howard Hodgkin: Complete Prints*, Museum of Modern Art,
 Oxford, 1977 (n.p.); Pat Gilmour, 'Howard Hodgkin', *The Print Collector's
 Newsletter*, vol. 12, no. 1, March–April 1981, p. 3; Jeremy Lewison, 'Howard
 Hodgkin', *Carte d'Arte*, 1986, pp. 19–22; Lenore Miller, *Howard Hodgkin Prints:
 Vision and Collaboration*, Dimock Gallery, George Washington University,
 Washington, D.C., 1994 (n.p.).

Public collections

The Arts Council Collection, Hayward Gallery, London (complete set);
 The British Council, London (complete set); Tate Gallery, London
 (complete set).

18 Indian View H, from 'Indian Views'
1971

Screenprint in colours

On J Green paper

Signed, numbered and dated 71 in pencil, lower right

Edition of 75, with an unrecorded number of artist's proofs and trial proofs

Printed by Chris Prater, with the assistance of Christopher Betambeau,
 at Kelpra Studio, London

With the rubber stamp initial K of the printer in black plus number 7844,
 verso

Published by Leslie Waddington Prints, London, 1971

Image and sheet: 580 x 776 mm. (22³/₄ x 30¹/₂ in.)

Note: There are some uninscribed proofs with a white, unprinted border.

Literature

W. Oliver, 'Simple – but Subtle', *The Yorkshire Post*, 5 November 1971, p. 3;
 Carol Kroch, 'Quality of Calmness in Prints', *The Daily Telegraph*, 16 November
 1971; Arthur Hackney, 'David Hockney – Howard Hodgkin', *Arts Review*,
 vol. 24, no. 4, 26 February 1972, p. 105; Shelagh Hardie, 'Howard Hodgkin –
 John Hoskin,' *Arts Review*, vol. 24, no. 13, 1 July 1972, p. 398; Timothy Hyman,
 'Howard Hodgkin', *Studio International*, vol. 189, no. 975, May–June 1975, p. 183;
 and vol. 190, no. 976, July–August 1975, p. 88; Margaret Mcleod, *Howard Hodgkin:
 A Recorded Talk on his Paintings, 'Indian Views', Screenprints and Lithographs*,
 British Council Touring Exhibition, 1976 (n.p.); 'Howard Hodgkin Talking
 to Pat Gilmour About his Prints', 1 April 1976 (notes of recorded interview);
 Penelope Marcus, *Howard Hodgkin: Complete Prints*, Museum of Modern Art,
 Oxford, 1977 (n.p.); Pat Gilmour, 'Howard Hodgkin', *The Print Collector's
 Newsletter*, vol. 12, no. 1, March–April 1981, p. 3; Jeremy Lewison, 'Howard
 Hodgkin', *Carte d'Arte*, 1986, pp. 19–22; Lenore Miller, *Howard Hodgkin Prints:
 Vision and Collaboration*, Dimock Gallery, George Washington University,
 Washington, D.C., 1994 (n.p.).

Public collections

The Arts Council Collection, Hayward Gallery, London (complete set);
 The British Council, London (complete set); Tate Gallery, London
 (complete set).

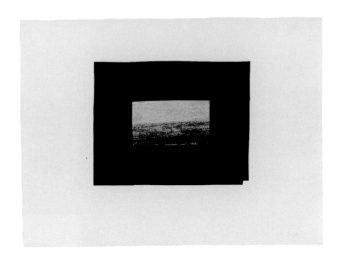

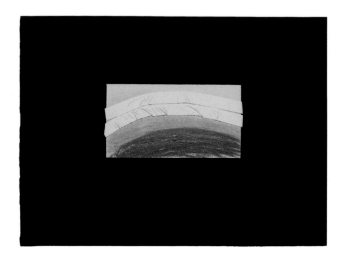

19 Indian View I, from 'Indian Views'
1971

Screenprint in colours

On J Green paper

Signed, numbered and dated 71 in pencil, lower right

Edition of 75, with an unrecorded number of artist's proofs and trial proofs

Printed by Chris Prater, with the assistance of Christopher Betambeau,
at Kelpra Studio, London

With the rubber stamp initial K of the printer in black plus number 7841,
verso

Published by Leslie Waddington Prints, London, 1971

Image and sheet: 580 x 776 mm. (22³/₄ x 30¹/₂ in.)

Note: There are some uninscribed proofs with a white, unprinted border.

Literature

W. Oliver, 'Simple – but Subtle', *The Yorkshire Post*, 5 November 1971, p. 3;
Carol Kroch, 'Quality of Calmness in Prints', *The Daily Telegraph*, 16 November
1971; Arthur Hackney, 'David Hockney – Howard Hodgkin', *Arts Review*,
vol. 24, no. 4, 26 February 1972, p. 105; Shelagh Hardie, 'Howard Hodgkin –
John Hoskin,' *Arts Review*, vol. 24, no. 13, 1 July 1972, p. 398; Timothy Hyman,
'Howard Hodgkin', *Studio International*, vol. 189, no. 975, May–June 1975,
p. 183; and vol. 190, no. 976, July–August 1975, p. 88; Margaret Mcleod,
*Howard Hodgkin: A Recorded Talk on his Paintings, 'Indian Views', Screenprints
and Lithographs*, British Council Touring Exhibition, 1976 (n.p.); 'Howard
Hodgkin Talking to Pat Gilmour About his Prints', 1 April 1976 (notes
of recorded interview); Penelope Marcus, *Howard Hodgkin: Complete Prints*,
Museum of Modern Art, Oxford, 1977 (n.p.); Pat Gilmour, 'Howard Hodgkin',
The Print Collector's Newsletter, vol. 12, no. 1, March–April 1981, p. 3; Jeremy
Lewison, 'Howard Hodgkin', *Carte d'Arte*, 1986, pp. 19–22; Lenore Miller,
Howard Hodgkin Prints: Vision and Collaboration, Dimock Gallery, George
Washington University, Washington, D.C., 1994 (n.p.).

Public collections

The Arts Council Collection, Hayward Gallery, London (complete set);
The British Council, London (complete set); Tate Gallery, London
(complete set).

20 Indian View J, from 'Indian Views'
1971

Screenprint in colours

On J Green paper

Signed, numbered and dated 71 in pencil, lower centre

Edition of 75, with an unrecorded number of artist's proofs and trial proofs

Printed by Chris Prater, with the assistance of Christopher Betambeau,
at Kelpra Studio, London

With the rubber stamp initial K of the printer in black plus number 7850,
verso

Published by Leslie Waddington Prints, London, 1971

Image and sheet: 580 x 776 mm. (22³/₄ x 30¹/₂ in.)

Note: There are some uninscribed proofs with a white, unprinted border.

Literature

W. Oliver, 'Simple – but Subtle', *The Yorkshire Post*, 5 November 1971, p. 3;
Carol Kroch, 'Quality of Calmness in Prints', *The Daily Telegraph*, 16 November
1971; Arthur Hackney, 'David Hockney – Howard Hodgkin', *Arts Review*,
vol. 24, no. 4, 26 February 1972, p. 105; Shelagh Hardie, 'Howard Hodgkin –
John Hoskin,' *Arts Review*, vol. 24, no. 13, 1 July 1972, p. 398; Timothy Hyman,
'Howard Hodgkin', *Studio International*, vol. 189, no. 975, May–June 1975,
p. 183; and vol. 190, no. 976, July–August 1975, p. 88; Margaret Mcleod,
*Howard Hodgkin: A Recorded Talk on his Paintings, 'Indian Views', Screenprints
and Lithographs*, British Council Touring Exhibition, 1976 (n.p.); 'Howard
Hodgkin Talking to Pat Gilmour About his Prints', 1 April 1976 (notes
of recorded interview); Penelope Marcus, *Howard Hodgkin: Complete Prints*,
Museum of Modern Art, Oxford, 1977 (ill.) (n.p.); Pat Gilmour, 'Howard
Hodgkin', *The Print Collector's Newsletter*, vol. 12, no. 1, March–April 1981,
p. 3; Jeremy Lewison, 'Howard Hodgkin', *Carte d'Arte*, 1986, pp. 19–22;
Lenore Miller, *Howard Hodgkin Prints: Vision and Collaboration*, Dimock
Gallery, George Washington University, Washington, D.C., 1994 (n.p.);
Richard Riley, *Out of Print: British Printmaking, 1946–1976*, British Council
Touring Exhibition, 1994–2000, p. 45 (ill. colour, p. 32).

Public collections

The Arts Council Collection, Hayward Gallery, London (complete set);
The British Council, London (complete set); Tate Gallery, London
(complete set).

Colour reproduction on p. 11.

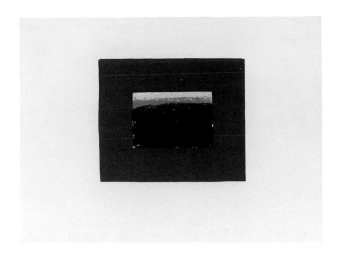

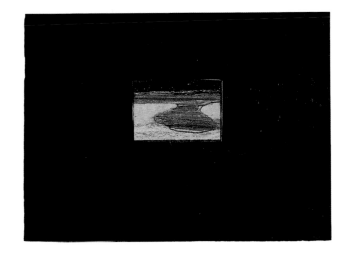

21 Indian View K, from 'Indian Views'
1971

Screenprint in colours

On J Green paper

Signed, numbered and dated 71 in pencil, lower right

Edition of 75, with an unrecorded number of artist's proofs and trial proofs

Printed by Chris Prater, with the assistance of Christopher Betambeau, at Kelpra Studio, London

With the rubber stamp initial K of the printer in black plus number 7840, verso

Published by Leslie Waddington Prints, London, 1971

Image and sheet: 580 x 776 mm. (22³/₄ x 30¹/₂ in.)

Note: There are some uninscribed proofs with a white, unprinted border.

Literature

W. Oliver, 'Simple – but Subtle', *The Yorkshire Post*, 5 November 1971, p. 3; Carol Kroch, 'Quality of Calmness in Prints', *The Daily Telegraph*, 16 November 1971; Arthur Hackney, 'David Hockney – Howard Hodgkin', *Arts Review*, vol. 24, no. 4, 26 February 1972, p. 105; Shelagh Hardie, 'Howard Hodgkin – John Hoskin,' *Arts Review*, vol. 24, no. 13, 1 July 1972, p. 398; Timothy Hyman, 'Howard Hodgkin', *Studio International*, vol. 189, no. 975, May–June 1975, p. 183; and vol. 190, no. 976, July–August 1975, p. 88; Margaret Mcleod, *Howard Hodgkin: A Recorded Talk on his Paintings, 'Indian Views', Screenprints and Lithographs*, British Council Touring Exhibition, 1976 (n.p.); 'Howard Hodgkin Talking to Pat Gilmour About his Prints', 1 April 1976 (notes of recorded interview); Penelope Marcus, *Howard Hodgkin: Complete Prints*, Museum of Modern Art, Oxford, 1977 (n.p.); Pat Gilmour, 'Howard Hodgkin', *The Print Collector's Newsletter*, vol. 12, no. 1, March–April 1981, p. 3; Jeremy Lewison, 'Howard Hodgkin', *Carte d'Arte*, 1986, pp. 19–22; Lenore Miller, *Howard Hodgkin Prints: Vision and Collaboration*, Dimock Gallery, George Washington University, Washington, D.C., 1994 (n.p.).

Public collections

The Arts Council Collection, Hayward Gallery, London (complete set); The British Council, London (complete set); Tate Gallery, London (complete set).

22 Indian View L, from 'Indian Views'
1971

Screenprint in colours

On J Green paper

Signed, numbered and dated 71 in pencil, lower right

Edition of 75, with an unrecorded number of artist's proofs and trial proofs

Printed by Chris Prater, with the assistance of Christopher Betambeau, at Kelpra Studio, London

With the rubber stamp initial K of the printer in black plus number 7843, verso

Published by Leslie Waddington Prints, London, 1971

Image and sheet: 580 x 776 mm. (22³/₄ x 30¹/₂ in.)

Note: There are some uninscribed proofs with a white, unprinted border.

Literature

W. Oliver, 'Simple – but Subtle', *The Yorkshire Post*, 5 November 1971, p. 3; Carol Kroch, 'Quality of Calmness in Prints', *The Daily Telegraph*, 16 November 1971; Arthur Hackney, 'David Hockney – Howard Hodgkin', *Arts Review*, vol. 24, no. 4, 26 February 1972, p. 105; Shelagh Hardie, 'Howard Hodgkin – John Hoskin,' *Arts Review*, vol. 24, no. 13, 1 July 1972, p. 398; Timothy Hyman, 'Howard Hodgkin', *Studio International*, vol. 189, no. 975, May–June 1975, p. 183; and vol. 190, no. 976, July–August 1975, p. 88 (ill.); Margaret Mcleod, *Howard Hodgkin: A Recorded Talk on his Paintings, 'Indian Views', Screenprints and Lithographs*, British Council Touring Exhibition, 1976 (n.p.); 'Howard Hodgkin Talking to Pat Gilmour About his Prints', 1 April 1976 (notes of recorded interview); Penelope Marcus, *Howard Hodgkin: Complete Prints*, Museum of Modern Art, Oxford, 1977 (n.p.); Pat Gilmour, 'Howard Hodgkin', *The Print Collector's Newsletter*, vol. 12, no. 1, March–April 1981, p. 3; Jeremy Lewison, 'Howard Hodgkin', *Carte d'Arte*, 1986, pp. 19–22; Lenore Miller, *Howard Hodgkin Prints: Vision and Collaboration*, Dimock Gallery, George Washington University, Washington, D.C., 1994 (n.p.); Richard Riley, *Out of Print: British Printmaking, 1946–1976*, British Council Touring Exhibition, 1994–2000, p. 45 (ill.).

Public collections

The Arts Council Collection, Hayward Gallery, London (complete set); The British Council, London (complete set); Tate Gallery, London (complete set).

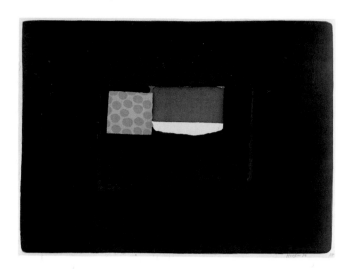

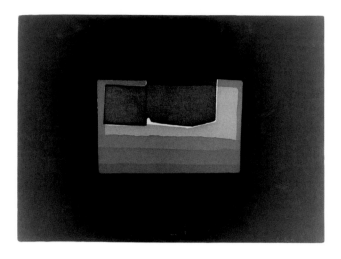

23 Interior (Day)
1973–74

Aquatint from three copper plates printed in black, violet and green
On cream Velin Arches mould-made paper
Signed, numbered and dated 74 in pencil, lower right
Edition of 75, with 16 artist's proofs, 2 printer's proofs, 1 trial proof,
 some stage proofs and 1 B.A.T.
Proofed and printed by Maurice Payne at the Petersburg Studios, London
Published by Petersburg Press, 1974
Plate and sheet: 445 x 600 mm. (17¹/₂ x 23⁵/₈ in.)

Note: Some plates were also used in *Interior (Night)*.

Literature

'Howard Hodgkin Talking to Pat Gilmour About his Prints', 1 April 1976
 (notes of recorded interview); Penelope Marcus, *Howard Hodgkin: Complete
 Prints*, Museum of Modern Art, Oxford, 1977 (n.p.); Pat Gilmour, 'Howard
 Hodgkin', *The Print Collector's Newsletter*, vol. 12, no. 1, March–April 1981, p. 3.

Public collections

Tate Gallery, London.

Colour reproduction on p. 52.

24 Interior (Night)
1973–74

Aquatint from three copper plates printed in black, red and orange
On cream Velin Arches mould-made paper
Signed, numbered and dated 74 in pencil, lower right
Edition of 75, with 16 artist's proofs, 2 printer's proofs, 1 trial proof,
 some stage proofs and 1 B.A.T.
Proofed and printed by Maurice Payne at the Petersburg Studios, London
Published by Petersburg Press, 1974
Plate and sheet: 445 x 600 mm. (17¹/₂ x 23⁵/₈ in.)

Note: Some plates were also used in *Interior (Day)*.

Literature

'Howard Hodgkin Talking to Pat Gilmour About his Prints', 1 April 1976
 (notes of recorded interview); Penelope Marcus, *Howard Hodgkin: Complete
 Prints*, Museum of Modern Art, Oxford, 1977 (n.p.); Pat Gilmour, 'Howard
 Hodgkin', *The Print Collector's Newsletter*, vol. 12, no. 1, March–April 1981, p. 3.

Public collections

Tate Gallery, London.

Colour reproduction on p. 53.

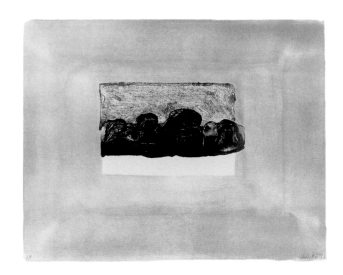

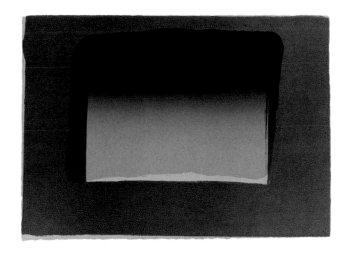

25 After Luke Howard, from 'For John Constable'
1976

Lithograph from three zinc plates printed in two shades of blue, and sepia
On TH Saunders paper (250 gsm)
Signed and dated 76 in pencil, lower right
Numbered in pencil, lower left
Edition of 100, with 21 artist's proofs, an unrecorded number of printer's
 proofs and 1 B.A.T.
Printed by Ian Lawson at Aymestrey Water Mill, Herefordshire
Published by Bernard Jacobson Ltd, London, 1976
Image and sheet: 447 x 568 mm. (17$^{1}/_{2}$ x 22$^{1}/_{4}$ in.)

Note: The portfolio 'For John Constable' was made as a tribute to John
 Constable on the occasion of the bi-centenary of his birth in 1976. It further
 comprises the following eighteen prints, all of which were made in 1976:

Untitled, screenprint by Ivor Abrahams; *Suffolk Child*, etching with collage
 by Peter Blake; *Untitled*, photograph by Bill Brandt; *Untitled*, screenprint
 by Patrick Caulfield; *Six Drawings from the series 'From Life...'*, screenprint
 with collage by Robyn Denny; *Untitled*, drypoint etching by Barry Flanagan;
 Untitled, etching by Duncan Grant; *Untitled*, engraving by Anthony Gross;
 Willow Water No. II, screenprint by Ivon Hitchens; *Untitled*, etching by David
 Hockney; *Country Dance*, relief by Alexander Hollweg; *Untitled*, lithograph
 with collage by John Hoyland; *Calendar*, aquatint by Terence Millington;
 Untitled, photo etching by Margaret Priest; *Untitled*, lithograph by Michael
 Sandle; *Untitled*, lithograph with collage by Richard Smith; *Untitled*,
 etching with hand colouring by Norman Stevens; *Untitled*, aquatint
 by William Tillyer.

Literature

Elizabeth Underhill, *For John Constable*, Tate Gallery, London, 17 February–
 5 May 1976 (n.p.); Rosemary Simmons, 'Constable Portfolio', *Arts Review*,
 vol. 28, no. 5, 5 March 1976, p. 117; 'Howard Hodgkin Talking to Pat Gilmour
 About his Prints', 1 April 1976 (notes of recorded interview); Penelope
 Marcus, *Howard Hodgkin: Complete Prints*, Museum of Modern Art, Oxford,
 1977 (n.p.); Pat Gilmour, 'Howard Hodgkin', *The Print Collector's Newsletter*,
 vol. 12, no. 1, March–April 1981, p. 3.

Public collections

National Gallery of Australia, Canberra; Tate Gallery, London.

26 Sky, from 'More Indian Views'
1976

Lithograph from three zinc plates printed in beige, blue and a blue
 to violet blend
On TH Saunders paper (250 gsm)
Signed and dated 76 in pencil, lower right, verso
Numbered in pencil, lower left, verso
Edition of 60, with an unrecorded number of proofs and 1 B.A.T.
Printed by Ian Lawson at Aymestrey Water Mill, Herefordshire
With the printer's chopmark, lower right
Published by Bernard Jacobson Ltd, London, 1976
Image and sheet: 220 x 305 mm. (8$^{5}/_{8}$ x 12 in.)

Literature

Margaret Mcleod, *Howard Hodgkin: A Recorded Talk on his Paintings, 'Indian Views',
 Screenprints and Lithographs*, British Council Touring Exhibition, 1976 (n.p.);
 'Howard Hodgkin Talking to Pat Gilmour About his Prints', 1 April 1976
 (notes of recorded interview); Penelope Marcus, *Howard Hodgkin: Complete
 Prints*, Museum of Modern Art, Oxford, 1977 (n.p.); Jacqueline Brody,
 'Howard Hodgkin, *More Indian Views* (1976)', *The Print Collector's Newsletter*,
 vol. 7, no. 6, January–February 1977, p. 181; Pat Gilmour, 'Howard Hodgkin',
 The Print Collector's Newsletter, vol. 12, no. 1, March–April 1981, p. 3.

Public collections

The British Council, London (complete set).

Colour reproduction on p. 32.

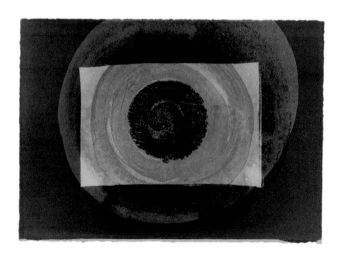

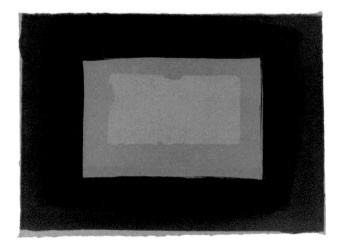

27 Sun, from 'More Indian Views'
1976

Lithograph from seven zinc plates printed in beige, two shades of blue,
 orange, red, black and white
On TH Saunders paper (250 gsm)
Signed and dated 76 in pencil, lower right, verso
Numbered in pencil, lower left, verso
Edition of 60, with an unrecorded number of proofs, and 1 B.A.T.
Printed by Ian Lawson at Aymestrey Water Mill, Herefordshire
With the printer's chopmark, lower right
Published by Bernard Jacobson Ltd, London, 1976
Image and sheet: 220 x 305 mm. (8⅝ x 12 in.)

Literature

Margaret Mcleod, *Howard Hodgkin: A Recorded Talk on his Paintings, 'Indian Views',*
 Screenprints and Lithographs, British Council Touring Exhibition, 1976 (n.p.);
 'Howard Hodgkin Talking to Pat Gilmour About his Prints', 1 April 1976
 (notes of recorded interview); Penelope Marcus, *Howard Hodgkin: Complete*
 Prints, Museum of Modern Art, Oxford, 1977 (ill.) (n.p.); Jacqueline Brody,
 'Howard Hodgkin, *More Indian Views* (1976)', *The Print Collector's Newsletter*,
 vol. 7, no. 6, January–February 1977, p. 181; Pat Gilmour, 'Howard Hodgkin',
 The Print Collector's Newsletter, vol. 12, no. 1, March–April 1981, p. 3.

Public collections

The British Council, London (complete set).

Colour reproduction on p. 33.

28 Window, from 'More Indian Views'
1976

Lithograph from six zinc plates printed in beige, brown and four shades
 of green
On TH Saunders paper (250 gsm)
Signed and dated 76 in pencil, lower right, verso
Numbered in pencil, lower left, verso
Edition of 60, with an unrecorded number of proofs, and 1 B.A.T.
Printed by Ian Lawson at Aymestrey Water Mill, Herefordshire
With the printer's chopmark, lower right
Published by Bernard Jacobson Ltd, London, 1976
Image and sheet: 220 x 305 mm. (8⅝ x 12 in.)

Literature

Margaret Mcleod, *Howard Hodgkin: A Recorded Talk on his Paintings, 'Indian Views',*
 Screenprints and Lithographs, British Council Touring Exhibition, 1976 (n.p.);
 'Howard Hodgkin Talking to Pat Gilmour About his Prints', 1 April 1976
 (notes of recorded interview); Penelope Marcus, *Howard Hodgkin: Complete*
 Prints, Museum of Modern Art, Oxford, 1977 (n.p.); Jacqueline Brody,
 'Howard Hodgkin, *More Indian Views* (1976)', *The Print Collector's Newsletter*,
 vol. 7, no. 6, January–February 1977, p. 181; Pat Gilmour, 'Howard Hodgkin',
 The Print Collector's Newsletter, vol. 12, no. 1, March–April 1981, p. 3.

Public collections

The British Council, London (complete set).

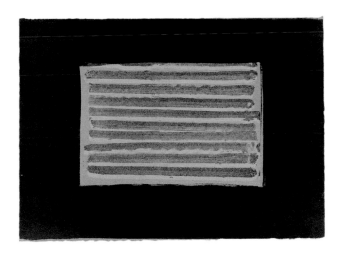

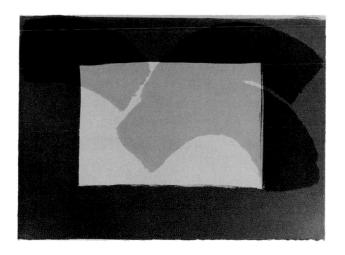

29 Shutter, from 'More Indian Views'
1976

Lithograph from three zinc plates printed in beige, blue and violet
On TH Saunders paper (250 gsm)
Signed and dated 76 in pencil, lower right, verso
Numbered in pencil, lower left, verso
Edition of 60, with an unrecorded number of proofs, and 1 B.A.T.
Printed by Ian Lawson at Aymestrey Water Mill, Herefordshire
With the printer's chopmark, lower right
Published by Bernard Jacobson Ltd, London, 1976
Image and sheet: 220 x 305 mm. (8⅝ x 12 in.)

Literature

Margaret Mcleod, *Howard Hodgkin: A Recorded Talk on his Paintings, 'Indian Views', Screenprints and Lithographs*, British Council Touring Exhibition, 1976 (n.p.); 'Howard Hodgkin Talking to Pat Gilmour About his Prints', 1 April 1976 (notes of recorded interview); Penelope Marcus, *Howard Hodgkin: Complete Prints*, Museum of Modern Art, Oxford, 1977 (n.p.); Jacqueline Brody, 'Howard Hodgkin, *More Indian Views* (1976)', *The Print Collector's Newsletter*, vol. 7, no. 6, January–February 1977, p. 181; Pat Gilmour, 'Howard Hodgkin', *The Print Collector's Newsletter*, vol. 12, no. 1, March–April 1981, p. 3.

Public collections

The British Council, London (complete set).

30 Palm, from 'More Indian Views'
1976

Lithograph from three zinc plates printed in beige, blue and orange
On TH Saunders paper (250 gsm)
Signed and dated 76 in pencil, lower right, verso
Numbered in pencil, lower left, verso
Edition of 60, with an unrecorded number of proofs, and 1 B.A.T.
Printed by Ian Lawson at Aymestrey Water Mill, Herefordshire
With the printer's chopmark, lower right
Published by Bernard Jacobson Ltd, London, 1976
Image and sheet: 220 x 305 mm. (8⅝ x 12 in.)

Literature

Margaret Mcleod, *Howard Hodgkin: A Recorded Talk on his Paintings, 'Indian Views', Screenprints and Lithographs*, British Council Touring Exhibition, 1976 (n.p.); 'Howard Hodgkin Talking to Pat Gilmour About his Prints', 1 April 1976 (notes of recorded interview); Penelope Marcus, *Howard Hodgkin: Complete Prints*, Museum of Modern Art, Oxford, 1977 (n.p.); Jacqueline Brody, 'Howard Hodgkin, *More Indian Views* (1976)', *The Print Collector's Newsletter*, vol. 7, no. 6, January–February 1977, p. 181; Pat Gilmour, 'Howard Hodgkin', *The Print Collector's Newsletter*, vol. 12, no. 1, March–April 1981, p. 3.

Public collections

The British Council, London (complete set).

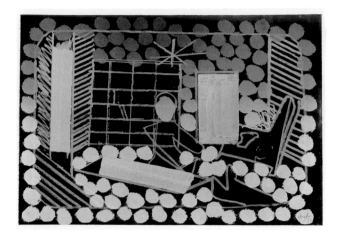

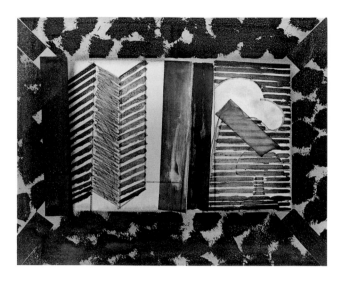

31 Julian and Alexis

1977

Lithograph from four zinc plates printed in violet (with a blend), black,
 grey and white, with hand colouring in green gouache
On cream Velin Arches mould-made paper (250 gsm)
Signed and dated 77 in pencil, lower right
Numbered in pencil, lower left
Edition of 30, with an unrecorded number of proofs, and 1 B.A.T.
Printed by Ian Lawson at Aymestrey Water Mill, Herefordshire
Hand coloured by the artist and Sam Hodgkin under the artist's supervision
With the printer's chopmark
Published by Bernard Jacobson Ltd, London, 1977
Image and sheet: 699 x 1016 mm. (27¹/₂ x 40 in.)

Literature

Penelope Marcus, *Howard Hodgkin: Complete Prints*, Museum of Modern Art,
 Oxford, 1977 (n.p.); Jacqueline Brody, 'Howard Hodgkin, *Julian and Alexis*
 (1977)', *The Print Collector's Newsletter*, vol. 8, no. 5, November–December
 1977, p. 144; Pat Gilmour, 'Howard Hodgkin', *The Print Collector's Newsletter*,
 vol. 12, no. 1, March–April 1981, p. 3 (ill., p. 2); Elizabeth Knowles (ed.),
 Howard Hodgkin: Prints 1977 to 1983, Tate Gallery, London, 1985, p. 14; Jeremy
 Lewison, 'Howard Hodgkin', *Carte d'Arte*, 1986, pp. 19, 21.

Public collections

Museum of Modern Art, New York; National Gallery of Australia, Canberra.

Colour reproduction on p. 56.

32 Nick

1977

Soft-ground etching with sugar lift and aquatint from two copper plates
 printed in black and green, with hand colouring in watercolour (yellow
 and pink wash, and blue for the border)
On Crisbrook hand-made paper
Signed and dated 77 in pencil, lower right
Numbered in pencil, lower left
Edition of 100, with 15 artist's proofs, 3 printer's proofs, 2 trial proofs, some
 stage proofs and 1 B.A.T.
Proofed by Maurice Payne
Printed by Maurice Payne and Danny Levy at the Petersburg Studios, London
Hand coloured by Maurice Payne and Danny Levy at the Petersburg Studios,
 New York
Published by Petersburg Press, 1977
Plate: 445 x 560 mm. (17¹/₂ x 22 in.)
Sheet: 470 x 585 mm. (18¹/₂ x 23 in.)

Literature

Penelope Marcus, *Howard Hodgkin: Complete Prints*, Museum of Modern Art,
 Oxford, 1977 (n.p.); Pat Gilmour, 'Howard Hodgkin', *The Print Collector's
 Newsletter*, vol. 12, no. 1, March–April 1981, p. 3; Elizabeth Knowles (ed.),
 Howard Hodgkin: Prints 1977 to 1983, Tate Gallery, London, 1985, pp. 9, 13;
 Mary Rose Beaumont, 'Howard Hodgkin at the Whitechapel Art Gallery,
 the Tate Gallery and Bernard Jacobson', *Arts Review*, vol. 37, no. 20, 11
 October 1985, p. 515 (ill.); Enrico Crispolti (intro.), *Howard Hodgkin: Opera
 grafica 1977–1983*, British Council Touring Exhibition, 1985–90, pp. 9, 49
 (ill. colour, cover); Jeremy Lewison, 'Howard Hodgkin', *Carte d'Arte*, 1986,
 pp. 19–20 (ill., p. 21); Judith Dunham, 'Howard Hodgkin's Accumulated
 Memories', *PrintNews*, vol. 8, no. 1, winter 1986, p. 6 (ill., p. 7); 'Cor britânica.
 Belas gravuras do inglês Howard Hodgkin', *Veja*, 22 July 1987, p. 117 (ill.);
 The Tate Gallery: Illustrated Catalogue of Acquisitions 1984–86, London, 1988,
 pp. 385–86 (ill., p. 385); 'Grabados de Howard Hodgkin', *El Sur*, 17 July 1988
 (ill.); Lenore Miller, *Howard Hodgkin Prints: Vision and Collaboration*, Dimock
 Gallery, George Washington University, Washington, D.C., 1994 (n.p.).

Public collections

The British Council, London; Museum of Panjab University at Chandigarh,
 India; Tate Gallery, London.

Colour reproduction on p. 60.

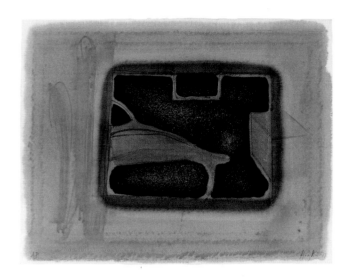

33 A Furnished Room
 1977
Soft-ground etching and aquatint from two copper plates printed in orange-
 red, with hand colouring in green and orange watercolour
On Arches mould-made paper (250 gsm)
Signed and dated 77 in pencil, lower right
Numbered in pencil, lower left
Edition of 100, with 14 artist's proofs, 4 printer's proofs, 9 trial proofs
 and 1 B.A.T.
Proofed by Maurice Payne and Danny Levy at the Petersburg Studios,
 London and New York
Printed and hand coloured by Ken Farley at the Petersburg Studios,
 New York
Published by Petersburg Press, 1977
Plate: 533 x 688 mm. (21 x 27 in.)
Sheet: 538 x 693 mm. (21^1/$_4$ x 27^1/$_4$ in.)

Colour reproduction on p. 57.

34 Jarid's Porch
 1977
Lithograph from one aluminium plate printed in black, with hand colouring
 in gouache (grey wash border and yellow)
On Lexington hand-made paper
Signed and dated 77 in pencil, lower right
Numbered in pencil, lower left
Edition of 100, with 14 artist's proofs, 2 printer's proofs, 2 trial proofs and
 1 B.A.T.
Proofed by Bruce Porter
Printed and hand coloured by Bruce Porter and Jim Welty at the Petersburg
 Studios, New York
Published by Petersburg Press, 1977
Image and sheet: 525 x 612 mm. (20^5/$_8$ x 24^1/$_8$ in.)

Literature
Pat Gilmour, 'Howard Hodgkin', *The Print Collector's Newsletter*, vol. 12, no. 1,
 March–April 1981, p. 3; Judith Dunham, 'Howard Hodgkin's Accumulated
 Memories', *PrintNews*, vol. 8, no. 1, winter 1986, p. 6.

Colour reproduction on p. 62.

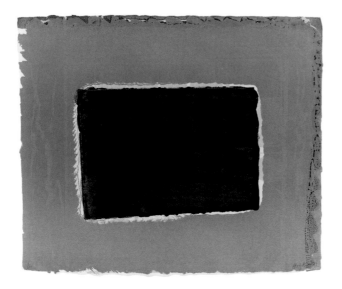

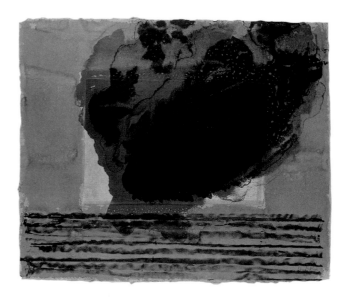

35 Nick's Room
1977

Lithograph from three aluminium plates printed in yellow, orange
 and brown, with hand colouring in violet gouache
On Lexington hand-made paper
Signed and dated 77 in pencil, lower right
Numbered in pencil, lower left
Edition of 100, with 16 artist's proofs, 2 printer's proofs, 3 trial proofs
 and 1 B.A.T.
Proofed by Bruce Porter
Printed and hand coloured by Bruce Porter and Jim Welty at the Petersburg
 Studios, New York
Published by Petersburg Press, 1977
Image and sheet: 525 x 618 mm. (20⁵⁄₈ x 24³⁄₈ in.)

Literature

Pat Gilmour, 'Howard Hodgkin', *The Print Collector's Newsletter*, vol. 12,
 no. 1, March–April 1981, p. 3.

Public collections

The British Council, London.

Colour reproduction on p. 61.

36 A Storm
1977

Lithograph from three aluminium plates printed in green and two shades
 of blue, with hand colouring in gouache (a green wash background with
 a second wash in blue and a blue border)
On Lexington hand-made paper
Signed and dated 77 in pencil, lower right
Numbered in pencil, lower left
Edition of 100, with 14 artist's proofs, 2 printer's proofs, 7 trial proofs
 and 1 B.A.T.
Proofed by Bruce Porter
Printed and hand coloured by Bruce Porter and Jim Welty at the Petersburg
 Studios, New York
Published by Petersburg Press, 1977
Image and sheet: 517 x 613 mm. (20³⁄₈ x 24¹⁄₈ in.)

Literature

Pat Gilmour, 'Howard Hodgkin', *The Print Collector's Newsletter*, vol. 12, no. 1,
 March–April 1981, p. 3; Jeremy Lewison, 'Howard Hodgkin', *Carte d'Arte*,
 1986, pp. 19, 21; *The Tate Gallery: Illustrated Catalogue of Acquisitions 1984–86*,
 London, 1988, p. 386 (ill.); John Russell (intro.), *Howard Hodgkin. Graphic Work:
 Fourteen Hand-coloured Lithographs and Etchings 1977–1987*, Lumley Cazalet,
 London, 1990 (n.p.).

Public collections

The British Council, London; The Fogg Art Museum, Harvard University Art
 Museums, Cambridge, Massachusetts; The Government Art Collection,
 London; Tate Gallery, London.

Colour reproduction on p. 63.

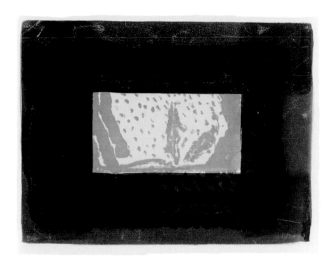

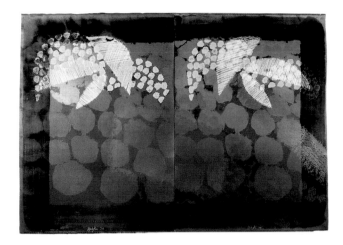

37 Birthday Party
1977–78

Lithograph from a stone printed in sepia and green, with hand colouring
in two shades of blue gouache

On Velin Arches mould-made paper (300 gsm)

Signed and dated 77 in pencil, lower right

Numbered in pencil, lower left

Edition of 50, with an unrecorded number of artist's proofs and working
proofs

Printing begun by Judith Solodkin at Solo Press Inc., New York, 1977

Subsequently torn down in England and hand coloured by Alan Cox
and Don Bessant at Sky Editions, London, 1978

Published by Bernard Jacobson Ltd, London, 1978

Image: 383 x 503 mm. (15 x 19¾ in.)

Sheet: 406 x 524 mm. (16 x 20⅝ in.)

Note: The numbering and dating on this print are not always consistent.
One copy is signed, dated 1974 and numbered out of 100. It was probably
signed later and erroneously numbered and dated by the artist. Another
copy was signed, dated 73 and numbered out of 50. Some proofs are
unsigned and unnumbered.

Literature

Suzanne Boorsch, 'New Editions. Howard Hodgkin', *ARTnews*, vol. 78, no. 7,
September 1979, pp. 42, 44.

Public collections

The British Council, London.

38 For Bernard Jacobson
1977–79

Lithograph from four zinc plates printed in black, a blue to lilac blend,
and two shades of red-brown, with hand colouring in black gouache
(on the border) and pochoir hand colouring in blue and two shades
of yellow wax crayon

On two sheets of cream Velin Arches mould-made paper dyed blackish
purple before printing

Signed and dated 79 in pencil, lower centre, on both sheets

Numbered in pencil in the lower left on the left-hand sheet and in the lower
right on the right-hand sheet

Edition of 80, with 15 artist's proofs and an unrecorded number of working
proofs

Printed and hand coloured by Alan Cox and Don Bessant at Sky Editions,
London

Published by Bernard Jacobson Ltd, London, 1979

Overall: 1058 x 1499 mm. (41⅝ x 59 in.)

Each sheet: 1058 x 749 mm. (41⅝ x 29½ in.)

Literature

Jacqueline Brody, 'Howard Hodgkin, *For Bernard Jacobson* (1979),' *The Print
Collector's Newsletter*, vol. 10, no. 6, January–February 1980, p. 201 (ill.);
Recent Acquisitions for the Print Collection, Tate Gallery, London, 1980–81
(n.p.); Pat Gilmour, 'Howard Hodgkin', *The Print Collector's Newsletter*, vol. 12,
no. 1, March–April 1981, p. 5; *Prints by Six British Painters: Stephen Buckley, Robyn
Denny, Howard Hodgkin, John Hoyland, Richard Smith, John Walker*, Tate Gallery,
London, 1981–82 (n.p.); *The Tate Gallery: Illustrated Catalogue of Acquisitions
1980–82*, London, 1984, p. 260 (ill.); Elizabeth Knowles (ed.), *Howard Hodgkin:
Prints 1977 to 1983*, Tate Gallery, London, 1985, pp. 9, 16; Mary Rose Beaumont,
'Howard Hodgkin at the Whitechapel Art Gallery, the Tate Gallery and
Bernard Jacobson', *Arts Review*, vol. 37, no. 20, 11 October 1985, p. 515; Jeremy
Lewison, 'Howard Hodgkin', *Carte d'Arte*, 1986, pp. 19, 21 (ill. colour, p. 22);
Simon Wilson, *Tate Gallery: An Illustrated Companion*, London, 1989, p. 257 (ill.).

Public collections

Art Gallery of Western Australia, Perth; The Arts Council Collection, Hayward
Gallery, London; The British Council, London; The Government Art
Collection, London; National Gallery of Australia, Canberra; Philadelphia
Museum of Art, Philadelphia; Tate Gallery, London; Whitworth Art Gallery,
Manchester.

Colour reproduction on p. 65.

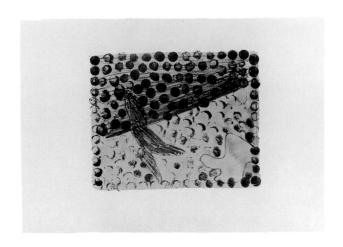

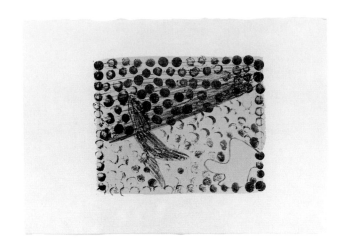

39 Green Chateau I
1978

Lithograph from one zinc plate printed in green, with hand colouring
 in green gouache
On Velin Arches mould-made paper (300 gsm)
Signed with initials and dated 78 in pencil, lower centre
Numbered in pencil, lower left
Edition of 12, with an unrecorded number of artist's proofs and working
 proofs
Printed and hand coloured by Alan Cox and Don Bessant at Sky Editions,
 London
Published by Bernard Jacobson Ltd, London, 1978
Image: 167 x 210 mm. (6¹/₂ x 8¹/₄ in.)
Sheet: 267 x 378 mm. (10¹/₂ x 14³/₄ in.)

Note: Printed from the same zinc plate as the other three prints in this
 series. Some proofs are unsigned and unnumbered.

Literature

Jacqueline Brody, 'Howard Hodgkin, *Green Chateau* (1978)', *The Print Collector's
 Newsletter*, vol. 9, no. 5, November–December 1978, p. 162; Pat Gilmour,
 'Howard Hodgkin', *The Print Collector's Newsletter*, vol. 12, no. 1, March–
 April 1981, p. 3.

40 Green Chateau II
1978

Lithograph from one zinc plate printed in green with hand colouring
 in yellow gouache
On Velin Arches mould-made paper (300 gsm)
Signed with initials and dated 78 in pencil, lower centre
Numbered in pencil, lower left
Edition of 12, with an unrecorded number of artist's proofs and working
 proofs
Printed and hand coloured by Alan Cox and Don Bessant at Sky Editions,
 London
Published by Bernard Jacobson Ltd, London, 1978
Image: 167 x 210 mm. (6¹/₂ x 8¹/₄ in.)
Sheet: 267 x 378 mm. (10¹/₂ x 14³/₄ in.)

Note: Printed from the same zinc plate as the other three prints in this series.
 Some proofs are unsigned and unnumbered.

Literature

Jacqueline Brody, 'Howard Hodgkin, *Green Chateau* (1978)', *The Print Collector's
 Newsletter*, vol. 9, no. 5, November–December 1978, p. 162; Pat Gilmour,
 'Howard Hodgkin', *The Print Collector's Newsletter*, vol. 12, no. 1, March–
 April 1981, p. 3.

Colour reproduction on p. 66.

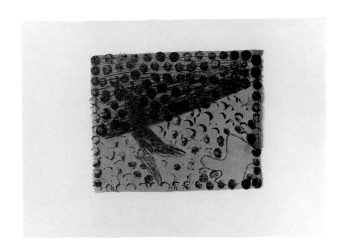

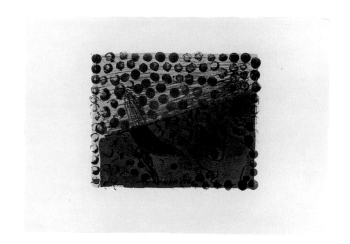

41 Green Chateau III
1978

Lithograph from one zinc plate printed in green with hand colouring
 in pink gouache
On Velin Arches mould-made paper (300 gsm)
Signed with initials and dated 78 in pencil, lower centre
Numbered in pencil, lower left
Edition of 12, with an unrecorded number of artist's proofs and working
 proofs
Printed and hand coloured by Alan Cox and Don Bessant at Sky Editions,
 London
Published by Bernard Jacobson Ltd, London, 1978
Image: 167 x 210 mm. (6$^{1}/_{2}$ x 8$^{1}/_{4}$ in.)
Sheet: 267 x 378 mm. (10$^{1}/_{2}$ x 14$^{3}/_{4}$ in.)

Note: Printed from the same zinc plate as the other three prints in this series.
 Some proofs are unsigned and unnumbered.

Literature

Jacqueline Brody, 'Howard Hodgkin, *Green Chateau* (1978)', *The Print Collector's
 Newsletter*, vol. 9, no. 5, November–December 1978, p. 162; Pat Gilmour,
 'Howard Hodgkin', *The Print Collector's Newsletter*, vol. 12, no. 1, March–April
 1981, p. 3.

42 Green Chateau IV
1978

Lithograph from one zinc plate printed in green with hand colouring
 in green and red gouache
On Velin Arches mould-made paper (300 gsm)
Signed with initials and dated 78 in pencil, lower centre
Numbered in pencil, lower left
Edition of 12, with an unrecorded number of artist's proofs and working
 proofs
Printed and hand coloured by Alan Cox and Don Bessant at Sky Editions,
 London
Published by Bernard Jacobson Ltd, London, 1978
Image: 167 x 210 mm. (6$^{1}/_{2}$ x 8$^{1}/_{4}$ in.)
Sheet: 267 x 378 mm. (10$^{1}/_{2}$ x 14$^{3}/_{4}$ in.)

Note: Printed from the same zinc plate as the other three prints in this series.
 Some proofs are unsigned and unnumbered.

Literature

Jacqueline Brody, 'Howard Hodgkin, *Green Chateau* (1978)', *The Print Collector's
 Newsletter*, vol. 9, no. 5, November–December 1978, p. 162; Pat Gilmour,
 'Howard Hodgkin', *The Print Collector's Newsletter*, vol. 12, no. 1, March–April
 1981, p. 3.

Colour reproduction on p. 67.

43 You and Me

1978

Lithograph from two zinc plates printed in two shades of pink, with hand
colouring in green watercolour

On Arches torchon paper (356 gsm)

Signed with initials and dated 78 in pencil, lower centre

Numbered in pencil, lower left

Edition of 100, with an unrecorded number of artist's proofs and working
proofs

Printed and hand coloured by Alan Cox and Don Bessant at Sky Editions,
London

Published by Bernard Jacobson Ltd, London, 1978

Image: 207 x 382 mm. (8¹⁄₈ x 15 in.)

Sheet: 227 x 411 mm. (8⁷⁄₈ x 16¹⁄₈ in.)

Note: Some proofs are unsigned and unnumbered.

Literature

Suzanne Boorsch, 'New Editions. Howard Hodgkin', *ARTnews*, vol. 78, no. 7,
September 1979, pp. 42, 44; Marina Vaizey, 'Howard Hodgkin's Prints
(Waddington)', *The Sunday Times*, 27 April 1980, p. 40; Pat Gilmour, 'Howard
Hodgkin', *The Print Collector's Newsletter*, vol. 12, no. 1, March–April 1981, p. 3.

Colour reproduction on p. 74.

44 Alexander Street

1978

Lithograph from three zinc plates printed in emerald green, red brown
and grey with hand colouring in yellow watercolour and red gouache

On Velin Arches mould-made paper (300 gsm)

Signed and dated 78 in pencil, lower centre

Numbered in pencil, lower left

Edition of 90, with an unrecorded number of artist's proofs, trial proofs
and working proofs

Printed and hand coloured by Alan Cox and Don Bessant at Sky Editions,
London

Published by Bernard Jacobson Ltd, London, 1978

Image and sheet: 340 x 612 mm. (13¹⁄₄ x 24¹⁄₈ in.)

Note: Some prints are dated 79.

Literature

Pat Gilmour, 'Howard Hodgkin', *The Print Collector's Newsletter*, vol. 12, no. 1,
March–April 1981, p. 3.

Colour reproduction on p. 75.

45 Bed
1973/74–1978

Aquatint from two copper plates printed in black, red and orange, with hand
 colouring in orange gouache
On cream Velin Arches mould-made paper
Signed with initials in pencil and numbered, lower centre
Not dated
Edition of 50, with 4 artist's proofs
Proofed and printed by Maurice Payne at the Petersburg Studios, London,
 1973–74
Hand coloured by Sam Hodgkin under the artist's supervision, 1978
Published by Petersburg Press, 1978
Plate: 445 x 600 mm. (17¹/₂ x 23⁵/₈ in.)
Sheet: 206 x 310 mm. (8 x 12¹/₈ in.)

Note: *Interior (Day)* and *Interior (Night)* were torn down after publication.
 Their broad borders, signature, numbering and date were torn off. Fifty
 copies of each print were hand coloured, signed, numbered and dated
 again, and these were *Breakfast* and *Bed*, respectively.

Literature

Lenore Miller, *Howard Hodgkin Prints: Vision and Collaboration*, Dimock Gallery,
 George Washington University, Washington, D.C., 1994 (n.p.).

46 Breakfast
1973/74–1978

Aquatint from three copper plates printed in green and violet, with hand
 colouring in orange gouache
On cream Velin Arches mould-made paper
Signed with initials in pencil and numbered, lower centre
Not dated
Edition of 50, with 6 artist's proofs
Proofed and printed by Maurice Payne at the Petersburg Studios, London,
 1973–74
Hand coloured by Sam Hodgkin under the artist's supervision, 1978
Published by Petersburg Press, 1978
Plate. 445 x 600 mm. (17¹/₂ x 23⁵/₈ in.)
Sheet: 206 x 310 mm. (8 x 12¹/₈ in.)

Note: *Interior (Day)* and *Interior (Night)* were torn down after publication.
 Their broad borders, signature, numbering and date were torn off. Fifty
 copies of each print were hand coloured, signed, numbered and dated
 again, and these were *Breakfast* and *Bed*, respectively.

Literature

Lenore Miller, *Howard Hodgkin Prints: Vision and Collaboration*, Dimock Gallery,
 George Washington University, Washington, D.C., 1994 (n.p.).

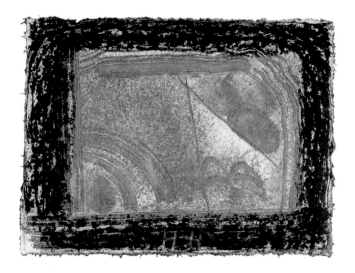

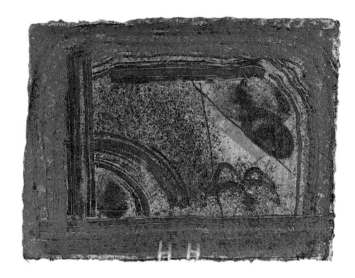

47 Cardo's Bar (Black)
1978–79

Soft-ground etching from one copper plate printed in orange, with hand
 colouring in black oil crayon
On John Koller HMP hand-made paper
Signed with initials in yellow crayon, lower centre
Not dated
Numbered in pencil, lower centre, verso
Edition of 60, with 12 artist's proofs, 3 printer's proofs, 1 trial proof
 and 1 B.A.T.
Proofed, printed and hand coloured by Ken Farley at the Petersburg
 Studios, New York, winter, 1978–79
Published by Petersburg Press, 1979
Plate: 152 x 203 mm. (6 x 8 in.)
Sheet: 115 x 152 mm. (4¹/₂ x 6 in.)

Note: Printed from the same copper plate as *Cardo's Bar (Red)*.

Literature

Pat Gilmour, 'Howard Hodgkin', *The Print Collector's Newsletter*, vol. 12, no. 1,
 March–April 1981, p. 3; Elizabeth Knowles (ed.), *Howard Hodgkin: Prints 1977
 to 1983*, Tate Gallery, London, 1985, p. 9; *The Tate Gallery: Illustrated Catalogue
 of Acquisitions 1984–86*, London, 1988, pp. 386–87 (ill., p. 386); Rosemary
 Simmons, 'Howard Hodgkin: New Hand-coloured Prints', *Printmaking
 Today*, no. 2, spring 1991, p. 8.

Public collections

Tate Gallery, London.

Colour reproduction on p. 78.

48 Cardo's Bar (Red)
1979

Soft-ground etching from one copper plate printed in orange and purple,
 with hand colouring in watercolour (a green wash background) and
 red oil crayon
On John Koller HMP hand-made paper
Signed with initials in white crayon, lower centre
Not dated
Numbered in pencil, lower centre, verso
Edition of 50, with 12 artist's proofs, 3 printer's proofs, 1 trial proof
 and 1 B.A.T.
Proofed, printed and hand coloured by Ken Farley at the Petersburg
 Studios, New York
Published by Petersburg Press, 1979
Plate: 152 x 203 mm. (6 x 8 in.)
Sheet: 115 x 152 mm. (4¹/₂ x 6 in.)

Note: Printed from the same copper plate as *Cardo's Bar (Black)*.

Literature

Pat Gilmour, 'Howard Hodgkin', *The Print Collector's Newsletter*, vol. 12, no. 1,
 March–April 1981, p. 3; Elizabeth Knowles (ed.), *Howard Hodgkin: Prints 1977
 to 1983*, Tate Gallery, London, 1985, p. 16; Mary Rose Beaumont, 'Howard
 Hodgkin at the Whitechapel Art Gallery, the Tate Gallery and Bernard
 Jacobson', *Arts Review*, vol. 37, no. 20, 11 October 1985, p. 515; *The Tate Gallery:
 Illustrated Catalogue of Acquisitions 1984–86*, London, 1988, p. 387 (ill.);
 Rosemary Simmons, 'Howard Hodgkin: New Hand-coloured Prints',
 Printmaking Today, no. 2, spring 1991, p. 8.

Public collections

Tate Gallery, London.

Colour reproduction on p. 79.

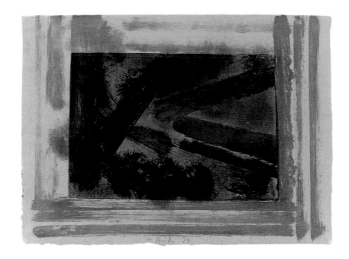

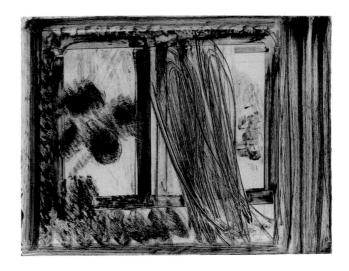

49 Here We Are in Croydon

1979

Lithograph from one aluminium plate printed in black, with hand colouring
 in watercolour (a brown wash background) and gouache (a red triangle
 beneath the watercolour wash and a red border)

On Moulin d'Auvergne hand-made paper (280 gsm)

Signed, numbered and dated 79 in blue crayon, lower centre

Edition of 100, with 20 artist's proofs, 3 printer's proofs, 2 trial proofs
 and 1 B.A.T.

Proofed by John Hutcheson

Printed and hand coloured by John Hutcheson and Jim Welty
 at the Petersburg Studios, New York

Published by Petersburg Press, 1979

Image and sheet: 559 x 765 mm. (22 x 30¹⁄₈ in)

Literature

Pat Gilmour, 'Howard Hodgkin', *The Print Collector's Newsletter*, vol. 12,
 no. 1, March–April 1981, p. 3; Åsmund Thorkildsen, 'Howard Hodgkin på
 Høvikodden', *Drammens Tidende og Buskeruds Blad*, 12 February 1987; *The Tate
 Gallery: Illustrated Catalogue of Acquisitions 1984–86*, London, 1988, pp. 387–88
 (ill., p. 387); Guy Burn, 'Prints: Lumley Cazalet', *Arts Review*, vol. 42, no. 14,
 13 July 1990, p. 374.

Public collections

National Gallery of Australia, Canberra; Tate Gallery, London.

Colour reproduction on p. 82.

50 Late Afternoon in the Museum of Modern Art,
 from 'In the Museum of Modern Art'

1979

Soft-ground etching from one copper plate printed in black

On buff BFK Rives mould-made paper

Signed, numbered and dated '79 in red crayon, lower centre

Edition of 100, with 20 artist's proofs, 3 printer's proofs and 1 B.A.T.

Proofed by Ken Farley

Printed by Ken Farley and John Hutcheson at the Petersburg Studios,
 New York

Published by Petersburg Press, 1979

Plate: 762 x 1015 mm. (30 x 40 in.)

Sheet: 755 x 1000 mm. (29³⁄₄ x 39³⁄₈ in.)

Note: Printed from the same copper plate as *Early Evening in the Museum
 of Modern Art*. At an earlier stage this print was called *Inside the Museum
 of Modern Art*.

Literature

Jacqueline Brody, 'Howard Hodgkin, *Alone in the Museum of Modern Art*
 and *Not Quite Alone in the Museum of Modern Art* (1979)', *The Print Collector's
 Newsletter*, vol. 10, no. 3, July–August 1979, p. 93; Pat Gilmour, 'Howard
 Hodgkin', *The Print Collector's Newsletter*, vol. 12, no. 1, March–April 1981,
 p. 4 (ill.); *Prints by Six British Painters: Stephen Buckley, Robyn Denny, Howard
 Hodgkin, John Hoyland, Richard Smith, John Walker*, Tate Gallery, London,
 1981–82 (n.p.); *The Tate Gallery: Illustrated Catalogue of Acquisitions 1980–82*,
 London, 1984, p. 261; Mary Rose Beaumont, 'Howard Hodgkin at the
 Whitechapel Art Gallery, the Tate Gallery and Bernard Jacobson', *Arts
 Review*, vol. 37, no. 20, 11 October 1985, p. 515; Jeremy Lewison, 'Howard
 Hodgkin', *Carte d'Arte*, 1986, p. 23 (ill., p. 19); Åsmund Thorkildsen, 'Howard
 Hodgkin på Høvikodden', *Drammens Tidende og Buskeruds Blad*, 12 February
 1987; Lenore Miller, *Howard Hodgkin Prints: Vision and Collaboration*, Dimock
 Gallery, George Washington University, Washington, D.C., 1994 (n.p.).

Public collections

National Gallery of Australia, Canberra (complete set); Tate Gallery, London
 (complete set).

Colour reproduction on p. 68.

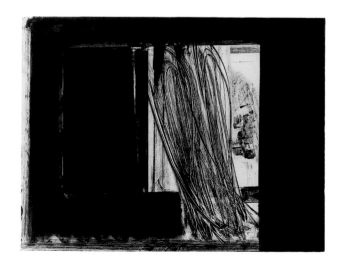

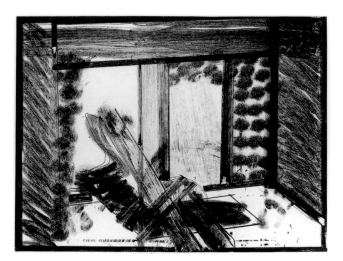

51 Early Evening in the Museum of Modern Art,
from 'In the Museum of Modern Art'
1979

Soft-ground etching from one copper plate printed in black, with hand
colouring in black gouache
On grey BFK Rives mould-made paper
Signed, numbered and dated '79 in red crayon, lower centre
Edition of 100, with 20 artist's proofs, 3 printer's proofs and 1 B.A.T.
Proofed by Ken Farley
Printed and hand coloured by Ken Farley and John Hutcheson
at the Petersburg Studios, New York
Published by Petersburg Press, 1979
Plate: 762 x 1015 mm. (30 x 40 in.)
Sheet: 745 x 985 mm. (29¼ x 38¾ in.)

Note: Printed from the same copper plate as *Late Afternoon in the Museum
of Modern Art*. At an earlier stage this print was called *Shadows in the
Museum of Modern Art*.

Literature

Jacqueline Brody, 'Howard Hodgkin, *Alone in the Museum of Modern Art*
and *Not Quite Alone in the Museum of Modern Art* (1979)', *The Print Collector's
Newsletter*, vol. 10, no. 3, July–August 1979, p. 93; Pat Gilmour, 'Howard
Hodgkin', *The Print Collector's Newsletter*, vol. 12, no. 1, March–April 1981,
p. 4. (ill.); *Prints by Six British Painters: Stephen Buckley, Robyn Denny, Howard
Hodgkin, John Hoyland, Richard Smith, John Walker*, Tate Gallery, London,
1981–82 (n.p.); *The Tate Gallery: Illustrated Catalogue of Acquisitions 1980–82*,
London, 1984, p. 261; Mary Rose Beaumont, 'Howard Hodgkin at the
Whitechapel Art Gallery, the Tate Gallery and Bernard Jacobson', *Arts
Review*, vol. 37, no. 20, 11 October 1985, p. 515; Jeremy Lewison, 'Howard
Hodgkin', *Carte d'Arte*, 1986, p. 23; Åsmund Thorkildsen, 'Howard Hodgkin
på Høvikodden', *Drammens Tidende og Buskeruds Blad*, 12 February 1987;
Gertrud Købke Sutton, 'Engelsk intimitet', *Information*, 15 April 1987 (ill.);
Lenore Miller, *Howard Hodgkin Prints: Vision and Collaboration*, Dimock Gallery,
George Washington University, Washington, D.C., 1994 (n.p.); Jennifer
Mundy (ed.), *Brancusi to Beuys: Works from the Ted Power Collection*, Tate Gallery,
London, 1996–97, p. 62 (ill.).

Public collections

National Gallery of Australia, Canberra (complete set); Tate Gallery, London
(complete set).

52 Thinking Aloud in the Museum of Modern Art,
from 'In the Museum of Modern Art'
1979

Soft-ground etching from one copper plate printed in black
On yellowish grey Hodgkinson hand-made paper
Signed, numbered and dated '79 in red crayon, lower centre
Edition of 100, with 20 artist's proofs, 3 printer's proofs and 1 B.A.T.
Proofed by Ken Farley
Printed by Ken Farley and John Hutcheson at the Petersburg Studios,
New York
Published by Petersburg Press, 1979
Plate: 762 x 1015 mm. (30 x 40 in.)
Sheet: 780 x 1030 mm. (30⅝ x 40½ in.)

Note: Printed from the same copper plate as *All Alone in the Museum of Modern
Art*. At an earlier stage this print was called *Not Quite Alone in the Museum
of Modern Art*.

Literature

Jacqueline Brody, 'Howard Hodgkin, *Alone in the Museum of Modern Art*
and *Not Quite Alone in the Museum of Modern Art* (1979)', *The Print Collector's
Newsletter*, vol. 10, no. 3, July–August 1979, p. 93; Pat Gilmour, 'Howard
Hodgkin', *The Print Collector's Newsletter*, vol. 12, no. 1, March–April 1981,
p. 4 (ill.); *Prints by Six British Painters: Stephen Buckley, Robyn Denny, Howard
Hodgkin, John Hoyland, Richard Smith, John Walker*, Tate Gallery, London,
1981–82 (n.p.); *The Tate Gallery: Illustrated Catalogue of Acquisitions 1980–82*,
London, 1984, p. 261; Mary Rose Beaumont, 'Howard Hodgkin at the
Whitechapel Art Gallery, the Tate Gallery and Bernard Jacobson', *Arts
Review*, vol. 37, no. 20, 11 October 1985, p. 515; Jeremy Lewison, 'Howard
Hodgkin', *Carte d'Arte*, 1986, p. 23; Åsmund Thorkildsen, 'Howard Hodgkin
på Høvikodden', *Drammens Tidende og Buskeruds Blad*, 12 February 1987;
Lenore Miller, *Howard Hodgkin Prints: Vision and Collaboration*, Dimock Gallery,
George Washington University, Washington, D.C., 1994 (n.p.) (ill.); Jennifer
Mundy (ed.), *Brancusi to Beuys: Works from the Ted Power Collection*, Tate Gallery,
London, 1996–97, p. 62 (ill.).

Public collections

Albright-Knox Art Gallery, Buffalo, New York; British Museum, London;
National Gallery of Art, Washington, D.C.; National Gallery of Australia,
Canberra (complete set); Tate Gallery, London (complete set); Victoria
and Albert Museum, London.

Colour reproduction on p. 69.

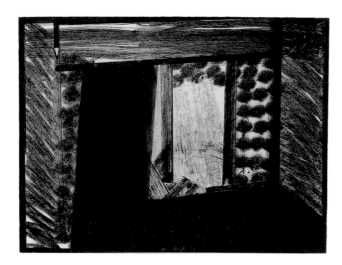

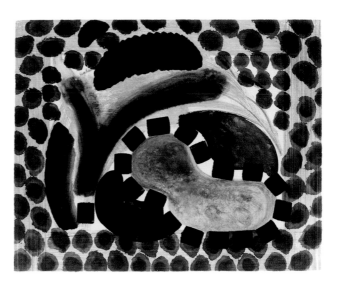

**53 All Alone in the Museum of Modern Art,
from 'In the Museum of Modern Art'**
1979

Soft-ground etching from one copper plate printed in black, with hand
colouring in black gouache
On grey BFK Rives mould-made paper
Signed, numbered and dated '79 in red crayon, lower centre
Edition of 100, with 20 artist's proofs, 3 printer's proofs and 1 B.A.T.
Proofed by Ken Farley
Printed and hand coloured by Ken Farley and John Hutcheson
at the Petersburg Studios, New York
Published by Petersburg Press, 1979
Plate: 762 x 1015 mm. (30 x 40 in.)
Sheet: 750 x 990 mm. (29¹/₂ x 39 in.)

Note: Printed from the same copper plate as *Thinking Aloud in the Museum
of Modern Art*. At an earlier stage this print was called *Alone in the Museum
of Modern Art*.

Literature

Jacqueline Brody, 'Howard Hodgkin, *Alone in the Museum of Modern Art*
and *Not Quite Alone in the Museum of Modern Art* (1979)', *The Print Collector's
Newsletter*, vol. 10, no. 3, July–August 1979, p. 93; Pat Gilmour, 'Howard
Hodgkin', *The Print Collector's Newsletter*, vol. 12, no. 1, March–April 1981,
p. 4 (ill.); *Prints by Six British Painters: Stephen Buckley, Robyn Denny, Howard
Hodgkin, John Hoyland, Richard Smith, John Walker*, Tate Gallery, London,
1981–82 (n.p.) (ill.); *The Tate Gallery: Illustrated Catalogue of Acquisitions 1980–82*,
London, 1984, p. 261 (ill., p. 260); Mary Rose Beaumont, 'Howard Hodgkin
at the Whitechapel Art Gallery, the Tate Gallery and Bernard Jacobson',
Arts Review, vol. 37, no. 20, 11 October 1985, p. 515; Jeremy Lewison, 'Howard
Hodgkin', *Carte d'Arte*, 1986, p. 23; Judith Dunham, 'Howard Hodgkin's
Accumulated Memories', *PrintNews*, vol. 8, no. 1, winter 1986 (ill., p. 5);
Åsmund Thorkildsen, 'En samtale med Howard Hodgkin', *Kunst og Kultur*,
no. 4, 1987, p. 222; Åsmund Thorkildsen, 'Howard Hodgkin på Høvikodden',
Drammens Tidende og Buskeruds Blad, 12 February 1987; Lenore Miller, *Howard
Hodgkin Prints: Vision and Collaboration*, Dimock Gallery, George Washington
University, Washington, D.C., 1994 (n.p.).

Public collections

British Museum, London; National Gallery of Australia, Canberra (complete
set); Tate Gallery, London (complete set).

54 David's Pool at Night
1979–85

Soft-ground etching and aquatint from one copper plate (drawn by the artist
in 1979) printed in black, with hand colouring in black ink
On white Hahnemühle mould-made paper
Signed with initials and dated 85 in pencil, lower centre
Numbered in pencil, lower left
Edition of 100, with 20 artist's proofs, 3 printer's proofs, 1 trial proof
and 1 B.A.T.
Proofed by Aldo Crommelynck, 1979
Printed at the Atelier Crommelynck, Paris, 1985
Hand coloured by Cinda Sparling, New York, 1985
Published by Petersburg Press, 1985
Image and sheet: 640 x 790 mm. (25¹/₈ x 31 in.)

Note: Printed from the same plate as *David's Pool*. In the Tate Gallery
catalogue raisonné (1985) the print has been incorrectly entitled
'David's Pool Black'.

Literature

Jacqueline Brody, 'Howard Hodgkin, *David's Pool* and *David's Pool at Night*
(1985)', *The Print Collector's Newsletter*, vol. 17, no. 1, March–April 1986, p. 17;
Margaret Moorman, 'New Editions. Howard Hodgkin', *ARTnews*, vol. 85,
no. 8, October 1986, p. 105.

Public collections

The Art Institute of Chicago, Chicago; Cleveland Museum of Art, Cleveland,
Ohio; Whitworth Art Gallery, Manchester.

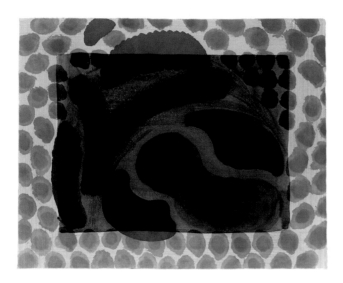

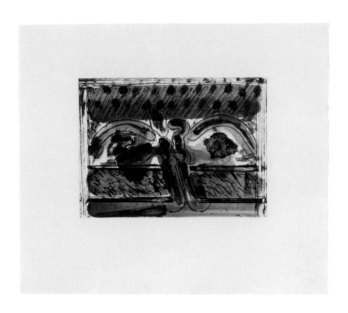

55 David's Pool
1979–85

Soft-ground etching and aquatint from one copper plate (drawn by the artist
in 1979) printed in green, with hand colouring in blue ink
On white Hahnemühle mould-made paper
Signed with initials, numbered and dated 85 in pencil, lower centre
Edition of 100, with 20 artist's proofs, 3 printer's proofs, 1 trial proof
and 2 B.A.T.s
Proofed by Aldo Crommelynck, 1979
Printed at the Atelier Crommelynck, Paris, 1985
Hand coloured by Cinda Sparling, New York, 1985
Published by Petersburg Press, 1985
Image and sheet: 640 x 790 mm. (25¹/₈ x 31 in.)

Note: Printed from the same plate as *David's Pool at Night*.
For this print, the artist was awarded the Henry Moore Foundation Prize
at the 9th British International Print Biennale in Bradford.
A unique version exists with hand colouring in red, green and blue ink.

Literature

W. Oliver, 'Cartwright Hall, Bradford: Ninth British International Print
Biennale', *The Yorkshire Post*, 22 March 1986; Jacqueline Brody, 'Howard
Hodgkin, *David's Pool* and *David's Pool at Night* (1985)', *The Print Collector's
Newsletter*, vol. 17, no. 1, March–April 1986, p. 17; 'Christie's Events:
Sponsorship', *Christie's International Magazine*, May–June 1986, p. 78
(ill. colour); Guy Burn, 'Odette Gilbert Gallery', *Arts Review*, vol. 38, no. 15,
1 August 1986, p. 419; Margaret Moorman, 'New Editions. Howard Hodgkin',
ARTnews, vol. 85, no. 8, October 1986, p. 105; Åsmund Thorkildsen,
'En samtale med Howard Hodgkin', *Kunst og Kultur*, no. 4, 1987, p. 222
(referred to as 'David's Pool in Hollywood'); Åsmund Thorkildsen,
'Howard Hodgkin på Høvikodden', *Drammens Tidende og Buskeruds Blad*,
12 February 1987; 'Emoções bem gravadas', *Isto E*, 22 July 1987 (ill.); Lora
Urbanelli, 'Howard Hodgkin', *Rhode Island School of Design*, vol. 74, no. 2,
October 1987 (ill., p. 43).

Public collections

Rhode Island School of Design, Providence, Rhode Island.

Colour reproduction on p. 83.

56 DH in Hollywood
1979–85

Soft-ground etching from one copper plate (drawn by the artist in 1979)
printed in black, with hand colouring in orange-red, brown and green
watercolour, and red and blue oil pastel
On off-white BFK mould-made paper
Signed with initials, numbered and dated 85 in pencil, lower centre
Edition of 100, with 20 artist's proofs, 3 printer's proofs, 2 trial proofs
and 1 B.A.T.
Proofed by Aldo Crommelynck, 1979
Printed at the Atelier Crommelynck, Paris, 1985
Hand coloured by Cinda Sparling, New York, 1985
Published by Petersburg Press, 1985
Image: 195 x 265 mm. (7⁵/₈ x 10³/₈ in.)
Sheet: 213 x 280 mm. (8¹/₈ x 11 in.)

Note: Based on *D.H. in Hollywood*, oil on wood, 1980–84.

Literature

Guy Burn, 'Odette Gilbert Gallery', *Arts Review*, vol. 38, no. 15, 1 August 1986,
p. 419.

Colour reproduction on p. 87.

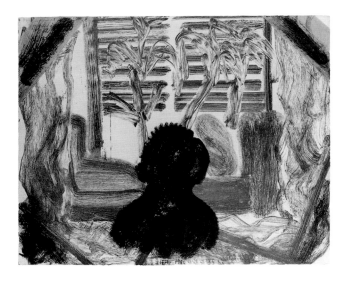

57 After Lunch
1980

Soft-ground etching and aquatint from one copper plate printed in black,
with hand colouring in black gouache
On buff Velin Arches mould-made paper
Signed with initials and dated 1980 in red crayon, lower centre
Numbered in red crayon, lower left
Edition of 100, with 20 artist's proofs, 4 printer's proofs, 2 trial proofs
and 1 B.A.T.
Proofed by Ken Farley
Printed and hand coloured by Ken Farley and John Hutcheson
at the Petersburg Studios, New York
Published by Petersburg Press, 1980
Plate: 585 x 790 mm. (23 x 31 in.)
Sheet: 565 x 760 mm. (22¼ x 29⅞ in.)

Public collections

The Art Institute of Chicago, Chicago; The British Council, London;
The Fogg Art Museum, Harvard University Art Museums, Cambridge,
Massachusetts; Museum of Modern Art, New York.

58 Those...Plants
1980

Soft-ground etching from three copper plates printed in sepia, with hand
colouring in watercolour (a yellow wash background) and green gouache
On Stoneridge mould-made etching paper
Signed with initials and dated 1980 in black wax crayon, lower centre
Numbered in black wax crayon, lower left
Edition of 100, with 20 artist's proofs, 4 printer's proofs, 1 trial proof
and 1 B.A.T.
Proofed by Ken Farley
Printed and hand coloured by Ken Farley and John Hutcheson
at the Petersburg Studios, New York
Published by Petersburg Press, 1980
Plate: 840 x 1055 mm. (33 x 41½ in.)
Sheet: 825 x 1040 mm. (32½ x 41 in.)

Note: The intended title for this print was 'Those Fucking Plants',
a quotation from a conversation.

Literature

The Tate Gallery: Illustrated Catalogue of Acquisitions 1980–82, London, 1984,
p. 261 (ill.); Elizabeth Knowles (ed.), *Howard Hodgkin: Prints 1977 to 1983*,
Tate Gallery, London, 1985, p. 16.

Public collections

Tate Gallery, London.

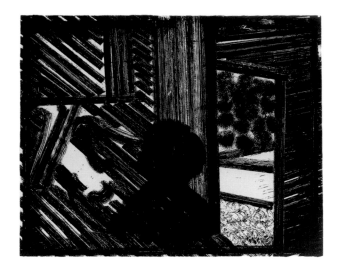

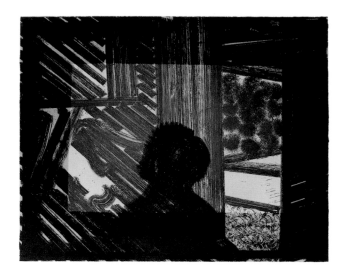

59 Artist and Model
1980

Soft-ground etching from two copper plates printed in black, with hand
colouring in watercolour (a yellow wash background)
On Stoneridge mould-made etching paper
Signed with initials and dated 1980 in brown wax crayon, lower centre
Numbered in brown wax crayon, lower left
Edition of 100, with 20 artist's proofs, 4 printer's proofs, 1 trial proof
and 1 B.A.T.
Proofed by Ken Farley
Printed and hand coloured by Ken Farley and John Hutcheson at the
Petersburg Studios, New York
Published by Petersburg Press, 1980
Plate: 840 x 1055 mm. (33 x 41½ in.)
Sheet: 825 x 1040 mm. (32½ x 41 in.)

Note: Printed from the same set of plates as *Artist and Model (in green and
yellow)*. A pre-edition proof was hand coloured by the artist in red and
brown oil crayon and pink and green gouache. A unique impression is
signed with initials and hand coloured by the artist with gouache and
oil crayon.

Literature

Bruce Chatwin (intro.), *Indian Leaves: Howard Hodgkin. With a Portrait of the Artist
by Bruce Chatwin*, London and New York, 1982, p. 17; *The Tate Gallery: Illustrated
Catalogue of Acquisitions 1980–82*, London, 1984, p. 261 (ill.); Ib Sinding,
'Ornamentale rum', *Jyllands Posten*, 15 April 1987 (ill.).

Public collections
Tate Gallery, London.

Colour reproduction on p. 86.

60 Artist and Model (in green and yellow)
1980

Soft-ground etching from two copper plates printed in sepia, with hand
colouring in watercolour (a yellow wash background) and green gouache
On Stoneridge mould-made etching paper
Signed with initials and dated 1980 in red crayon, lower centre
Numbered in red crayon, lower left
Edition of 100, with 20 artist's proofs, 4 printer's proofs, 1 trial proof
and 1 B.A.T.
Proofed by Ken Farley
Printed and hand coloured by Ken Farley and John Hutcheson at the
Petersburg Studios, New York
Published by Petersburg Press, 1980
Plate: 840 x 1055 mm. (33 x 41½ in.)
Sheet: 825 x 1040 mm. (32½ x 41 in.)

Note: Printed from the same set of plates as *Artist and Model*.

Literature

Bruce Chatwin (intro.), *Indian Leaves: Howard Hodgkin. With a Portrait
of the Artist by Bruce Chatwin*, London and New York, 1982, p. 17.

Public collections
Tate Gallery, London.

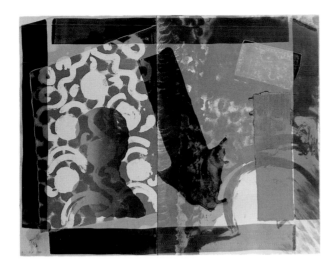

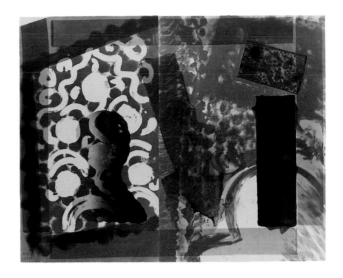

61 Moonlight
1980

Lithograph from four aluminium plates using tusche and washes, printed
 in transparent red, orange and a red to orange blend, with hand colouring
 in ivory black watercolour and blue and green gouache
On two sheets of buff BFK Rives mould-made paper (300 gsm)
Signed with initials and dated 1980 in pencil, in the lower left on the left-
 hand sheet
Numbered in pencil in the lower right on the left-hand sheet, verso
Numbered in pencil in the lower right on the right-hand sheet, verso
Edition of 100, with 13 artist's proofs, 2 printer's proofs, 2 Solo Press
 impressions, 1 trial proof and 1 B.A.T.
Proofed and printed by Judith Solodkin at Solo Press Inc., New York
Hand coloured by Cinda Sparling, New York
With the Solo Press blindstamp, lower right
Published by Bernard Jacobson Ltd, London, 1980
Overall image and sheet: 1118 x 1403 mm. (44 x 55¹/₄ in.)
Left sheet: 1118 x 641 mm. (44 x 25¹/₄ in.)
Right sheet: 1118 x 762 mm. (44 x 30 in.)

Note: Printed from the same set of plates as *Black Moonlight*.

Literature

Pat Gilmour, 'Howard Hodgkin', *The Print Collector's Newsletter*, vol. 12, no. 1,
 March–April 1981, p. 5 (ill., front cover); Deborah Phillips, 'New Editions:
 Howard Hodgkin', *ARTnews*, vol. 80, no. 7, September 1981, p. 161; *Prints by
 Six British Painters: Stephen Buckley, Robyn Denny, Howard Hodgkin, John Hoyland,
 Richard Smith, John Walker*, Tate Gallery, London, 1981–82 (n.p.); *The Tate
 Gallery: Illustrated Catalogue of Acquisitions 1980–82*, London, 1984, p. 262 (ill.);
 Elizabeth Knowles (ed.), *Howard Hodgkin: Prints 1977 to 1983*, Tate Gallery,
 London, 1985, p. 16; Mary Rose Beaumont, 'Howard Hodgkin at the
 Whitechapel Art Gallery, the Tate Gallery and Bernard Jacobson', *Arts
 Review*, vol. 37, no. 20, 11 October 1985, p. 515; Jeremy Lewison, 'Howard
 Hodgkin', *Carte d'Arte*, 1986, pp. 21–22; 'Cor britânica. Belas gravuras do
 inglês Howard Hodgkin', *Veja*, 22 July 1987, p. 117 (ill.); John Russell (intro.),
 *Howard Hodgkin. Graphic Work: Fourteen Hand-coloured Lithographs and Etchings
 1977–1987*, Lumley Cazalet, London, 1990 (n.p.); Robin Stemp, 'Howard
 Hodgkin: Ganz Gallery', *Arts Review*, vol. 42, 2 November 1990, p. 600
 (ill. colour); Lenore Miller, *Howard Hodgkin Prints: Vision and Collaboration*,
 Dimock Gallery, George Washington University, Washington, D.C., 1994 (n.p.).

Public collections

British Museum, London (maquette), National Gallery of Australia,
 Canberra; New Orleans Museum of Art, New Orleans; Tate Gallery, London.

Colour reproduction on p. 38.

62 Black Moonlight
1980

Lithograph from four aluminium plates using tusche and washes, printed
 in transparent blacks ranging from beige to black, with hand colouring
 in gouache and watercolour in three shades of black (jet, lamp and ivory)
On two sheets of buff BFK Rives mould-made paper (300 gsm)
Signed with initials and dated 1980 in pencil, lower left
Numbered in pencil, lower right
Edition of 50, with 17 artist's proofs, 2 printer's proofs, 2 Solo Press
 impressions, 3 trial proofs and 1 B.A.T.
Proofed and printed by Judith Solodkin at Solo Press Inc., New York
Hand coloured by Cinda Sparling, New York
With the Solo Press blindstamp, lower right
Published by Bernard Jacobson Ltd, London, 1980
Overall image and sheet: 1118 x 1403 mm. (44 x 55¹/₄ in.)
Left sheet: 1118 x 641 mm. (44 x 25¹/₄ in.)
Right sheet: 1118 x 762 mm. (44 x 30 in.)

Note: Printed from the same set of plates as *Moonlight*.

Literature

Pat Gilmour, 'Howard Hodgkin', *The Print Collector's Newsletter*, vol. 12, no. 1,
 March–April 1981, p. 5; *The Tate Gallery: Illustrated Catalogue of Acquisitions
 1980–82*, London, 1984, p. 262; Elizabeth Knowles (ed.), *Howard Hodgkin:
 Prints 1977 to 1983*, Tate Gallery, London, 1985, p. 16; David Alston, *Under
 the Cover of Darkness: Night Prints* (organized by the Arts Council of Great
 Britain), City Art Gallery, Bristol (touring), 1986, p. 25, no. 4 (ill., p. 24);
 John Russell (intro.), *Howard Hodgkin. Graphic Work: Fourteen Hand-coloured
 Lithographs and Etchings 1977–1987*, Lumley Cazalet, London, 1990 (n.p.);
 Lenore Miller, *Howard Hodgkin Prints: Vision and Collaboration*, Dimock
 Gallery, George Washington University, Washington, D.C., 1994 (n.p.);
 David Sylvester, 'An Artist whose Métier is Black and White', *The Daily
 Telegraph*, 6 August 1994, p. 6; *Howard Hodgkin: Arbeiten auf Papier von 1971
 bis 1995*, Staatliches Museum für Naturkunde und Vorgeschichte,
 Oldenburg (touring), 1998, p. 86.

Public collections

National Gallery of Art, Washington, D.C.

Colour reproduction on p. 39.

63 Red Eye
1980–81

Lithograph from a stone using red cosmetic lipstick, printed in black,
 with hand colouring in raw Sienna and carthame red gouache
On buff Velin Arches mould-made paper (250 gsm)
Signed with initials and dated 81 in pencil, lower centre
Numbered in pencil, lower right, verso
Edition of 100, with 30 artist's proofs, 2 printer's proofs, 2 Solo Press
 impressions, 2 trial proofs and 1 B.A.T.
Proofed by Judith Solodkin
Printed by Arnold Brooks at Solo Press Inc., New York
Hand coloured by Cinda Sparling
With the Solo Press blindstamp, lower right
Published by Bernard Jacobson Ltd, London, 1981
Image and sheet: 262 x 312 mm. (10¹⁄₄ x 12¹⁄₄ in.)

Note: Trial proof 1 is printed in black only, and has been printed on
 white BFK Rives.

Literature

Jacqueline Brody, 'Howard Hodgkin, *Redeye* (1981)', *The Print Collector's
 Newsletter,* vol. 13, no. 3, July–August 1982, p. 98; *The Tate Gallery: Illustrated
 Catalogue of Acquisitions 1984–86*, London, 1988, p. 388 (ill.).

Public collections
Tate Gallery, London.

64 Souvenir
1981

Screenprint from five screens printed in five shades of black
On Arches Aquarelle mould-made paper
Signed with initials and dated 81 in pencil to the left of lower centre
Numbered in pencil, lower left
Edition of 100, with 20 artist's proofs, 3 printer's proofs and 1 B.A.T.
Proofed by Bruce Porter and Norman Lassiter
Printed by Norman Lassiter, New York
Published by Petersburg Press, 1981
Image and sheet: 1143 x 1397 mm. (45 x 55 in.)

Note: A unique, hand-coloured version exists which is signed with initials,
 dated 81 and inscribed AP9 in pencil, recto. On the reverse of the framed
 print the inscription reads 'Painted Souvenir oil paint on AP9 of 'Souvenir'
 1981 silk screen print on paper', signed Howard Hodgkin and dated 1988.
 It was hand coloured in burnt Sienna and viridian green oil paint. Its
 wooden frame is also painted in burnt Sienna.

Literature

Jacqueline Brody, 'Howard Hodgkin, *One Down, Two to Go* (1982)', *The Print
 Collector's Newsletter,* vol. 13, no. 1, March–April 1982, p. 22; *The Tate Gallery:
 Illustrated Catalogue of Acquisitions 1980–82*, London, 1984, p. 262 (ill.);
 Elizabeth Knowles (ed.), *Howard Hodgkin: Prints 1977 to 1983*, Tate Gallery,
 London, 1985, p. 12 (ill., cover); Jeremy Lewison, 'Howard Hodgkin', *Carte
 d'Arte*, 1986, p. 23 (ill., p. 20); Guy Burn, 'Odette Gilbert Gallery', *Arts Review*,
 vol. 38, no. 15, 1 August 1986, p. 419; Judith Dunham, 'Howard Hodgkin's
 Accumulated Memories', *PrintNews*, vol. 8, no. 1, winter 1986, p. 6 (ill.);
 Lenore Miller, *Howard Hodgkin Prints: Vision and Collaboration*, Dimock Gallery,
 George Washington University, Washington, D.C., 1994 (n.p.) (ill.).

Public collections
The British Council, London; Tate Gallery, London.

Colour reproduction on p. 72.

65 One Down
1981–82

Lithograph from three aluminium plates printed in classic black,
transparent brown/black and violet black, with hand colouring
in gouache (three different greys)

On buff Velin Arches mould-made paper (300 gsm)

Signed with initials and dated 81 in pencil, lower centre

Numbered in pencil, lower left

Edition of 100, with 27 artist's proofs, 2 printer's proofs, 2 Solo Press
impressions, 1 trial proof and 1 B.A.T.

Proofed and printed by Judith Solodkin at Solo Press Inc., New York

Hand coloured by Cinda Sparling, New York

With the Solo Press blindstamp in the lower right and the printer's seal
in the lower left

Published by Bernard Jacobson Ltd, London, 1982

Image and sheet: 914 x 1220 mm. (36 x 48 in.)

Literature

Jacqueline Brody, 'Howard Hodgkin, *One Down, Two to Go* (1982)', *The Print
Collector's Newsletter*, vol. 13, no. 1, March–April 1982, p. 22; Mary Rose
Beaumont, 'Howard Hodgkin at the Whitechapel Art Gallery, the Tate
Gallery and Bernard Jacobson', *Arts Review*, vol. 37, no. 20, 11 October 1985,
p. 515; Jeremy Lewison, 'Howard Hodgkin', *Carte d'Arte*, 1986, pp. 21–22;
Howard Hodgkin: Arbeiten auf Papier von 1971 bis 1995, Staatliches Museum
für Naturkunde und Vorgeschichte, Oldenburg (touring), 1998, pp. 48,
86 (ill. colour, p. 49).

66 Two to Go
1981–82

Lithograph from three aluminium plates printed in classic black,
transparent grey and velvet black, with hand colouring in gouache
(four different greys)

On buff Velin Arches mould-made paper (300 gsm)

Signed with initials and dated 81 in pencil, lower centre

Numbered in pencil, lower left

Edition of 100, with 25 artist's proofs, 2 printer's proofs, 2 Solo Press
impressions and 1 B.A.T.

Proofed and printed by Judith Solodkin at Solo Press Inc., New York

Hand coloured by Cinda Sparling, New York

With the Solo Press blindstamp in the lower right and the printer's seal
in the lower left

Published by Bernard Jacobson Ltd, London, 1982

Image and sheet: 914 x 1220 mm. (36 x 48 in.)

Literature

Jacqueline Brody, 'Howard Hodgkin, *One Down, Two to Go* (1982)', *The Print
Collector's Newsletter*, vol. 13, no. 1, March–April 1982, p. 22; Mary Rose
Beaumont, 'Howard Hodgkin at the Whitechapel Art Gallery, the Tate
Gallery and Bernard Jacobson', *Arts Review*, vol. 37, no. 20, 11 October 1985,
p. 515; Jeremy Lewison, 'Howard Hodgkin', *Carte d'Arte*, 1986, pp. 21–22;
Åsmund Thorkildsen, 'Howard Hodgkin på Høvikodden', *Drammens Tidende
og Buskeruds Blad*, 12 February 1987 (ill.); Gertrud Købke Sutton, 'Engelsk
intimitet', *Information*, 15 April 1987 (ill.); 'Cor britânica. Belas gravuras
do inglês Howard Hodgkin', *Veja*, 22 July 1987, p. 117 (ill.); *Howard Hodgkin:
Arbeiten auf Papier von 1971 bis 1995*, Staatliches Museum für Naturkunde
und Vorgeschichte, Oldenburg (touring), 1998, p. 86.

Public collections

The British Council, London; University of Kentucky Art Museum,
Lexington, Kentucky.

Colour reproduction on p. 71.

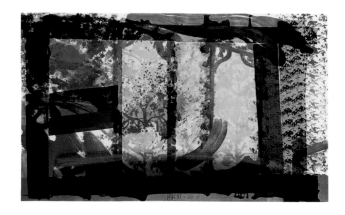

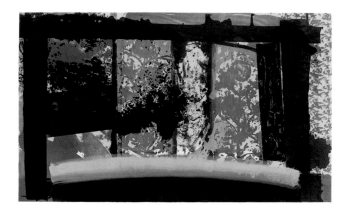

67 Bleeding
1981–82

Lithograph from three aluminium plates using tusche washes, printed
 in transparent dark green, light green and fire red, with hand colouring
 in gouache (an orange to red blend, pink, green and deep red)
On buff Velin Arches mould-made paper (300 gsm)
Signed with initials, numbered and dated 82 in pencil, lower centre
 (the artist's proofs are dated 81)
Edition of 100, with 33 artist's proofs, 2 printer's proofs, 2 Solo Press
 impressions, 5 black separation proofs and 1 B.A.T.
Proofed and printed by Judith Solodkin at Solo Press Inc., New York
Hand coloured by Cinda Sparling, New York
With the Solo Press blindstamp in the lower right and the printer's seal
 in the lower left
Published by Bernard Jacobson Ltd, London, 1982
Image and sheet: 914 x 1517 mm. (36 x 59⅝ in.)

Note: Printed from the same set of plates as *Mourning*.

Literature

Frances Spalding, 'Howard Hodgkin: Tate Gallery and Bernard Jacobson',
 Arts Review, vol. 34, no. 20, 24 September 1982, p. 484; Elizabeth Knowles
 (ed.), *Howard Hodgkin: Prints 1977 to 1983*, Tate Gallery, London, 1985, p. 16;
 Jeremy Lewison, 'Howard Hodgkin', *Carte d'Arte*, 1986, pp. 21–22 (ill., p. 23);
 Elizabeth Miller, *Hand-coloured British Prints*, Victoria and Albert Museum,
 London, 1987, p. 48 (ill. colour); *The Tate Gallery: Illustrated Catalogue of
 Acquisitions 1984–86*, London, 1988, p. 389; Lenore Miller, *Howard Hodgkin Prints:
 Vision and Collaboration*, Dimock Gallery, George Washington University,
 Washington, D.C., 1994 (n.p.) (ill. colour, front cover); Friedhelm Hütte
 and Alistair Hicks, *Contemporary Art at Deutsche Bank London*, Frankfurt
 am Main, 1996, pp. 50, 145 (ill. colour, p. 56).

Public collections

Albright-Knox Art Gallery, Buffalo, New York; Victoria and Albert Museum,
 London.

Colour reproduction on p. 42.

68 Mourning
1982

Lithograph from three aluminium plates using tusche washes, printed
 in grey, black and violet (mixed), with hand colouring in gouache (grey
 wash background, grey and grey to jet black blend, jet black) and ivory
 black watercolour
On buff Velin Arches mould-made paper (300 gsm)
Signed with initials and dated 82 in pencil, lower centre
Numbered in pencil, lower left
Edition of 50, with 15 artist's proofs, 2 printer's proofs, 2 Solo Press
 impressions and 1 B.A.T.
Proofed by Judith Solodkin
Printed by Judith Solodkin assisted by Arnold Brooks at Solo Press Inc.,
 New York
Hand coloured by Cinda Sparling, New York
With the Solo Press blindstamp, lower right
Published by Bernard Jacobson Ltd, London, 1982
Image and sheet: 920 x 1524 mm. (36¼ x 60 in.)

Note: Printed from the same set of plates as *Bleeding*.

Literature

Frances Spalding, 'Howard Hodgkin: Tate Gallery and Bernard Jacobson',
 Arts Review, vol. 34, no. 20, 24 September 1982, p. 484 (ill.); Guy Burn, 'Artists'
 New Prints: Bernard Jacobson', *Arts Review*, vol. 34, no. 26, 17–31 December
 1982, p. 677; Elizabeth Knowles (ed.), *Howard Hodgkin: Prints 1977 to 1983*, Tate
 Gallery, London, 1985, p. 16; *The Tate Gallery: Illustrated Catalogue of Acquisitions
 1984–86*, London, 1988, pp. 388–89 (ill.); Lenore Miller, *Howard Hodgkin Prints:
 Vision and Collaboration*, Dimock Gallery, George Washington University,
 Washington, D.C., 1994 (n.p.) (ill.).

Public collections

Tate Gallery, London.

Colour reproduction on p. 43.

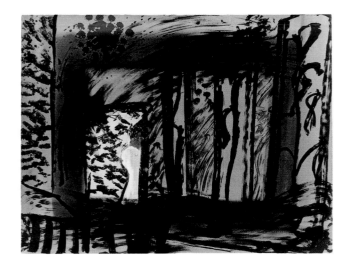

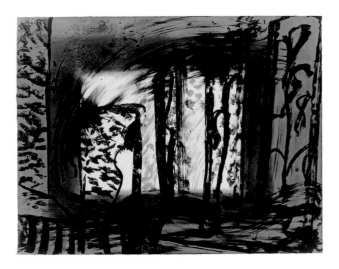

69 Blood

1982–85

Lithograph from three aluminium plates printed in three shades of
 black, with hand colouring in watercolour (black wash border, pink
 wash ground) and gouache (a red wash ground, and yellow and crimson)
On buff Velin Arches mould-made paper (270 gsm)
Signed with initials, numbered and dated 83 in pencil, lower centre
Edition of 50, with 16 artist's proofs, 2 printer's proofs, 2 trial proofs
 and 1 B.A.T.
Proofed by Perry Tymeson
Printed by Perry Tymeson with the assistance of Elizabeth Mahoney
 at the Petersburg Studios, New York, 1983
Hand coloured by Cinda Sparling, New York, 1985
Published by Petersburg Press, 1985
Image and sheet: 790 x 1018 mm. (31 x 40 in.)

Note: Printed from the same set of plates as *Sand*.

Literature

Elizabeth Knowles (ed.), *Howard Hodgkin: Prints 1977 to 1983*, Tate Gallery,
 London, 1985, p. 14; Jacqueline Brody, 'Howard Hodgkin, *Blood* and *Sand*
 (1982–85)', *The Print Collector's Newsletter*, vol. 16, no. 3, July–August 1985,
 p. 100; Jeremy Lewison, 'Howard Hodgkin', *Carte d'Arte*, 1986, pp. 21, 23;
 Richard Huntington, 'The Illusion is Enticing in Hodgkin's Prints', *Buffalo
 News*, 4 January 1986; Judith Dunham, 'Howard Hodgkin's Accumulated
 Memories', *PrintNews*, vol. 8, no. 1, winter 1986, p. 6; 'Emoções bem
 gravadas', *Isto E*, 22 July 1987 (ill.).

Public collections

The Government Art Collection, London.

Colour reproduction on p. 85.

70 Sand

1982–85

Lithograph from three aluminium plates printed in black and autumn
 brown, with hand colouring in watercolour (two black wash borders)
On buff Velin Arches mould-made paper (270 gsm)
Signed with initials, numbered and dated 83 in pencil, lower centre
Edition of 50, with 16 artist's proofs, 2 printer's proofs, 1 working proof
 and 1 B.A.T.
Proofed by Perry Tymeson
Printed by Perry Tymeson with the assistance of Elizabeth Mahoney
 at the Petersburg Studios, New York, 1983
Hand coloured by Cinda Sparling, New York, 1985
Published by Petersburg Press, 1985
Image and sheet: 790 x 1018 mm. (31 x 40 in.)

Note: Printed from the same set of plates as *Blood*.

Literature

Elizabeth Knowles (ed.), *Howard Hodgkin: Prints 1977 to 1983*, Tate Gallery,
 London, 1985, p. 16; Jacqueline Brody, 'Howard Hodgkin, *Blood* and *Sand*
 (1982–85)', *The Print Collector's Newsletter*, vol. 16, no. 3, July–August 1985,
 p. 100; Richard Huntington, 'The Illusion is Enticing in Hodgkin's Prints',
 Buffalo News, 4 January 1986; Lenore Miller, *Howard Hodgkin Prints: Vision and
 Collaboration*, Dimock Gallery, George Washington University, Washington,
 D.C., 1994 (n.p.) (ill. colour).

Public collections

The Government Art Collection, London.

Colour reproduction on p. 85.

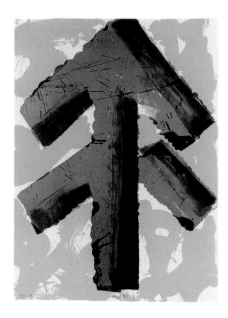

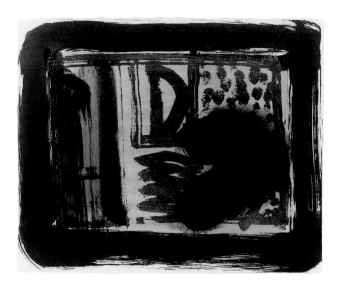

71 Welcome, from 'Art and Sport' (also called Winter Sports)
 1983

Lithograph from three aluminium plates printed in red, green and black
On unsized BFK Rives paper (250 gsm)
Signed with initials and dated 83 in pencil, lower centre
Numbered in pencil, lower left (1–50 in Roman numerals and 1–150
 in Arabic numerals)
Edition of 200, with 45 artist's proofs, 2 printer's proofs and 1 B.A.T.
Proofed and printed by Perry Tymeson at the Petersburg Studios,
 New York, 1983
Published by Visconti Art, Vienna, and Lazo Vuji'c, 1984
Produced for the XIV Olympic Winter Games in Sarajevo, Yugoslavia, 1984
Image and sheet: 850 x 620 mm. (33^1/$_2$ x 24^3/$_8$ in.)

Note: The official art portfolio 'Art and Sport' for the XIV Sarajevo Olympic
 Winter Games further comprises the following prints, all of which date
 from 1983 (except for one by Henry Moore which dates from 1982), and
 all of which were numbered and signed by the artists:

Ski-tracks, lithograph by Piero Dorazio; *The Jump*, etching by Jean-Michel
 Folon; *Peace*, etching by Emilio Greco; *The Winner*, lithograph by Gottfried
 Helnwein; *The Mountain*, etching and aquatint by D'zevad Hozo; *The Tortoise
 and the Hare*, mezzotint by Kyu-Baik Hwang; *Skis*, lithograph by Jiri Kolár;
 Reclining Mother and Child with blue background, lithograph by Henry Moore,
 1982; *Reclining Mother and Child with grey background*, lithograph by Henry
 Moore; *Six Heads Olympians*, lithograph by Henry Moore (also titled 'The
 Olympians'); *Bob*, lithograph by Mimmo Paladino; *The Celebration*, screenprint
 by Michelangelo Pistoletto; *Snowflake*, lithograph by James Rosenquist;
 Sarajevo, etching by Giuseppe Santomaso; *Victory*, etching and mezzotint
 by Gabrijel Stüpica; *Graffiti*, etching and aquatint by Cy Twombly; *Speed Skater*,
 screenprint by Andy Warhol.

Each print was also produced as a limited edition poster of the same size, not
 numbered. Each carried an impression of the inscription 'Olympic Games
 Sarajevo 1984'.

Public collections
Museum of Modern Art, New York; Olympic Museum, Lausanne (entire
 portfolio).

72 Green Room
 1986

Lift-ground etching and aquatint from two copper plates printed in green
 and red, with hand colouring in veronese green and green egg tempera
On BFK Rives wove paper (240 gsm)
Signed with initials and dated 86 in pencil, lower centre
Numbered in pencil, lower left
Edition of 100, with 10 artist's proofs, 3 printer's proofs, 1 trial proof
 and 1 B.A.T.
Printed and hand coloured by Jack Shirreff at the 107 Workshop, Wiltshire
Published by Bernard Jacobson Ltd, London, 1986
Plate: 610 x 760 mm. (24 x 29^7/$_8$ in.)
Sheet: 512 x 618 mm. (20^1/$_8$ x 24^3/$_8$ in.)

Note: One trial proof is inscribed in pencil in the lower centre 'HH 86 1st TP
 Listening Ear Green Room A love H'. One artist's proof, inscribed in pencil
 in the lower centre 'AP HH 86' contains hand colouring in red egg tempera
 in the upper centre.

Colour reproduction on p. 109.

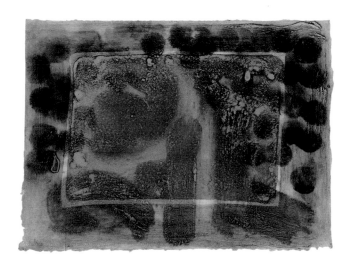

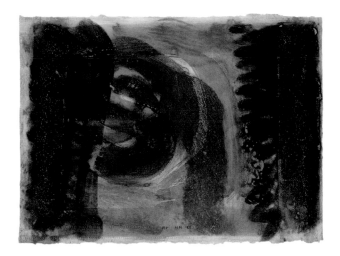

73 Blue Listening Ear
1986

Lift-ground etching and aquatint with carborundum from three aluminium
plates printed in different tones of red, warm black and cool black, with
hand colouring in cobalt blue egg tempera

On TH Saunders NOT paper (240 gsm)

Signed with initials and dated 86 in pencil, lower centre

Numbered in pencil, lower left

Edition of 100, with 10 artist's proofs, 3 printer's proofs and 1 B.A.T.

Printed and hand coloured by Jack Shirreff at the 107 Workshop, Wiltshire

Published by Bernard Jacobson Ltd, London, 1986

Plate: 610 x 760 mm. (24 x 29$^{7}/_{8}$ in.)

Sheet: 475 x 644 mm. (18$^{5}/_{8}$ x 25$^{1}/_{4}$ in.)

Colour reproduction on p. 107.

74 Listening Ear (also called Red Listening Ear)
1986

Intaglio print with carborundum from three aluminium plates printed
in two shades of black and two shades of red ochre and chrome yellow
(mixed), with hand colouring in alizarin red egg tempera

On TH Saunders NOT paper (240 gsm)

Signed with initials and dated 86 in pencil, lower centre

Numbered in pencil, lower left

Edition of 100, with 9 artist's proofs, 3 printer's proofs and 1 B.A.T.

Printed and hand coloured by Jack Shirreff at the 107 Workshop, Wiltshire

Published by Bernard Jacobson Ltd, London, 1986

Plate: 610 x 760 mm. (24 x 29$^{7}/_{8}$ in.)

Sheet: 475 x 644 mm. (18$^{5}/_{8}$ x 25$^{1}/_{4}$ in.)

Colour reproduction on p. 106.

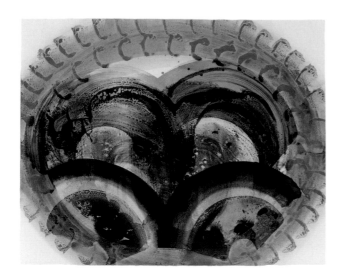

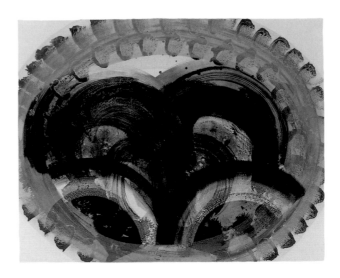

75 Red Palm

1986–87

Lithograph from three aluminium plates using lithographic tusche washes, printed in green, light blue and red-orange, with pochoir hand colouring in ultramarine blue, Naples yellow and emerald green gouache

On buff Arches cover paper (300 gsm)

Signed with initials, numbered and dated 86 in pencil, lower centre

Edition of 85, with 15 artist's proofs, 2 printer's proofs, 3 Solo Press impressions and 2 B.A.T.s

Proofed and printed by Judith Solodkin at Solo Press Inc., New York

Hand coloured by Cinda Sparling, New York

With the Solo Press blindstamp, lower right

Published by Waddington Graphics, London, 1987

Image and sheet: 1080 x 1350 mm. (42¹/₂ x 53¹/₄ in.)

Note: Printed from the same set of plates as *Black Palm*.

Literature

Jacqueline Brody, 'Howard Hodgkin, *Red Palm* (1986)', *The Print Collector's Newsletter*, vol. 18, no. 1, March–April 1987, p. 21; Antony Peattie (interview), *Howard Hodgkin: Hand-coloured Prints 1986–1991*, Waddington Graphics, London, 1991, pp. 27–29, 37 (ill. colour, p. 29); Rosemary Simmons, 'Howard Hodgkin: New Hand-coloured Prints', *Printmaking Today*, no. 2, spring 1991, p. 7; *Howard Hodgkin: Arbeiten auf Papier von 1971 bis 1995*, Staatliches Museum für Naturkunde und Vorgeschichte, Oldenburg (touring), 1998, pp. 15, 54 (ill. colour, p. 55).

Public collections

National Gallery of Australia, Canberra.

Colour reproduction on p. 92.

76 Black Palm

1986–87

Lithograph from three aluminium plates printed in three densities of black with pochoir hand colouring in lamp black, light grey and medium grey gouache

On buff Arches cover paper (300 gsm)

Signed with initials and numbered in pencil, lower centre

Not dated

Edition of 40, with 11 artist's proofs, 2 printer's proofs, 2 Solo Press impressions and 2 B.A.T.s

Proofed and printed by Judith Solodkin at Solo Press Inc., New York

Hand coloured by Cinda Sparling, New York

With the Solo Press blindstamp, lower right

Published by Waddington Graphics, London, 1987

Image and sheet: 1080 x 1350 mm. (42¹/₂ x 53¹/₄ in.)

Note: Printed from the same set of plates as *Red Palm*. At an earlier stage this print was called 'Red Palm (State)'.

Literature

Jacqueline Brody, 'Howard Hodgkin, *Red Palm* (1986)', *The Print Collector's Newsletter*, vol. 18, no. 1, March–April 1987, p. 21; Antony Peattie (interview), *Howard Hodgkin: Hand-coloured Prints 1986–1991*, Waddington Graphics, London, 1991, pp. 27, 30–31, 37 (ill. colour, p. 31); *Howard Hodgkin: Arbeiten auf Papier von 1971 bis 1995*, Staatliches Museum für Naturkunde und Vorgeschichte, Oldenburg (touring), 1998, pp. 15, 56 (ill. colour, p. 57).

Colour reproduction on p. 93.

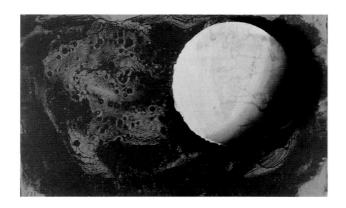

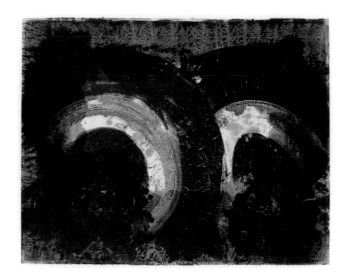

77 Moon
1987

Lithograph from one aluminium plate using a graphite wash, printed in
 blue, with pochoir hand colouring in scarlet lake red and white gouache
On PH-neutral Chiffon buff archival paper (250 gsm)
Signed with initials and dated 87 in pencil, lower centre
Numbered in pencil, lower left
Edition of 35, with 12 artist's proofs, 2 printer's proofs, 2 Solo Press
 impressions, 2 trial proofs and 1 B.A.T.
Proofed and printed by Judith Solodkin at Solo Press Inc., New York
Hand coloured by Cinda Sparling, New York
With the Solo Press blindstamp, lower right
Published by The Friends of the Philadelphia Museum of Art, Philadelphia,
 1988
Image and sheet: 307 x 508 mm. (12 x 20 in.)

Public collections
Philadelphia Museum of Art, Philadelphia.

78 Black Monsoon
1987–88

Lithograph from three aluminium plates printed in three shades of black
 with pochoir hand colouring in light grey, dark grey and transparent
 lamp black gouache
On white Arches cover paper (300 gsm)
Signed with initials, numbered and dated 87 or 88 in pencil, lower centre
Edition of 40, with 11 artist's proofs, 2 printer's proofs, 2 Solo Press
 impressions, 6 trial proofs and 1 B.A.T.
Proofed by Judith Solodkin
Printed by Arnold Brooks at Solo Press Inc., New York
Hand coloured by Cinda Sparling, New York
With the Solo Press blindstamp, lower right
Published by Waddington Graphics, London, 1988
Image and sheet: 1080 x 1350 mm. (42$^{1}/_{2}$ x 53$^{1}/_{4}$ in.)

Note: Printed from the same set of plates as *Monsoon*.

Literature
Antony Peattie (interview), *Howard Hodgkin: Hand-coloured Prints 1986–1991*,
 Waddington Graphics, London, 1991, pp. 27, 34–35, 37 (ill. colour, p. 35);
 Rosemary Simmons, 'Howard Hodgkin: New Hand-coloured Prints',
 Printmaking Today, no. 2, spring 1991, p. 8; Susan Tallman, *The Contemporary
 Print from Pre-Pop to Postmodern*, London, 1996, p. 144 (ill. colour, plate 223,
 p. 174); *Howard Hodgkin: Arbeiten auf Papier von 1971 bis 1995*, Staatliches
 Museum für Naturkunde und Vorgeschichte, Oldenburg (touring), 1998,
 pp. 15, 58, 86 (ill. colour, p. 59).

Public collections
The Fitzwilliam Museum, Cambridge.

Colour reproduction on p. 94.

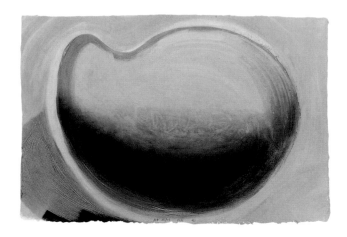

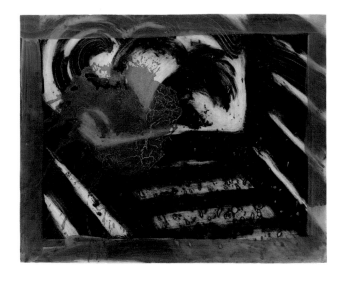

83 Mango

1990–91

Intaglio print with carborundum from one aluminium plate printed
in viridian green and apricot yellow, with hand colouring in veronese
green egg tempera

On Du Chene hand-made paper (600 gsm)

Signed with initials, numbered and dated 91 in pencil, lower centre

Edition of 55, with 15 artist's proofs, 3 printer's proofs and 1 B.A.T.

Proofed by Jack Shirreff

Printed by Jack Shirreff with the assistance of Andrew Smith and Samuel
Lee at the 107 Workshop, Wiltshire

Hand coloured by Jack Shirreff

Published by Waddington Graphics, London, 1991

Plate: 900 x 1220 mm. (35$^1/_2$ x 48 in.)

Sheet: 760 x 1115 mm. (29$^7/_8$ x 43$^7/_8$ in.)

Literature

Antony Peattie (interview), *Howard Hodgkin: Hand-coloured Prints 1986–1991*,
Waddington Graphics, London, 1991, pp. 3–4, 7, 10–11, 25 (ill. colour, p. 11);
Rosemary Simmons, 'Howard Hodgkin: New Hand-coloured Prints',
Printmaking Today, no. 2, spring 1991 (ill., p. 7); *Howard Hodgkin: Arbeiten
auf Papier von 1971 bis 1995*, Staatliches Museum für Naturkunde und
Vorgeschichte, Oldenburg (touring), 1998, pp. 15, 70 (ill. colour, p. 71).

Public collections

The British Council, London.

Colour reproduction on p. 122.

84 In an Empty Room

1990–91

Intaglio print with carborundum from two aluminium plates printed
in black and three shades of red, with hand colouring in ivory black,
and cadmium yellow and green egg tempera (mixed)

On Velin Arches paper (300 gsm)

Signed with initials, numbered and dated 91 in pencil, lower centre

Edition of 55, with 15 artist's proofs, 3 printer's proofs and 1 B.A.T.

Proofed by Jack Shirreff

Printed by Jack Shirreff with the assistance of Andrew Smith and Samuel
Lee at the 107 Workshop, Wiltshire

Hand coloured by Jack Shirreff

Published by Waddington Graphics, London, 1991

Plate: 1370 x 1600 mm. (53$^7/_8$ x 63 in.)

Sheet: 1205 x 1495 mm. (47$^3/_8$ x 58$^3/_4$ in.)

Literature

Antony Peattie (interview), *Howard Hodgkin: Hand-coloured Prints 1986–1991*,
Waddington Graphics, London, 1991, pp. 3, 7, 12–13, 25 (ill. colour, p. 13);
Rosemary Simmons, 'Howard Hodgkin: New Hand-coloured Prints',
Printmaking Today, no. 2, spring 1991, p. 7; Susan Tallman, *The Contemporary
Print from Pre-Pop to Postmodern*, London, 1996 (ill. colour, plate 224, p. 175);
Howard Hodgkin: Arbeiten auf Papier von 1971 bis 1995, Staatliches Museum für
Naturkunde und Vorgeschichte, Oldenburg (touring), 1998, pp. 15, 64, 88
(ill. colour, p. 65).

Public collections

The British Council, London; Tate Gallery, London.

Colour reproduction on p. 120.

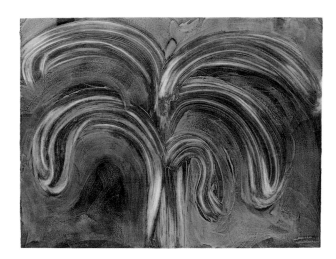

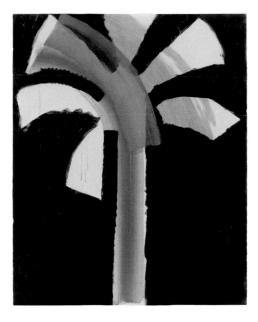

85 Indian Tree

1990–91

Intaglio print with carborundum from one aluminium plate printed in
 vermillion red and red ochre (mixed), with hand colouring in veronese
 green egg tempera

On Velin Arches paper (300 gsm)

Signed with initials, numbered and dated 91 in pencil, lower centre

Edition of 55, with 15 artist's proofs, 3 printer's proofs and 1 B.A.T.

Proofed by Jack Shirreff

Printed by Jack Shirreff with the assistance of Andrew Smith and Samuel
 Lee at the 107 Workshop, Wiltshire

Hand coloured by Jack Shirreff

Published by Waddington Graphics, London, 1991

Plate: 1070 x 1370 mm. (42 x 53⁷⁄₈ in.)

Sheet: 920 x 1213 mm. (36¹⁄₄ x 47⁵⁄₈ in.)

Literature

Antony Peattie (interview), *Howard Hodgkin: Hand-coloured Prints 1986–1991*,
 Waddington Graphics, London, 1991, pp. 3, 5, 7, 14–15, 25 (ill. colour, p. 15);
 Howard Hodgkin: Arbeiten auf Papier von 1971 bis 1995, Staatliches Museum für
 Naturkunde und Vorgeschichte, Oldenburg (touring), 1998, pp. 15, 72, 86
 (ill. colour, p. 73).

Public collections

The British Council, London; Tate Gallery, London.

Colour reproduction on p. 36.

86 Night Palm

1990–91

Intaglio print with carborundum from two aluminium plates printed in
 black and viridian green, with hand colouring in two shades of cadmium
 yellow and two shades of green egg tempera (mixed)

On Velin Arches paper (300 gsm)

Signed with initials, numbered and dated 91 in pencil, lower right

Edition of 55, with 15 artist's proofs, 3 printer's proofs and 1 B.A.T.

Proofed by Jack Shirreff

Printed by Jack Shirreff with the assistance of Andrew Smith and Samuel
 Lee at the 107 Workshop, Wiltshire

Hand coloured by Jack Shirreff

Published by Waddington Graphics, London, 1991

Plate: 1600 x 1370 mm. (63 x 53⁷⁄₈ in.)

Sheet: 1495 x 1205 mm. (58¹⁄₄ x 47³⁄₈ in.)

Literature

Antony Peattie (interview), *Howard Hodgkin: Hand-coloured Prints 1986–1991*,
 Waddington Graphics, London, 1991, pp. 7, 16–17, 25 (ill. colour, p. 17);
 Rosemary Simmons, 'Howard Hodgkin: New Hand-coloured Prints',
 Printmaking Today, no. 2, spring 1991, p. 7; *Howard Hodgkin: Arbeiten auf Papier
 von 1971 bis 1995*, Staatliches Museum für Naturkunde und Vorgeschichte,
 Oldenburg (touring), 1998, pp. 15, 74 (ill. colour, p. 75); Marco Livingstone
 (intro.), *Signature Pieces: Contemporary British Prints and Multiples*, Alan Cristea
 Gallery, London, 1999, p. 24 (ill. colour, p. 25).

Public collections

The British Council, London; The Government Art Collection, London;
 Tate Gallery, London.

Colour reproduction on p. 112.

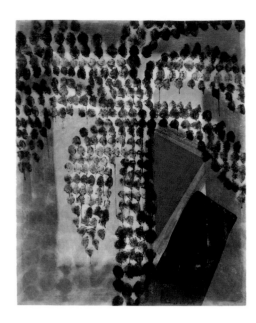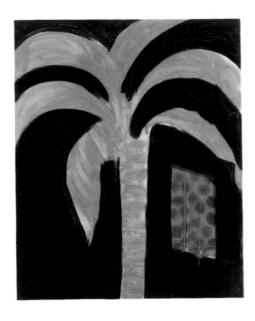

87 Street Palm

1990–91

Intaglio print with carborundum from three aluminium plates printed
in green, green and yellow (mixed), ultramarine blue and white (mixed),
with hand colouring in vermillion red egg tempera

On Velin Arches paper (300 gsm)

Signed with initials, numbered and dated 91 in pencil, lower right

Edition of 55, with 15 artist's proofs, 3 printer's proofs and 1 B.A.T.

Proofed by Jack Shirreff

Printed by Jack Shirreff with the assistance of Andrew Smith and Samuel
Lee at the 107 Workshop, Wiltshire

Hand coloured by Jack Shirreff

Published by Waddington Graphics, London, 1991

Plate: 1600 x 1370 mm. (63 x 53⁷/₈ in.)

Sheet: 1495 x 1215 mm. (58³/₄ x 47³/₄ in.)

Literature

Antony Peattie (interview), *Howard Hodgkin: Hand-coloured Prints 1986–1991*,
Waddington Graphics, London, 1991, pp. 7, 18–19, 25 (ill. colour, p. 19);
Rosemary Simmons, 'Howard Hodgkin: New Hand-coloured Prints',
Printmaking Today, no. 2, spring 1991, p. 7; Jacqueline Brody, 'Howard
Hodgkin, *Street Palm* (1990)', *The Print Collector's Newsletter*, vol. 24, no. 3,
July–August 1993, pp. 108–09; *Howard Hodgkin: Arbeiten auf Papier von 1971
bis 1995*, Staatliches Museum für Naturkunde und Vorgeschichte,
Oldenburg (touring), 1998, p. 62 (ill. colour, p. 63); Sabine Arlitt,
'Farb-Magier', *Tages-Anzeiger/Züri tip*, 16 October 1998, p. 61 (ill. colour).

Public collections

The British Council, London.

Colour reproduction on p. 113.

88 Palm and Window

1990–91

Intaglio print with carborundum from two aluminium plates printed in
green and black, with hand colouring in ultramarine blue egg tempera

On Velin Arches paper (300 gsm)

Signed with initials, numbered and dated 91 in pencil, lower centre

Edition of 55, with 15 artist's proofs, 4 printer's proofs and 1 B.A.T.

Proofed by Jack Shirreff

Printed by Jack Shirreff with the assistance of Andrew Smith and Samuel
Lee at the 107 Workshop, Wiltshire

Hand coloured by Jack Shirreff

Published by Waddington Graphics, London, 1991

Plate: 1600 x 1370 mm. (63 x 53⁷/₈ in.)

Sheet: 1495 x 1205 mm. (58³/₄ x 47³/₈ in.)

Literature

Antony Peattie (interview), *Howard Hodgkin: Hand-coloured Prints 1986–1991*,
Waddington Graphics, London, 1991, pp. 7, 20–21, 25 (ill. colour, p. 21);
Rosemary Simmons, 'Howard Hodgkin: New Hand-coloured Prints',
Printmaking Today, no. 2, spring 1991, p. 7 (ill. colour, front cover);
Howard Hodgkin: Arbeiten auf Papier von 1971 bis 1995, Staatliches Museum
für Naturkunde und Vorgeschichte, Oldenburg (touring), 1998, pp. 15,
66 (ill. colour, p. 67).

Public collections

The British Council, London; Tate Gallery, London.

Colour reproduction on p. 116.

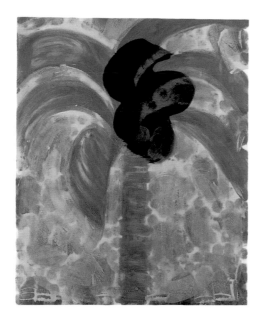

89 Flowering Palm
1990–91

Intaglio print with carborundum from three aluminium plates printed in
two shades of green and vermillion red, with hand colouring in cadmium
yellow and citron yellow egg tempera (mixed)
On Velin Arches paper (300 gsm)
Signed with initials, numbered and dated 91 in pencil, lower centre
Edition of 55, with 15 artist's proofs, 4 printer's proofs and 1 B.A.T.
Proofed by Jack Shirreff
Printed by Jack Shirreff with the assistance of Andrew Smith and Samuel
Lee at the 107 Workshop, Wiltshire
Hand coloured by Jack Shirreff
Published by Waddington Graphics, London, 1991
Plate: 1600 x 1370 mm. (63 x 53⁷/₈ in.)
Sheet: 1495 x 1205 mm. (58³/₄ x 47³/₈ in.)

Literature

Antony Peattie (interview), *Howard Hodgkin: Hand-coloured Prints 1986–1991*,
Waddington Graphics, London, 1991, pp. 7, 22–23, 25 (ill. colour, p. 23);
Rosemary Simmons, 'Howard Hodgkin: New Hand-coloured Prints',
Printmaking Today, no. 2, spring 1991, p. 7; *Howard Hodgkin: Arbeiten auf Papier
von 1971 bis 1995*, Staatliches Museum für Naturkunde und Vorgeschichte,
Oldenburg (touring), 1998, pp. 15, 68 (ill. colour, p. 69).

Public collections

The British Council, London.

Colour reproduction on p. 117.

90 Put Out More Flags
1992

Lift-ground etching and aquatint from one copper plate, with carborundum
from three aluminium plates, printed in black and three shades of green,
with hand colouring in cadmium orange, cobalt blue and cadmium yellow
egg tempera
On 100% cotton paper from Two Rivers paper mill, Watchet, Somerset
(400 gsm), hand made by Jim Patterson
Signed with initials and dated 92 in pencil, lower centre
Numbered in pencil, lower left
Edition of 75, with 25 artist's proofs, 5 printer's proofs and 1 B.A.T.
Proofed, printed and hand coloured by Jack Shirreff at the
107 Workshop, Wiltshire
Published by the Modern Art Museum of Fort Worth, Fort Worth, Texas, 1992
Plate: 510 x 660 mm. (20¹/₈ x 26 in.)
Sheet: 420 x 524 mm. (16¹/₂ x 20⁵/₈ in.)

Note: On its 100th anniversary in 1992, the Modern Art Museum of Fort
Worth commissioned prints from nineteen artists, including Howard
Hodgkin. All proceeds from the sale of the *Centennial Print Project* were
used to establish *The Artists' Fund*, a permanent endowment fund which
supports the exhibition program of the Modern Art Museum of Fort
Worth. This print is sometimes erroneously called 'Put More Flags
Out Now'.

Public collections

The Modern Art Museum of Fort Worth, Fort Worth, Texas.

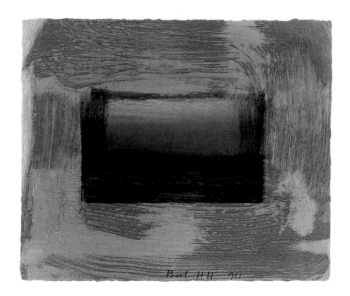

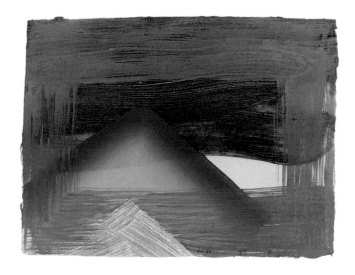

91 Red Print

1994

Intaglio print with carborundum from one aluminium plate printed
 in orange and green, with hand colouring in hélios red egg tempera

On BFK Rives (300 gsm)

Signed with initials, numbered and dated 94 in pencil, lower centre

Edition of 200, with 10 artist's proofs, 5 printer's proofs and 1 B.A.T.

Proofed, printed and hand coloured by Jack Shirreff at the
 107 Workshop, Wiltshire

Published by Thames & Hudson, London, 1994

Plate: 405 x 405 mm. (15$^7/_8$ x 15$^7/_8$ in.)

Sheet: 220 x 260 mm. (8$^5/_8$ x 10$^1/_4$ in.)

Note: The print was inserted in the *deluxe* edition of the monograph by
 Andrew Graham-Dixon, *Howard Hodgkin*, London (Thames & Hudson), 1994.

Colour reproduction on p. 22.

92 Snow

1995

Intaglio print with carborundum from two aluminium plates printed in
 orange and two shades of grey, with hand colouring in cadmium scarlet
 and cadmium yellow acrylic

On 100% cotton paper from Two Rivers paper mill, Watchet, Somerset
 (200 gsm), hand made by Jim Patterson

Signed with initials, numbered and dated 95 in pencil, lower centre

Edition of 80, with 10 artist's proofs, 3 printer's proofs and 1 B.A.T.

Proofed, printed and hand coloured by Jack Shirreff at the
 107 Workshop, Wiltshire

Published by the Metropolitan Museum of Art, New York, 1995

With the blindstamp of the Metropolitan Museum of Art – The Mezzanine
 Gallery, verso

Plate: 405 x 452 mm. (15$^7/_8$ x 17$^3/_4$ in.)

Sheet: 285 x 365 mm. (11$^1/_4$ x 14$^1/_4$ in.)

Literature

Jacqueline Brody, 'Howard Hodgkin, *Snow* (1995)', *The Print Collector's
 Newsletter*, vol. 27, no. 1, March–April 1996, pp. 27–28.

Public collections

The Metropolitan Museum of Art, New York.

Colour reproduction on p. 23.

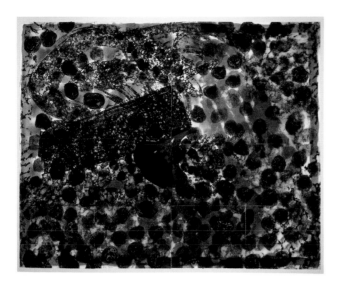

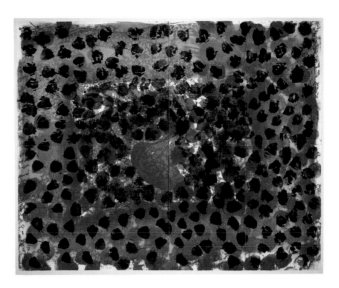

93 Venice, Morning, from 'Venetian Views'
1995

Lift-ground etching and aquatint from three copper plates, with carborundum
from two aluminium plates printed in: 1. ultramarine blue with black for
the borders; 2. viridian green with black for the borders; 3. black and red;
4. red ochre and citron yellow with a relief-roll of chrome yellow and white;
5. black in four tones using red and viridian green to adjust the blacks
With hand colouring in cadmium red, phthalo green-blue shade and carbon
black acrylic. The exterior border is hand coloured in phthalo green-green
shade acrylic
On 16 sheets of torn Velin Arches blanc (300 gsm)
Signed with initials, numbered and dated 1995 in pencil on the second sheet,
lower left
Edition of 60, with 14 artist's proofs, 3 printer's proofs and 1 B.A.T.
Proofed by Jack Shirreff
Printed by Jack Shirreff, assisted by Andrew Smith and David Sully
at the 107 Workshop, Wiltshire
Hand coloured by Jack Shirreff
Published by Alan Cristea Gallery, London, 1995
Each plate: 1070 x 1680 mm. (42 x 66 in.)
Overall sheet: 1600 x 1965 mm. (63 x 77⅛ in.)
Individual sheets: 400 x 490 mm. (15¾ x 19¼ in.)

Note: Printed from the same set of five plates as the other three
'Venetian Views'.

Literature

Craig Hartley (intro.), *Howard Hodgkin: Venetian Views* 1995, Alan Cristea Gallery,
London, 1995 (n.p.) (ill. colour); Iain Gale, 'In the Realm of the Senses',
The Independent, 28 November 1995, pp. 8–9; *Howard Hodgkin: Arbeiten auf Papier
von 1971 bis 1995*, Staatliches Museum für Naturkunde und Vorgeschichte,
Oldenburg (touring), 1998, pp. 15–16, 79–88 (ill. colour, p. 89).

Public collections

The Modern Art Museum of Fort Worth, Fort Worth, Texas (complete set);
Tate Gallery, London (complete set).

Colour reproduction on p. 14.

94 Venice, Afternoon, from 'Venetian Views'
1995

Lift-ground etching and aquatint from three copper plates, with carborundum
from two aluminium plates printed in: 1. red ochre and apricot yellow, with
borders in yellow and varying tones of these colours using a base medium;
2. red ochre and apricot yellow with various tones of these colours;
3. nasturtium orange and primavere yellow; 4. varying tones of red ochre
with a relief-roll of white; 5. red ochre, raw Sienna, nasturtium orange
and apricot yellow
With hand colouring in cadmium yellow acrylic for the borders, over
painted in selected areas with mars yellow acrylic. Dots are made
with phthalo blue-green acrylic, using a large amount of pigment
On 16 sheets of torn Velin Arches blanc (300 gsm)
Signed with initials, numbered and dated 1995 in pencil on the second
sheet, lower left
Edition of 60, with 14 artist's proofs, 3 printer's proofs and 1 B.A.T.
Proofed by Jack Shirreff
Printed by Jack Shirreff, assisted by Andrew Smith and David Sully
at the 107 Workshop, Wiltshire
Hand coloured by Jack Shirreff
Published by Alan Cristea Gallery, London, 1995
Each plate: 1070 x 1680 mm. (42 x 66 in.)
Overall sheet: 1600 x 1965 mm. (63 x 77⅛ in.)
Individual sheets: 400 x 490 mm. (15¾ x 19¼ in.)

Note: Printed from the same set of five plates as the other three
'Venetian Views'.

Literature

Craig Hartley (intro.), *Howard Hodgkin: Venetian Views* 1995, Alan Cristea Gallery,
London, 1995 (n.p.) (ill. colour); Iain Gale, 'In the Realm of the Senses',
The Independent, 28 November 1995, pp. 8–9; Andrew Patrick, *Artaid '98*,
Edinburgh City Art Centre, Edinburgh, 1998, p. 24 (ill. colour, cover and p. 24);
Howard Hodgkin: Arbeiten auf Papier von 1971 bis 1995, Staatliches Museum
für Naturkunde und Vorgeschichte, Oldenburg (touring), 1998, pp. 15–16,
79–88, 90 (ill. colour, p. 91).

Public collections

The Metropolitan Museum of Art, New York; The Modern Art Museum
of Fort Worth, Fort Worth, Texas (complete set); Tate Gallery, London
(complete set).

Colour reproduction on p. 15.

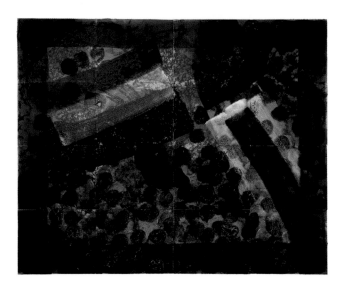

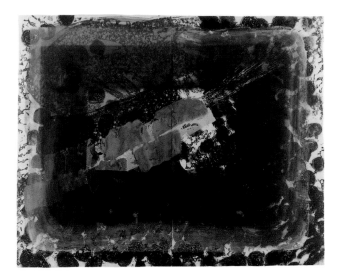

95 Venice, Evening, from 'Venetian Views'
1995

Lift-ground etching and aquatint from three copper plates with carborundum
from two aluminium plates printed in: 1. blue-black and black; 2. viridian
green and black and various tones of black; 3. black; 4. nasturtium orange,
primavere yellow and red ochre, with a relief-roll of white and citron
yellow; 5. two tones of black. Before printing all 16 sheets were hand
coloured in blue acrylic, after printing they were hand coloured in zinc
white acrylic and while still wet, carbon black acrylic was worked into
selected areas and used to create the border

On 16 sheets of torn Velin Arches blanc (300 gsm)

Signed with initials, numbered and dated 1995 in pencil on the second
sheet, lower left

Edition of 60, with 14 artist's proofs, 3 printer's proofs and 1 B.A.T.

Proofed by Jack Shirreff

Printed by Jack Shirreff, assisted by Andrew Smith and David Sully
at the 107 Workshop, Wiltshire

Hand coloured by Jack Shirreff

Published by Alan Cristea Gallery, London, 1995

Each plate: 1070 x 1680 mm. (42 x 66 in.)

Overall sheet: 1600 x 1965 mm. (63 x 77³/₈ in.)

Individual sheets: 400 x 490 mm. (15³/₄ x 19¹/₄ in.)

Note: Printed from the same set of five plates as the other three
'Venetian Views'.

Literature

Craig Hartley (intro.), *Howard Hodgkin: Venetian Views* 1995, Alan Cristea Gallery,
London, 1995 (n.p.) (ill. colour); Iain Gale, 'In the Realm of the Senses',
The Independent, 28 November 1995, pp. 8–9; Nan Rosenthal, 'Howard
Hodgkin. *Venice, Evening*', *The Metropolitan Museum of Art Bulletin*, vol. 54,
fall 1996, pp. 64–65 (ill. colour, p. 65); *Masterpieces of Modern Printmaking*, Alan
Cristea Gallery, London, 1997, pp. 30–31; *Howard Hodgkin: Arbeiten auf Papier
von 1971 bis 1995*, Staatliches Museum für Naturkunde und Vorgeschichte,
Oldenburg (touring), 1998, pp. 15–16, 79–88, 92 (ill. colour, p. 93).

Public collections

The Government Art Collection, London; The Metropolitan Museum of
Art, New York; The Modern Art Museum of Fort Worth, Fort Worth, Texas
(complete set); New Orleans Museum of Art, New Orleans; Tate Gallery,
London (complete set).

Colour reproduction on p. 18.

96 Venice, Night, from 'Venetian Views'
1995

Lift-ground etching and aquatint from three copper plates, with carborundum
from two aluminium plates printed in: 1. Prussian blue, two shades of red,
chrome yellow, with black for the borders; 2. violet, ultramarine blue and
green, with central image in various tones of black; 3. black; 4. black and
carmine red, with a relief-roll of whites; 5. two tones of black, with a relief-
roll in selected areas of white and raw umber

With hand colouring in zinc white acrylic on the central panel, carbon black
and titanium white and medium (mixed), borders painted in titanium
white and carbon black acrylic on the inside border

On two sheets of Velin Arches blanc (300 gsm)

Signed with initials, numbered and dated 1995 in pencil, lower centre
of the left sheet

Edition of 30, with 10 artist's proofs, 3 printer's proofs and 1 B.A.T.

Proofed by Jack Shirreff

Printed by Jack Shirreff, assisted by Andrew Smith and David Sully
at the 107 Workshop, Wiltshire

Hand coloured by Jack Shirreff

Published by Alan Cristea Gallery, London, 1995

Each plate: 1070 x 1680 mm. (42 x 66 in.)

Overall sheet: 1590 x 1950 mm. (62¹/₂ x 76³/₄ in.)

Individual sheets: 1590 x 975 mm. (62¹/₂ x 38³/₈ in.)

Note: Printed from the same set of five plates as the other three
'Venetian Views'.

Literature

Craig Hartley (intro.), *Howard Hodgkin: Venetian Views* 1995, Alan Cristea
Gallery, London, 1995 (n.p.) (ill. colour); Iain Gale, 'In the Realm of the
Senses', *The Independent*, 28 November 1995, pp. 8–9; *Howard Hodgkin:
Arbeiten auf Papier von 1971 bis 1995*, Staatliches Museum für Naturkunde
und Vorgeschichte, Oldenburg (touring), 1998, pp. 15–16, 79–88, 94
(ill. colour, p. 95).

Public collections

The Modern Art Museum of Fort Worth, Fort Worth, Texas (complete set);
Tate Gallery, London (complete set).

Colour reproduction on p. 19.

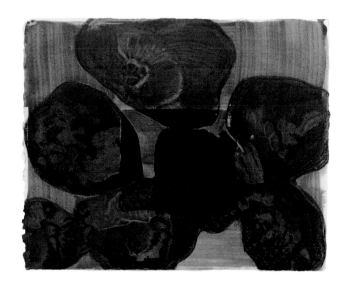

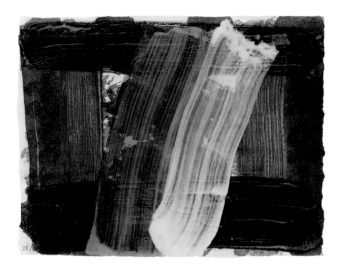

97 Window
1996

Intaglio print with carborundum from one aluminium plate printed in
 cobalt blue and green (mixed), two shades of green (mixed) and chrome
 yellow, with hand colouring in cadmium green and grey (bone black and
 zinc white, mixed) acrylic
On BFK Rives wove paper (240 gsm)
Signed with initials and dated 1996 in pencil, lower right
Numbered in pencil, lower left
Edition of 50, with 10 artist's proofs, 5 printer's proofs and 1 B.A.T.
Proofed, printed and hand coloured by Jack Shirreff at the 107 Workshop,
 Wiltshire
Published by the Kunstverein für die Rheinlande und Westfalen, Düsseldorf,
 1996
Plate: 305 x 410 mm. (12 x 16 in.)
Sheet: 235 x 280 mm. (9^1/$_4$ x 11 in.)

Note: A unique, specially hand-coloured version is inscribed in pencil, lower
 left, 'Raimund from Howard'. It is hand coloured in red-brown crayon and
 inscribed 'Autumn Window', verso. It was made for the exhibition at the
 Kunstverein für die Rheinlande und Westfalen, Düsseldorf, 1996.

Colour reproduction on p. 49.

98 Summer
1997

Lift-ground etching and aquatint from two copper plates, with carborundum
 from two aluminium plates printed in six shades of green, with hand
 colouring in cadmium orange and cadmium yellow acrylic
On 100% cotton paper from Two Rivers paper mill, Watchet, Somerset
 (300 gsm), hand made by Jim Patterson
Signed with initials and dated 97 in pencil, lower right
Numbered in pencil, lower left (1–80 in Arabic numerals and 81–100
 in Roman numerals)
Edition of 100, with 10 artist's proofs, 5 printer's proofs and 1 B.A.T.
Proofed by the artist and Jack Shirreff
Printed by Jack Shirreff, assisted by Andrew Smith and Claire Wait
 at the 107 Workshop, Wiltshire
Hand coloured by Jack Shirreff
Published by the Metropolitan Museum of Art, New York, 1997
With the blindstamp of the Metropolitan Museum of Art –
 The Mezzanine Gallery, verso
Plate: 405 x 507 mm. (15^7/$_8$ x 20 in.)
Sheet: 290 x 372 mm. (11^3/$_8$ x 14^5/$_8$ in.)

Literature
Alan Cristea (intro.), *Howard Hodgkin. Volume I: Small Prints*, Alan Cristea
 Gallery, London, 2001 (n.p.) (ill. colour).

Public collections
The Metropolitan Museum of Art, New York.

Colour reproduction on p. 6.

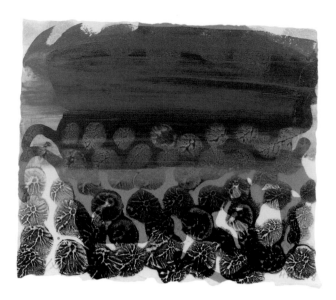

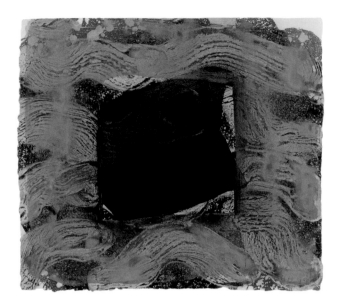

99 In a Public Garden
 1997–98

Lift-ground etching and aquatint from one copper plate, with
 carborundum from one aluminium plate, printed in red, ultramarine
 blue and titanium white, with hand colouring in green acrylic
On 100% cotton paper from Two Rivers paper mill, Watchet, Somerset
 (270 gsm), hand made by Jim Patterson
Signed with initials in pencil, and dated 97 or 98, lower right
Numbered in pencil, lower left (1–35 in Roman numerals and 1–35
 in Arabic numerals)
Edition of 70, with 20 artist's proofs, 5 printer's proofs and 1 B.A.T.
Proofed by the artist and Jack Shirreff
Printed by Jack Shirreff, assisted by Andrew Smith and Claire Wait
 at the 107 Workshop, Wiltshire
Hand coloured by Jack Shirreff
Published by the Kunstverein für die Rheinlande und Westfalen,
 Düsseldorf, 1998
Plate: 380 x 380 mm. (15 x 15 in.)
Sheet: 240 x 280 mm. (9¹/₂ x 11 in.)

Note: Some prints were signed up to 80.

Literature
Alan Cristea (intro.), *Howard Hodgkin. Volume I: Small Prints*, Alan Cristea
 Gallery, London, 2001 (n.p.) (ill. colour).

Colour reproduction on p. 47.

100 Books for the Paris Review
 1997–99

Lift-ground etching and aquatint from three copper plates, with
 carborundum from one aluminium plate, printed in three shades
 of grey and two shades of black, with hand colouring in ultramarine
 blue, green and cadmium red acrylic
On 100% cotton paper from Two Rivers paper mill, Watchet, Somerset
 (350 gsm), hand made by Jim Patterson
Signed with initials and dated 97, 98 or 99 in pencil, lower right
Numbered in pencil, lower left (1–20 numbered in Roman numerals
 and 1–80 numbered in Arabic numerals)
Edition of 100, with 20 artist's proofs, 5 printer's proofs and 1 B.A.T.
Proofed by the artist and Jack Shirreff
Printed by Jack Shirreff, assisted by Andrew Smith and Claire Wait
 at the 107 Workshop, Wiltshire
Hand coloured by Jack Shirreff
Published by The Paris Review, New York, 1998
Plate: 560 x 510 mm. (22 x 20¹/₈ in.)
Sheet: 380 x 420 mm. (15 x 16¹/₂ in.)

Literature
Alan Cristea (intro.), *Howard Hodgkin. Volume I: Small Prints*, Alan Cristea
 Gallery, London, 2001 (n.p.) (ill. colour).

Public collections
Tate Gallery, London.

Colour reproduction on p. 46.

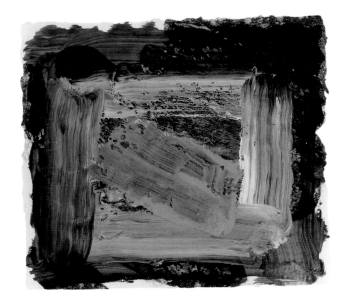

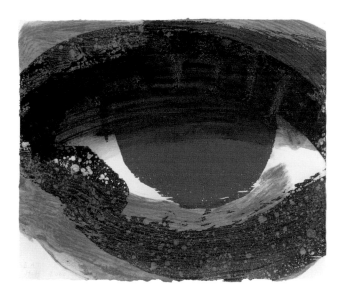

101 Norwich
1999–2000

Lift-ground etching and aquatint from two copper plates, with carborundum
from one aluminium plate, printed in black, grey and ultramarine blue,
with hand colouring in ultramarine blue, titanium white and cadmium
red acrylic
On 100% cotton paper from Two Rivers paper mill, Watchet, Somerset
(270 gsm), hand made by Jim Patterson
Signed with initials and dated 99 or 2000 in pencil, lower right
Numbered in pencil, lower left (1–40 in Roman numerals and 1–40
in Arabic numerals)
Edition of 80, with 15 artist's proofs, 5 printer's proofs and 1 B.A.T.
Proofed by the artist and Jack Shirreff
Printed by Jack Shirreff assisted by Andrew Smith and Claire Wait
at the 107 Workshop, Wiltshire
Hand coloured by Jack Shirreff
Published by Alan Cristea Gallery, London, 1999
Plate: 505 x 610 mm. (19⁷/₈ x 24 in.)
Sheet: 415 x 470 mm. (16¹/₄ x 18¹/₂ in.)

Literature
Alan Cristea (intro.), *Howard Hodgkin. Volume I: Small Prints*, Alan Cristea
Gallery, London, 2001 (n.p.) (ill. colour).

Public collections
Tate Gallery, London.

Colour reproduction on p. 25.

102 Eye
2000

Lift-ground etching and aquatint from two copper plates, with carborundum
from one aluminium plate, printed in ultramarine blue, bone black and
cadmium orange, with hand colouring in carbon black acrylic
On 100% cotton paper from Two Rivers paper mill, Watchet, Somerset
(280 gsm), hand made by Jim Patterson
Signed with initials and dated 2000 in pencil, lower left
Numbered in pencil, lower right (1–40 in Roman numerals and 1–40
in Arabic numerals)
Edition of 80, with 18 artist's proofs, 5 printer's proofs and 1 B.A.T.
Proofed by the artist and Jack Shirreff
Printed by Jack Shirreff assisted by Andrew Smith and Claire Wait
at the 107 Workshop, Wiltshire
Hand coloured by Jack Shirreff
Published by The Institute of Contemporary Arts at the Philadelphia
Museum of Art, Philadelphia, and Alan Cristea Gallery, London, 2000
Plate: 407 x 457 mm. (16 x 18 in.)
Sheet: 284 x 330 mm. (11¹/₄ x 13 in.)

Literature
Alan Cristea (intro.), *Howard Hodgkin. Volume I: Small Prints*, Alan Cristea
Gallery, London, 2001 (n.p.) (ill. colour).

Colour reproduction on p. 129.

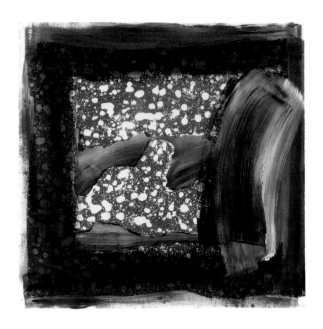

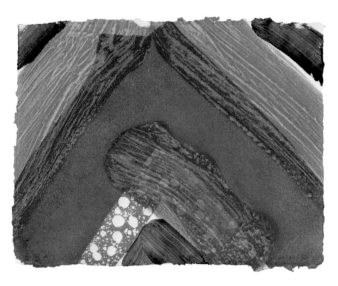

103 Frost
2000–02

Lift-ground etching and aquatint from one copper plate printed in cerulean
blue and ultramarine blue (mixed), with hand colouring in ultramarine
blue and zinc white acrylic
On Velin Arches paper (300 gsm)
Signed with initials and dated MM or MMI in pencil, lower centre or right
Numbered in pencil, lower centre or lower left
Edition of 50, with 15 artist's proofs, 5 printer's proofs and 1 B.A.T.
Proofed by Jack Shirreff, Andrew Smith and Claire Wait
Printed by Jack Shirreff assisted by Andrew Smith and Claire Wait
 at the 107 Workshop, Wiltshire
Hand coloured by Jack Shirreff
Published by Alan Cristea Gallery, London, 2001
Plate: 1220 x 1220 mm. (48 x 48 in.)
Sheet: 1162 x 1157 mm. (45³/₄ x 45¹/₂ in.)

Literature
Alan Cristea (intro.), *Howard Hodgkin. Volume I: Small Prints*, Alan Cristea
 Gallery, London, 2001 (n.p.) (ill. colour).

Colour reproduction on p. 126.

104 You Again
2000–02

Lift-ground etching and aquatint from two copper plates, with
 carborundum from one plastic plate, printed in shades of green,
 and apricot and vermillion (mixed), with hand colouring in carbon
 black acrylic
On 100% cotton paper from Two Rivers paper mill, Watchet, Somerset
 (280 gsm), hand made by Jim Patterson
Signed with initials and dated MM or MMI in pencil, lower right
Numbered in pencil, lower left
Edition of 50, with 15 artist's proofs, 5 printer's proofs and 1 B.A.T.
 (numbered I BAT)
Proofed by Jack Shirreff, Andrew Smith and Claire Wait
Printed by Jack Shirreff assisted by Andrew Smith and Claire Wait
 at the 107 Workshop, Wiltshire
Hand coloured by Jack Shirreff
Published by Alan Cristea Gallery, London, 2001
Plate: 380 x 483 mm. (15 x 19 in.)
Sheet: 280 x 355 mm. (11 x 14 in.)

Literature
Alan Cristea (intro.), *Howard Hodgkin. Volume I: Small Prints*, Alan Cristea
 Gallery, London, 2001 (n.p.) (ill. colour).

Colour reproduction on p. 131.

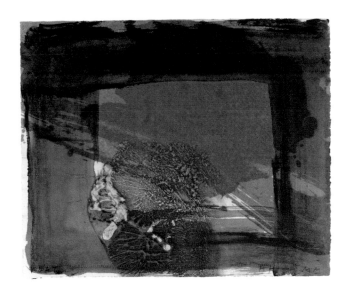

105 Rain
2000–02

Lift-ground etching and aquatint from two copper plates, with carborundum from one plastic plate, printed in green/grey, USA bone black grey and a complementary viridian/vermillion grey, with hand colouring in green acrylic

On 100% cotton paper from Two Rivers paper mill, Watchet, Somerset (280 gsm), hand made by Jim Patterson

Signed with initials and dated MM or MMI in pencil, lower right

Numbered in pencil, lower left

Edition of 50, with 15 artist's proofs, 5 printer's proofs and 1 B.A.T.

Proofed by Jack Shirreff, Andrew Smith and Claire Wait

Printed by Jack Shirreff assisted by Andrew Smith and Claire Wait at the 107 Workshop, Wiltshire

Hand coloured by Jack Shirreff

Published by Alan Cristea Gallery, London, 2001

Plate: 380 x 448 mm. (15 x 17$^{1}/_{2}$ in.)

Sheet: 267 x 310 mm. (10$^{1}/_{2}$ x 12$^{1}/_{8}$ in.)

Literature

Alan Cristea (intro.), *Howard Hodgkin. Volume I: Small Prints*, Alan Cristea Gallery, London, 2001 (n.p.) (ill. colour).

Public collections

Tate Gallery, London.

Colour reproduction on p. 136.

106 Dawn
2000–02

Sugar lift-ground etching and aquatint from two copper plates, printed in USA bone black and violet (mixed), with hand colouring in bone black and red, zinc white and alizarin red acrylic

On 100% cotton paper from Two Rivers paper mill, Watchet, Somerset (280 gsm), hand made by Jim Patterson

Signed with initials and dated MMI in pencil, lower left or lower right

Numbered in pencil, lower right

Edition of 60, with 15 artist's proofs, 5 printer's proofs and 1 B.A.T.

Proofed by Jack Shirreff, Andrew Smith and Claire Wait

Printed by Jack Shirreff assisted by Andrew Smith and Claire Wait at the 107 Workshop, Wiltshire

Hand coloured by Jack Shirreff

Published by Alan Cristea Gallery, London, 2001

Plate: 380 x 460 mm. (15 x 18 in.)

Sheet: 260 x 320 mm. (10$^{1}/_{4}$ x 12$^{1}/_{2}$ in.)

Literature

Alan Cristea (intro.), *Howard Hodgkin. Volume I: Small Prints*, Alan Cristea Gallery, London, 2001 (n.p.) (ill. colour).

Colour reproduction on p. 137.

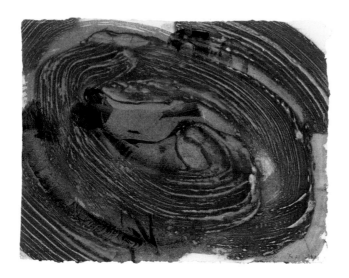

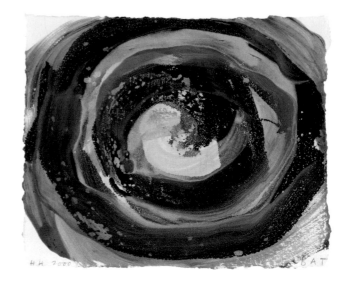

107 Tears, Idle Tears
2000–02

Lift-ground etching and aquatint from one copper plate, with
 carborundum from one plastic plate, printed in ocean blue and
 ultramarine blue, with hand colouring in bone black acrylic
On 100% cotton paper from Two Rivers paper mill, Watchet, Somerset
 (280 gsm), hand made by Jim Patterson
Signed with initials and dated MM or MMI in pencil, lower right
Numbered in pencil, lower left
Edition of 60, with 15 artist's proofs, 5 printer's proofs and 1 B.A.T.
Proofed by Jack Shirreff, Andrew Smith and Claire Wait
Printed by Jack Shirreff assisted by Andrew Smith and Claire Wait
 at the 107 Workshop, Wiltshire
Hand coloured by Jack Shirreff
Published by Alan Cristea Gallery, London, 2001
Plate: 430 x 500 mm. (17 x 19³/₄ in.)
Sheet: 292 x 365 mm. (11¹/₂ x 14¹/₄ in.)

Note: Based on the poem 'Tears, Idle Tears' from *The Princess* by Alfred
 Lord Tennyson

Tears, idle tears, I know not what they mean,
Tears from the depth of some divine despair
Rise in the heart, and gather to the eyes,
In looking on the happy Autumn-fields,
And thinking of the days that are no more.

Fresh as the first beam glittering on a sail,
That brings our friends up from the underworld,
Sad as the last which reddens over one
That sinks with all we love below the verge;
So sad, so fresh, the days that are no more.

Ah, sad and strange as in dark summer dawns
The earliest pipe of half-awaken'd birds
To dying ears, when unto dying eyes
The casement slowly grows a glimmering square;
So sad, so strange, the days that are no more.

Dear as remember'd kisses after death,
And sweet as those by hopeless fancy feign'd
On lips that are for others; deep as love,
Deep as first love, and wild with all regret;
O Death in Life, the days that are no more!

Literature
Alan Cristea (intro.), *Howard Hodgkin. Volume I: Small Prints*, Alan Cristea
 Gallery, London, 2001 (n.p.) (ill. colour).

Public collections
Tate Gallery, London.

Colour reproduction on p. 144.

108 Away
2000–02

Sugar lift-ground etching and aquatint from one copper plate printed
 in USA bone black, with hand colouring in Turner's yellow, cadmium
 red and green acrylic
On 100% cotton paper from Two Rivers paper mill, Watchet, Somerset
 (280 gsm), hand made by Jim Patterson
Signed with initials and dated 2000 or MMI in pencil, lower left or right
Numbered in pencil, lower right
Edition of 50, with 15 artist's proofs, 5 printer's proofs and 1 B.A.T.
Proofed by Jack Shirreff, Andrew Smith and Claire Wait
Printed by Jack Shirreff assisted by Andrew Smith and Claire Wait
 at the 107 Workshop, Wiltshire
Hand coloured by Jack Shirreff
Published by Alan Cristea Gallery, London, 2001
Plate: 393 x 405 mm. (15¹/₂ x 15⁷/₈ in.)
Sheet: 234 x 280 mm. (9¹/₄ x 11 in.)

Literature
Alan Cristea (intro.), *Howard Hodgkin. Volume I: Small Prints*, Alan Cristea
 Gallery, London, 2001 (n.p.) (ill. colour).

Colour reproduction on p. 145.

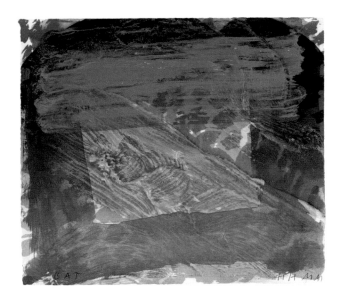

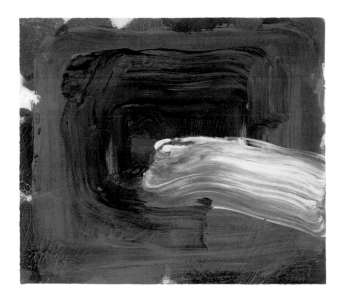

109 Strictly Personal

2000–02

Lift-ground etching and aquatint from two copper plates, with carborundum from one plastic plate, printed in ultramarine, cobalt and turquoise blue, red, vermillion and pink, and pale red/violet (mixed), with hand colouring in scarlet and green acrylic

On 100% cotton paper from Two Rivers paper mill, Watchet, Somerset (280 gsm), hand made by Jim Patterson

Signed with initials and dated MM or MMI in pencil, lower right

Numbered in pencil, lower left

Edition of 55, with 15 artist's proofs, 5 printer's proofs and 1 B.A.T.

Proofed by Jack Shirreff, Andrew Smith and Claire Wait

Printed by Jack Shirreff assisted by Andrew Smith and Claire Wait at the 107 Workshop, Wiltshire

Hand coloured by Jack Shirreff

Published by Alan Cristea Gallery, London, 2001

Plate: 420 x 457 mm. (16¹⁄₂ x 18 in.)

Sheet: 300 x 343 mm. (11³⁄₄ x 13¹⁄₂ in.)

Literature

Alan Cristea (intro.), *Howard Hodgkin. Volume I: Small Prints*, Alan Cristea Gallery, London, 2001 (n.p.) (ill. colour).

Public collections

Tate Gallery, London.

Colour reproduction on p. 140.

110 Cigarette

2000–02

Sugar lift-ground etching and aquatint from two copper plates, with carborundum from one aluminium plate, printed in ultramarine blue, ocean blue and cobalt blue, with hand colouring in red, zinc white and burnt Sienna acrylic

On 100% cotton paper from Two Rivers paper mill, Watchet, Somerset (280 gsm), hand made by Jim Patterson

Signed with initials and dated MM or MMI in pencil, lower right

Numbered in pencil, lower left

Edition of 55, with 15 artist's proofs, 5 printer's proofs and 1 B.A.T.

Proofed by Jack Shirreff, Andrew Smith and Claire Wait

Printed by Jack Shirreff assisted by Andrew Smith and Claire Wait at the 107 Workshop, Wiltshire

Hand coloured by Jack Shirreff

Published by Alan Cristea Gallery, London, 2001

Plate: 420 x 460 mm. (16¹⁄₂ x 18 in.)

Sheet: 285 x 330 mm. (11¹⁄₄ x 13 in.)

Literature

Alan Cristea (intro.), *Howard Hodgkin. Volume I: Small Prints*, Alan Cristea Gallery, London, 2001 (n.p.) (ill. colour).

Colour reproduction on p. 141.

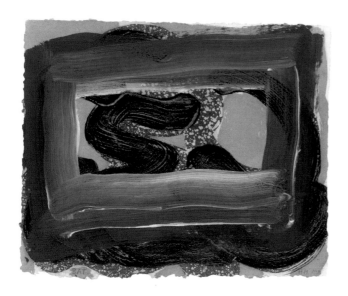

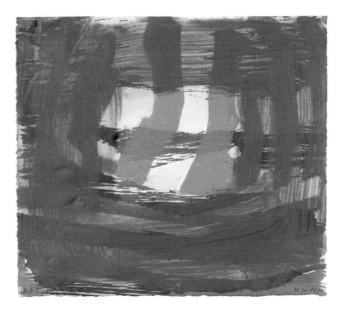

111 Seafood

2000–02

Lift-ground etching and aquatint from two copper plates, with carborundum
 from one plastic plate, printed in USA bone black (twice) and French black,
 with hand colouring in cyan and zinc white acrylic
On 100% cotton paper from Two Rivers paper mill, Watchet, Somerset
 (280 gsm), hand made by Jim Patterson
Signed with initials and dated MM or MMI in pencil, lower right
Numbered in pencil, lower left
Edition of 55, with 15 artist's proofs, 5 printer's proofs and 1 B.A.T.
Proofed by Jack Shirreff, Andrew Smith and Claire Wait
Printed by Jack Shirreff assisted by Andrew Smith and Claire Wait
 at the 107 Workshop, Wiltshire
Hand coloured by Jack Shirreff
Published by Alan Cristea Gallery, London, 2001
Plate: 560 x 635 mm. (22 x 25 in.)
Sheet: 426 x 521 mm. (16³/₄ x 20¹/₂ in.)

Literature

Alan Cristea (intro.), *Howard Hodgkin. Volume I: Small Prints*, Alan Cristea
 Gallery, London, 2001 (n.p.) (ill. colour).

Public collections

Tate Gallery, London.

Colour reproduction on p. 133.

112 Home

2000–02

Lift-ground etching and aquatint from one copper plate printed in rubis
 and red, with carborundum from one plastic plate, printed in apricot
 and vermillion (mixed), with hand colouring in green acrylic
On 100% cotton paper from Two Rivers paper mill, Watchet, Somerset
 (280 gsm), hand made by Jim Patterson
Signed with initials and dated MM or MMI in pencil, lower right
Numbered in pencil, lower left
Edition of 50, with 15 artist's proofs, 5 printer's proofs and 1 B.A.T.
Proofed by Jack Shirreff, Andrew Smith and Claire Wait
Printed by Jack Shirreff assisted by Andrew Smith and Claire Wait
 at the 107 Workshop, Wiltshire
Hand coloured by Jack Shirreff
Published by Alan Cristea Gallery, London, 2001
Plate: 508 x 533 mm. (20 x 21 in.)
Sheet: 368 x 414 mm. (14¹/₂ x 16¹/₄ in.)

Literature

Alan Cristea (intro.), *Howard Hodgkin. Volume I: Small Prints*, Alan Cristea
 Gallery, London, 2001 (n.p.) (ill. colour).

Colour reproduction on p. 130.

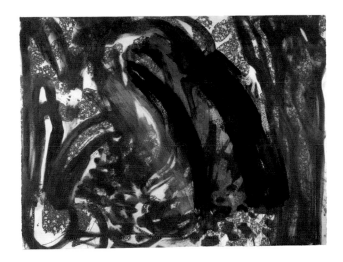

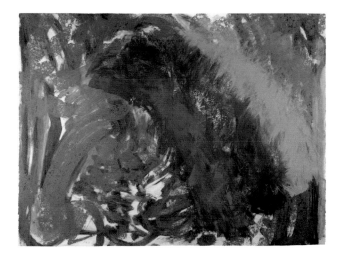

113 Into the Woods, Spring, from 'Into the Woods'
2001–02

Lift-ground etching and aquatint from four copper plates, with carborundum
　from four aluminium plates, printed in ultramarine blue, turquoise and
　white (mixed), zinc white and ocean blue, with hand colouring in green,
　phthalo blue and zinc white acrylic
On 85% cotton and 15% linen mould-made paper from Arjo Wiggins
　Moulin du Gué (350 gsm)
Signed with initials and dated MMI in pencil, lower right
Numbered in pencil, lower left
Edition of 19, with 10 artist's proofs, 3 printer's proofs and 1 B.A.T.
Proofed by Jack Shirreff, Andrew Smith and Claire Wait
Printed by Jack Shirreff assisted by Andrew Smith and Claire Wait
　at the 107 Workshop, Wiltshire
Hand coloured by Jack Shirreff
Published by Alan Cristea Gallery, London, 2001
Plates: 2235 x 1232 mm. (88 x 48¹/₂ in.) (2 aluminium plates);
　2235 x 153 mm. (88 x 6 in.) (2 aluminium plates);
　1085 x 1423 mm. (42³/₄ x 56 in.) (4 copper plates)
Overall sheet: 2032 x 2666 mm. (80 x 105 in.)
Sheet: 2032 x 1333 mm. (80 x 52¹/₂ in.) (2 sheets)

Note: Printed from the same set of plates as the other three 'Into the Woods'.

Literature

Alan Cristea (intro.), *Howard Hodgkin. Volume II: Into the Woods*, Alan Cristea
　Gallery, London, 2001 (n.p.) (ill. colour).

Public collections

The Metropolitan Museum of Art, New York (complete set).

Colour reproduction on p. 148.

114 Into the Woods, Summer, from 'Into the Woods'
2001–02

Lift-ground etching and aquatint from four copper plates, with carborundum
　from four aluminium plates, printed in two shades of green, two shades
　of green (mixed), turquoise blue and zinc white, with hand colouring in red,
　cerulean blue and zinc white, and bright opaque green and zinc white acrylic
On 85% cotton and 15% linen mould-made paper from Arjo Wiggins Moulin
　du Gué (350 gsm)
Signed with initials and dated MMI in pencil, lower right
Numbered in pencil, lower left
Edition of 19, with 10 artist's proofs, 3 printer's proofs and 1 B.A.T.
Proofed by Jack Shirreff, Andrew Smith and Claire Wait
Printed by Jack Shirreff assisted by Andrew Smith and Claire Wait
　at the 107 Workshop, Wiltshire
Hand coloured by Jack Shirreff
Published by Alan Cristea Gallery, London, 2001
Plates: 2235 x 1232 mm. (88 x 48¹/₂ in.) (2 aluminium plates);
　2235 x 153 mm. (88 x 6 in.) (2 aluminium plates);
　1085 x 1423 mm. (42³/₄ x 56 in.) (4 copper plates)
Overall sheet: 2032 x 2666 mm. (80 x 105 in.)
Sheet: 2032 x 1333 mm. (80 x 52¹/₂ in.) (2 sheets)

Note: Printed from the same set of plates as the other three 'Into the Woods'.

Literature

Alan Cristea (intro.), *Howard Hodgkin. Volume II: Into the Woods*, Alan Cristea
　Gallery, London, 2001 (n.p.) (ill. colour).

Public collections

The Metropolitan Museum of Art, New York (complete set).

Colour reproduction on p. 149.

115 Into the Woods, Autumn, from 'Into the Woods'
2001–02

Lift-ground etching and aquatint from four copper plates, with carborundum
 from four aluminium plates, printed in sanguine, a lighter tone of sanguine,
 with hand colouring in cadmium red, burnt Sienna, red and cyan acrylic
On 85% cotton and 15% linen mould-made paper from Arjo Wiggins
 Moulin du Gué (350 gsm)
Signed with initials and dated MMI in pencil, lower right
Numbered in pencil, lower left
Edition of 19, with 10 artist's proofs, 3 printer's proofs and 1 B.A.T.
Proofed by Jack Shirreff, Andrew Smith and Claire Wait
Printed by Jack Shirreff assisted by Andrew Smith and Claire Wait
 at the 107 Workshop, Wiltshire
Hand coloured by Jack Shirreff
Published by Alan Cristea Gallery, London, 2001
Plates: 2235 x 1232 mm. (88 x 48¹/₂ in.) (2 aluminium plates);
 2235 x 153 mm. (88 x 6 in.) (2 aluminium plates);
 1085 x 1423 mm. (42³/₄ x 56 in.) (4 copper plates)
Overall sheet: 2032 x 2666 mm. (80 x 105 in.)
Sheet: 2032 x 1333 mm. (80 x 52¹/₂ in.) (2 sheets)

Note: Printed from the same set of plates as the other three 'Into the Woods'.

Literature

Alan Cristea (intro.), *Howard Hodgkin. Volume II: Into the Woods*, Alan Cristea
 Gallery, London, 2001 (n.p.) (ill. colour).

Public collections

The Metropolitan Museum of Art, New York (complete set).

Colour reproduction on p. 152.

116 Into the Woods, Winter, from 'Into the Woods'
2001–02

Lift-ground etching and aquatint from four copper plates, with carborundum
 from four aluminium plates, printed in bone black, and ultramarine blue
 (mixed) and bone black, Van Dyck and zinc white, with hand colouring
 in red, carbon black and cyan acrylic
On 85% cotton and 15% linen mould-made paper from Arjo Wiggins
 Moulin du Gué (350 gsm)
Signed with initials and dated MMI in pencil, lower right
Numbered in pencil, lower left
Edition of 19, with 10 artist's proofs, 3 printer's proofs and 1 B.A.T.
Proofed by Jack Shirreff, Andrew Smith and Claire Wait
Printed by Jack Shirreff assisted by Andrew Smith and Claire Wait
 at the 107 Workshop, Wiltshire
Hand coloured by Jack Shirreff
Published by Alan Cristea Gallery, London, 2001
Plates: 2235 x 1232 mm. (88 x 48¹/₂ in.) (2 aluminium plates);
 2235 x 153 mm. (88 x 6 in.) (2 aluminium plates);
 1085 x 1423 mm. (42³/₄ x 56 in.) (4 copper plates)
Overall sheet: 2032 x 2666 mm. (80 x 105 in.)
Sheet: 2032 x 1333 mm. (80 x 52¹/₂ in.) (2 sheets)

Note: Printed from the same set of plates as the other three 'Into the Woods'.

Literature

Alan Cristea (intro.), *Howard Hodgkin. Volume II: Into the Woods*, Alan Cristea
 Gallery, London, 2001 (n.p.) (ill. colour).

Public collections

The Metropolitan Museum of Art, New York (complete set).

Colour reproduction on p. 153.

117 Sea
 2002–03

Sugar lift-ground etching and aquatint from one copper plate, printed in blue
 black, with hand colouring in ultramarine blue, zinc white and cyan acrylic
On 100% cotton paper from Two Rivers paper mill, Watchet, Somerset
 (270 gsm), hand made by Jim Patterson
Signed with initials, numbered and dated in pencil
Edition of 100, with 15 artist's proofs, 5 printer's proofs and 1 B.A.T.
Proofed by Jack Shirreff
Printed by Jack Shirreff assisted by Andrew Smith and Claire Wait
 at the 107 Workshop, Wiltshire
Hand coloured by Jack Shirreff
Published by Thames & Hudson, London, 2003
Plate: 357 x 380 mm. (14 x 14⅛ in.)
Sheet: 232 x 265 mm. (9⅛ x 10⅜ in.)

Note: The print was inserted in the *de-luxe* edition of the catalogue raisonné
 Howard Hodgkin Prints by Liesbeth Heenk, London (Thames & Hudson), 2003.

Colour reproduction on p. 2.

118 'Two's Company'
 2002–03

Series of four sugar lift-ground etchings and aquatints from two copper
 plates, with carborundum from one plastic plate
Two's Company (a) printed in burnt Sienna, vermillion and zinc white,
 with hand colouring in cadmium yellow and cyan acrylic
Two's Company (b) printed in burnt Sienna, vermillion, and cobalt blue
 and zinc white (mixed), with hand colouring in cadmium yellow and
 cyan acrylic
Two's Company (c) printed in sepia, black and zinc white, with hand
 colouring in cobalt blue, bone black and cyan acrylic
Two's Company (d) printed in grey, vermillion and zinc white, with hand
 colouring in cyan acrylic
On 100% cotton paper from Two Rivers paper mill, Watchet, Somerset
 (270 gsm), hand made by Jim Patterson
Signed with initials, numbered and dated in pencil
Editions of 20, with 4 artist's proofs, 5 printer's proofs and 1 B.A.T.
Proofed by Jack Shirreff
Printed by Jack Shirreff assisted by Andrew Smith and Claire Wait
 at the 107 Workshop, Wiltshire
Hand coloured by Jack Shirreff
Published by the Elton John AIDS Foundation, London, and Alan Cristea
 Gallery, London, 2003
Plates: 610 x 710 mm. (24 x 28 in.)
Sheets: 375 x 460 mm. (14¾ x 18 in.)

Note: All four 'Two's Company' prints are printed from the same set of
 plates. The four prints are treated as one edition of 80, of which 40 are
 numbered in Arabic numerals and 40 in Roman numerals. The series
 was not completed when this publication went to press.

Book illustrations

The Way We Live Now
1990

Author: Susan Sontag (born 1933)
The text was first published in *The New Yorker*, 1986
Illustrations by Howard Hodgkin, 1990

The book contains seven lift-ground etchings and aquatints, including
 front and end papers and unbound print
Lift-ground aquatints from copper plates printed in colours with hand
 colouring in egg tempera, on cream Fabriano Ingres Avorio paper (160 gsm)
Dust jacket: hand colouring in cadmium yellow egg tempera, on Fabriano
 Ingres Azzurro paper (160 gsm)
The lift-ground aquatints and dust jacket are hand coloured by Jack Shirreff
Printed and hand coloured by Jack Shirreff at the 107 Workshop, Wiltshire
Published by Karsten Schubert, London, 1991

The total book edition of 243 consists of:
An edition of 200, numbered 1–200
25 artist's proofs, 7 printer's proofs, 5 hors commerce copies and 6 copies
 for presentation purposes, numbered I–VI

Each book is accompanied by a separate, unbound print of one
 of the illustrations

Edition of the unbound plate: 50, numbered 1/50–50/50
Signed with initials and dated 91 in pencil, lower centre

The book is signed by the artist and author in pencil on the justification page
The justification is numbered in pencil
Book design by Gordon House, London
Book binding by Dieter Schulke, Perstella, Wimborne, Dorset
Text is set in Bembo, printed by C.H. Printing, Corsham, Wiltshire,
 on Arjomari Rivoli blanc casse paper (240 gsm)
Page: 286 x 212 mm. (11¼ x 8¼ in.)
Book: 304 x 221 mm. (12 x 8⅝ in.)
Cardboard brown box of issue: 338 x 242 mm. (13¼ x 9½ in.)
Cardboard brown box of issue has a printed title label on the front with
 the names of the author, artist and publisher, numbering in pencil

A paperback facsimile was published by Jonathan Cape Ltd, London, 1991

Note: All royalties from this book are donated to CRUSAID, the British
 National Fundraising Charity for AIDS, who, in turn, divides the funds
 equally between other AIDS charities in the United Kingdom and the
 United States.

Fear Gives Everything its Hue, its High
Lift-ground etching and aquatint from one copper plate printed in vermillion
 red, with hand colouring in cobalt blue egg tempera
Front paper (double-page plate between front flyleaf and page 1)
Plate: 610 x 455 mm. (24 x 17⅞ in.)
Sheet: 293 x 422 mm. (11½ x 16⅝ in.)

Colour reproduction on p. 98.

In Touch
Checking In
Lift-ground etching and aquatint from two copper plates printed in black
 and vermillion red, with hand colouring in veronese green egg tempera
Plate 1 (double-page plate between pages 8 and 9)
Plate: 610 x 455 mm. (24 x 17⅞ in.)
Sheet: 293 x 422 mm. (11½ x 16⅝ in.)

Colour reproduction on p. 99.

As You'd Been Wont – Wantonly
Wantonly
Eros Past

Lift-ground etching and aquatint from one copper plate printed in chrome
 yellow and apricot (mixed), with hand colouring in bone black and flesh
 colour (yellow ochre, cadmium yellow and zinc white, mixed) egg tempera
Plate 2 (double-page plate between pages 16 and 17)
Plate: 610 x 455 mm. (24 x 17⅞ in.)
Sheet: 293 x 422 mm. (11½ x 16⅝ in.)

Colour reproduction on p. 102.

The Hospital Room was Choked with Flowers
Everybody Likes Flowers
Surplus Flowers
The Room … was Filling up with Flowers

Lift-ground etching and aquatint from two copper plates printed in green
 and red ochre, with hand colouring in bone black and cadmium red
 egg tempera
Plate 3 (three-page fold-out plate between pages 24 and 25)
Plate: 760 x 455 mm. (29⅞ x 17⅞ in.)
Sheet: 293 x 632 mm. (11½ x 24⅞ in.)

Colour reproduction on p. 103.

But He Did Stop Smoking
He Didn't Miss Cigarettes at All

Lift-ground etching and aquatint from two copper plates printed
 in vermillion red and green, with hand colouring in vermillion red
 and cobalt blue egg tempera
Plate 4 (four-page fold-out plate between pages 32 and 33)
Plate: 455 x 940 mm. (17⅞ x 37 in.)
Sheet: 300 x 850 mm. (11¾ x 33½ in.)

Colour reproduction on p. 103.

Dust jacket

Paper without printing, but with hand colouring in cadmium yellow
 egg tempera
Sheet: 303 x 890 mm. (11⅞ x 35 in.)

Literature

Cathy Courtney, 'Susan Sontag & Howard Hodgkin, *The Way We Live Now*',
 Art Monthly, vol. 146, 1991, p. 27; Geordie Greig, 'The Fine Art of Healing
 by Art', *The Sunday Times Magazine*, 10 March 1991, pp. 42–46 (ill. colour);
 Barbara MacAdam, 'Speaking of the Unspeakable', *ARTnews*, vol. 91, no. 3,
 March 1992, p. 20; Zoe Heller, 'Howard's Way', *Harpers & Queen*, April 1992,
 pp. 152–56 (ill.); Maggie Parham, 'Art for AIDS' Sake', *The Evening Standard
 Magazine*, 8 May 1992, pp. 76–77 (ill. colour); James Cary Parkes, 'The Way
 We Live Now', *The Pink Paper*, 6 September 1992; Riva Castleman, *A Century
 of Artists Books*, Museum of Modern Art, New York, 1994–95, p. 198 (ill. colour).

Public collections

Museum of Modern Art, New York; National Gallery of Art, Washington, D.C.;
 National Gallery of Australia, Canberra (one plate only); The Olympic
 Collection, Lillehammer.

Evermore

1996–97

Author: Julian Barnes (born 1946)

The text is a short story from *Cross Channel*, published in 1996

Illustrations by Howard Hodgkin, 1996

The book contains six lift-ground etchings and aquatint printed in colours, plus a frontispiece

Four prints and the frontispiece contain hand colouring in acrylics

The front and end papers are the same

Etchings printed on Aquarelle Arches NOT surface cold-pressed (185 gsm)

Frontispiece on Venables laid gelatine-sized document paper circa 1950 (185 gsm)

The six prints and the frontispiece are bound in text

Etchings printed by Jack Shirreff, Andrew Smith and Samuel Lee at the 107 Workshop, Wiltshire

Hand coloured by Jack Shirreff

Published by Palawan Press, London, 1996

The total book edition of 754 consists of:

A *de-luxe* blue edition of 72; a standard edition of 182; a trade edition of 500

The *de-luxe* blue edition consists of:

An edition of 50, numbered 1–50; 10 artist's proofs, inscribed A.P. 1/10–10/10 of which some have been dedicated to the collaborators; 10 hors commerce impressions, inscribed H.C. 1/10–10/10; 1 printer's proof and 1 B.A.T.

The justification of the book is numbered, signed and inscribed with a poem ('No morning dawns...') by the author in black pen-and-ink, and is signed and dated 1996 by the artist in pencil

Each copy of the *de-luxe* blue edition is accompanied by two separate, unbound lift-ground etchings and aquatint in colour, with hand colouring in acrylics

Both etchings are signed with initials, dated 96 or 97 and numbered by the artist in pencil at the lower centre, verso

The book cover of the *de-luxe* blue edition is hand coloured in primary cyan blue acrylic on Somerset white (300 gsm)

The text is set in Plantin Light and printed lithography on Fabriano 5 (160 gsm) which is hand coloured in primary cyan blue acrylic by Jack Shirreff

The book and two separate prints are enclosed in a portfolio cardboard box and slipcase in a silver book cloth which are both designed and produced by BookWorks, London

The title 'Evermore' is foil-blocked in silver onto the slipcase

The book was coordinated by Thomas Dane, designed by Herman Lelie and bound by BookWorks, London

Type set by Goodfellow & Egan, Cambridge

Lithography by Terracotta Press, Wembley

Measurements of the *de-luxe* blue edition:

Book: 183 x 135 x 12 mm. (7^1/$_8$ x 5^1/$_4$ x 1/$_2$ in.)

Portfolio box: 328 x 249 x 27 mm. (12^7/$_8$ x 9^3/$_4$ x 1 in.)

Slipcase: 334 x 257 x 34 mm. (13^1/$_8$ x 10^1/$_8$ x 1^1/$_4$ in.)

The standard edition consists of:

An edition of 150, numbered 1–150; 15 artist's proofs, inscribed A.P.1/10–10/10; 15 hors commerce impressions, inscribed H.C. 1/15–15/15; of which some are individually dedicated to collaborators; 1 printer's proof and 1 B.A.T.

The paper on which the text of the standard edition is printed is not hand coloured like the *de-luxe* blue edition

The justification page of the book is numbered and signed by the author in black pen-and-ink, and signed and dated 1996 by the artist in pencil

The book is enclosed in a silver cardboard slipcase designed by Jack Shirreff

The book was coordinated by Thomas Dane, designed by Herman Lelie and bound by BookWorks, London

Type set by Goodfellow & Egan, Cambridge

Lithography by Terracotta Press, Wembley

Measurements of the standard edition:

Book: 183 x 135 x 12 mm. (7^1/$_8$ x 5^1/$_4$ x^1/$_2$ in.)

Slipcase: 191 x 139 x 22 mm. (7^1/$_2$ x 5^1/$_2$ x 7/$_8$ in.)

Front and end papers

Lift-ground etching and aquatint from one copper plate printed in red

Plate: 300 x 355 mm. (11^3/$_4$ x 14 in.)

Sheet: 185 x 270 mm. (7^1/$_4$ x 10^5/$_8$ in.)

Frontispiece

Paper without printing, but with hand colouring in titanium white, bone black and red acrylic

Sheet: 185 x 135 mm. (7^1/$_4$ x 5^1/$_4$ in.)

Untitled (black crosses)

Lift-ground etching and aquatint from one copper plate printed in black,
with hand colouring in bone black acrylic

Plate: 300 x 355 mm. (11³/₄ x 14 in.)

Sheet: 185 x 270 mm. (7¹/₄ x 10⁵/₈ in.)

Untitled (blood spots)

Lift-ground etching and aquatint from one copper plate printed in red ochre,
with hand colouring in cadmium red acrylic

Plate: 300 x 355 mm. (11³/₄ x 14 in.)

Sheet: 185 x 270 mm. (7¹/₄ x 10⁵/₈ in.)

Untitled (Morris car)

Lift-ground etching and aquatint from one copper plate printed in
ultramarine blue with hand colouring in cadmium orange, bone black
and green acrylic

Plate: 300 x 355 mm. (11³/₄ x 14 in.)

Sheet: 185 x 270 mm. (7¹/₄ x 10⁵/₈ in.)

Untitled (landscape)

Lift-ground etching and aquatint from one copper plate printed in
ultramarine blue with hand colouring in green and raw Sienna acrylic

Plate: 300 x 355 mm. (11³/₄ x 14 in.)

Sheet: 185 x 270 mm. (7¹/₄ x 10⁵/₈ in.)

Note: A set of unbound, unfolded prints is in the collection of the publisher.

Literature

Rosemary Simmons, 'Getting Lost in Fear and Happiness', *Printmaking Today*,
vol. 6, no. 4, winter 1997, pp. 7–8.

Public collections

Imperial War Museum, London (regular edition); Victoria and Albert
Museum (National Art Library), London (*de-luxe* blue edition).

Uneditioned prints

Untitled
1971
Lithograph from four zinc plates printed in yellow, green, red and white
On Arches (250 gsm)
One proof signed and dated 71 in pencil, lower right and numbered 1/1
 in pencil, lower left, another proof inscribed 'For Ketterer Felix Man?
 Schmidt 996'
With the printer's proof stamp (twice), verso
Only proofed, not published
Printed by Stanley Jones at Curwen Prints Ltd, London
Image: 274 x 365 mm. ($10^3/_4$ x $14^1/_4$ in.)
Sheet: 533 x 673 mm. (21 x $26^1/_2$ in.)

Note: Commissioned by Felix Man for the portfolio 'Europäische Graphik
 VII. Englische Künstler'.

Literature
'Howard Hodgkin Talking to Pat Gilmour About his Prints', 1 April 1976
 (notes of recorded interview); Penelope Marcus, *Howard Hodgkin: Complete
 Prints*, Museum of Modern Art, Oxford, 1977 (n.p.).

Public collections
Tate Gallery, London.

Note: Another version has been made which lacks the white chalk in
 the red shape.

Untitled (Indian Leaves)
1982
Lithograph from three aluminium plates printed in blue, red and yellow
On Japanese Gampi Torinoko paper (95 gsm)
Not signed, numbered or dated
1 B.A.T.
Only proofed, not published
Printed by Perry Tymeson and John Hutcheson at the Petersburg Studios,
 New York
Sheet: 230 x 763 mm. (9 x 30 in.)

Note: Wrap-around cover that was intended to be used for the *de-luxe* edition
 of the publication *Indian Leaves*. With an introduction by Bruce Chatwin
 (Petersburg Press), London and New York, 1982.

Untitled (Forty Paintings)
1984

Lithograph from three aluminium plates printed in three shades of green
On Somerset creme paper (250 gsm)
One proof unsigned, another inscribed 'Antony love Howard' in pencil,
 lower centre
1 B.A.T. inscribed BAT and signed with initials and dated 84 in pencil, lower
 centre
Printed by Perry Tymeson at the Petersburg Studios, New York, 1984
Image and sheet: 272 x 417 mm. (10³/₄ x 16³/₈ in.)

Note: Commissioned by George Brazilier in New York for the American
 de-luxe edition of the exhibition catalogue *Howard Hodgkin: Forty Paintings
 1973–84* (British Council Touring Exhibition), 1984–85.
The sheet of the B.A.T. has full margins: 343 x 508 mm. (13¹/₂ x 20 in.)
 and its image is untrimmed: 292 x 445 mm. (11¹/₂ x 17¹/₂ in.).
The print and book were intended to be enclosed in a specially made box
 or slipcase.

Limited edition reproductive prints

Artificial Flowers

1975

Screenprint in violet, red, green and orange
On white cartridge paper
Signed with initials and dated 75 in pencil, lower right or left
Numbered in pencil, lower right
Edition of 250, with 5 artist's proofs and 15 printer's proofs
Imprinted at the lower left: After the painting 'Artificial Flowers'
 by Howard Hodgkin 250 copies printed in England by John Vince
 for opening of Arnolfini, Narrow Quay 1975
Printed by John Vince at the Bath Academy of Art, Corsham
Published by the Arnolfini Gallery, Bristol
Image size: 290 x 400 mm. (11$^3/_8$ x 15$^3/_4$ in.)
Sheet size: 355 x 453 mm. (14 x 17$^3/_4$ in.)

Note: Based on *Artificial Flowers*, oil on wood, 1975. Also published as an
 unsigned and uneditioned A2 poster to commemorate the opening
 of the new Arnolfini Gallery at Narrow Quay in Bristol in October 1975,
 in conjunction with the exhibition of paintings by Howard Hodgkin

Public collections
Tate Gallery, London.

Lotus

1980

Screenprint from 20 screens with embossing
On Velin Arches mould-made paper
Signed and dated 80 in pencil, lower centre
Numbered, lower left
Edition of 100, with 15 artist's proofs and a few printer's proofs
Printed by Douglas Corker at Kelpra Studio, London
With the rubber stamp initial K of the printer
Published by Bernard Jacobson Ltd, London
Image and sheet: 740 x 916 mm. (29$^1/_8$ x 36 in.)

Note: Based on *Lotus*, textile dyes on hand-made Indian paper, 1978.

Public collections
The British Council, London; Tate Gallery, London.

Still Life

1980

Screenprint from 18 screens
On Velin Arches mould-made paper
Signed with initials and dated 1980 in pencil, lower centre
Numbered in pencil, lower left
Edition of 100, with an unknown number of artist's proofs
 and printer's proofs
Printed by Douglas Corker at Kelpra Studio, London
With the rubber stamp initial K of the printer in black
Published by Bernard Jacobson Ltd, London
Image and sheet: 800 x 725 mm. (31$^1/_2$ x 28$^1/_2$ in.)

Note: Based on *Still Life*, textile dyes on hand-made Indian paper, 1978.

Public collections
The British Council, London.

Tropic Fruit

1981

Screenprint from 23 screens
On Velin Arches mould-made paper
Signed with initials and dated 81 in pencil, lower centre
Numbered in pencil, lower right or lower left
Edition of 100, with 15 artist's proofs
Printed by Douglas Corker at Kelpra Studio, London
With the rubber stamp initial K of the printer in black
Published by Bernard Jacobson Ltd, London
Sheet and image size: 785 x 938 mm. (30$^7/_8$ x 36$^7/_8$ in.)

Note: Based on *Tropic Fruit*, textile dyes on hand-made Indian paper,
 1978. Some proofs were not signed, dated or numbered.

Public collections
The British Council, London.

Red Bermudas
1982
Offset lithograph printed in 5 colours with a black border
On Huntsman Velvet paper (170 gsm)
Signed with initials in white crayon, lower centre
Numbered in white crayon, lower left, and dated 82, lower right
Edition of 150, with 40 artist's proofs
Printed by Adrian Lack at Senecio Press, Charlbury, Oxfordshire
Published by the Museum of Modern Art, Oxford, with the financial
 support of Marlborough Fine Art, London, and Bernard Jacobson
 Ltd, London
Produced in aid of the Museum of Modern Art Building Appeal, Oxford
Sheet: 440 x 440 mm. (17¼ x 17¼ in.)

Note: Based on *Red Bermudas*, oil on wood, 1978–80.

Public collections
The Government Art Collection, London.

In a French Restaurant
1982
Screenprint in 29 colours from 29 screens
On TH Saunders Waterford white (300 gsm)
Signed in red crayon, lower right
Edition of 500, with 50 artist's proofs and 4 printer's proofs
Printed by Cromacomp, New York
Published by Petersburg Press
Imprinted below: Howard Hodgkin paintings Knoedler Gallery
 New York 1980
"In a French Restaurant", oil on wood © Howard Hodgkin 1979
 Petersburg Press
Sheet: 1210 x 1460 mm. (47⅝ x 57½ in.)

Note: Based on *In a French Restaurant*, oil on wood, 1977–79.

Public collections
Lincoln Center for the Performing Arts, New York.

Venetian Glass
1989
Screenprint in 6 colours from 6 screens
On Huntsman Velvet paper (180 gsm)
Signed with initials in pencil, lower centre
Numbered and dated 89 in pencil, lower right
Edition of 72, with 9 artist's proofs and 10 replacement proofs
Printed by G & B Arts Ltd, London
Published by the Lincoln Center/List Art Posters & Prints, New York
Sheet: 838 x 875 mm. (33 x 34½ in.)
Image: 677 x 845 mm. (26⅝ x 33¼ in.)

Note: Based on *Venetian Glass*, oil on wood, 1984–87. Also produced
 as a poster in an edition of 1500 for the Mostly Mozart Festival
 at the Avery Fisher Hall, Lincoln Center for the Performing Arts,
 New York, postersize: 966 x 870 mm. (38 x 34½ in.)

Public collections
Lincoln Center for the Performing Arts, New York.

In Tangier
1991
Screenprint in 22 colours from 22 screens
On Huntsman velvet paper (300 gsm)
Signed with initials, numbered and dated 91 in pencil, lower centre
Edition of 72, with 14 artist's proofs, 8 printer's proofs and 10 replacement
 proofs
Proofed by Robert Blanton and Thomas Little
Printed by Isaiah Singelton and José Velasquez at Brand X Editions Ltd,
 New York
Published by the Lincoln Center/List Art Posters & Prints, New York
Sheet: 960 x 870 mm. (37¾ x 34½ in.)

Note: Based on *In Tangier*, oil on wood, 1987–90. Also produced as a poster
 in an edition of 1000 printed by Brand X Editions Ltd, New York, 1992,
 postersize: 813 x 890 mm. (32 x 35 in.)

Public collections
Lincoln Center for the Performing Arts, New York.

Gossip

1995

Screenprint in 23 colours from 23 screens

On Somerset smooth paper (300 gsm)

Signed with initials in pencil and dated 95, lower centre

Edition of 108, with 14 artist's proofs, 9 printer's proofs
 and 10 replacement proofs

Proofed by Joseph Stauber and Steven Sangenario

Printed by Agustin Rijo and Ronald LeGates at Brand X Editions Ltd,
 New York

Published by the Lincoln Center/List Art Posters & Prints, New York

With the printer's chopmark, lower right corner

Image: 743 x 1038 mm. (29$^{1}/_{4}$ x 40$^{7}/_{8}$ in.)

Sheet: 915 x 1195 mm. (36 x 47 in.)

Note: Based on *Gossip*, oil on wood, 1994–95. Also produced as a poster
 in an edition of 1000 printed by Brand X Editions Ltd, New York,
 postersize: 915 x 1195 mm. (36 x 47 in.)

Public collections

Lincoln Center for the Performing Arts, New York.

New Worlds

1999

Screenprint from 18 screens in about 21 colours

On velin Arches paper (300 gsm)

Signed with initials in pencil, dated 99 and numbered (1–30 in
 Roman numerals and 1–30 in Arabic numerals), lower centre

Edition of 60, with 10 artist's proofs and 2 printer's proofs

Printed by Bob Saich at Advanced Graphics, London

Published by Alan Cristea Gallery, London, and Royal Mail, London

Image: 260 x 272 mm. (10$^{1}/_{4}$ x 10$^{3}/_{4}$ in.)

Sheet: 450 x 450 mm. (17$^{3}/_{4}$ x 17$^{3}/_{4}$ in.)

Bamboo
2000

Screenprint from 38 screens in 38 colours
On Somerset Texture (300 gsm)
Signed with initials in pencil, lower centre
Edition of 108, with 18 artist's proofs, 9 printer's proofs, 1 B.A.T.
 and 10 replacement proofs
Printed by Jon Wise and Steven Sangenario at Brand X Editions Ltd,
 New York
Published by the Lincoln Center/List Art Posters & Prints, New York
With the printer's chopmark, lower right
Sheet: 668 x 776 mm. (26$^{1}/_{4}$ x 30$^{1}/_{2}$ in.)

Note: Based on *Bamboo*, oil on wood, 1995–97. Also produced as a poster
 in an edition of 750, printed by Brand X Editions Ltd, New York,
 postersize: 840 x 890 mm. (33 x 35 in.)

Public collections
Lincoln Center for the Performing Arts, New York.

Chronology
List of exhibitions
Bibliography
Photographic credits
Index

Chronology

1932
Born on 6 August in London.

1940–43
Lived in the United States.

1949–50
Studied art at the Camberwell School of Art in London. Printmaking was not part of the course.

1950
Started to collect Indian miniatures.

1950–54
Studied art at the Bath Academy of Art in Corsham. The book jackets by Clifford and Rosemary Ellis triggered Hodgkin's interest in lithography.

1953
Made his first print, the lithograph *Acquainted with the Night*, with Henry Cliffe at the Bath Academy of Art in Corsham.

1954–56
Became assistant art master at the Charterhouse School near Godalming in Surrey.

1955
Married Julia Lane, an art student; two sons, Sam and Louis.

1956–66
Taught at the Bath Academy of Art in Corsham.

1964
First visit to India. Hodgkin would make trips to India almost every year.
Contributed to the *ICA Screen-print project* together with twenty-three other artists. The screenprints were all made with Chris Prater at Kelpra Studio in London.

1966–72
Taught at the Chelsea School of Art in London.

1970–76
Trustee of the Tate Gallery, London.

1971
Publication of *Indian Views* by Leslie Waddington Prints in London.

1973–74
Introduced to intaglio printing by Maurice Payne at the Petersburg Studios in London. Hodgkin would continue to work with Petersburg until 1985.

1975
Severely ill due to amoebiasis.
Separated from his wife.

1976
First solo exhibition of his prints at the Tate Gallery in London. For this exhibition Hodgkin was interviewed by Pat Gilmour on 1 April.
Published his first prints with Bernard Jacobson in London. Hodgkin continued to work with him until 1986.

1976–77
Artist in residence at Brasenose College in Oxford.

1977
Appointed Commander of the British Empire (CBE).
First applied hand colouring to *Julian and Alexis*.
Produced *Nick* which marked a new phase in Hodgkin's printmaking.
Began to work with Judith Solodkin at Solo Press in New York.

1978–85
Trustee of the National Gallery, London.

1980
Started to work with Cinda Sparling as his hand colourist.

1981–82
Prints toured Australia, organized by the British Council.

1984
Represented Britain at the XLI Venice Biennale.

1985
First major retrospective of his prints at the Tate Gallery in London.
David's Pool won the Henry Moore Foundation Prize at the 9th British International Print Biennale in Bradford.
Awarded the Turner prize.
Received Hon. D. Litt. from the University of London.

1985–90
Prints toured Europe, North Africa and South America, organized by the British Council.

1986
Began to collaborate with Jack Shirreff at the 107 Workshop in Wiltshire. The group of prints *Green Room*, *Blue Listening Ear* and *Listening Ear* marked the beginning of a new phase in Hodgkin's printmaking career. In this group

of prints Hodgkin first used the techniques of carborundum, lift-ground etching and aquatint.
First use of egg tempera as a medium for hand colouring.

1986–91
Produced large prints inspired by posters seen in the metro in Paris in the late 1950s or early 1960s.

1988
Appointed Honorary Fellow of Brasenose College in Oxford.
The duo *Monsoon* and *Black Monsoon* are the last lithographs Hodgkin made at Solo Press in New York.

1990
Interviewed by Antony Peattie on 11 December for the exhibition catalogue *Howard Hodgkin: Hand-coloured Prints 1986–1991*, Waddington Graphics, London.

1992
Awarded knighthood.

1994
Publication of the first monograph on Hodgkin written by Andrew Graham-Dixon.

1995
Produced the important series of four 'Venetian Views', published by Alan Cristea Gallery in London.
First use of acrylics as a medium for hand colouring.

1997
Awarded Shakespeare Prize (Alfred Toepfer Foundation F.V.S.).

1998–99
Important solo exhibition in Germany: *Howard Hodgkin: Arbeiten auf Papier von 1971 bis 1995* at the Staatliches Museum für Naturkunde und Vorgeschichte in Oldenburg. The exhibition toured to Ratingen.

1999
Appointed Honorary Fellow of the London Institute.

2000
Awarded Honorary Doctorate from the University of Oxford.

2000–03
Produced his largest set of prints 'Into the Woods', published by Alan Cristea Gallery, London.

List of exhibitions

Solo exhibitions

1969

Howard Hodgkin: 5 Rooms, Alecto Gallery, London, 15 April–16 May.

1970

Howard Hodgkin, Arnolfini Gallery, Bristol, 16 September–22 October.

Howard Hodgkin: Paintings and Prints, Dartington Hall, Totnes, 29 October–18 November.

1971

Howard Hodgkin: Recent Prints, Park Square Gallery, Leeds, 3–27 November.

1972

Howard Hodgkin: Screenprints, Waddington Galleries, London, 8–30 March.

Howard Hodgkin: Recent Screenprints / Indian Views, Arnolfini Gallery, Bristol, 22 June–19 July.

1976

Howard Hodgkin Prints, Tate Gallery, London, 4 May–13 June.

1976–78

Howard Hodgkin: A Recorded Talk on his Paintings, 'Indian Views', Screenprints and Lithographs (British Council Touring Exhibition), touring India.

1977–79

Howard Hodgkin: Complete Prints, Museum of Modern Art, Oxford, 12 June–10 July 1977; touring in the Southern Arts Association area and later throughout England until the end of October 1979.

1980

Howard Hodgkin Prints, Bernard Jacobson Gallery, New York, 22 April–7 June.

Howard Hodgkin, Petersburg Press, New York and London, 24 April–31 May.

1981

Twenty Prints by Howard Hodgkin, Bernard Jacobson Gallery, New York, 28 April–30 May.

Howard Hodgkin, Lawrence V. Dillon Gallery, Seattle, Washington, May.

Prints by Howard Hodgkin, Jane Bickerton Fine Arts, Atlanta, Georgia, beginning of May–31 July.

1981–82

Howard Hodgkin Recent Prints (coordinated by the University of Queensland Art Museum with the assistance of the British Council), Macquarie Galleries, Sydney, 26 October–21 November 1981; touring in Australia to Melbourne University Gallery, Melbourne, February–March 1982; Queen Victoria Museum and Art Gallery, Launceston, March–May 1982; Contemporary Art Society of South Australia, Parkside, May–June 1982; Art Gallery of Western Australia, Perth, June–July 1982; Newcastle Region Art Gallery, Newcastle, August–September 1982; University of Queensland Art Museum, Brisbane, September–October 1982.

1982

Howard Hodgkin: Recent Prints, Bernard Jacobson Gallery, London, 18 September–9 October.

Howard Hodgkin's Indian Leaves, Tate Gallery, London, 22 September–7 November.

Prints: Howard Hodgkin, Jacobson/Hochman Gallery, New York, 9 November–4 December.

Howard Hodgkin Prints from 1967–1982, Petersburg Press, New York and London, December.

1984

Howard Hodgkin, Bernard Jacobson Gallery, New York, 10 April–22 May.

Howard Hodgkin. Prints Made in New York (Bath Festival Exhibition), Festival Gallery, Bath, 25 May–16 June.

Howard Hodgkin: A Selection of Prints, Marsha Mateyka Gallery, Washington D.C., 13 October–10 November.

1985

Howard Hodgkin. Works on Paper. Paintings Created in India, 1978. Hand Colored Prints, 1977–83, L.A. Louver Gallery, Venice, California 8 January–2 February.

Howard Hodgkin: Works on Paper, The Harcus Gallery, Boston, Massachusetts, 15 June–24 July.

Howard Hodgkin: New Prints and Selected Graphics since 1977, Petersburg Press, London, 1 September–end October.

Howard Hodgkin: Prints, Bernard Jacobson Gallery, London, 18 September–21 October.

Howard Hodgkin: Prints 1977 to 1983, Tate Gallery, London, 18 September–1 December.

Howard Hodgkin: Prints, Mary Ryan Gallery, New York, 28 September–16 October.

Howard Hodgkin: Important Works on Paper 1977–85, Dolan Maxwell Gallery, Philadelphia, 1–31 December.

1985–86

Howard Hodgkin: Prints, Albright-Knox Art Gallery, Buffalo, New York, 11 December 1985–19 January 1986.

1985–90

Howard Hodgkin: Opera grafica 1977–1983 (British Council Touring Exhibition), Italy (Galleria Comunale d'Arte Moderna, Bologna, 12 October–9 December 1985; Galleria d'Arte Moderna, Verona, 18 January–16 February 1986; Palazzo dei Leoni, Messina, 23 February–16 March 1986; Museo Bellomo, Siracusa, 25 March–12 April 1986); and as *Howard Hodgkin: Prints 1977–83* touring in Sweden (Galleri Cardinel, Helsingborg, 20 September–5 October 1986; Konstmuseum, Kolmar, 8 October–23 November 1986); Poland (Studio Galeria, Warsaw, 1 December 1986–5 January 1987); Finland (Gallery Kluuvi, Helsinki, 7–20 January 1987); Norway (Henie-Onstad Artcenter, Høvikodden, 7 February–8 March 1987; Ibsenhuset, Skien, 12–22 March 1987); Denmark (Horsens Kunstmuseum, Lund, 11 April–10 May 1987); as *Howard Hodgkin: Gravuras 1977–83* touring in Brazil (Museu Nacional de Belas Artes, Rio de Janeiro, 23 July–16 August 1987; Galeria de Arte do Conjunto Cultural Caixa Economia Federal Brasilia, Brasilia, 1–19 September 1987; Museu de Arte de São Paolo 'Assis Chateaubriand', São Paolo, 1 October–1 November 1987; Museu de Arte do Rio Grande do Sul, Porto Alegre, 12 November–6 December 1987); as *Howard Hodgkin: Grabados 1977–83* touring in Uruguay (Museo Nacional de Artes Plasticas y Visuales, Montevideo, 20–30 April 1988); and Chile (Universidad Santa Maria, Valparaiso, 9–24 June 1988; Sala Universitaria, Concepcion, 13–29 July 1988; Chilean British Institute, Santiago, 29 August–9 September 1988); with the addition of four recent works from Waddington Graphics, London and as *Howard Hodgkin: Prints 1977–1988* (updated edition) touring in Spain (Museo de Bellas Artes de Bilbao, Bilbao, 6–30 March 1989; Centro Cultural, Caixa de Terrasa, Terrasa, 4–28 May 1989; Sala de la Caja de Ahorros de Valencia, Valencia, 1 June–15 July 1989; Centro Cultural 'Garcia Barbon', Vigo, 2–28 August 1989; Caja de Ahorros de Leon, Leon, 1–30 October 1989; Torreon de Lozoya, Segovia, 10–26 November 1989; Caja de Ahorros Provincial de Valladolid, Valladolid, 2–19 December 1989; Palacio Almudi, Murcia, 28 February–15 March 1990); as *Howard*

Hodgkin: Epreuves 1977–1988 touring in
Morocco (Dudayas Museum, Rabat, 18 April–
12 May 1990); and in Greece (Zoumboulakis
Gallery, Athens, 27 September–6 October
1990; Municipal Library, Thessaloniki,
11–25 October 1990).

1986
Howard Hodgkin. Selected Prints: 1979–85,
Marsha Mateyka Gallery, Washington, D.C.,
7–28 February.
Howard Hodgkin Prints 1966–1986, Bernard
Jacobson Gallery, New York, 17 May–14 June.
Howard Hodgkin: Prints, Odette Gilbert Gallery,
London, 30 July–13 September.
Howard Hodgkin Prints 1966–1986, Jan Turner
Gallery, Los Angeles, 12 September–
11 October.

1987
Howard Hodgkin Works on Paper, The Harcus
Gallery, Boston, Massachusetts, end of
June–24 July.

1988
*Howard Hodgkin: Hand-colored Lithographs and
Etchings*, Barbara Ingber Gallery, New York,
8 March–16 April.
Selected Prints: Howard Hodgkin, Gallery Ikeda-
Bijutsu, Tokyo, 7–19 November.
Howard Hodgkin: Solo Prints, Solo Gallery,
New York, 8 November–10 December.
Howard Hodgkin at Björn Olsson Gallery,
Björn Olsson Gallery, Stockholm,
10–22 December.

1989
Prints Howard Hodgkin, Solo Gallery, New York,
January–February.
Howard Hodgkin: Selected Graphics, Marsha
Mateyka Gallery, Washington, D.C., 11 March–
15 April.
Howard Hodgkin, Gallery Ikeda-Bijutsu, Tokyo,
17–29 July.
Howard Hodgkin: Prints 1977–1986, Marian Locks
Gallery, Philadelphia, 10 October–
4 November.
Howard Hodgkin: Etchings and Lithographs 1980–86,
Joanne Chappel Gallery, San Francisco.

1990
*Howard Hodgkin. Graphic Work: Fourteen Hand-
coloured Lithographs and Etchings 1977–1987*,
Lumley Cazalet, London, 21 June–20 July.
Howard Hodgkin: Paintings and Graphics,
Ganz Gallery, Cambridge, 15 October–
10 November.
Howard Hodgkin: Prints 1980–88, Reynolds/Minor
Gallery, Richmond, Virginia.

1991
*'The Way We Live Now' by Susan Sontag and Howard
Hodgkin*, Karsten Schubert, London,
21 March–20 April.
Howard Hodgkin: Hand-coloured Prints 1986–1991,
Waddington Graphics, London, 27 March–
20 April.
*Susan Sontag and Howard Hodgkin – The Way
We Live Now*, Brooke Alexander Editions,
New York, 3–25 May.
Howard Hodgkin: Hand-coloured Prints, Castlefield
Gallery, Manchester, 25 May–13 July.
Howard Hodgkin: Selected Prints, Locks Gallery,
Philadelphia, 16 October–9 November.
Howard Hodgkin, Ikeda & Lokker, London.

1992
Howard Hodgkin: Graphik, Hachmeister Galerie,
Münster, 20 March–2 May.
Howard Hodgkin: Hand-coloured Prints 1986–1991,
Kerlin Gallery, Dublin, 12 September–
7 October.

1992–93
*The Way We Live Now: Susan Sontag & Howard
Hodgkin* (British Council Touring Exhibition),
Tythe Barn Gallery, near Llantwit Major,
South Glamorgan, 4 April–2 May 1992; Royal
Festival Hall, South Bank, London, 9 May–
7 June 1992; London Lighthouse, London,
22 August–20 September 1992; Hove Museum
and Art Gallery, Hove, 26 September–
25 October 1992; Chertsey Museum, Chertsey,
31 October–28 November 1992; Marie Curie
Centre, Liverpool, 9 January–7 February 1993;
Polytechnic, Nottingham, 13 February–
14 March 1993; Croydon, dates unknown;
City Arts Centre, Edinburgh, 3 July–1 August
1993; Duncan of Jordanstone College,
Dundee, 18 October–12 November 1993.

1994
Howard Hodgkin Prints: Vision and Collaboration,
Dimock Gallery, George Washington
University, Washington, D.C., 22 September–
26 October.

1995
*Carborundum Etchings (1987–1994) by Howard
Hodgkin*, Belloc Lowndes Fine Art, Chicago,
Illinois, 25 May–15 July.
Howard Hodgkin Prints, Smith Andersen Gallery,
Palo Alto, California, 31 May–27 June.
Howard Hodgkin Prints 1977–1995, Jim Kempner
Fine Art, New York, 1 November–
23 December.
Howard Hodgkin: Venetian Views 1995, Alan
Cristea Gallery, London, 22 November–
22 December.

1996
Howard Hodgkin: Graphik, Hachmeister Galerie,
Münster, 24 February–28 March.
Howard Hodgkin, Galerie Hete A.M. Hünermann,
Düsseldorf, 6 September–25 October.

1996–97
Howard Hodgkin 'Indian Views' 1971, Art Inc.,
New Delhi, 8 December 1996–15 January 1997.

1997
Howard Hodgkin Original Prints, Wiseman
Originals, London, 30 January–26 March.
Howard Hodgkin Prints 1977–1987, Susan Sheehan
Gallery, New York, 3 February–8 March.

1998
Howard Hodgkin: Etchings with Hand Colouring,
Wiseman Originals, London, 19 May–early
July.
Sir Howard Hodgkin: Original Prints (organized
by Wiseman Originals), Acadia, London,
18 June–August.
Howard Hodgkin. Handcoloured Etchings, Ingleby
Gallery, Edinburgh, 5 August–12 September.
Howard Hodgkin, Galerie Lutz & Thalmann,
Zurich, 18 September–14 November.
*Howard Hodgkin: A Selection of Hand-colored
Lithographs and Etchings from the 70s through
the 90s*, Jim Kempner Fine Art, New York,
6 November–24 December.

1998–99
*Howard Hodgkin: Arbeiten auf Papier von 1971
bis 1995*, Staatliches Museum für Naturkunde
und Vorgeschichte, Oldenburg, 4 October–
1 November 1998; Freunde und Forderer
des Museums in Ratingen, Ratingen,
4 December 1998–31 January 1999.

1999
Howard Hodgkin: Etchings with Handcolouring,
Wiseman Originals, London, 19 May–30 June.

1999–2000
Howard Hodgkin: Etchings with Handcolouring,
Wiseman Originals, New York, 13 December
1999–31 January 2000.

2001
Howard Hodgkin. Volume I: Small Prints, Alan
Cristea Gallery, London, 4 May–2 June.
Howard Hodgkin. Small Prints, Ingleby Gallery,
Edinburgh, 6 June–21 July.
Howard Hodgkin. Volume II: Into the Woods,
Alan Cristea Gallery, London, 7–30 June.
Howard Hodgkin, Robert Sandelson Gallery,
London, 12 June–28 July (included
paintings).

2002

Howard Hodgkin: Hand-painted Etchings,
Pace Prints, New York, 18 January–
9 March.

Howard Hodgkin: Small Prints, Galerie Lutz &
Thalmann, Zurich, 8 February–27 March.

*Howard Hodgkin: Into the Woods (2001–2): Four
Large Prints*, Galerie Lutz & Thalmann, Zurich,
22 August–21 September.

2003

Howard Hodgkin: Paintings and Prints, Robert
Sandelson Gallery, London, 4 February–
16 March.

Group exhibitions

1955

Corsham Lithographs and Other Prints, Dartington
Hall, Totnes, 4 June–26 August.

1964

ICA Screen-print project, The Institute of
Contemporary Arts, London, 10–28
November.

1965

Op and Pop: Aktuell engelsk Konst, Riksförbundet
för bildande konst och SAN, Stockholm.

*The 5th International Biennial Exhibition of Prints
in Tokyo*, National Museum of Modern Art,
Tokyo, November–December.

ICA 65 Print Fair, The Institute of Contemporary
Arts, London, 1–21 December.

Premio Internazionale Biella per l'Incisione, Circolo
degli artisti, Biella, December.

1967

Jeunes peintres anglais, Galerie Alice Pauli,
Lausanne, 16 February–14 March.

Graphik junger Engländer, Marie-Suzanne Feigel,
Basel, 8 April–3 May.

*Cinquième Biennale de Paris: Manifestation Biennale
et Internationale des jeunes artistes*, Musée d'Art
Moderne de la Ville de Paris, Paris,
30 September– 5 November.

Transatlantic Graphics 1960–67, Laing Art
Gallery and Museum, Newcastle-upon-Tyne,
30 September–21 October; Camden Arts
Centre, London, 7 November–16 December.

1968

*EA. Arte Moltiplicata: Prints by Young British
Artists*, Galleria Milano, Milan, 11 April–
early June.

*The 6th International Biennial Exhibition of Prints
in Tokyo*, National Museum of Modern Art,
Tokyo, 2 November–15 December.

1968–69

British International Print Biennale, Cartwright
Hall Art Gallery, Bradford, 23 November
1968–19 January 1969.

1969

Hodgkin, Smith, Alecto Gallery, London,
1–28 February.

Ayres, Davie, Hodgkin, Scott, Forum Stadtpark,
Graz (in collaboration with the Alecto
Gallery, London), 14–30 March.

12 Britische Artisten: Graphik und Objekte,
Künstlerhaus-Galerie, Vienna,
18 September–19 October.

Pop Art Graphics, Carnegie Festival of Music
and the Arts, London.

1970–71

Kelpra Prints (Arts Council of Great Britain
Touring Exhibition), Hayward Gallery, London,
17 June–7 July 1970; Kupferstichkabinett
Staatliche Museen Preussischer Kulturbesitz,
Berlin, 5 September –end October 1970;
a smaller version of the exhibition toured
in centres outside London from the
beginning of 1971.

1971

Britisk Grafikk (British Council Exhibition
in collaboration with the Kgl.
utenriksdepartement, Oslo), Kunstnernes
Hus, Oslo, 13–21 March.

Graphics from Editions Alecto London,
Desmos Gallery, Athens, 26 November–
26 December.

1972

Original Prints by David Hockney and Howard Hodgkin,
Ashgate Gallery, Farnham, 15 February–
9 March.

Alecto International – 10th Anniversary Exhibition,
Glasgow School of Art, Glasgow,
21 February–March.

Contemporary Prints, Ulster Museum, Belfast
(in collaboration with Waddington Galleries,
London), 5 July–10 September.

1973

Estampes anglaises actuelles, Galerie Stadler, Paris,
8 February–3 March.

British Artists' Prints 1961–1970, National
Museum of Fine Arts, Valletta, Malta, March.

Present Impressions: Prints 1973, Oxford Gallery,
Oxford, 22 October–28 November.

1974

Graveurs anglais contemporains, Cabinet des
estampes du musée d'art et histoire, Geneva,
5 April–5 May.

1975

*British Art: mid-70s. Englische Kunst Mitte der
Siebzigerjahre*, Jahrhunderthalle Hoechst,
Leverkusen, 26 March–25 April; Forum
Leverkusen, 7–28 May.

*Figurative Paintings from Tokyo: Paintings and Prints
by the British Exhibitors in the 1st International
Biennial Exhibition of Figurative Painting in Tokyo*,
Portsmouth City Museum and Art Gallery,
Portsmouth, 31 May–6 July.

1976

For John Constable, Tate Gallery, London,
17 February–5 May.

For John Constable, Atmosphere, London,
February– May.

A Selection from the Print Department, Tate Gallery,
London, 18 May–13 June.

1976–77

Graphics '76: Britain, University of Kentucky
Art Gallery, Lexington, Kentucky, 22 February–
14 March 1976; Mason County Museum,
Maysville, Kentucky, 1–31 August 1976;
Milwaukee Fine Arts Gallery, University
of Wisconsin, Milwaukee, Wisconsin,
10 September–12 December 1976; Carroll
Reece Museum, East Tennessee State
University, Johnson City, Tennessee,
2 January–6 February 1977; Stephens College,
Columbia, Missouri, 3 April–1 May 1977;
Stevenson Union, Southern Oregon State
College, Ashland, Oregon, 15 May–12 June
1977; Morehead University, Morehead,
Kentucky, 14 August–18 September 1977;
Springfield Art Museum, Springfield,
Missouri, 2–30 October 1977.

1977

*Artists at Curwen: A Celebration of the Gift of Artists'
Prints from the Curwen Studio*, Tate Gallery,
London, 23 February–11 April.

1978

A Selection from the Print Department, Tate Gallery,
London, 13 March–30 June.

*Petersburg Press: An Exhibition of Rare Prints and
Books Published by Petersburg Press (1968–1978)*,
L.A. Louver Gallery, Venice, California,
16 May–27 June.

*Howard Hodgkin: New Hand-coloured Lithographs;
Alistair Crawford: Paintings and Prints*, Ian
Birksted Gallery, London, 25 November–
14 December.

1979

Colour 1950–1978, Durham Light Infantry
Museum and Durham Art Gallery, Durham,
13 January–11 March.

Sixth British International Print Biennale,
 Cartwright Hall Art Gallery, Bradford,
 20 May–22 July.

1979–80
The Craft of Art, Walker Art Gallery, Liverpool,
 3 November 1979–3 February 1980.

1980
Printed Art: A View of Two Decades, Museum
 of Modern Art, New York, 14 February–
 1 April.
*Prints by Howard Hodgkin: 1977–1979; Claes
 Oldenburg: 1971–1979*, Waddington Galleries,
 London, 10 April–10 May.
Art Exhibition, Town Hall, Malmesbury,
 20–28 June.
*Kelpra Studio: An Exhibition to Commemorate the
 Rose and Chris Prater Gift*, Tate Gallery, London,
 9 July–25 August.
Obra Gràfica Britànica, Fundació Joan Miró,
 Barcelona, 18 September–26 October.

1980–81
Recent Acquisitions for the Print Collection,
 Tate Gallery, London, 19 November 1980–
 15 February 1981.

1981
*New Publications by Henry Moore, Michael Heindorff
 and Howard Hodgkin*, Bernard Jacobson Gallery,
 London, April–May.
Landscape: The Printmaker's View, Tate Gallery,
 London, 13 May–26 July.
Original Prints, Arnolfini Gallery, Bristol,
 4–29 August.
New Publications, Jacobson/Hochman Gallery,
 New York, 27 October–28 November.
*Recent Lithographs and Etchings by David Hockney,
 Frank Stella, Howard Hodgkin, Jasper Johns and
 Robert Motherwell*, Petersburg Press, London,
 December.
*New Work by Ivor Abrahams, Frank Auerbach, Robyn
 Denny, Michael Heindorff, Howard Hodgkin,
 Richard Smith, William Tillyer*, Bernard Jacobson
 Gallery, London, December.

1981–82
Prints: Acquisitions 1977–1981, Museum of
 Modern Art, New York, November 1981–
 5 January 1982.
*Prints by Six British Painters: Stephen Buckley, Robyn
 Denny, Howard Hodgkin, John Hoyland, Richard
 Smith, John Walker*, Tate Gallery, London,
 18 November 1981–28 February 1982.

1982
The Print Collection: a Selection, Tate Gallery,
 London, 9 March–6 June.

Howard Hodgkin, Norman Adams, Oxford Gallery,
 Oxford, 19 April–12 May.

1982–83
Big Prints (Arts Council of Great Britain Touring
 Exhibition), Southampton City Art Gallery,
 Southampton, 17 April–23 May 1982;
 Fruitmarket Gallery, Edinburgh, 29 May–
 26 June 1982; Central Museum and Art Gallery,
 Dudley, 21 August–25 September 1982; Arts
 Centre, Aberystwyth, 9 October–6 November
 1982; Cooper Gallery, Barnsley, 1 January–
 6 February 1983; Wolverhampton Art Gallery,
 Wolverhampton, 12 February–19 March 1983.
Kelpra Studio: 25 Years, Wigan Education Art
 Centre, Wigan, 1 November–17 December
 1982; Milton Keynes Exhibition Gallery,
 Milton Keynes, 8–29 January 1983.

1983–85
*The British Art Show: Old Allegiances and New
 Directions 1979–1984* (Arts Council of Great
 Britain Touring Exhibition), Hayward
 Gallery, London, 10 February–17 April 1983;
 Wolverhampton Art Gallery, Wolverhampton,
 23 April–21 May 1983; Herbert Art Gallery
 and Museum, Coventry, 4 June–10 July 1983;
 Bolton Museum and Art Gallery, Bolton,
 16 July–20 August 1983; Graves Art Gallery,
 Sheffield, 27 August–2 October 1983; City
 of Birmingham Museum and Art Gallery
 and Ikon Gallery, 2 November–22 December
 1984; Royal Scottish Academy, Edinburgh,
 19 January–24 February 1985; Mappin Art
 Gallery, Sheffield, 16 March–4 May 1985;
 Southampton Art Gallery, Southampton,
 18 May–30 June 1985.

1984
*Prints by Contemporary British Artists: Howard
 Hodgkin, Michael Heindorff, William Tillyer*,
 Marsha Mateyka Gallery, Washington, D.C.,
 4 February–3 March.
Art and Sports. Premiere Group Exhibition,
 Spectrum Fine Art Gallery, New York,
 29 September–28 October.

1985
Ninth British International Print Biennale,
 Cartwright Hall Art Gallery, Bradford,
 23 March–22 June.

1986
Recent Acquisitions: Contemporary Prints, University
 of Kentucky Art Museum, Lexington,
 Kentucky, 19 January–16 March.
In Black and White: Prints, Drawings and Photographs,
 Marsha Mateyka Gallery, Washington, D.C.,
 19 November–13 December.

1986–87
Under the Cover of Darkness: Night Prints (Arts
 Council of Great Britain Touring Exhibition),
 City Museum and Art Gallery, Bristol,
 4 October–8 November 1986; Durham Light
 Infantry Museum and Durham Art Gallery,
 Durham, 15 November–24 December 1986;
 Graves Art Gallery, Sheffield, 10 January–
 15 February 1987.
70s into 80s: Printmaking Now, Museum of Fine
 Arts, Boston, 22 October 1986–8 February
 1987.

1987
*Recent Prints: Richard Diebenkorn, Howard Hodgkin,
 Robert Motherwell*, Mary Ryan Gallery, New
 York, 28 February–21 March.
Hand-coloured British Prints, Victoria and Albert
 Museum, London, 18 March–5 July.
Contemporary Prints, Mary Ryan Gallery, New
 York, 19 August–16 September.
*Recent Acquisitions: Sam Francis, Howard Hodgkin,
 Shoichi Ida, Wayne Thiebaud, William T. Wiley*,
 Marsha Mateyka Gallery, Washington, D.C.,
 5–19 December.

1988
Prints in Series, Mary Ryan Gallery, New York,
 21 May–25 June.
Cunningham Benefit Art Exhibition and Sale,
 BlunHelman Gallery, New York, 1–4 June.
A Golden Age. The Artist Works with Paper,
 Meredith Long & Company, Texas, 19 July–
 9 September.
Modern and Contemporary Prints, Ikeda & Lokker,
 London.

1989
Works on Paper, Waddington Galleries, London,
 1–25 February.
Selections from the Permanent Collection, University
 of Kentucky Art Museum, Lexington,
 Kentucky, 24 April–summer.
School of London: Works on Paper, Odette
 Gilbert Gallery, London, 20 September–
 4 November.

1989–90
*The 1980s: Prints from the Collection of Joshua P.
 Smith*, National Gallery of Art, Washington,
 D.C., 17 December 1989–8 April 1990.
*Three Universities Collect: 20th-Century Works on
 Paper*, The Snite Museum of Art, University
 of Notre Dame, South Bend, Indiana,
 17 September–10 November 1989; Indiana
 University Art Museum, Bloomington,
 Indiana, 23 January–4 March 1990; University
 of Kentucky Art Museum, Lexington,
 Kentucky, 1 April–13 May 1990.

1992

Dürer to Diebenkorn: Recent Acquisitions of Art on Paper, National Gallery of Art, Washington, D.C., 10 May–7 September.

Centennial Prints in Honor of the 100th Anniversary of the Modern Art Museum of Fort Worth, Charles Cowles Gallery, New York, 21–23 May.

11: Mary Ryan Gallery 11th Year Anniversary Group Show, Mary Ryan Gallery, New York, 1–24 October.

Singular and Plural. Recent Accessions, Drawings and Prints: 1945 to 1991, Museum of Fine Arts, Houston, 9 June–23 August.

Mixed Exhibition, Bernard Jacobson Gallery, London, 8–23 December.

1994

Prints from Solo Impression Inc., New York, The College of Wooster Art Museum, Wooster, Ohio, 24 August–9 October.

National Westminster Bank: Contemporary Art Collection, Royal West of England Academy, Bristol, 11 September–1 October.

1994–95

A Century of Artists Books, Museum of Modern Art, New York, 23 October 1994–24 January 1995.

1994–2001

Out of Print: British Printmaking, 1946–1976 (British Council Touring Exhibition), France (Musée du Dessin et de l'Estampe Originale, Gravelines, 12 June–2 October 1994); Belgium (Cultureel Centrum Luchtbal, Antwerp, 12 November–18 December 1994); Italy (Associazione Culturale Italia Inghilterra, Cagliari, 20 March–28 April 1995; Circolo Artistico, Naples, 8 May–8 June 1995); Egypt (Museum of Modern Egyptian Art, Gezira,

17–28 October 1995); Cyprus (Arts Centre, Nicosia, 15 November 1995–15 January 1996); Spain (Museo de Bellas Artes de Bilbao, Bilbao, 4 April–30 May 1996; Museo de Arte Contemporaneo, Seville, 10 July–15 September 1996; La Curuña, Galicia, 6 November 1996–2 February 1997); United States (Museum of Art, Brigham Young University, Provo, Utah, 1 September–21 November 1997; Stedman Art Gallery, Rutgers State University of New Jersey, Camden, New Jersey, 12 January–25 February 1998; Springfield Museum of Art, Springfield, Ohio, 14 March–10 May 1998; Mary Washington College Galleries, Fredericksburg, Virginia, 22 January–21 March 1999); Poland (National Museum, Warsaw, 21 June–30 July 1999; Museum Sztuki, Lodz, 4 September–3 October 1999; Museum Gornoslaskie, Bytom, 18 November 1999–circa 9 January 2000); Germany (Roemer- und Pelizaeus Museum, Hildesheim, 15 March–31 July 2001).

1995

Where You Were Even Now: Alison Gajra, Anya Gallaccio, Howard Hodgkin, Maggie Roberts, Elizabeth Wright, Kunsthalle Winterthur, Winterthur, 13 May–8 July.

1996–97

Brancusi to Beuys: Works from the Ted Power Collection, Tate Gallery, London, 19 November 1996–16 February 1997.

Colour Etchings: Jim Dine, John Hoyland, Robert Motherwell, Mimmo Paladino, Howard Hodgkin, Joe Tilson, Alan Cristea Gallery, London, 4 December 1996–18 January 1997.

1997

Contemporary Master Graphics, Kelly Barrette Fine Art, Boston, 1–29 March.

Floral Affluence, Raab Boukamel Gallery, London, 19 March–26 April.

Masterpieces of Modern Printmaking, Alan Cristea Gallery, London, 23 June–1 August.

Prints by Howard Hodgkin and New Editions by Michael Craig-Martin, Mick Moon, Ian McKeever and Joe Tilson, Bobbie Greenfield Gallery, Santa Monica, 9 July–17 August.

Hockney to Hodgkin: British Master Prints 1960–1980, New Orleans Museum of Art, New Orleans, 12 July–31 August.

A Century of European Prints, 1925–1970, Mercury Gallery, London, 16 September–16 October.

A Century of European Prints, 1960–1997, Alan Cristea Gallery, London, 16 September–16 October.

1998

Contemporary Master Prints, Jim Kempner Fine Art, New York, 6 January–1 March.

Howard Hodgkin, Tobey, Soutter, Picasso, Hachmeister Galerie, Münster, 13 January–12 February.

ARTAID '98, Edinburgh City Art Centre, Edinburgh, 28 February–21 March.

1999

Signature Pieces. Contemporary British Prints and Multiples, Alan Cristea Gallery, London, 5 January–6 February.

Prints: Mimmo Paladino, Jennifer Bartlett, Howard Hodgkin, Jasper Johns, Georg Baselitz, Elizabeth Murray, Philip Guston, Locks Gallery, Philadelphia, 8 January–27 February.

Contemporary Master Prints, Stein Gallery, St Louis, Missouri, 18 June–31 July.

1999–2000

1995–2000. Five Years of Print Publishing, Alan Cristea Gallery, London, 17 November 1999–5 February 2000.

Bibliography

Solo exhibition catalogues

1976
Pat Gilmour, *Howard Hodgkin Prints* (leaflet), Tate Gallery, London.

1976–78
Margaret Mcleod, *Howard Hodgkin: A Recorded Talk on his Paintings, 'Indian Views', Screenprints and Lithographs* (British Council Touring Exhibition).

1977–79
Penelope Marcus, *Howard Hodgkin: Complete Prints*, Museum of Modern Art, Oxford (touring).

1981–82
Sean Rainbird (intro.), *Howard Hodgkin Recent Prints*, coordinated by the University of Queensland Art Museum with the assistance of the British Council (touring).

1985
Elizabeth Knowles (ed.), *Howard Hodgkin: Prints 1977 to 1983*, Tate Gallery, London.

1985–90
Enrico Crispolti (intro.), *Howard Hodgkin: Opera grafica 1977–1983* (British Council Touring Exhibition) (English and Portuguese dual text edition; French edition; Spanish edition. English text edition by Teresa Gleadowe. With an additional four prints, the leaflet was updated and retitled *Howard Hodgkin: Prints 1977–1988*).

1988
Junichi Shiota (intro.), *Selected Prints: Howard Hodgkin* (leaflet), Gallery Ikeda-Bijutsu, Tokyo.

1989
Howard Hodgkin, Gallery Ikeda-Bijutsu, Tokyo.

1990
John Russell (intro.), *Howard Hodgkin. Graphic Work: Fourteen Hand-coloured Lithographs and Etchings 1977–1987*, Lumley Cazalet, London.
Howard Hodgkin: Paintings and Graphics, Ganz Gallery, Cambridge.

1991
Yoko Ikeda and Raymond Lokker, *Howard Hodgkin*, Ikeda & Lokker, London.
Antony Peattie (interview), *Howard Hodgkin: Hand-coloured Prints 1986–1991*, Waddington Graphics, London.

1994
Lenore Miller, *Howard Hodgkin Prints: Vision and Collaboration*, Dimock Gallery, George Washington University, Washington, D.C.

1995
Craig Hartley (intro.), *Howard Hodgkin: Venetian Views 1995*, Alan Cristea Gallery, London.

1998–99
Raimund Stecker, *Howard Hodgkin: Arbeiten auf Papier von 1971 bis 1995*, Staatliches Museum für Naturkunde und Vorgeschichte, Oldenburg; Freunde und Forderer des Museums in Ratingen, Ratingen.

2001
Alan Cristea (intro.), *Howard Hodgkin. Volume I: Small Prints*, Alan Cristea Gallery, London.
Alan Cristea (intro.), *Howard Hodgkin. Volume II: Into the Woods*, Alan Cristea Gallery, London.

2002
Gabriele Lutz (intro.), *Howard Hodgkin*, Galerie Lutz & Thalmann, Zurich.

Group exhibition catalogues

1955
Corsham Lithographs & Other Prints, Dartington Hall, Totnes.

1965
Luigi Carluccio, *Premio Internazionale Biella per l'Incisione*, Circolo degli artisti, Biella.
The 5th International Biennial Exhibition of Prints in Tokyo, National Museum of Modern Art, Tokyo.
Op and Pop: Aktuell engelsk konst, Riksförbundet för bildande konst och SAN, Stockholm.

1967
Gene Baro, *Transatlantic Graphics 1960–67*, Laing Art Gallery and Museum, Newcastle-upon-Tyne; Camden Arts Centre, London.
Cinquième Biennale de Paris: Manifestation Biennale et Internationale des jeunes artistes, Musée d'Art Moderne de la Ville de Paris, Paris.

1968
The 6th International Biennial Exhibition of Prints in Tokyo, National Museum of Modern Art, Tokyo.
Marco Valsecchi (intro.), *EA. Arte Moltiplicata: Prints by Young British Artists*, Galleria Milano, Milan.

1968–69
Rosemary Simmons (intro.), *British International Print Biennale*, Cartwright Hall Art Gallery, Bradford.

1969
Kristian Sotriffer (intro.), *12 Britische Artisten: Graphik und Objekte*, Künstlerhaus-Galerie, Vienna.

1970–71
Ronald Alley (intro.), *Kelpra Prints* (Arts Council of Great Britain Touring Exhibition).

1971
Britisk Grafikk (British Council Exhibition in collaboration with the Kgl. utenriksdepartement, Oslo), Kunstnernes Hus, Oslo.
Charles Spencer (intro.), *Graphics from Editions Alecto London*, Desmos Gallery, Athens.

1972
Charles Spencer (intro.), *Alecto International – 10th Anniversary Exhibition*, Glasgow School of Art, Glasgow.

1973
Edward Lucie-Smith (intro.), *British Artists' Prints 1961–1970* (organized by the British Council in cooperation with the Ministry of Education and Culture), National Museum of Fine Arts, Valletta, Malta.
Edward Lucie-Smith (intro.), *Present Impressions: Prints 1973*, Oxford Gallery, Oxford.

1974
Pat Gilmour (intro.), *Graveurs anglais contemporains*, Cabinet des estampes du musée d'art et histoire, Geneva.

1975
Norbert Lynton, *British Art: mid-70s. Englische Kunst Mitte der Siebzigerjahre* (organized by the Serpentine Gallery, London), Jahrhunderthalle Hoechst, Leverkusen (touring).
Roland Penrose, *Figurative Paintings from Tokyo: Paintings and Prints by the British Exhibitors in the 1st International Biennial Exhibition of Figurative Painting in Tokyo*, Portsmouth City Museum and Art Gallery, Portsmouth.

1976
Elizabeth Underhill, *For John Constable* (leaflet), Tate Gallery, London.

1976–77
Pat Gilmour (intro.), *Graphics '76: Britain*,
 University of Kentucky Art Gallery, Lexington,
 Kentucky (touring).

1977
Pat Gilmour, *Artists at Curwen: A Celebration of
 the Gift of Artists' Prints from the Curwen Studio*,
 Tate Gallery, London.

1979
Colour 1950–1978, Durham Light Infantry
 Museum and Durham Art Gallery, Durham.
Sixth British International Print Biennale,
 Cartwright Hall Art Gallery, Bradford.

1979–80
Edward Lucie-Smith, *The Craft of Art*, Walker
 Art Gallery, Liverpool.

1980
Art Exhibition, Town Hall, Malmesbury.
Riva Castleman, *Printed Art: A View of
 Two Decades*, Museum of Modern Art,
 New York.
Pat Gilmour (intro.), *Kelpra Studio: An Exhibition
 to Commemorate the Rose and Chris Prater Gift*,
 Tate Gallery, London.
Julie Lawson (intro.), *Obra Gràfica Britànica*,
 Fundació Joan Miró, Barcelona.

1980–81
Recent Acquisitions for the Print Collection, Tate
 Gallery, London.

1981
Landscape: The Printmaker's View, Tate Gallery,
 London.

1981–82
Elizabeth Underhill, *Prints by Six British Painters:
 Stephen Buckley, Robyn Denny, Howard Hodgkin,
 John Hoyland, Richard Smith, John Walker*, Tate
 Gallery, London.

1982–83
Frances Carey (intro.), *Big Prints* (Arts
 Council of Great Britain Touring
 Exhibition).
A. R. Taylor, *Kelpra Studio: 25 Years*, Wigan
 Education Art Centre, Wigan (touring).

1983–85
*The British Art Show: Old Allegiances and New
 Directions 1979–1984* (Arts Council of Great
 Britain Touring Exhibition).

1985
Ninth British International Print Biennale,
 Cartwright Hall Art Gallery, Bradford.

1986–87
David Alston, *Under the Cover of Darkness: Night
 Prints* (Arts Council of Great Britain Touring
 Exhibition).

1987
Elizabeth Miller, *Hand-coloured British Prints*,
 Victoria and Albert Museum, London.

1989
Works on Paper, Waddington Galleries, London.
Alistair Hicks (intro.), *School of London: Works on
 Paper*, Odette Gilbert Gallery, London.

1989–90
Ruth Fine (ed.), *The 1980s: Prints from the
 Collection of Joshua P. Smith*, National Gallery
 of Art, Washington, D.C.
*Three Universities Collect: 20th-Century Works
 on Paper*, Indiana University Art Museum,
 Bloomington, Indiana (touring).

1992
Andrew Robison, *Dürer to Diebenkorn: Recent
 Acquisitions of Art on Paper*, National Gallery
 of Art, Washington, D.C.

1994
Ruth Fine and Kathleen McManus Zurko, *Prints
 from Solo Impression Inc., New York*, The College
 of Wooster Art Museum, Wooster, Ohio.
Lord Alexander of Weedon (intro.), *National
 Westminster Bank: Contemporary Art Collection*,
 Royal West of England Academy, Bristol.

1994–95
Riva Castleman, *A Century of Artists Books*,
 Museum of Modern Art, New York.

1994–2000
Richard Riley, *Out of Print: British Printmaking,
 1946–1976* (British Council Touring Exhibition).

1995
Roman Kurzmeyer, *Where You Were Even Now:
 Alison Gajra, Anya Gallaccio, Howard Hodgkin,
 Maggie Roberts, Elizabeth Wright*, Kunsthalle
 Winterthur, Winterthur.

1996–97
Jennifer Mundy (ed.), *Brancusi to Beuys: Works from
 the Ted Power Collection*, Tate Gallery, London.

1997
A Century of European Prints, 1925–1970, Mercury
 Gallery, London.
A Century of European Prints, 1960–1997, Alan
 Cristea Gallery, London.
Pat Gilmour, *Hockney to Hodgkin: British Master
 Prints 1960–1980*, New Orleans Museum of Art,
 New Orleans.

1998
Andrew Patrick, *ARTAID '98*, Edinburgh City
 Art Centre, Edinburgh.

1999
Marco Livingstone (intro.), *Signature Pieces:
 Contemporary British Prints and Multiples*,
 Alan Cristea Gallery, London.

Periodicals and newspaper articles

1964
Oswell Blakeston, 'Screen-print Project I.C.A.',
 The Arts Review, vol. 16, no. 23, 28 November–
 12 December, p. 8.

1966
Gene Baro, 'Britain's New Printmakers',
 Art in America, vol. 54, no. 3, May–June,
 pp. 96–98.

1967
Charles Spencer, 'Reproductibles', *Art & Artists*,
 vol. 1, no. 12, March, pp. 52–57.
Chris Prater, 'Experiment in Screenprinting',
 Studio, vol. 174, no. 895, December, p. 293.

1969
Simon Field, 'London: Editions Alecto',
 Art & Artists, vol. 4, no. 1, April, pp. 56–58.
'Print News', *The Sunday Times*, 20 April.
Pat Gilmour, 'Howard Hodgkin: Alecto
 Gallery', *Arts Review*, vol. 21, no. 8, 26 April,
 p. 277.

1970
'Two Exhibitions', *Dartington Hall News*,
 30 October, p. 7.
Auberry Pryor, 'Modern Primitives', *The Western
 Morning News*, 13 November, p. 5.

1971
W. Oliver, 'Simple – but Subtle', *The Yorkshire
 Post*, 5 November, p. 3.
Carol Kroch, 'Quality of Calmness in Prints',
 The Daily Telegraph, 16 November.

1972

'Ashgate Gallery: Art Combined with Irony and Satire', *Farnham Herald*, 18 February, p. 24.

Arthur Hackney, 'David Hockney – Howard Hodgkin', *Arts Review*, vol. 24, no. 4, 26 February, p. 105.

B.W., 'Trio at the Ashgate', *Surrey and Hants News and Mail*, 1 March.

Shelagh Hardie, 'Howard Hodgkin – John Hoskin', *Arts Review*, vol. 24, no. 13, 1 July, p. 398.

1975

Timothy Hyman, 'Howard Hodgkin', *Studio International*, vol. 189, no. 975, May–June, pp. 178, 180–81, 183; and vol. 190, no. 976, July–August, p. 88.

1976

Rosemary Simmons, 'Constable Portfolio', *Arts Review*, vol. 28, no. 5, 5 March, p. 117.

1977

Jacqueline Brody, 'Howard Hodgkin, *More Indian Views* (1976)', *The Print Collector's Newsletter*, vol. 7, no. 6, January–February, p. 181.

Jacqueline Brody, 'Howard Hodgkin, *Julian and Alexis* (1977)', *The Print Collector's Newsletter*, vol. 8, no. 5, November–December, p. 144.

1978

Linda Lee Bolton, 'Howard Hodgkin: Riverside Studios', *Arts Review*, vol. 30, no. 20, 13 October, p. 551.

Jacqueline Brody, 'Howard Hodgkin, *Green Chateau* (1978)', *The Print Collector's Newsletter*, vol. 9, no. 5, November–December, p. 162.

1979

'The Wonder of Paper Cut-outs', *Durham Advertiser*, 5 January, p. 9.

William Varley, 'Durham: Colour', *The Guardian*, 26 January, p. 10.

Jacqueline Brody, 'Howard Hodgkin, *Alone in the Museum of Modern Art* and *Not Quite Alone in the Museum of Modern Art* (1979)', *The Print Collector's Newsletter*, vol. 10, no. 3, July–August, p. 93.

Suzanne Boorsch, 'New Editions. Howard Hodgkin', *ARTnews*, vol. 78, no. 7, September, pp. 42, 44.

William Feaver, 'Crafty Stuff', *The Observer*, 16 December, p. 18.

Frances Spalding, 'A Deck of Cards', *Arts Review*, vol. 31, no. 25, 21 December, p. 710.

1980

Jacqueline Brody, 'Howard Hodgkin, *For Bernard Jacobson* (1979)', *The Print Collector's Newsletter*, vol. 10, no. 6, January–February, p. 201.

Marina Vaizey, 'Howard Hodgkin's Prints (Waddington)', *The Sunday Times*, 27 April, p. 40.

Fenella Crichton, 'London: Claes Oldenburg and Howard Hodgkin', *Art & Artists*, vol. 15, no. 2, June, pp. 40–43.

1981

Pat Gilmour, 'Howard Hodgkin', *The Print Collector's Newsletter*, vol. 12, no. 1, March–April, pp. 2–5.

Catherine Fox, 'Getting to Know Hodgkin's Art, A Delight', *The Atlanta Constitution*, June.

Deborah Phillips, 'New Editions: Howard Hodgkin', *ARTnews*, vol. 80, no. 7, September, p. 161.

1982

Jacqueline Brody, 'Howard Hodgkin, *One Down, Two to Go* (1982)', *The Print Collector's Newsletter*, vol. 13, no. 1, March–April, p. 22.

Jacqueline Brody, 'Howard Hodgkin, *Redeye* (1981)', *The Print Collector's Newsletter*, vol. 13, no. 3, July–August, p. 98.

Frances Spalding, 'Howard Hodgkin: Tate Gallery and Bernard Jacobson', *Arts Review*, vol. 34, no. 20, 24 September, p. 484.

Marina Vaizey, 'The Spirit of India', *The Sunday Times*, 26 September, p. 31.

John Russell Taylor, 'Tradition Remaining Strong and Rich', *The Times*, 28 September, p. 8.

Geeta Kapur, 'Hodgkin's *Indian Leaves*', *Art Monthly*, no. 61, November, p. 10.

Kn. Thurlbeck, 'Hodgkin at M. Knoedler and Petersburg Press', *Art Gallery Scene*, December, p. 4.

Guy Burn, 'Artists' New Prints: Bernard Jacobson', *Arts Review*, vol. 34, no. 26, 17–31 December, pp. 676–77.

1983

John McEwen, 'Howard Hodgkin – Indian Leaves', *Studio International*, vol. 196, no. 998, January–February, p. 57.

Jacqueline Brody, 'Howard Hodgkin, *Red Bermudas* (1982)', *The Print Collector's Newsletter*, vol. 13, no. 6, January–February, p. 218.

1984

Max Wykes-Joyce, 'Howard Hodgkin – Prints Made in New York', *Art & Artists*, no. 213, June, p. 27.

1985

Jacqueline Brody, 'Howard Hodgkin, *Blood and Sand* (1982–85)', *The Print Collector's Newsletter*, vol. 16, no. 3, July–August, p. 100.

Timothy Hyman, 'Howard Hodgkin. Making a Riddle Out of the Solution', *Art & Design*, vol. 1, no. 8, September, pp. 6–11.

John Russell Taylor, 'Toughness under the Lyric Grace', *The Times*, 24 September, p. 9.

Brian Sewell, 'The Mark of a Hypnotist', *The London Standard*, 3 October, p. 23.

Frances Spalding, 'The Nub of Feeling', *The Times Literary Supplement*, 4 October, p. 1103.

Mary Rose Beaumont, 'Howard Hodgkin at the Whitechapel Art Gallery, the Tate Gallery and Bernard Jacobson', *Arts Review*, vol. 37, no. 20, 11 October, p. 515.

John Spurling, 'Dotted about the Place', *The New Statesman*, 4 November, p. 32.

Jacqueline Brody, 'Howard Hodgkin. Prints 1977 to 1983 (Tate Gallery)', *The Print Collector's Newsletter*, vol. 16, no. 5, November–December, p. 182.

1986

Jeremy Lewison, 'Howard Hodgkin', *Carte d'Arte*, pp. 19–24.

Richard Huntington, 'The Illusion is Enticing in Hodgkin's Prints', *Buffalo News*, 4 January.

W. Oliver, 'Cartwright Hall, Bradford: Ninth British International Print Biennale', *The Yorkshire Post*, 22 March, p. 12.

Jacqueline Brody, 'Howard Hodgkin, *David's Pool* and *David's Pool at Night* (1985)', *The Print Collector's Newsletter*, vol. 17, no. 1, March–April, p. 17.

Susan Fischer, 'Dolan Maxwell Gallery, Philadelphia', *New Art Examiner*, vol. 13, April, p. 60.

'Christie's Events: Sponsorship', *Christie's International Magazine*, May–June, p. 78.

Keith Clements, 'Artists & Places – Nine: Howard Hodgkin', *The Artist*, vol. 101, no. 8, August, pp. 12–14.

Guy Burn, 'Odette Gilbert Gallery', *Arts Review*, vol. 38, no. 15, 1 August, p. 419.

Margaret Moorman, 'New Editions: Howard Hodgkin', *ARTnews*, vol. 85, no. 8, October, p. 105.

Judith Dunham, 'Howard Hodgkin's Accumulated Memories', *PrintNews*, vol. 8, no. 1, winter, pp. 4–7, 25.

1987

Åsmund Thorkildsen, 'Howard Hodgkin på Høvikodden', *Drammens Tidende og Buskeruds Blad*, 12 February.

Even Hebbe Johnsrud, 'Howard Hodgkin', *Aftenposten*, 19 February.

'Litografier i Ibsenhuset', *Telemark Arbeiderblad*, 12 March.

'Anerkjent brite i Ibsenhuset', *Varden*, 14 March.

Jacqueline Brody, 'Howard Hodgkin, *Red Palm* (1986)', *The Print Collector's Newsletter*, vol. 18, no. 1, March–April, p. 21.

Paul Nielsen, 'Den unikke kunst leveret af britte', *Horsens Folkeblad*, 13 April.

Ib Sinding, 'Ornamentale rum', *Jyllands-Posten/ Morgenavisen*, 15 April.

Gertrud Købke Sutton, 'Engelsk intimitet', *Information*, 15 April.

Christine Temin, 'Hodgkin Paints Sensual Emotions', *Boston Globe*, 27 June.

'Cor britânica. Belas gravuras do inglês Howard Hodgkin', *Veja*, 22 July, p. 117.

'Emoções bem Gravadas', *Isto E*, 22 July.

Reynaldo Roels Jr., 'Ingles, mas sem radicalismos', *Jornal do Brasil*, 24 July.

Lora Urbanelli, 'Howard Hodgkin', *Rhode Island School of Design*, vol. 74, no. 2, October, p. 43.

1988

'Grabados británicos', *El Sur*, 13 July.

'Grabados de Howard Hodgkin', *El Sur*, 17 July.

1989

Guy Burn, 'Prints: Curwen Gallery', *Arts Review*, vol. 41, no. 1, 13 January, pp. 11–13.

1990

Guy Burn, 'Prints: Lumley Cazalet', *Arts Review*, vol. 42, no. 14, 13 July, pp. 374–75.

'Underground Art', *The Economist*, 28 July, p. 90.

Robin Stemp, 'Howard Hodgkin: Ganz Gallery', *Arts Review*, vol. 42, 2 November, p. 600.

1991

Geordie Greig, 'The Fine Art of Healing by Art', *The Sunday Times Magazine*, 10 March, pp. 42–46.

Robert Hartman, 'Windsor Knot', *The Daily Telegraph*, 22 March, p. 23.

Rosemary Simmons, 'Howard Hodgkin: New Hand-coloured Prints', *Printmaking Today*, no. 2, spring, pp. 7–8.

Marina Vaizey, 'A Map of the Modern', *The Sunday Times*, 7 April, p. 13.

Cathy Courtney, 'Susan Sontag & Howard Hodgkin, *The Way We Live Now*', *Art Monthly*, vol. 146, May, p. 27.

Robert Clark, 'Manchester: Howard Hodgkin', *The Guardian*, 27 June.

Martin Vincent, 'Hodgkin Prints – Castlefield Gallery', *City Life – Greater Manchester's What's On*, July.

1992

Jack Hughes, 'Cries & Whispers: London Transport', *The Independent on Sunday*, 12 January, p. 22.

Barbara MacAdam, 'Speaking of the Unspeakable', *ARTnews*, vol. 91, no. 3, March, p. 20.

Zoe Heller, 'Howard's Way', *Harpers & Queen*, April, pp. 152–56.

'An Abstract Awareness', *The Pink Paper*, 3 May.

Maggie Parham, 'Art for AIDS' Sake', *The Evening Standard Magazine*, 8 May, pp. 76–77.

David Lee, 'BBC Billboard Project', *Arts Review*, vol. 44, June, pp. 234–35.

James Cary Parkes, 'The Way We Live Now', *The Pink Paper*, 6 September.

1993

Jacqueline Brody, 'Howard Hodgkin, *Street Palm* (1990)', *The Print Collector's Newsletter*, vol. 24, no. 3, July–August, pp. 108–09.

Martin Filler, 'Howard Hodgkin is Tired of Being a Minor Artist', *The New York Times*, 5 December, p. 43.

1994

David Sylvester, 'An Artist whose Métier is Black and White', *The Daily Telegraph*, 6 August, p. 6.

Robin Cembalest, 'Artists Experiment between the Covers at MoMa', *Forward. Ethnic Newsletter*, 18 November, p. 10.

1995

Jacqueline Brody, 'Howard Hodgkin, *Venetian Views* (1995)', *The Print Collector's Newsletter*, vol. 26, no. 3, July–August, pp. 104–05.

Iain Gale, 'In the Realm of the Senses', *The Independent*, 28 November, pp. 8–9.

1996

Jacqueline Brody, 'Howard Hodgkin, *Snow* (1995)', *The Print Collector's Newsletter*, vol. 27, no. 1, March–April, pp. 27–28.

Brooks Adams, 'Hodgkin's Subtexts', *Art in America*, vol. 84, May, pp. 90–97, 125.

Nan Rosenthal, 'Howard Hodgkin. *Venice, Evening*', *The Metropolitan Museum of Art Bulletin*, vol. 54, fall, pp. 64–65.

1997

Margaret Rosoff, 'Art for the People', *Print*, vol. 51, May–June, pp. 78–85.

Rosemary Simmons, 'Jack Shirreff and 107 Workshop: Getting Lost in Fear and Happiness', *Printmaking Today*, vol. 6, no. 4, winter, pp. 7–8.

1998

Anna Sansom, 'Home is Where the Art is', *Harpers & Queen*, August, p. 48.

Sabine Arlitt, 'Farb-Magier', *Tages-Anzeiger / Züri tip*, 16 October, p. 61.

1999

Paul Levy, 'IMAX Presents Hodgkin in the Round', *The Wall Street Journal Europe*, 14–15 May, p. 15.

General literature

Charles Spencer (ed.), *A Decade of Printmaking*, London and New York, 1973.

Riva Castleman, *Contemporary Prints*, New York, 1973.

Pamela Zoline, 'Chris Prater and Kelpra Studios', *Arts Review*, vol. 29, no. 16, 5 August 1977, p. 504.

Edward Lucie-Smith, 'Prints at Bradford', *Art & Artists*, vol. 14, no. 3, July 1979, pp. 18–21.

Riva Castleman, *Printed Art: A View of Two Decades*, exh. cat., The Museum of Modern Art, New York, 1980.

Elizabeth Underhill (et. al.), *Catalogue of the Print Collection*, Tate Gallery, London, 1980.

Colta Ives, *The Painterly Print: Monotypes from the Seventeenth to the Twentieth Century*, exh. cat., The Metropolitan Museum of Art, New York, 1980.

Air and Space Appeal Fund Contemporary Art Auction, exh. cat., AIR Gallery, London, 15 October 1980, no. 71.

Bruce Chatwin (intro.), *Indian Leaves: Howard Hodgkin. With a Portrait of the Artist by Bruce Chatwin*, London and New York, 1982.

Michael Compton (intro.), *Howard Hodgkin's Indian Leaves*, exh. cat., Tate Gallery, London, 1982.

Julian Andrews (intro.), *The British Council Collection 1938–1984*, London, 1984.

The Tate Gallery: Illustrated Catalogue of Acquisitions 1980–82, London, 1984.

David Sylvester, 'Howard Hodgkin interviewed by David Sylvester', in *Howard Hodgkin: Forty Paintings 1973–84* (British Council Touring Exhibition), 1984–85.

The Tate Gallery: Illustrated Catalogue of Acquisitions 1984–86, London, 1988, pp. 386–89.

David Brown (intro.), *Corsham: A Celebration. The Bath Academy of Art 1946–72*, exh. cat., Victoria Art Gallery, Bath (touring), 1988–89.

Amanda Mitchison, 'An Object-Lesson in Art', *The Independent Magazine*, 18 February 1989, pp. 44–47.

Simon Wilson, *Tate Gallery: An Illustrated Companion*, London, 1989, pp. 256–57.

Frances Carey and Antony Griffiths, *Avant-garde British Printmaking 1914–1960*, exh. cat., British Museum, London, 1990.

Silvie Turner, 'Printmaking Studios in Britain: the Continuing Tradition', *Print Quarterly*, vol. 7, no. 4, December 1990, pp. 397–413.

Robin Garton (ed.), *British Printmakers 1855–1955: A Century of Printmaking from the Etching Revival to St Ives*, Devizes, 1992.

Antony Peattie (interview), *Howard Hodgkin*, exh. cat., Anthony d'Offay Gallery, London, and Knoedler & Company, New York, 1993–94.

Andrea Rose (intro.), *The British Council Collection 1984–1994*, The British Council, London, 1995.

Galerie Wolfgang Ketterer, Editionen 1963–1995, Galerie Wolfgang Ketterer, Munich, 1995.

Antony Griffiths, *Prints and Printmaking: An Introduction to the History and Techniques*, London, 1980 and 1996.

Susan Tallman, *The Contemporary Print from Pre-Pop to Postmodern*, London, 1996.

Michael Auping (et. al.), *Howard Hodgkin Paintings*, exh. cat., London and the Modern Art Museum of Fort Worth, Fort Worth, Texas, 1995.

Riva Castleman, *Prints of the Twentieth Century*, London, 1976 and 1997.

Georg Imdahl (intro.), *Howard Hodgkin: Recent Work*, exh. cat., Galerie Lawrence Rubin, Zurich, 1997.

Alan Cristea Gallery 1998–99, Alan Cristea Gallery, London, 1998.

John Hutchings (intro.), *Forty Years at Curwen Studio 1958–1998*, exh. cat., Curwen Gallery and The New Academy Gallery, London, 1998.

Alan Cristea Gallery 1999–2000, Alan Cristea Gallery, London, 1999.

Andrew Graham-Dixon, *Howard Hodgkin* (revised and expanded edition), London, 1994 and 2001.

Artist's statements and interviews

1966

Jasia Reichardt (ed.), 'On Figuration and the Narrative in Art. Statements by Howard Hodgkin, Patrick Hughes, Patrick Procktor, and Norman Toynton', *Studio International*, vol. 172, no. 881, September, pp. 140–44.

1976

'Howard Hodgkin Talking to Pat Gilmour About his Prints', recorded conversation of interview, plus unpublished notes (tape and notes kept at the Tate Gallery Archive, London), 1 April.

1980

'Peter Blake and Howard Hodgkin in California', *Ambit*, no. 83, pp. 3–11.

1986

Luciana Mottola, 'I Begin Pictures Full of Hope. Four Questions Posed to Howard Hodgkin', *891. International Artists' Magazine*, vol. 3, no. 7, December, pp. 12–15.

1987

Åsmund Thorkildsen, 'En samtale med Howard Hodgkin', *Kunst og Kultur*, no. 4, pp. 220–34.

1991

Antony Peattie (interview), *Howard Hodgkin: Hand-coloured Prints 1986–1991*, exh. cat., Waddington Graphics, London.

1992

'The Way We Live Now', interview with the BBC, 30 April (transmitted on 1 May).

Photographic credits

Colour plates

The figures refer to the pages on which the plates appear:

The British Council © The Artist 71

Petersburg Press 87

© Queen's Printer and Controller of HMSO, 2003. UK Government Art Collection 85

© Tate Gallery, London, 2003 10, 11, 28, 52, 53, 63, 69, 78, 79

Catalogue raisonné

The figures refer to the entry numbers:

The British Council © The Artist 32, 36, 38, 66

Copyright British Museum, London 10

National Gallery of Australia, Canberra 31

Philadelphia Museum of Art: Gift of the Friends of the Philadelphia Museum of Art 77

© Queen's Printer and Controller of HMSO, 2003. UK Government Art Collection 70

© Tate Gallery, London, 2003 23, 47, 48

Index